ACTIVIST ART
IN SOCIAL JUSTICE
PEDAGOGY

Studies in the
Postmodern Theory of Education

Shirley R. Steinberg
General Editor

Vol. 403

The Counterpoints series is part of the Peter Lang Education list.
Every volume is peer reviewed and meets
the highest quality standards for content and production.

PETER LANG
New York • Washington, D.C./Baltimore • Bern
Frankfurt • Berlin • Brussels • Vienna • Oxford

ACTIVIST ART
IN SOCIAL JUSTICE
PEDAGOGY

Engaging Students in Glocal Issues through the Arts

EDITED BY *Barbara Beyerbach &*
R. Deborah Davis

PETER LANG
New York • Washington, D.C./Baltimore • Bern
Frankfurt • Berlin • Brussels • Vienna • Oxford

Library of Congress Cataloging-in-Publication Data

Activist art in social justice pedagogy: engaging students in glocal issues through the arts /
edited by Barbara Beyerbach, R. Deborah Davis.
p. cm. — (Counterpoints: studies in the postmodern theory of education; v. 403)
Includes bibliographical references.
1. Social justice—Study and teaching. 2. Teaching—Social aspects.
3. Critical pedagogy. 4. Art in education—Social aspects.
5. Arts—Study and teaching. I. Beyerbach, Barbara. II. Davis, R. Deborah.
LC192.2.A38 372.5'044—dc23 2011018237
ISBN 978-1-4331-1231-7 (hardcover)
ISBN 978-1-4331-1230-0 (paperback)
ISSN 1058-1634

Bibliographic information published by **Die Deutsche Nationalbibliothek.**
Die Deutsche Nationalbibliothek lists this publication in the "Deutsche
Nationalbibliografie"; detailed bibliographic data is available
on the Internet at http://dnb.d-nb.de/.

The paper in this book meets the guidelines for permanence and durability
of the Committee on Production Guidelines for Book Longevity
of the Council of Library Resources.

© 2011 Peter Lang Publishing, Inc., New York
29 Broadway, 18th floor, New York, NY 10006
www.peterlang.com

Printed in the United States of America

Contents

Acknowledgments

We would like to acknowledge the many activist artists, educators, and students whose work has inspired us to write this book. We also thank the contributors, their colleagues, and students whose collective work has provided us with a year of learning and wonderful resources to share. Special thanks to our SUNY Oswego Curriculum and Instruction Department Chair, Pam Michel, for always supporting our work. For reading several chapters of the work and providing encouragement, feedback, and valuable suggestions, we thank members of the writing group—Jean Ann, Bonita Hampton, Mary Harrell, Sharon Kane, Tania Ramalho, Bobbi Schnorr, and Chris Walsh. Thanks to Traci Terpening and Beth Canale for reading and editing many of the chapters. And last, but certainly not least, thanks to our families for their encouragement and support.

Transformation: Dreaming Change

A MIXED MEDIA COMPOSITION BY
CYNTHIA CLABOUGH

Artist Statement

As a young girl wondering what the future would bring I watched boys go off to play soldier, returning scarred and broken. I saw the big brothers and sisters of my generation gunned down for daring to protest. It is forty years later and the story continues to unfold much the same. So just before I am consumed by grief and frozen by the overwhelming enormity of the problems around me, I remind myself that I have the power to change the world by imagining that things are different. What if we buried all the weapons of violence, could people then be free to soar through the sky? Animals able to move freely? Mingle freely? Would the earth and sky burst forth in passionate colors? The power of art is it can deliver you to another reality.

Introduction

BARBARA BEYERBACH

I am watching a video of a group of young Afro-Brazilian girls, perhaps second or third graders, on a rooftop of a *favela* dwelling in Rio de Janeiro, arguably one of the most violent places on earth. They are playing violins—slowly, note-by-note—bowing the tune of John Lennon's "Imagine." With them, drummers from AfroReggae's troupe, a group made up largely of former or would-be drug traffickers from the *favela*, are setting the beat and singing the vocals in English. The tempo shifts, the drummers accelerate, the lyrics become Portuguese rap, and the message of hope and peace explodes from this rooftop through a most unlikely juxtaposition of sounds and images. Embodying the meaning of "glocalization," global themes are transmuted by local contexts to make meaning relevant to the lives of these diverse community members. Traditional African drumming, classic European violin, hip-hop beats, London-based Beatles lyrics, and samba rhythms combine to form a powerful synergy of creative expression in this moving piece, reflecting the hybridity of our times (*Nenhum Motivo Explica a Guerra*, 2006). These participants are members of one of AfroReggae's 60 programs in Rio's *favelas*, aimed at bringing about social change through community-based arts and activism.

Communicating with people around the world and sharing dreams and visions for a better tomorrow is in some ways easier than ever before. The Internet, as well as ease of travel, creates spaces for us to learn from and build upon each other's work. Consider a couple of examples. On YouTube you can see and hear musicians

from around the world collaborating to perform in *Playing for Change, Song around the World* (Mama, 2010; Playing for Change, 2010). Visual artists can collaborate to produce a mural supported by Judith Baca and the Social and Public Arts Resource Center (SPARC) called *World Wall: A Vision of the Future Without Fear*, which can be viewed virtually, and is now traveling as an exhibition throughout the world (http://www.sparcmurals.org).

Yet the potential to misunderstand, misinterpret, and be misinformed is also great. Wars proliferate; poverty is widespread; and racism, sexism, and other forms of social injustice continue to exist. In an era of new, multimedia, and web-based learning, critical viewing is becoming increasingly important as a basis for K–16 instruction. Books abound demonstrating the importance of including the arts, and critical media literacy, in K–12 teaching (Davis, 2008; Hetland, Winner, Veenema, & Sheridan, 2007; Macedo & Steinberg, 2007).

Nevertheless, in many school contexts, particularly in financially strapped urban and rural settings, art educator positions are being eliminated as part of a back-to-basics movement. A recent RAND study on arts learning and state policies (Zakaras & Lowell, 2008) found that arts are experienced by a small, wealthy segment of the population that is aging, and that a small percentage of funding goes to arts learning. Yet the arts have a documented history of engaging marginalized youth in learning and social change. Artists have always had a role in imagining a more socially just, inclusive world—many have devoted their lives to realizing this possibility. In a culture ever more embedded in performance and the visual, examining the role of arts in multicultural teaching for social justice is a timely focus. In this work, authors describe a number of models for integrating the arts in K–16 teaching for social justice. Chapters by various activist artists/educators will describe successful activist artist movements contributing to social change in the United States and around the world. They share the knowledge gained from these movements and document how they have changed both participants and social contexts. Approaches to using activist art to learn and to teach a richer, multicultural curriculum are examined and critiqued. These examples of activist artists and their strategies illustrate how study of and engagement in activist art processes can deepen both critical literacy and commitment to social justice.

In Chapter 1, I draw from my own experiences as a painter, teacher educator, and activist for social change to describe how art helps me think more deeply about social issues. I examine research on and describe strategies and approaches to social justice through the arts, laying a framework for the rest of the book. Chapters 2 and 3 examine artist activist movements by visual artists and musicians in rural and urban contexts in both Brazil and the United States. In Chapter 2, Tania Ramalho and Leah Russell examine the role of visual artists in the Landless Movement in Brazil as well as the Farmworker Movement in the United States, illustrating how

artists can play a pivotal role in social change, and how engaging learners in the arts can further their understanding of the world. In Chapter 3, Leah Russell examines the role of AfroReggae in the lives of *favela* residents in Rio de Janeiro, drawing comparisons with the hip-hop movement in the United States.

In Chapter 4, Jacquelyn Kibbey, an artist and art educator, draws from educational theorists as she describes how essential art is in helping learners critically analyze and understand media representations of the world around them. She grounds her work in the collaboration she has with an area high school committed to social justice through the arts. In Chapter 5, teacher educator Mary Harrell draws from analytical psychology to describe learning processes and outcomes of her preservice and practicing teachers in her "Imagination Through the Curriculum" approach. Chapter 6 extends the focus on critical literacy as Dennis Parsons, a literacy educator, describes the photo-documentary work and reflections of preservice teachers in a two-week immersion course in New York City schools. In Chapter 7, Jane Winslow, a filmmaker and professor, describes undergraduate students' documentary film work in social justice-oriented projects in her course on film editing.

Chapter 8 focuses on the work of elementary educator Chris Capella, Native American art teacher at the Onondaga Nation School, as documented and interpreted by literacy educator Jennifer Kagan. Chapter 9 continues a critical analysis of Native American Art and Artists, by art historian Lisa Roberts Seppi, who provides a detailed analysis of two artists' work, illustrating the social justice issues raised. Chapters 10 and 11 both focus on the role of feminist artists and processes in social change. In Chapter 10, Carrie Nordlund, Peg Speirs, Marilyn Stewart, and Judy Chicago collaborate to describe development and impacts of the K-12 curriculum developed for Judy Chicago's seminal feminist contribution, *The Dinner Party*. In Chapter 11, art historian Lisa Langlois examines learning of undergraduates in a general education visual literacy course that focuses on gender as a lens for analyzing visual and performance arts, and that engages learners in activist art projects to enhance their understanding of and commitment to social change.

The authors of Chapter 12, who are English and Communications Studies professors and their students, continue to examine pedagogies for engaging undergraduates in provocative art experiences that impact their understanding of social issues. In this chapter, Patricia Clark, Ulises Mejias, Peter Cavana, Sharon M. Strong, and Daniel Herson collaborate to describe and analyze the impact of a computer simulation in which they participated on understanding of and commitment to eradicating racism. In Chapter 13, visual artist Barbara Stout describes how issues of race, gender, and sexuality are explored and examined through her portraiture work. In Chapter 14, we again broaden the lens to global issues as visual artist activist Suzanne Bellamy describes her role in the Transition Towns move-

ment for social change. Chapter 15 synthesizes themes from prior chapters and shares additional K–16 resources for social justice through the arts.

This collection of work contributes to the local U.S. multicultural education movement, opening doors to global forces for change, as we become strong allies of progressive movements within and outside our borders. The chapters address global movements through the arts in critical multicultural education. Some provide theoretical grounding, examining contested definitions of artist, activist, spectator, and social justice. Others provide rich examples of curriculum framed around activist art pedagogy. This book is relevant to those (1) interested in learning and teaching more about artist/activist social movements around the globe; (2) involved in preparing preservice teachers to teach for equity and social justice; (3) concerned about learning how to engage diverse learners through the arts; and (4) teaching courses related to arts-based multicultural and global education, critical literacy, and culturally relevant teaching. We aim to inspire educators K–16 to think about how to integrate arts for social justice across the curriculum.

References

Davis, J. (2008). *Why our schools need the arts*. New York: Teachers College Press.

Hetland, L., Winner, E., Veenema, S., & Sheridan, K. (2007). *Studio thinking: The benefits of visual arts education*. New York: Teachers College Press.

Macedo, D., & Steinberg, S. R. (2007). *Media literacy*. New York: Peter Lang.

Mama, C. (2010). *Playing for change*. Retrieved August 7, 2010, from http://www.youtube.com/watch?v=I23Bkk92124

Nenhum motivo explica a guerra. (2006). Dir. Caca Diegues. Prod. Renata Magalhaes & Flora Gil. Warner Music Brasil Ltda., DVD.

Playing for Change. (2010). *Songs around the world*. Retrieved from www.playingforchange.com

Social and Public Art Resource Center (SPARC). (2010). *World wall: A vision of the future without fear*. Retrieved August 7, 2010, from http://www.sparcmurals.org

Zakaras, L., & Lowell, J. (2008). *Cultivating demand for the arts: Arts learning, arts engagement, and state arts policy*. Santa Monica, CA: RAND Corporation.

Social Justice Education Through the Arts

BARBARA BEYERBACH

Introduction

As a painter I can speak from personal experience about the role my work plays in my understanding of the world. Often when I travel I take photographs and work from these photos in my painting. Other times I seek source images to help me think about an issue I am researching. After travel to Benin, West Africa, in 2006, for example, I was fascinated by the role of women in the marketplace, as well as by the colorful fabrics, fruits, and merchandise in this bustling space. I was perplexed by the presence of Western baseball caps and Disney t-shirts amid brightly patterned, traditional West African fabrics and foods. I was disturbed by the amount of discarded plastic on the grounds in and surrounding the market in this country, which had no infrastructure for waste management. I reflected deeply as I painted the marketplace—on colonization; postcolonial relationships between Benin, France, and the United States; the role of women in the society; the environment; my role as spectator; and the ethics of appropriating images.

For me, painting—usually a process of representation of a place that holds special meaning for me—is always a powerful process of reflection and theorizing, as well as a deeply sensual engagement with the colors, hues, and rhythms of a place. Many learners find the arts to be not only a means of self-expression, but also of understanding one's self and the world in a different way.

In this chapter, I will:

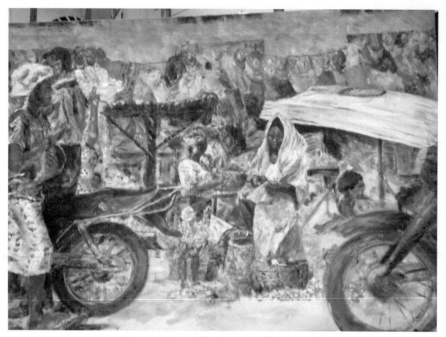

Figure 1. Benin Marketplace, *B. Beyerbach.*

1. Address the question of why a "social justice through the arts in education" approach makes sense;
2. Describe examples of preservice teacher assignments examining artists' roles in activist movements, promoting multicultural understanding and social justice; and
3. Share approaches to and examples of using the arts in the United States and beyond to deepen multicultural understanding and teaching for social justice.

I begin by sharing a couple of images from my paintings and reflections about them to illustrate how art provides a reflective space for questioning existing patterns and theorizing about social contexts and change.

Why Social Justice Through the Arts? A Personal Response

I was taking a course on the use of Photoshop and Illustrator, and working on an assignment to represent a massacre using one of these software programs. I began my project by reflecting on massacres that have occurred through the ages, re-

searching some of these, and choosing eventually to examine more deeply a contemporary and less-well-known massacre. I honed in on a news report of a 2005 massacre in Kenya, reported through several Internet news sites (BBC News, 2005, July, 13; IRIN, 2005). I imagine there must have been only one reporter on the scene, since the same source photos were used at these sites. I began to study these images—a mother with a wounded child, a man soldier, a pile of clothed bodies, and a nurse tending a woman who had been shot in the face. It struck me, as I looked at these photos, that the sky was bright blue with a few fluffy white clouds on that day. I began to draw and paint from several of the human images, cropping photos, studying facial expressions, imagining what it must feel like to witness such an event in one's home community. I scanned some of these drawings to become "layers" in Photoshop, along with cropped images from the photos.

The process of painting for me slows down the barrage of images pulsing in my consciousness. Art allows me to take some things in deeper, imagine the consequences, and dream of alternatives. It allows me to make a "statement" in ways that words do not, to empathize with strangers, to struggle with my role in issues of social injustice. The argument that led to this particular massacre in the village of Turbi, in which 22 children and dozens of adults were killed, most likely revolved around a long-standing dispute over pastures and water access (BBC News, 2005, July 18). Livestock was stolen; children were hacked with machetes as they walked to school. People were hungry. People were dead. I reflected on the incredible privilege I carry in the world, to always have plenty of food, to never witness piles of

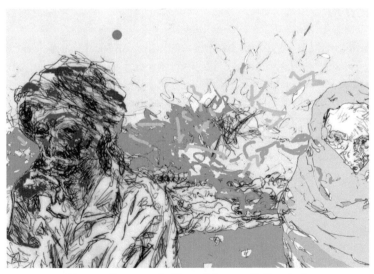

Figure 2. Drawing for Kenya Massacre, B. Beyerbach.

dead bodies freshly massacred in my neighborhood. I wondered about my role and responsibilities as I examined these images, weaving them into a photomontage that expressed my feelings of despair and hopes for the world.

Completing this assignment was meaningful to me on a number of levels. I developed some technical skills in manipulating images in software programs, as well as research skills in finding information from alternative news sources. I learned a little more about Kenya and that region of Africa—its people, struggles, and conflicts. I learned more about myself: my privilege, choices, and ignorance. I created a work to try to represent the strength, anguish, and hope I "saw" in the faces of the strangers captured by the photographer whose source images I appropriated to complete this work. As I worked on my own representations in this studio class, I listened to fellow students discuss the Holocaust, the Armenian massacre, and other atrocities. I marveled at the pedagogy of our professor, Cynthia Clabough, artist activist and now chair of the State University of New York at Oswego Art Department, who is noted for integrating social justice issues into all of her assignments, and for orchestrating displays of student work to engage and inform a broader audience. "This is what it means to teach for social justice," I thought. *The Benin Marketplace* and *The Kenya Massacre* are but two of my experiences of art process contributing to my deeper understanding of issues of power, oppression, and commitment to social change. My experiences as a learner in this course inspire me to bring a "social justice through the arts" approach to my teaching.

Using Social Justice Through the Arts in *Culturally Relevant Teaching*

In my hometown I have also focused my paintings on local issues of social justice, painting images of the polluted Lake Ontario and of a burned-out, abandoned paper plant that now displays a "For Sale: Will Remodel to Suit" sign amid the industrial debris remaining on this property near the lake. I use these images in my teaching of an undergraduate course, *Culturally Relevant Teaching*, in which I invite preservice teachers to imagine the history that led to the images they are viewing, and to raise questions about roles, responsibilities, and issues represented. I also integrate art experiences in this course, for example, by having these preservice teachers create a visual image representing their culture. They bring in their images—some paintings, some computer graphics, and many photomontages or collages—and we hang them around the room and take a silent gallery walk. We describe what we see, and then each individual talks about his or her image, sharing connections to his or her identity and culture. For example, one student brings an image of a Celtic ring that represents the importance of her Irish heritage in her

upbringing. She also juxtaposes images of beer bottles and football, sharing that her family bonded around the television, drinking beer and watching sporting events. Another brings a photo collage of extended family members who shared a two-story home in a working-class neighborhood. Another divides her images into two disconnected puzzle pieces, sharing that she knows little about her father's heritage, but knows a great deal about the Italian American cultural foods and traditions represented in the larger puzzle-piece drawing from her mother's side of the family. This begins a semester-long journey into examining our own and each other's cultural autobiographies.

In another assignment I have students examine popular culture, first surveying what books, cartoons, TV shows, video games, and so forth, with which their own K–6 practicum students are engaging. They then critically examine and deconstruct stereotypes represented in these, search for and reflect on more culturally relevant media, and share the resources they find. In a third arts-based assignment, preservice teachers study a single ethnic group in the United States and plan a "social justice through the arts" lesson where they highlight art/artists from that group and their contributions to social change. Preteachers bring in images from contemporary art, graphic novels, spoken word from YouTube videos, and music lyrics from contemporary performers, and are eager to share resources they have found in engaging multimedia presentations. They start from the contemporary work and research the meanings represented in the work through a history of that group's experiences within the United States. They help each other to understand the impact of multiple oppressions on the lived experiences of their contemporaries. Their presentations are alive in a way that previous groups using more traditional forms of presentation were not.

Similarly, Naidus (2007) uses media literacy and "culture jamming" exercises in which she has students bring in offensive ads from magazines and then hangs them on the wall to have her students deconstruct the meaning within them. "Culture jamming, also known as subvertizing, involves a practitioner subverting the force of an advertisement through satire in order to reveal its real message. For instance, Ester Hernandez's well known poster of a skeleton holding a basket of grapes entitled 'Sun-Mad Raisins' redirects the original advertisement's message about the sweetness of Sun Maid Raisins to the issue of the poisoning of farm workers" (p. 148). Naidus's students eagerly construct and share their own images using "subvertizing" and become increasingly interested in media literacy.

Finally, I have my preservice teachers examine curriculum for K–12 learners integrating social justice through the arts. We take Lee Ann Bell's storytelling project (Bell, 2010) and use a jigsaw approach, forming small groups. Each group reports on one of her four types of stories and how it is used to develop an antiracist stance and commitment. Bell's work is a rich resource of poetry, images,

songs, and narrative stories that are organized into a coherent theoretical model that helps preservice teachers deconstruct how:

1. *stock stories* reproduce racism and white privilege;
2. *concealed stories* reclaim memory and insider knowledge of subjugated groups;
3. *resistance stories* share antiracist legacies and ally work providing examples of activism; and
4. *emerging/transforming stories* challenge racism in everyday life.

Bell includes activist visual art, poetry, music, and theater, with a wealth of curricular ideas and activities aimed at social change in the storytelling project curriculum. Preservice teachers explore how they would use both the curricular materials and the framework in their own practicum experience. They go beyond this to find moving stories that convey issues in powerful ways. An example is the group who presented on Chicana/o issues by sharing the powerful YouTube video of spoken word artist Amalia Ortiz (2010), whose poetry—juxtaposed with images of atrocities against women in Juarez—communicates disturbing information about violence against women that compels us to action.

In my own teaching experience, I have found that using the arts to teach about social justice issues engages students and challenges them to think deeply. They connect to contemporary arts in ways that they do not connect to more traditional texts, and engage with the issues on a deeper level. They share their own stories and examples from others they have encountered, and personalize the learning. They are quicker to identify patterns and understand issues and are less inclined to construct walls of resistance. Bell's work is one of several useful frameworks for developing curriculum aimed at teaching about social justice through the arts.

Approaches and Examples of Teaching Social Justice Through the Arts

There is a wide range of successful strategies for engaging learners of all ages in meaningful artist activist projects, and many of these are adaptable to local community needs. Strategies investigated in the literature include:

- Studying activist artists' work;
- Studying artists' lives and activism, including what Lippard (2009) describes as avant-garde artists, political artists, and community artists;

- Engaging students in activist arts projects;
- Enhancing learning through arts-based education; and
- Developing critical literacy through engagement with the arts.

Each of these strategies is employed and expanded upon by various authors throughout this book.

Naidus, in "Teaching Art as a Subversive Activity" (2005), says the concept of art for social change dates back to the 15th century, with the invention and use of the printing press to raise issues about injustices experienced by peasants under feudal lords and the church. The arts have been promoted as a means for engaging diverse learners, as a strategy to promote multicultural global awareness, and as a vehicle for improving student achievement (Cahan & Kocur, 1996; Hetland, Winner, Veenema, & Sheridan, 2007; Runell Hall, 2008).

The visual and performance arts have been promoted by many as a means to support teaching for social justice, and artists have a long tradition of social activism (Martinez, 2008; Powell & Speiser, 2005; Menkart, Murray, & View, 2004). There is a proliferation of work clarifying what it means to teach for and about social justice, from a variety of perspectives (Russo & Fairbrother, 2009). Maurianne Adams (2010) synthesizes scholars' descriptions of the roots of social justice pedagogy emerging from grass-roots, community, or academic traditions, identifying six principles of practice:

- Balance emotional and cognitive components of learning;
- Acknowledge and support the personal while "illuminating the systemic";
- Attend to social relations in the classroom;
- Use reflection, experience, and student-centered learning;
- Value awareness, personal growth, and change; and
- "Acknowledge and seek to transform the many ways in which identity-based social position and power, privilege and disadvantage, shape participant interactions in the classroom and everyday contexts" (pp. 60–61).

For example, Adams cites the influence of Boal's *Theater of the Oppressed* as creating a space for actor/audience dialogue about oppressions, leading to deeper understandings of societies as well as possibilities for political awareness and change. Parkes, Gore, and Elsworth (2010) draw on poststructural theory to help teachers envision social justice pedagogy where they help students to become free by providing them with the tools

> that allow them to disassemble their own subjectivities, and reconstitute themselves in new forms.... We can assist our students in this task when we make

available mediating artifacts that can act as tools to serve our practice of free-dom, in the same way that discourses may have acted as constitutive agents in our social construction. (p. 178)

Recent authors (Desai, Hamlin, & Mattson, 2010; Bell, 2010) have expanded our understanding of *how* to apply various approaches to teaching social justice through the arts.

One useful framework for thinking about social justice through the arts comes from Desai and colleagues' *History as Art, Art as History* (2010), in which two art ed-ucators and a historian apply the methods of their fields to produce a methodology for using visual texts in teaching both art and history, focusing on issues of social justice. They share both a methodology and a set of interdisciplinary resources and teaching strategies for engaging middle and secondary students with issues con-cerning the topics of citizenship, race, and the United States and the world. In her "Using Visual Historical Methods in the K–12 Classroom: Tactical Heuristics" (2010), Rachel Mattson describes five heuristics that are useful for teaching stu-dents to read contemporary art in a historical framework:

- *Source heuristics* (from Wineburg) raise questions such as who created the work of art and why;
- *The insider/outsider frame heuristic* (from Wexler) has students describe what they see both outside the frame (e.g., the title of the work) and inside the frame (e.g., what objects, settings, images are portrayed with what materials);
- *Reading intertextually* (from Jaffee) engages students in reading written sources relating to the material within and outside the frame;
- *Applying historical interpretive strategies*, such as framing historical ques-tions and making historical arguments, helps students read artwork more deeply; and
- *Interpreting visual codes and conventions*, for example, using juxtaposition as a narrative method, offers students new modes of expression and under-standing.

In the tool kit section of the book in which Mattson's essay appears (Desai et al., 2010), there are in-depth examples of models applying these heuristics in teaching middle and high school students. The tool kit is organized around topics, each of which includes a historical essay introducing important debates, a mini archive of artwork and historical documents speaking to the theme, and a "teaching connec-tions" section that offers strategies for teaching with the materials. The teaching connections section introduces visual principles that are critical in nature, drawing from Olivia Gude's theoretical work (Desai et al., 2010). They offer explicit strate-

gies that can be taught to foster visual literacy. Rather than promoting an under-standing of art in purely aesthetic terms, these visual art strategies also include:

- *Borrowing*, or taking from an existing image to re-imagine the original to create new meaning;
- *Juxtaposition*, or placing items side by side to create new meaning or stim-ulate curiosity or disruption;
- *Recontextualization*, such as placing a familiar object in a new setting;
- *Interaction of Text and Image*, to challenge the viewer or to invite exploration;
- *Mash-up*, such as digitally combining music from one song with vocals from another, to integrate formerly unconnected forms; and
- *Layering*, to collect surfaces that build upon each other, or to create layers of meaning. (Collage is a visual layering approach.)

In the mini units at the end of the book, these strategies are integrated into teach-ing connections such as "observe, react, respond," or "constructing visual knowl-edge," promoting critical analysis and creation. Sets of questions for looking inside and outside the frame guide discussions of the art and introduce learners to a new vocabulary for meaning making.

Desai (2010) argues that "artists can challenge linear narratives of the past and the idea of 'objective' representations of history" (p. 49), thus reframing our under-standing of history. Artists provide an "embodied" way of knowing, involving mul-tiple senses and including an emotional component. Contemporary artists, she argues, are often interested in seeking out marginalized voices and creating a space where they are "heard." She identifies four methods used by contemporary artists—archive, oral history, historical reenactment, and autobiography/memoir—and ar-gues that these are relevant classroom practices for understanding both art and history. She suggests that "as an antidote to the mind-numbing culture of testing and correct answers, students can explore works of contemporary art models for enacting their own critical approaches to historical information and navigating the messy and difficult matter of the past" (Desai, 2010).

Quinn, in her article "Social Justice and Arts Education" (2010), opens with the statement that "all humans are innately artists" (p. 224), instantly deconstructing the hierarchy between artist and viewer, and challenging educators to educate all students in the arts. She traces the debate about the role and meaning of art in human history, reminding us that Aristotle suggested art was a form of civic edu-cation. Others have argued that art is a public good, a means to heightened expe-rience, a form of cultural history, a means of political action, and a human right. She says: "It is vital, a social justice concern, in fact, that all youth are offered an arts education" (p. 224). She traces the view that arts stimulate cognitive development

to Vgotsky, and draws on Maxine Greene's argument that arts engage all students and foster intellectual growth and development of the social imagination, leading students to develop the potential to invent visions of what should and might be. "Many theorists and practitioners have called for an arts education that clearly links the arts to social change" (p. 227), drawing from social reconstructionist, multicultural, and critical art education.

Quinn cites examples of collaborative art processes used by contemporary artist activists who create temporary activist and online projects. Two of these are the God Bless Graffiti Coalition, Inc., founded to fight anti-graffiti trends, and the Critical Art Ensemble, a group exploring issues around biotechnology. She identifies contemporary artists such as Nancy Pauly, whose work explores images of Abu Ghraib and raises consciousness about human rights issues, and Nancy Parks, who uses video games and new media in a "reconstructionist" arts education. She points out, however, that while these examples of social justice arts education exist, most art education is still dominated by a more formalist model in which aesthetics is disconnected from social context and social movements. This is what we aim to change. However, beyond developing social justice art education pedagogy, we want to see activist art processes and works infused throughout the curriculum as a means of engaging all learners in social justice education.

Many artists have been excluded from the mainstream throughout the course of history. There is increased attention to the study and collection of "outsider art," that is, art produced by those not schooled in "formal" processes. Publications such as *Raw Visions* and the *Folk Art Messenger* serve as resources for teachers and students to learn about the work of historically marginalized groups. I recently attended the annual conference of the Folk Art Society in Santa Fe. This was a wonderful opportunity to see the work of local Native American and Mexican American artists in the region, as well as the folk art collections of area residents. For example, we were able to hear Native American artist Margarete Bagshaw speak and to see her paintings. Margarete is a third-generation, full-time female painter, building on and transforming the traditions of her mother, Helen Hardin, and her grandmother, Pablita Velarde. She spoke of the tensions both of carrying on traditions as well as expressing her own creativity using modernist, contemporary abstractions in her work.

I also was privileged to meet collage artist John Williams at this conference. John creates rich-textured collages of historic figures, as well as landscapes, after carefully researching the individual and seeking to capture his inner emotional state. John's mother shared with me that John has Asperger's Syndrome, and is a strong visual learner. John describes his own world as chaotic and uses art to focus and channel his energy (Yandura, 2010). Though individuals with Asperger's Syndrome are often known for having difficulties reading and understanding social

cues, John's work is striking in its representation of personalities of historic figures, particularly through the representation of the eyes. His work, along with background information, is available on his website (http://www.johnmwilliamsfineart.com/) and is featured in *Drawing Autism* (Mullin & Grandin, 2009), a book featuring over 50 artists with autism. Mullin has extensive experience working with youth with autism and their families, and Grandin is a professor who also is autistic. The work represented in this collection is creative and compelling. I was inspired both by John Williams and his powerful advocate mother to learn more about the artists in this collection, as well as other artists with disabilities. I read an article about Pure Vision Arts, a studio and gallery for self-taught artists with developmental disabilities, in the *Folk Art Messenger* (Gengarelly, 2010) and was able to view vibrant work by artists in this collective, as well as learn of the individual stories of the artists and their allies. As an educator, I want to help to create such spaces within all of our public schools.

There have been numerous examples of activist artists contributing to social movements over the course of history. Studying the works and lives of these artists helps bring history alive. The introduction of this book shared three examples of activist artists who lead global initiatives for social change: AfroReggae, Playing for Change, and SPARC's World Wall. I will share a few additional examples of the variety of contributions activist art educators have made to a number of social movements in order to illustrate the types and variety of ways they work for social change with K–16 learners.

- In *Black Ants and Buddhists*, Cowhey (2006) offers a rich narrative about interactions with her preschool students around issues of social justice, starting from an inquiry about whether to kill an ant in the classroom. Preschoolers learn to value diverse life forms and to challenge injustices. She incorporates many examples of how the arts are integrated to help children think about social justice issues.
- In the United States, elementary school children from all over the country engage in an activist arts project designing "fundred dollar bills" to advocate for environmental cleanup of lead-poisoned soil in New Orleans. The fundred dollar bills will be delivered to Congress by a vaulted truck that visits their community to raise awareness and collect the bills, through the Fundred Dollar Bill Project (2010).
- Children of all ages create culturally relevant "Books of Hope" for K–12 learners in countries around the world, responding to the needed topics identified by educators in that particular school/country (Books of Hope, 2010). Children research and learn about the country and topic, and communicate with children from other countries.

- Children in North and South Korea draw images of peace for an installation in a demilitarized zone between these countries (Meyer, 2009).
- High school students collaborate with local artists, led by Judith Baca in Los Angeles to create historical murals on diverse ethnic groups' contributions to California history (Social and Public Art Resource Center, 2011).
- Peace Jam provides arts-based, multimedia programs for all ages exploring stories and work of 12 Nobel peace laureates, generating a worldwide movement of youth (Peace Jam, 2010).
- Performance artists Shawna Dempsey and Lorri Millan, in their performance *Lesbian National Parks and Services*, pose as forest rangers in their community, promoting friendly relationships with visitors and providing tourists directions and information. As part of their "out" reach activities, they pass out brochures that assert that "camouflage (though a useful short-term strategy) does not ensure long-term species survival. Be visible. Swell the ranks. Assert your territory. Never forget, lesbian life is an essential part of any healthy community" (Borsa, 2009, p. 25). They hope to debunk myths about gay and lesbian community members.
- The Feminist Art Project (n.d.) provides a space for artists, curators, teachers, and visual art professionals across cultural backgrounds and generations to develop and promote art events educating about a range of social justice issues.
- Art Rage, the Norton Putter Gallery, in Syracuse, New York, is a gallery collective focused on sponsoring artist activist exhibits for social change. Featuring artists such as Ellen Blalock, whose work includes the Central New York Family Project honoring the lives of lesbian, gay, bisexual, and transgender families, and *Beyond Boundaries in Ghana*, a documentary film on a cross-cultural exchange collaborative between Ghana and Syracuse, Art Rage engages schools and the community with contemporary artist activists.

These are but a few of the examples of the range of approaches to social justice through the arts. Authors in subsequent chapters will provide information on additional projects and strategies that provide inspiration and guidance to educators to engage learners in social justice through the arts.

References

Adams, M. (2010). Roots of social justice pedagogies in social movements. In T. Chapman & N. Hobbel (Eds.), *Social justice pedagogy across the curriculum: The practice of freedom*. New York: Routledge.

BBC News. (2005, July 13). Kenya massacre: Survivor's tales. Retrieved November 3, 2005, from http://news.bbc.co.uk/2/hi/africa/4678973.stm

BBC News. (2005, July 18). Seven arrested over Kenya attack. Retrieved November 3, 2005, from http://news.bbc.co.uk/2/hi/Africa/4694571.stm

Bell, L.A. (2010). *Storytelling for social justice: Connecting narrative and the arts in antiracist teaching.* New York: Routledge.

Books of Hope. (2010). *Books of hope.* Retrieved August 10, 2010, from www.booksofhope.org

Borsa, J. (2009). Rebels with a cause: The parodies and pleasures of our own disguises. *Paradoxa, International Feminist Art Journal, 23*, 20–29.

Cahan, S., & Kocur, Z. (Eds.). (1996). *Contemporary art and multicultural education.* New York: New Museum of Contemporary Art; Routledge.

Cowhey, M. (2006). *Black ants and Buddhists: Thinking critically and teaching differently in the primary grades.* Portland, ME: Stenhouse Publishers.

Desai, D. (2010). Artists in the realm of historical methods. In D. Desai, J. Hamlin, & R. Mattson (Eds.), *History as art, art as history.* New York: Routledge.

Desai, D., Hamlin, J., & Mattson, R. (Eds.). (2010). *History as art, art as history.* New York: Routledge.

The Feminist Art Project. (n.d.). Retrieved August 12, 2010, from http://feministartproject.rutgers.edu

The Fundred Dollar Bill Project. (n.d.). Retrieved August, 8, 2010, from http://fundred.org

Gengarelly, T. (2010). The artists of pure vision. *Folk Art Messenger, 21*(3), 11–14.

Hetland, L., Winner, E., Veenema, S., & Sheridan, K. (2007). *Studio thinking: The benefits of visual arts education.* New York: Teachers College Press.

IRIN. (2005, July 18). Kenya: 9,000 now displaced in tense Marsabit. Retrieved November 3, 2005, from http://en.wikipedia.org/wiki/Turbi_Village_massacre

Lippard, L. R. (2009). "Trojan Horses: Activist Art and Power." In: F. Frascina (Ed.). *Modern art culture: A reader.* New York: Routledge

Martinez, E. (2008). *500 years of Chicana women's history.* New Brunswick, NJ: Rutgers University Press.

Menkart, D., Murray, A., & View, J. (2004). *Putting the movement back into civil rights teaching: A resource guide for K–12 classrooms.* Washington, DC: McArdle Printing.

Mattson, R. (2010). Using visual historical methods in the K–12 classroom: Tactical heuristics. In D. Desai, J. Hamlin, & R. Mattson (Eds.), *History as art, art as history.* New York: Routledge.

Meyer, R. (2009). The amazed world of Ik-Joong Kang. *The Artist, 26*(5), 32–37.

Mullin, J., & Grandin, T. (2009). *Drawing autism.* New York: Mark Batty Publisher.

Naidus, B. (2005). Teaching art as a subversive activity. In M. Powell & V. Marco-Speiser (Eds.), *The arts, education, and social change: Little signs of hope.* New York: Peter Lang.

Naidus, B. (2007). Feminist activist art pedagogy: Unleashed and engaged. *NWSA Journal, 19*(1), 137–146, 148–155.

Ortiz, A. (2010). *Women of Juarez.* Retrieved October 21, 2010, from http://www.youtube.com/watch?v=dWJjPDe2pWk

Parkes, R., Gore, J., & Elsworth, W. (2010). After poststructuralism: Rethinking the discourse of social justice pedagogy. In T. Chapman & N. Hobbel (Eds.), *Social justice pedagogy across the curriculum: The practice of freedom.* New York: Routledge.

Peace Jam (2010). Peace Jam. Retrieved August 12, 2010, from www.peacejam.org

Powell, M., & Marco-Speiser, V. (Eds.). (2005). *The arts, education, and social change: Little signs of hope.* New York: Peter Lang.

Quinn, T. (2010). Social justice and arts education: Spheres of freedom. In T. Chapman & N. Hobbel (Eds.), *Social justice pedagogy across the curriculum: The practice of freedom.* New York: Routledge.

Runnell Hall, M. (Ed.). (2008). *Conscious women rock the page: Using hip-hop fiction to incite social change.* New York: Sister Outsider Entertainment, LLC.

Russo, P., & Fairbrother, A. (2009). Teaching for social justice pre-k–12: What are we talking about? In R.D. Davis & B. Beyerbach (Eds.), *"How do we know they know?" A conversation about pre-service teachers learning about culture and social justice.* New York: Peter Lang.

Social and Public Art Resource Center (SPARC). (2011) [Brochure]. Retrieved from: http://www.sparcmurals.org

Yandura, P. (2010). Profile of an artist: John Williams. *Folk Art Messenger, 22*(1), 4–7.

Learning about the Farmworkers and the Landless Rural Workers Movements Through the Arts

TANIA RAMALHO AND LEAH RUSSELL

Two movements—Farmworkers in the United States and the Landless Rural Workers in Brazil—are connected through a common spirit and guiding praxis that give voice to the exploited and marginalized rural workers in these countries. Artists from movement member and ally ranks have used visual media such as photography and mural painting to contribute iconic images that continue to educate about these causes. The work of performance artists, cinema and video directors, and writers and musicians has engaged audiences in consciousness-raising processes that have spurred support for the movements and for social change.

This chapter offers narratives of how arts and pedagogies of activist artists have shaped our understanding and deepened our engagement and commitment to social justice struggles of agricultural workers globally. Russell, a European American woman who holds a graduate degree in Latin American Studies, describes the Farmworker movement and her work as photographer and facilitator of a youth arts group for migrant youth during a summer fellowship in the Student Action with Farmworkers (SAF) program. Ramalho, a Brazilian American professor with a passion for the power of critical pedagogy, provides a brief history of the Landless Rural Workers movement in Brazil and discusses examples of movement artwork.

ONE

Art and Justice in the Farmworker Movement

LEAH RUSSELL

In this section I offer a basic introduction to the Farmworker movement and a summary of issues facing immigrant/migrant farmworking communities today. In doing so, I create a political and historical context for the subsequent discussion. Then I share a personal narrative of my experiences within the movement, explaining my involvement and backing up general claims made in the historical section with observations and testimonies from the fields. Next, I present my observations on how the organizations I have worked with and the people I have met use art to promote social justice and further their understanding of social issues, providing examples from a range of actors, artistic abilities, and approaches. Finally, I ponder some possible implications for educators and critical thinking points for classroom discussion, along with brief descriptions of a few helpful resources for teachers.

Legislative and Political Factors That Created a Cycle of Injustice

When the labor laws of the 1930s were passed, distinguishing farm labor from other forms of work and excluding farmworkers from basic workers' rights, state policy thereby set the stage for human rights violations in the century to come (United States farmworker, 2007). At the time the majority of U.S. farms were small, family owned and operated, and much of the nation's farmwork was done by poor whites and African Americans. From the beginning of state protection of workers, with laws such as the Fair Labor Standards Act of 1938, the concepts of minimum wage and overtime pay simply did not apply to farmworkers (United States farmworker, 2007). Through my work with the movement, I came to see this as an intentional exemption that foreshadowed future injustices and revealed the inherently racist implications of our national labor policy. Even the act's provisions preventing child labor and ensuring decent working conditions did not apply to farmwork until 1966, when campaigns for farmworkers' rights led by

leader Cesar Chavez succeeded in bringing the issue of farmworker justice onto the national stage.[1]

Little did policymakers of the 1930s know that within the century the nation would see the emergence of big agribusiness, sweeping technological developments, and major shifts in farmworker demographics brought about by new international policies such as those drafted by the North American Free Trade Agreement (NAFTA) in 1994 ("Fact Sheet", 2008). Regardless, their exemption of farmwork paved the way for massive capital gains for an evolving and rapidly expanding industry and, consequently, the oppression of millions of citizens, foreign guest workers, and undocumented immigrants. NAFTA had a devastating effect on agricultural economies in Mexico, driving at least two million Mexican farmers out of business and leaving workers with few options for survival other than migration to the United States, where the demand for unskilled labor was ever increasing (Rubenstein, 2007–2008; Farmworkers and Immigration, 2007). Neoliberal policies of the 1980s and 1990s encouraging deregulation, privatization, and the scaling back of government programs in Latin America, contributed to the destabilization of local economies and accelerated the rate of mass migration northward toward the United States (Pollan, 2007). Each year, jobless people leave their homelands in Central and South America and head north toward the U.S.-Mexican border to take their chances at a dangerous crossing, in search of a new life and a way to provide for their families. Though estimates vary, at least hundreds of thousands—probably millions—make it across every year. Once inside the U.S. border, immigrants face the often-harsh realities of life in the "Promised Land." Some find work in unskilled labor or service industries. Millions end up doing seasonal farmwork.

Contemporary Issues

Today's farmworkers, whether documented or not, deal with a multitude of work-related problems, including dangerous working conditions, poor housing, lack of access to water in the fields, lack of information on pesticide exposure, unreasonably long workdays and no days off, no health benefits, no job security, and no access to legal recourse should a boss decide to withhold paychecks ("Law Denies Protection," 2010). Twelve percent of farmworkers earn less than minimum wage and half earn less than $7,500 a year, which is still a far cry from a living wage in many states ("Migrant Farmer Workers," 2010). Despite the emergence of non-profit organizations that advocate for farmworkers' rights and provide a range of services such as legal assistance, health care, and education to immigrant/migrant communities, major human rights violations continue. Farmworkers in some states, including New York, are still being denied basic rights such as overtime pay, days

off, disability insurance, and collective bargaining protection ("Justice," 2010). Through decades of campaigning, politicians and activists have drawn attention to the responsibility of employers to provide drinking water in the fields to prevent severe dehydration and heat stroke; to inform workers of pesticide uses and risks, especially to pregnant women; and to meet housing standards, particularly when docking workers' pay for housing. In reality, many laws passed by the efforts of hardworking political allies are not strictly enforced in the fields. My experience has shown me that such conditions often remain the same.

Unlike farmworkers of the 1930s, most immigrant and even many non-immigrant farmworkers today are seasonal migrants. They travel to different regions, following rotating harvests, to maximize the number of working days each year. The need to migrate in order to compensate for lack of job security in any one area poses a range of problems for farmworkers and their families, especially in terms of access to consistent medical care, education, and other public services. Migrant children are often taken out of school, and many are kept from continuing to the next grade because of the number of days missed. One might imagine that psychological distress from being constantly uprooted and moved, frequently combined with pressure to work to contribute to the family income, makes it considerably more difficult for migrant youth to succeed academically. This hypothesis seems quite plausible considering that the graduation rates among migrant teenagers is only roughly 50 percent ("Migrant Farmer Workers," 2010).

Undocumented workers face additional hardships because of language barriers, cultural differences, social prejudices, and their status as illegal residents. In many cases they live under real or imagined threats of arrest and deportation, which means an increased likelihood of being separated from family members, losing income and any possessions, and spending time in detention or even in jail when facilities are overcrowded. Constant threats prevent many from challenging their superiors or going to authorities for help in cases of emergency or rights violations.

Employers are aware of this reality and some, though not all, use it to their advantage, denying workers pay or other entitlements simply because they know that undocumented workers have few legal rights and little leverage, and can be easily replaced. Of course, the extent and frequency of workers' rights violations are particularly hard to measure and support with empirical evidence precisely because cases often go unreported. This ought to be an unsettling notion, since silence has potential implications among immigrant communities regarding issues outside of workers' rights violations, for example, in instances of domestic abuse, rape, assault, or theft, in which the victims feel that they have no trustworthy authorities to turn to for help.

Lack of access to legal recourse or to assistance in emergencies, due to financial limitations or fear of deportation, and brought on by a state policy that criminalizes undocumented immigrants, is not the only major problem. Immigrant farmworkers

are systematically marginalized in our society, excluded from equal legal protection, and also denied many social and cultural dignities. Most don't get time off to celebrate holidays or attend church on their day of worship. They certainly don't get out early to attend PTA meetings at their children's schools, and even if they did, few districts provide translators so that non-English-speaking parents can participate. Corporate media propaganda further worsens the situation by convincing the public that immigrants are here to "steal our jobs." Portraying immigrants as an imminent threat provides a convenient distraction in a time of economic recession and high unemployment, one that prevents most people from ever imagining that this level of human rights violations could be taking place within our national borders, let alone in our very communities. Regardless, millions of people in the past few decades have toiled under Third World conditions while living in a First World nation. Their suffering persists virtually unnoticed in our very own backyards.

The problem becomes much more difficult to ignore when injustices come to light. Many American consumers believe in voting with dollars, or having a political impact by choosing what to consume. So it makes sense that major food-producing companies would go out of their way to conceal labor practices and promote campaigns that emphasize the affordability and quality of their product while obscuring their methods for cutting costs.

When thinking about why the average citizen should consider the plight of farmworkers, the question of how the issue affects her/him personally—"What does this have to do with me?"—can be answered simply: "We all eat." How often are we asked to consider the hands that pick the food that lines grocery store shelves and graces our dining room tables? We take for granted that our savings on groceries could well mean that workers are being abused—not somewhere in a far-off, impoverished country, but right down the road. It is possible to live in a rural area, a small city, or in the suburbs outside a larger city, and frequently pass migrant camps without knowing it. I was shocked to find that there were people living in my town who worked for practically nothing and lived in overcrowded, run-down housing that sometimes lacked basic human necessities like a working stove, consistent hot water, or carbon monoxide detectors. Admittedly, I probably never would have thought about many of these issues were it not for being awarded a summer fellowship with Student Action with Farmworkers (SAF).

My Role as Student, Community Advocate, and Educator

I participated in the Student Action with Farmworkers' student internship program, Into the Fields. The organization, based in Durham, North Carolina, and affiliated with Duke University, recruits and trains roughly 30 interns and fellows

each summer and places them in host organizations in the Carolinas and a few other states to work in the areas of farmworkers' health and awareness, legal services, migrant education, community outreach, and advocacy. Some of the participants are children of farmworkers themselves. During a week of intensive training, participants study the history of the Farmworkers movement including information on legislation, important movement leaders, effective organizing strategies, the effects of pesticides, and other dangers related to farmwork. Before beginning work as advocates, students also undergo sensitivity training, attend workshops on deconstructing racism and prejudice, and witness testimonies from farmworkers. Job descriptions vary from placement to placement, but all interns must fulfill certain requirements and turn in assignments to SAF as separate from their work responsibilities. Students record assigned journal logs of their experience, and all are encouraged to remain involved in the movement in some way after the completion of their internship. All of us *Safistas*, as we call ourselves, would agree that the experience is life changing. By the final retreat, we see each other as a family united by

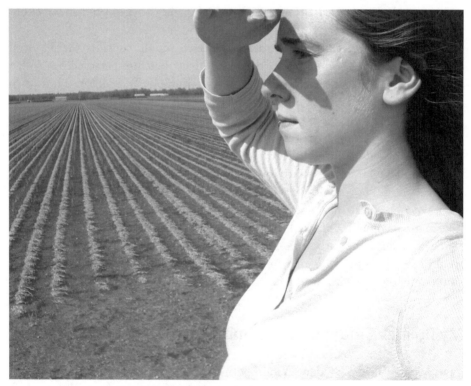

Figure 1. A photo of me looking out at the fields on a farm in upstate New York, where I interviewed farmworkers.

a common mission for justice, and we make a commitment to continue our work in our daily lives, studies, and careers.[2]

Advocates for farmworkers walk a fine line between understanding the silence and breaking it, gaining the confidence of workers who fear the devastating repercussions of letting anyone know they are here without documents while still making the issues they face visible to the public. We strive to facilitate opportunities for the voiceless to be heard and to make visible the invaluable contribution farmworkers make to our communities, our economy, and our society. We know that there is crippling fear in immigrant farmworking communities, because we have felt it there, noting the looks of uncertainty as workers hesitantly tell their stories. Tension and fear of police are so obvious that they often need not be said aloud. Mutually, we have felt the reluctance—among non-immigrant/migrant community members, law enforcement agents, and policymakers—to deal with the reality of injustice, owning up to their responsibility and using their privilege to facilitate change. We have witnessed the growing hysteria about immigrants provoked by blatantly racist media pundits. We have uncovered countless examples of propaganda that inject an already-heated debate with "facts" that are simply and certainly lies, fabrications, and manipulated data of racist ideology, distorted and partial truths. We have found that providing empirical evidence and demanding accurate, informed, and critical debate on the issues, in fact do very little in the way of changing people's minds. What we have found to be effective, however, is presenting the truth through a medium that makes the intangible tangible and reaches beyond rational arguments and facts. This medium gets to people's hearts, speaks to our sameness rather than our differences, touches our souls, and is fundamentally an expression of culture: art.

Photo-Documentary Work

All student participants in the Into the Fields program complete a photo-documentary project depicting their experience. At the summer program's final retreat, interns present their projects to the group and facilitators, sharing pictures, stories, quotes from interviews, new information, personal revelations, and the wisdom they have gained. The projects are filed in the program's archives to be shared with future *Safistas*, evaluated by researchers, and presented to the public at consciousness-raising events. The primary objective is to document the realities of farmworking communities and to share that information with other movement allies. Projects also have another important purpose. As the photographs capture everyday life in an artistic way, portraying the values, culture, struggles, and triumphs of a vast and diverse group of people living and working

in our communities, they tell a story, making visible the lives of those who live among us in silence.

In my photo project, I focused on documenting the living conditions of farmworkers in central and western New York. I traveled to migrant camps and spoke with farmworkers. I was stunned by many of the things I saw. One house with five bedrooms was home to 25 people, mostly adults, sharing the small living space. Grown men were sleeping on cots, one butted up to the next. The kitchen stove was not working and had not been for some time. The men stood aside for me to walk down the narrow hallway, looking sheepish and maybe ashamed of where they lived. Afterward we stood outside, surrounded by clotheslines full of freshly washed laundry waving gently in the summer breeze. It was very hot. The workers didn't seem to notice my shock, nor did they want to complain about the conditions. It seemed they accepted them as their only option, and the topic of conversation shifted to lighter things. They told me about their soccer league and how they loved to play scrimmage games even after a 12- or 14-hour work day in the stifling heat. Many of them were young and single, but others had wives in their home state of Mexico to whom they sent money every month. One man had not seen his wife and children in 15 years. His voice swelled with emotion when he spoke of them. He told me that someday he would go home to them.

Another migrant camp had several vacant buildings. I snapped a shot of an old window, propped open with a wooden kitchen spoon, and another of a little girl standing in a doorway. I spoke with a few teenage girls who lived there. They knew little Spanish and spoke an indigenous language. From the broken conversation I gathered that they were both mothers, no longer able to do farmwork because they spent the day caring for their young ones. One was pregnant again, her belly swollen. Both were shy and quite thin. I didn't inquire about the fathers or their whereabouts. Workers from the local migrant education program stopped by occasionally to check on the young women, and bring care packages with basic food items such as flour and beans. I wondered if they were getting enough nutrition or any prenatal care. In the same camp, I met another woman, an English-speaking American citizen of Mexican descent with three children. She shared with me her testimony of the many times she'd been stopped and questioned by the police for "looking Mexican." They often asked her for papers—official documents, rather than her New York State driver's license. She offered me a Coke as we sat at the kitchen table in her humble trailer. The woman's youngest daughter spoke candidly with me about school and told me that when she grows up she wants to become a lawyer so she can join the fight for farmworkers' rights.

In my presentation at the final retreat, I also discussed my main project, in which I developed a report on racial profiling and the detrimental effects of voluntary police cooperation with immigration forces on immigrant/migrant communities. I was

selected to speak at the final retreat's grand picnic, attended not only by other interns but also community allies and activists from Duke University as well as local farmworkers. I shared the story about the youth who wanted to be a lawyer. One of my photos, the self-portrait (Figure 1) looking out over onion fields in the Rochester, New York, area, was chosen to be included in the following year's program brochure. I was honored to have my work put out there for the public to see, and I realized that the project was of great personal significance because it encouraged me to continue to use photography as a means to document and act on behalf of social justice issues.

The Youth Arts Group

I was an SAF fellow at the Rural and Migrant Ministry of Poughkeepsie, New York. After completing the summer program, I stayed involved with the movement by volunteering for a couple of the Ministry's projects. I served on the planning committee for a rural women's conference, which I attended, and for a year I also helped facilitate meetings of the Youth Arts Group (YAG) of Newburgh, New York, which is an extension of the Rural and Migrant Ministry's Youth Empowerment Program. The group is comprised of high school students whose parents are or used to be employed as farmworkers. Its size varies from year to year, but it usually has at least 10 to 15 members. YAG meets on Friday night all year long from dinnertime until around 10 P.M. At the meetings, members have pizza, discuss upcoming community events, decide who will present at which conferences, plan presentations, share stories from their week, and work on art projects. The group always has a variety of talented individuals including poets, painters, musicians, sculptors, and more. Their art reflects their life experiences, family values, feelings about their parents' struggles, and their political views, especially on issues related to immigration, education, and community.

YAG created a mural (Figure 2) to be displayed as a centerpiece for its annual youth conference. The mural portrays some of the themes the youth wished to address in their conference presentations, written pieces, and group discussions. The themes for that year included issues such as violence/war, media influences, family struggles, political injustice, solitude, and the loss of innocence, and how these issues affect youth in particular. The youth participants used the mural as an artistic jumping-off point to stimulate conference attendees and to provoke thoughtful conversation and critical thinking. All of the artwork, themes, and interpretations came directly from the youth. They chose the materials, size, and design of the mural. The youth worked on the mural together for weeks, collaborating and encouraging one another. Those who had more experience with drawing and painting assured the rest, "You *do* know how to do this. Here, try."

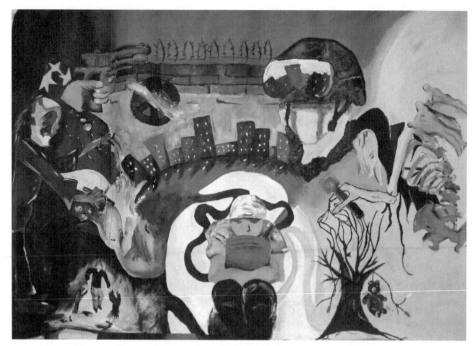

Figure 2. Detail of the mural created by the Youth Arts Group participants.

The mural project had a huge impact on the youth who participated in its creation. They often sacrificed other opportunities to stay and work late into the night. We talked often during these painting sessions about the meaning behind the images. The youth told me stories about how media and popular culture, as well as peer pressure from other youth at their schools, had affected their self-image and confidence in the past. They told me that becoming part of YAG had dramatically changed their perspectives, facilitating the development of self-esteem and critical thinking about media and other influences. In finding a support system and sense of community, they became more resistant to negative effects of societal issues and were empowered with the ability to let things that had once bogged them down simply roll off their shoulders. I remember feeling amazed by their maturity and offers of support to one another; I was truly inspired by their commitment to justice.

Resources for Educators: Moving Beyond Silence and Guilt to Alliance and Activism

Educators have the responsibility to provide students with access to a range of perspectives and reliable sources for information. Important issues such as immi-

gration, labor policy, human and workers' rights, and organizing are often complicated by personal biases and contaminated with propaganda. It is important that we teach students to approach sources with a critical lens, encouraging them to consider where information comes from and how it is used. There exist many religious and other non-profit organizations, state commissions, and student groups whose research findings complement official census data and offer counter-narratives to perspectives of corporate farm representatives and media pundits with racist, anti-immigrant, fear-mongering agendas. The websites described in this section and listed in the references offer art-based resources for teachers on these issues.

Art facilitates such critical engagement. From the birth of the movement in the 1960s, stencil and cartoon art have played important roles in promoting the causes of farmworkers. Ally organizations incorporate stencil or silhouette logos that make their affiliation easily recognizable during marches and demonstrations. The artwork speaks to the public, making difficult issues more accessible through creative expression, symbols and icons, and unforgettable images. For an excellent, comprehensive history of the use of art in the early decades of the Farmworker movement, see the website entitled *Cultivating Creativity,* by San Francisco State University (Rosen & Casey, 2007), which has galleries of artwork provided by its Labor Archives and Research Center.

The Student Action with Farmworkers website (2011), too, has several links to fact sheets about farmworkers and information on opportunities for students, activists, and researchers to get involved in the Farmworker movement. The winter 2007–2008 issue of the journal *The Social Contract* includes articles on the impact of NAFTA on immigration and agriculture. The U.S. Departments of Labor and Agriculture offer links to policies detailing regulations for employers of farmworkers, as well as legal documents such as the Fair Labor Standards Act and the Migrant and Seasonal Agricultural Protection Act (1997). The Southern Poverty Law Center has a webpage entitled "Know Your Rights: Legal Rights for Farmworkers" (2009) which explains the rights granted to workers regardless of status or documentation.

Teachers can provide access to the many sides of any story and encourage students to think for themselves in a context of open debate and mutual respect. Educators themselves have the opportunity to become involved and to offer students a chance to do so, moving beyond guilt to become true allies.

Notes

1. For more information on Cesar Chavez and the history of the United Farm Workers, see www.ufw.org.

2. For more information on Student Action with Farmworkers, visit its website at www.saf-unite.org.

References

Fact sheet: North American Free Trade Agreement. (2008, January). United States Department of Agriculture. Retrieved December 2, 2010, from http://www.fas.usda.gov/itp/policy/nafta/nafta.asp

Farmworkers and immigration. (2007). North Carolina Farmworker Institute. Retrieved November 12, 2010, from http://www.safunite.org/ncfarmworkers/NewFiles/SAF%20Fact%20Sheet%20IMGRN.pdf

Justice for farmworkers update. (2010, August 6). Labor-Religion Coalition. Retrieved November 17, 2010, from http://www.labor-religion.org/farmworkers-updates.htm

Know your rights: Legal rights for farmworkers. (2009, January). Southern Poverty Law Center. Retrieved November 3, 2010, from http://www.splcenter.org/get-informed/publications/know-your-rights-legal-rights-for-farmworkers#

Law denies protection to millions of workers. (2010). American Rights at Work. Retrieved November 22, 2010, from http://www.americanrightsatwork.org/publications/fact-sheets/law-denies-protection-to-millions-of-workers.html

Migrant and Seasonal Agricultural Worker Protection Act. (1997). U.S. Department of Labor. Retrieved December 6, 2010, from http://www.osha.gov/pls/epub/wageindex.download?p_file=F28165/wh1465.pdf

Migrant farmworkers in the United States. (2010). BOCES Geneseo Migrant Center. Retrieved November 10, 2010, from http://www.migrant.net/pdf/farmworkerfacts.pdf

Pollan, M. (2007, April 22). You are what you grow. *The New York Times*. Retrieved December 8, 2010, from http://www.nytimes.com/2007/04/22/magazine/22wwlnlede.t.html?_r=1&ei=5070&en=770602bee6doe6a3&ex=1184644800&pagewanted=print

Rosen, J., & Casey, C. (2007). *Cultivating creativity: The arts and the farm worker's movement during the 1960's and 70's*. Retrieved January 12, 2011, from http://www.library.sfsu.edu/exhibits/cultivating/default.html

Rubenstein, E. (2007–2008, Winter). An immigration fiscal impact statement. *The Social Contract*, *18*(2). Retrieved from http://www.thesocialcontract.com/artman2/publish/tsc_18_2/tsc_18_2_rubenstein_doa.shtml

Student Action with Farmworkers (2011). www.saf-unite.org

United States farmworker fact sheet (2007). North Carolina Farmworker Institute. Retrieved November 12, 2010, from http://www.ncfhp.org/pdf/usfws.pdf

T W O

The MST: Landless Workers Movement of Brazil

Tania Ramalho

I came to the United States to attend graduate school in 1976, the year the country was celebrating the 200th anniversary of its birth as a nation. I left behind my parents, family, friends and colleagues from work, and my country's recent history. Brazil was still in the grip of the military dictatorship (1964–1985) that shaped the young adult lives of my generation. We fought hard against the *milicos*, whose leaders got their training at the notorious School of Americas (SOA) in Panama and then in Fort Benning, Georgia, where they learned the military techniques, including torture, and the tactics and strategies to repress the revolutionary aspirations and organizations of peoples who did not want to follow capitalist development or Washington's model of democracy.

During the first 12 years of that violent period, against the backdrop of the Cold War, I worked as a teacher in elementary and then secondary schools in Rio, my home town. I attended college, finished a master's degree in Administration of Educational Systems, and became a mother. Like many of my peers in college, I was involved in student activism. Besides the end of the dictatorship, of course, I was passionate about two causes in particular: the defense of the Amazon region and its rain forest from destruction and appropriation by foreign corporations, and agrarian reform.

From Brazilian history, I learned that our pattern of land occupation was dictated by the kings of Portugal. From the first news of the Portuguese takeover in 1500, lands were granted to landlords favored by the courts. Large plantations were established in most of these very large tropical tracts, which eventually came to be named in Latin after the large Roman estates, *latifundia*. I was aware of the precarious working and living conditions of agricultural workers in these immense farms owned by the landowning elite from pre-independence times. I also knew about their displacement as agricultural mechanization made the labor of many obsolete. Such workers moved into the big cities, swelling the slums, or *favelas*, in São Paulo and Rio de Janeiro in the southeast, Salvador and Recife in the northeast, and Brasília in the middle of the country. Many stayed behind, homeless.

When the pro-capitalist, elites-propped dictatorship could no longer be sustained, hordes of displaced agricultural workers without means of support quickly organized. I lived in the United States at the time and have stayed here since, except for short trips. However, I have followed the developments in Brazil from a distance, and my passion for agrarian reform—the equitable distribution of lands to producers that changes the pattern of land occupation from unproductive to a more productive and just one—has remained alive. Today, my activist energy is also invested in the extraordinarily complex Landless Workers Movement (MST is the Portuguese short acronym for Movimento [dos Trabalhadores Rurais] Sem Terra—Movement of the Rural Workers Without Land, or simply, Landless Workers' Movement), and their now global involvement in issues of food safety and security, and rural workers' rights.

In this section I provide a brief history of the MST and discuss examples of visual and performance arts in the movement. These can be used in conjunction with books, articles, and website material to educate students about movements for social change in Brazil and Latin America, as well as related U.S. movements, such as the Farmworker movement; food production, safety and security; and questions of agricultural labor in Latin America and globally. All these issues point to the search of new patterns of sustainable living and development that humans need to devise and implement for joint survival, peace, and justice for all.

Brief History of Brazil's MST, Landless Workers Movement

The Landless Workers Movement arose from the social, political, and economic conditions shaping Brazilian society in the mid-to-late 20th century. Efforts at economic development bypassed masses of people from rural backgrounds, small farmers and the general rural working population—wage earners, sharecroppers, and squatters—who were forced out of land, jobs, and meager livelihoods. The MST explains this exclusion:

> They were expelled by an authoritarian project for the Brazilian countryside, headed by the military dictatorship that then limited the rights and liberties of all of society. This project announced the "modernization" of the countryside when truthfully it stimulated massive use of toxic chemical fertilizers and insecticides and mechanization based on hefty rural credit (exclusively for very large rural properties); at the same time, it increased the control of agriculture in the hands of agro-industrial conglomerates. (MST, 2009)

These trends were in line with Western capitalist agricultural development models designed to benefit wealthy landowners and agricultural corporations while ignoring the decline of the small, family-owned farm and farmworkers.

The MST also has much deeper roots in the earlier history of rural workers in Brazil. Fifty years after the abolition of slave labor, the first rural workers' union was established in the *latifundia* sugar-producing region of Campos (northern state of Rio de Janeiro) in 1933. In the 1950s there were only four more rural unions operating in four states, with limited freedom imposed by government laws that served the interests of landowning elites (Moraes, 1970).

In the 1940s, rural workers, unable to constitute labor unions legally, were organized by the Communist Party into peasant leagues. These struggled to survive and almost disappeared but became stronger during the relatively democratic period of the Kubitschek-Goulart administration (1956–1961). Peasant leagues' leaders and members were severely persecuted by the Castro-weary, anti-communist military dictatorship.

The first congress of the Landless Workers Movement took place in 1984, a time when Brazilians were clamoring for democratic elections to end the regrettable military regime through a nationwide progressive movement, *Diretas Já!*, or Direct Elections Now! The MST pressed the cause of just distribution of agricultural lands, showcasing the slogan "Without agrarian reform, there is no democracy," which linked the need for distribution of lands to economic and political democratization. As Brazil transitioned back to the elected representative governance model, landless workers cherished the new (1988) constitution's eminent domain articles that made legal the expropriation of unproductive lands.

In the account of its history, the MST (also referred to as "the movement") indicts both the continued influence of the Brazilian landowning oligarchy in state decisions and the first plan for agrarian reform after the military dictatorship that provided land for only 90,000 families, mostly by force through land invasions and occupation. In 1990, the MST made a commitment to expand nationally under the call "Occupy, Resist, and Produce," and in 1995, the Third Congress's slogan was "Agrarian Reform. Everyone's Struggle." The movement organized a National March for Agrarian Reform in 1997, showcasing the violence, including many assassinations of rural workers during attempts to seize unoccupied properties. The goals of the MST, they insisted, benefited not only landless workers but city dwellers as well, through increased production of healthy food for all (MST, 2009).

In 25 years of existence, the MST has survived a phase of conservative neoliberal administration that tried not only to make it illegal but to name it a terrorist organization as well. More recently, it has received some support from the left- and democratic-leaning administration of the Worker's Party. Pragmatic President Lula (2003–2010), however, has also supported the old alliance between landowners

and global agricultural corporations as a development strategy for Brazil (Tilly, Kennedy, & Ramos, 2009).

Today, with 350,000 families settled and producing food for consumption and the market, the MST continues its march toward land and food justice. It subscribes to a global movement against neoliberal economic policies affecting agriculture that show preference for market business models and result in further displacement of small farmers, farming cooperatives, and farmworkers, in particular in the nations of the south (ILO, 2003). In Brazil, single crops such as soy, cane, and eucalyptus trees destined for paper mills occupy lands where people could live and produce food. Business practices further include controlling all aspects of food production, from seeds (increasingly genetically engineered), pesticides (which poison workers), and mechanized crops, to marketing and distribution in large supermarket chains. Prices for agricultural commodities are set by large brokers in advanced capitalist economies. Through such market mechanisms, neocolonial relationships are reestablished between North and South. The MST writes:

> In response to the globalization of misery, there arises the globalization of struggle through *Via Campesina*, the organization that congregates rural workers' movements throughout the world around Agrarian Reform and food self-determination; that is, in the right that all peoples have—not markets—to decide what to produce and how to feed everyone. (MST, 2009; Via Campesina, 2010)

The globally interconnected struggles of MST landless workers in Brazil and of rural workers in other nations have become central to the understanding of our individual and local lives in contemporary society. A direct link here is to issues surrounding food security and safety that connect the people's right—to eat safe and nutritious food—to the rights of small farmers, cooperative farming, and farmworkers—to decent work. The International Labor Organization defines decent work as follows:

> Decent work sums up the aspirations of people in their working lives. It involves opportunities for work that is productive and delivers a fair income, security in the workplace and social protection for families, better prospects for personal development and social integration, freedom for people to express their concerns, organize and participate in the decisions that affect their lives and equality of opportunity and treatment for all women and men. (ILO, 2010)

Social justice advocates, activists, artists and teachers for social justice find in these questions, standards, and aspirations ample reasons and resources for learning and teaching, and organizing for global change.

MST's Art: Teaching Tools

Members of social movements, target populations, and allies alike produce ample artistic expressions conveying movement history, missions, goals, strategies, values, and visions. Movements are eminently pedagogical in their thrust. Students at any level of education, from elementary through graduate school, can learn about social justice issues and social movements, as well as about art, from critical examination of such movement-produced artifacts.

People involved in the Landless Workers Movement have produced much art. Internationally known Brazilian photographer Sebastião Salgado published the book *"Terra. Struggle of the Landless"* depicting the dignity of MST participants in face of the inhumane living conditions they experience (Salgado, 1997). The School of Modern Languages of the University of Nottingham in the U.K. has a digital archive, "The Sights and Voices of Dispossession: The Fight for the Land and the Emerging Culture of the MST (The Movement of the Landless Rural Workers of Brazil)" accessible through the Internet, and information about the site's resources is readily available (Landless Voice Web Archive, 2003).

The Nottingham archive contains two sets of documents categorized as Sights and Voices. Sights includes images of 16 children's drawings (10 of dancers; 21 of murals; and 9 of paintings); 3 references to films about the MST; and 165 photographs (6 of sculptures and 21 of theatrical productions). Under Voices, there are five categories: children's compositions, 17; essays, 3; music (CDs), 11; lyrics, 88; and poems, 46. The materials are readily available for examination on the archive's web pages. This section examines and describes four artifacts extracted from the Nottingham archive—a poem, the MST flag, a youth's composition about his experience living in an MST encampment, and the lyrics of a song. They provide additional information about the MST, and exemplify using the movement's art to learn about social justice issues and engage in activism.

Poetry

In this section, I use the poem "The Flag of the MST", by Pedro Tierra, as an example of a text teachers may share with students. I first describe the actual flag the picture of which, along with the poem, can be found in the Nottingham archive. The MST's flag (Carvalho, 2002) shows the contour map of Brazil in forests and crops in green (color of hope), inside a circle in white (color of peace), on a red rectangular field. Internationally, red is the color associated with revolutionary movements. Red also represents love, passion, life, beauty, and happiness. The words on the flag say, in Portuguese, "Movement of the Landless Rural Workers, Brazil."

The flag displays a couple. A man in the right corner of the map holds up a machete, a tool commonly used to cut cane and tall grasses. The gesture signifies the battle ahead: invading, occupying, and cultivating the land. The machete, like a knife, is a symbolically rich tool that represents much of an MST member's life of sacrifice, death, and liberation. A knife may signify martyrdom, or even severance from ignorance. These are certainly aspects of the experience of the members of the MST. The woman on the flag stands by the man's side clearly in a supportive role, a traditional gender role representation of heterosexual couples. The collar of her dress or scarf around the neck, also in red, is a reminder of blood spilled by comrades who lost their lives in violent encounters with the police. The couple design also forms the southernmost part of the Brazilian map, signifying deep patriotism of rural workers and the movement.

Pedro Tierra's poem (Tierra, 2002), *The Flag of the MST*, focuses on the power of the workers' hands, and their capabilities. These hands plant crops, and produce food. They also cut the barbwire surrounding unused tracts of land that MST workers invade and take possession of. Hands are capable of creation, the goal and preferred human action; nonetheless, they are also capable of violence and destruction when necessary, in the absence of justice. For the poet, the flag is raised because it represents the struggle for land and for life itself. MST's is the flag of freedom over which movement members swear never to reproduce the experience of the oppressor. It signals life and hope for many, through the return of the land to its sons and daughters, and their children born free.

Children's Writing

Teachers can find examples of children's writing in the Nottingham archive. Tony Regis Xavier de Souza (2002) was 12 years old when he wrote a composition in his third-grade class at the public school in the farm settlement Olho D'Agua, in the state of Minas Gerais. De Souza addresses privileged urban youth, telling his story as an orphan boy from a landless background. He learned the meaning of human rights and of freedom living in one of the MST's camps; the poor deserve to be happy, he affirms. He compliments the MST on its 15th anniversary for taking in street children and giving them hope.

De Souza was a resident of one of the black plastic makeshift "villages"–camps–MST members erect along highways near the lands where they want to settle. These villages may exist for years before workers are granted possession of lands. In these makeshift homes residents meet, organize, and attend school to become literate and learn from movement leaders.

Conscientization—understanding social, political, and economic forces shaping the lives of oppressed groups and individuals in society (Freire, 2000)—is a central

goal of the movement. Souza learned that the poor have rights to livelihood and happiness. He praises the MST on the occasion of its 15th anniversary for giving hope to the socially marginalized and excluded in Brasil.

Music

The cover of the first audio CD by MST's songwriters (http://www.landless-voices.org/vieira/archive-05.phtml?rd=COVEROFT435&ng=e&sc=1&th=4&se=2) shows a large group of rural workers standing shoulder to shoulder and holding the tools of their trade in a demonstration: scythes, sickles, and hoes. Their arms, hands, and fists indicate great determination to achieve the goals of justice. The all-male demonstrators are dressed in the modest clothes of peasants, and the man in the front left is sporting a straw hat often used under the tropical sun. Group members are relatively young and strong mestizos. Careful observation of the men's determined faces indicates how some of them are toothless, an indicator of poor health caused by poverty and lack of access to medical and dental care.

The title of this CD is *Arte em Movimento*, a double-entendre in Portuguese. *Arte* translates as art, *em movimento* means moving, or that which moves, which revolutionary movement music clearly achieves, leading people to reflect and act. Each of the 20 songs on this CD is available to listeners. Each one is fully orchestrated and sung in Portuguese. The lyrics of Jacir Strapazzan-Milico's song "Free America" (track 11 of the CD) (Strapazzan-Milico, 2002) has much material for teachers to explore.

The lyrics can be followed as one listens online. Some words in Portuguese, such as *America*, *liberdade* (liberty), and *imperialismo* (imperialism) can be heard clearly. Strapazzan-Milico wishes for a bright future for the people of the Americas who suffer and struggle for liberty through new social movements. The word America is commonly used as a synonym for the United States among United States nationals, also known as "Americans." In Latin American countries, America represents the tripartite continent as a whole, North, Central, and South America, and the Caribbean. The songwriter shows that no matter where you live in the Americas, our enemies are the forces of imperialism, oppressing workers and challenging the self-determination of peoples. Rural and city dwellers must engage in the anti-imperialist struggle together to someday celebrate victory—liberty.

Teachers and instructors have a wealth of revolutionary rhetoric to examine in the many texts in the Sights and Voices of Dispossession archive. The images are equally revealing of peoples of all ages, men and women, involved in one of the strongest social justice movements in the world today, the MST. This movement reaches out to many others both in developing and developed nations, for there is taking place everywhere a push by capitalists to transfer production from small, family-, or cooperatively owned farms, to corporate farms. As with the farm-

workers in the United States, the future of food production, safety, and security is in the hands of the small producers and the dispossessed. Their movements need allies from all walks of life who do not forget that they, too, need to eat and be healthy. Educators can share in their struggle by using movement arts and documents to inform, agitate and organize students and communities.

References

Carvalho, C. (2002). *MST flag* [photograph]. Retrieved January 12, 2001, from http://www.land-lessvoices.org/vieira/archive-05.phtml?rd=MSTSFLAG572&ng=e&sc=1&th=4&se=0

De Souza, T.R.X. (2002). *Congratulations MST*. Retrieved January 12, 2011, from http://www.landlessvoices.org/vieira/archive-05.phtml?rd=CONGRATU268&ng=e&sc=1&th=15&se=0

Freire, P. (2000). *Pedagogy of the oppressed*. (30th Anniversary ed.). New York: Continuum.

International Labor Organization. Bureau of Workers Activities. (2003). *Decent work in agriculture*. Background Paper. International Workers' Symposium on Decent Work in Agriculture, September 15–18, 2003, Geneva, Switzerland. Retrieved January 12, 2001, from http://www.ilo.org/public/english/dialogue/sector/techmeet/iwsdwa03/iwsdwa-r.pdf

International Labor Organization. (2010). *Themes. Decent work*. Retrieved January 12, 2011, from: http://www.ilo.org/global/Themes/Decentwork/lang—en/index.htm

Landless Voice Web Archive. (2003). [Home page for the University of Nottingham archive of the MST cultural artifacts.] Retrieved January 12, 2011, from http://www.landlessvoices.org/

Moraes, C. (1970). Peasant leagues in Brazil. In R. Stavenhagen (Ed.), *Agrarian problems and peasant movements in Latin America* (pp. 453–501). Garden City, NY: Doubleday.

MST. (2009). Nossa história [Our history]. Retrieved January 12, 2011, from http://www.mst.org.br/node/7702

Salgado, S. (1997). *Terra. Struggle of the landless*. London: Phaidon Press Limited. [Book of photographs by noted Brazilian photographer Sebastião Salgado; poems by Brazilian songwriter/singer Chico Buarque and Preface by Portuguese writer José Saramago.]

Strappazan-Milico, J. (2002). Free America. On *Art in movement* [CD]. Retrieved January 12, 2011, from: http://www.landlessvoices.org/vieira/archive-05.phtml?rd=FREEAMER034&ng=e&th=49&sc=1&se=0&cd=ARTINMOV039

Tierra, P. (2002). The flag of the MST. Retrieved January 12, 2011, from http://www.landless-voices.org/vieira/archive-05.phtml?rd=FLAGOFTH813&ng=e&sc=1&th=13&se=0

Tilly, C., Kennedy, M., and Ramos, T.L. (2009). Land reform under Lula. One step forward, one step back. *Dollars & Sense*. Retrieved January 12, 2011, from http://www.dollarsandsense.org/archives/2009/1009kennedyramostilly.html

Via Campesina. (2010). Retrieved January 12, 2011, from http://viacampesina.org/en/ [Home page of "the international movement of peasants, small- and medium-sized producers, landless, rural women, indigenous people, rural youth and agricultural workers."]

Art and Change in the AfroReggae Cultural Group

LEAH RUSSELL

In this chapter I explore the ways in which the AfroReggae Cultural Group contributes to social justice through the arts in Rio de Janeiro, Brazil. I begin by explaining my experience living in Rio and learning about the social issues that groups like AfroReggae work to change. It is my intention that this personal narrative will provide historical and cultural context for the discussion on social justice through the arts. The narrative also gives the situational context of my individual perspectives, how I came to these observations and conclusions as a student, and how I implement what I've learned as an instructor of Latin American Studies. Beyond the personal narrative, I offer information on the many programs AfroReggae runs for youth participants and on their strategies for maximizing their social impact.

First Visit to Rio

As my plane descended into the city of Rio de Janeiro, I frantically searched my carry-on for my camera, uncapped the lens, and snapped a few photos of the spectacular view. I had no idea Rio was so mountainous, lush with trees, and lined with sparkling beaches. Stepping out of the air-conditioned airport, I was hit by a wall of stifling heat. It had been a long journey, and though I was sweaty and exhausted, my body tingled with excitement. I took a cab from the outlying northern indus-

Figure 1. View from the airplane as I landed in Rio.

trial part of the city through downtown and into the posh and luxurious *Zona Sul*, or South Zone, to my family friend's apartment where I'd be staying for the next 5 months. I was 17 years old at the time and had no idea what to expect from this modern, tropical metropolis, but I felt what seemed to be an electric current pulsing from the heart of it. I realized I was half a world away from home, and smiled.

This was 2003 and quite a politically charged moment to be an American abroad. The world looked on as we entered Iraq, and while the upper-middle-class Brazilians I lived with watched the war unfold on television, another war was raging right within their city limits. It was a bloody war between two worlds that was growing dangerously close to my new home, and though at the time I knew neither the extent nor the cause of all the violence, signs of it were everywhere. Sometimes at night I heard what sounded like gunshots but was only, I was assured, some fireworks from post-soccer-game celebrations. Upon return from a trip to Bahia, I debarked from the cruise ship to find the city flooded with military police; there were young men in uniform with machine guns, fingers on the trigger, on every street corner from the dock to Ipanema. Alarmed, I turned to my Brazilian friend and asked her what they were doing there. She responded casually that "the traffickers must have done something." She was right. I read the newspaper later that week. Traffickers had seized several blocks of the city, shut down local shops,

halted traffic, and blown up a city bus, killing several people—11, I recall. I remember cutting out the article. I stared at it in disbelief. Yet the disruption, however disturbing, was brief, and daily life quickly returned to normal. Somehow we were removed from the violence, distanced from the point of conflict. I tucked the article away with the other clippings I had saved to show people back in the States. As the horror stories piled up, I began to realize what seemed for others too obvious to even mention—Brazil has a huge gun problem, and the solution was, more often than not, more guns.

The *favelas* were an instantaneous point of intrigue for me, in spite of the foreboding media representations as places of reckless violence, rampant organized crime, and the obvious rule prohibiting the presence of outsiders like me. These were poor communities, I was told, often run by gangs of drug traffickers, some of whom were as young as I. Majestic from a distance, the *favelas* sprawl up the city's hills with their modest homes toppling over one another in a steady climb toward the heavens. They struck me as beautiful, vibrant, and bursting with life. I saw this image everywhere, the shanty-covered hillsides, being sold to tourists on bags and shirts and oil-on-canvas paintings. I was fascinated by this apparent paradox: the *favelas* were portrayed as a blight on the city but simultaneously marketed and sold as a cultural icon, a postcard snapshot of the city's charm. I would later see this as part of a pattern; these dual representations echo throughout mainstream media, deliberate distortions that either romanticize or demonize targeted communities, marginalizing those who live there and their culture. But at the time, I simply felt like there had to be more to the story than what I was seeing at the market, hearing from my middle-class Brazilian friends, and reading in the news. Months later I left Brazil to go home and attend my own high school graduation. At the ceremony, I watched from the back row as my classmates walked across the stage, and I remember feeling like that part of my life was a distant memory and that so much had happened since. I had seen many difficult things and could no longer even imagine the innocence and ignorance I had unknowingly enjoyed only half a year before. I recall wishing I was back in Rio and thinking that my adventure there had just begun. I vowed to return someday.

During my time back home in the States, I kept in touch with my friends in Rio. They informed me of recent developments in their city at war with itself. I look back on an email a dear friend sent to me on April 14, 2004:

> Oi Leah!
>
> Aqui está tudo bem. As brigas entre as favelas pararam por enquanto. And I´m safe...scared but safe! Eleven people died during the five days of this civil war. Everything started because a drug dealer got free from jail. He was from Vidigal (the favela close to leblon) and he was pissed off because he wanted his

favela to be the leader in the business and it wasn't no more. Rocinha was leadering now. So he decided to invade Rocinha. He organized a false blitz (the brazilian word for the thing police do in the streets to check peoples documents) and he stole eleven cars from normal people to invade Rocinha. They got into the favela shooting all over. SINISTRO!

Enough of bad news!

Once again I marveled from a safe distance at the magnitude of the problems in the city of Rio and elsewhere in Brazil, a nation on the brink of entering the First World.

Second Visit to Rio

When I was 19 I returned to Rio for the summer. I was happy to be back in my home away from home, the *cidade maravilhosa*, or "marvelous city" as it is often called. The year was 2005, and I saw that the city was much the same, though I had changed a great deal since my first stay. I was now a bit older and braver; I had friends there and spoke the language well, knew my way around, and was ready to dive back into my other life in Brazil. I often ventured into Lapa, a bustling part of downtown and epicenter of the city's cultural activities, as well as historic Santa Teresa and other parts of the city I'd not gone to before. As I had on my previous trip, I saw military police in the streets. The traffic-related violence continued, spilling out of the *favelas* and into the city proper, though I mostly read about it in the news while sipping fancy coffee served to me by my host family's maid in the safety of a luxurious apartment that was guarded by a doorman. The family driver brought me to and from school so that I wouldn't have to ride the bus, as was common for middle-class college students studying at PUC-Rio. During the day I went to *Posto 9*, the section of the nearby Ipanema beach frequented by the most beautiful and wealthy, and at night I attended lavish dinner parties or stayed in to watch *novelas*, a passion shared by Brazilians of all classes. In general, life seemed to be pretty good for the Brazilians I knew, and the atmosphere was often light and carefree.

But whenever I walked out of the quiet sanctuary of the air-conditioned apartment and into the oppressive heat and chaos of the city, I witnessed devastating poverty, children and adults with disabilities and deformities, and pregnant women begging in the streets. I saw the way in which working-class people were treated by upper-middle-class people as they shared overlapping public spaces. I noted that the division between *cariocas* from the *asfalto* and those from *favelas* was not just economic but also social and, indeed, cultural. I went out to dance halls in Lapa

where live bands played samba and forró and where people from all parts of the city came together to share the dance floor, though even in these shared spaces there seemed to be clear divisions among people of the upper, middle, and working classes. Still, it became evident that music often served as a kind of catalyst, providing a forum for the sharing of common culture and experience, and provoked a sense of national pride and unity.

Learning about *Favela* Life and AfroReggae

In the years after that summer in Rio, I added Latin American Studies as a second major and dug into literature on Brazil. I learned about the history of *favelas*, how they grew because of immigration and industrialization, and the absence of government services and infrastructure. I read about the development of organized crime in *favelas* beginning with marijuana trafficking in the 1960s and exploding with the cocaine boom of the 1980s, with the industry becoming increasingly violent as more arms made their way into the country. The *abertura*, or transition to democracy, restored many of the freedoms that were restricted under the dictatorship, and though new government programs sought to alleviate poverty and hunger, few addressed the root causes of violence and crime in the *favelas*. The passive-aggressive state policy of neglect or military occupation remained largely unchanged, and the death tolls continued to rise steadily throughout the 1990s with most deaths among black males in *favelas*.

In the process of researching the development of *favelas* I came across the documentary *Favela Rising*, by Jeff Zimbalist and Matt Mochary (2005), which introduced me to the work of the AfroReggae Cultural Group. AfroReggae began in early 1993 as a small independent magazine distributed for free called *AfroReggae Noticias*. The founders, led by Jose Junior, were an average group of *funkeiros*, teens who put on funk parties in the city for fun and to make some cash. When a riot on the south zone beach of Arpoador provoked the arguably irrational government ban of funk music, Junior decided to throw a reggae party. The first few reggae parties were hugely successful, drawing people from all over the city. Surprised by the overwhelming response, the group was inspired to produce literature to satisfy the public interest in black music. The magazine was produced on donations, contained no ads, and promoted Afro-Brazilian cultural events and addressed social justice issues like poverty, race, and police violence. According to the founders, the project was very unorganized, a byproduct of "losers and dreamers, betting on the unknown" (quoted in Diegues, 2006). As the year went on, the project grew and gained attention from mainstream media. In response to a police-led massacre of innocent civilians in the *favela* of Vigario Geral, the group de-

cided to take its efforts to the next level, and one month later it began offering drumming workshops for children in the community. The following year the founders built the first Núcleo Comunitario de Cultura, a community cultural center offering programs in drumming, dance, and recycling, and so the AfroReggae Cultural Group was born.

From this tragic beginning, the driving force behind engagement with the community was to facilitate a non-violent response to the injustice suffered at the hands of reckless police, a broken criminal justice system, and a neglectful state. At the time, many people in Vigario felt a lot of hatred toward the police, creating an atmosphere of vulnerability and desire for retaliation that could easily have worked in favor of traffickers trying to recruit new members to the faction. The central goal of the new organization was to provide community members, especially youth, with an alternative outlet for the outrage they felt toward police and to lead them away from engagement in trafficking. The leaders saw music as a perfect means to elevate the self-esteem of participants and show people both inside and outside of the *favela* that there is more to the community than violence, destruction, and devastation. Gradually the programs grew and the organization's success fostered hope and attracted international attention. The programs expanded significantly when the group received a grant from the Ford Foundation in 1997 and became an NGO (Neate & Platt, 2010).

AfroReggae Programs

Currently the AfroReggae Cultural Group has more than 60 running programs and has community centers in five *favelas*: Vigario Geral, Parada de Lucas, Cantagálo, Complexo do Alemão, and Nova Era (AfroReggae, 2010; Neate & Platt, 2010). The center in Vigario Geral was the first *nucleo* established in 1993, but it has been rebuilt or relocated several times since then. The Vigario center will officially be moving into a huge new building inaugurated this year. The centers in Nova Era and Complexo do Alemão were inaugurated in 2007 and offer percussion, dance, graffiti, theater, and circus. The center in Cantagálo in the south zone focuses on circus, offering courses in acrobatics, juggling, comedy, circus techniques, and B-Boy. The center in Parada de Lucas is the most recent of the five and specializes in information technology, housing studios for new media and communications technology, a library, and computer labs with Internet access. The center in Lucas also offers percussion, dance, *capoeira*, comic drawing, and violin, and has recently inaugurated a full orchestra program (AfroReggae, 2010). The programs offered at each center vary in response to the needs and interests of the particular community it serves. There are over 2,000[1] youth and adolescents actively engaged in programs.

The organization also began a separate record company, several musical groups, a clothing line, radio and TV shows, and has produced CDs, films, books, and documentaries. It has also launched international programs in England and India, working with youth from all classes to confront social issues through art and culture. AfroReggae is well known all over Brazil and increasingly throughout the world as an atypical NGO and, indeed, a growing cultural movement. The movement is still led by Jose Junior, founder and now executive coordinator.

Today, the AfroReggae Cultural Group collaborates with a plethora of organizations and outside institutions such as universities, research institutes, non-profits, NGOs, and local governments, as well as with actors, musicians, politicians, and mainstream media figures. Still, it's all about the art, the music, and the major social issues that provoked the movement, which are addressed through a vast range of creative media and cultural expressions. Contributions from the state and from corporate sponsors such as the oil company Petrobras; Natura, a medical supplies company; Santander Bank; the media conglomerate known as Globo; RedBull; and Oi!, a telecommunications company, fund the organization's core programs and various short-term projects and make possible the maintenance of a full-time staff of more than 250 people. Celebrities such as musicians Caetano Veloso and Gilberto Gil and famous film director Caca Diegues lend their fame and artistic integrity to support AfroReggae's efforts to seek social justice through the arts. With all of these connections, AfroReggae has created quite a stir in academic discussions and has provoked a frenzy of media attention both nationally and abroad.

Social Benefits of AfroReggae

As the organization's network expanded, so too did the social benefits for participants, *favela* communities, movement leaders, and middle- and upper-class audiences throughout the rest of the city, which the organization engages on a regular basis. The organization not only offers participants educational programs and cultural activities; it also draws on national and international funding to provide *favela* residents with access to resources such as technology and multimedia outlets. The newly built community center Vigario Geral has a state-of-the-art computer center with 20 brand-new computers and wireless Internet. It also has a fully equipped recording studio and a DJ mixing studio. These facilities enable community members to access information and develop skills that can lead to employment opportunities for young musicians born and raised in the *favela*. Furthermore, the music produced within the *favela* by AfroReggae's many bands continues to spread the message behind the art, a message of social justice and new opportunities for much-needed change.

Though music is the focal point of many programs, AfroReggae offers several other avenues for increasing the likelihood of future employment for *favela* residents. The group's Projeto Empregabilidade, or Project Employability, focuses on job creation and works with outside companies to hire *favela* residents. Project staff review potential employees' backgrounds and refer them to a partner company, set up the first interview, and then monitor the employees' progress. The program is notable in that it assists former prisoners entering the job market, helping them find work rather than return to a life of crime. AfroReggae's *Urban Connections* aired an episode on the project on Multishow, which was viewed during visiting hours at Rio's prison Bangu 3 by inmates and their families. During this episode, Junior interviewed project coordinator Norton Guimarães, who spent 32 years of his life in crime and 11 in jail, and now helps other ex-convicts find jobs and stay out of trouble. Chinaider Pinheiro, who also used to be a criminal and left to join the movement, supervises the project and is responsible for overseeing the performance of each worker placed through the project. In its first year alone, the program has successfully employed 486 people, 222 of whom were either imprisoned or involved in crime and 102 of whom are still on probation. The program leaders, in partnership with Estapar Riopark and several other major companies, took the time in each partner employer's office to meet with employees to discuss the program and prevent discrimination against incoming ex-prisoner employees. The project is so successful that Junior hopes to raise the number of people employed through the program to over 1,000 in the next six months.

Short-term projects also provide temporary employment and training for individuals that help them gain the skills necessary to compete in the modern formal job market. For example, the filming of *5X Favela*, a film entirely written and produced within the *favelas*, was a recent project that involved several hundred and directly employed over 100 *favela* residents for the duration of its production. In the process, 50 people were fully trained to produce films and can now enter the cinema industry and compete for jobs. Since the film was directed by famous Brazilian cinema director Carlos Diegues, those trained in the process have the significant advantage of saying they have worked with and trained under him, giving them an edge up that few others have and making them all the more competitive in the market (*Urban Connections* on Multishow, January 8, 2010). Short-term projects that provide *favela* residents with the skills to enter the formal economy don't necessarily guarantee them a job, but—aside from the benefit of having temporary work—the increased opportunity for future employment is yet another undeniable social benefit. Workshops and regular programs also provide opportunities for participants to gain skills that can lead to employment. For example, 10 former participants in the Cantagalo circus group have landed jobs in the Ringling Bros. Circus, and 3 former participants are currently working in Cirque du Soleil (AfroReggae, 2010).

However, the benefits are not limited to participants in *favelas*. The organization puts on concerts throughout the city and encourages people from both sides of the border between *asfalto* and *favela* to come together to dance and form new understandings. Concerts put on in the *favelas* have at times required the organization's leaders to negotiate a ceasefire between rival drug gangs, an accomplishment that the national military, with all its might, has never been able to accomplish. In AfroReggae's 17 years, leaders have been able to negotiate several ceasefires between rival factions in Vigario Geral and Parada de Lucas. When the AfroReggae band played its first official concert in Vigario, Caetano Veloso joined in to sing a few songs, along with Regina Casé and Gilberto Gil, who attended to meet people and show support for the band's efforts to bring together communities divided by senseless war. The next day, the event was all over the papers. This first show stopped the war for a full seven days, an outcome that was shocking to all. In 2004, AfroReggae leaders negotiated another ceasefire for the showing of Shakespeare's *Antony and Cleopatra* put on by People's Palace Projects, an NGO created by British scholar Paul Heritage. The project staged this play and *Measure for Measure* in three *favelas*: Vigario Geral, Parada de Lucas, and Rocinha, as well as in an upscale theater in wealthy Leblon in the south zone. AfroReggae members acted in the plays alongside famous Brazilian stars, and the project paid for *favela* residents to attend the performances in Leblon. The two NGOs teamed up to do something crazy: they put on the play in the notorious "Gaza Strip" between Vigario and Lucas territories, an area whose ambient noise had been gunfire for almost two decades and had never been, of all things, the passionately recited lines of a Shakespeare masterpiece. Over 2,000 people from either side of the divide attended the event, and the shooting stopped for an incredible 18 days, the longest truce in the history of the rivalry (Neate & Platt, 2010; Diegues, 2006).

Several of AfroReggae's special projects focus on another crucial aspect of their work: breaking the barriers that divide the city and perpetuate violence, prejudice, and misunderstanding. They do this by creating a dialogue between groups that historically do not understand one another—police and youth, and police and criminals. Through the program *Papo de Responsa*, AfroReggae, in a partnership with the civil police and the state of Rio de Janeiro and supported by Natura, facilitates open discussion between law officers and former criminals and ex-prisoners in workshops to "prevent violence through words." The pairs of officers and ex-criminals travel to schools and businesses hosting informal "chats," and throughout the years the program has had over 20,000 participants. According to one participating officer, the program "tears down walls, opens roads, breaks prejudices and thereby reduces the intolerance that is often the cause of violence" (AfroReggae, 2010).

Another program, *Juventud e Policia*, or Youth and Police, launched in 2004, shares similar objectives and extends the program to another state in Brazil. The project is a collaborative effort among AfroReggae, the police of Minas Gerais, and the state government of Minas Gerais. The project acts in two phases. In the first, AfroReggae workshop leaders train police officers from Minas in the cultural forms practiced by youth participants such as percussion, street dance, basketball, graffiti, and theater. In the second, police take this knowledge and share it with the poor youth in the *favelas* in their state capital, Belo Horizonte. The project has already trained over 50 officers and inspired the filming of the documentary, also produced by AfroReggae, called *Policia Mineira*, which details the first phase of the project. Yet another project, *Antidote*, launched in 2006, promotes the breaking down of barriers through international seminars in which AfroReggae hosts guests from all over the world to present shows, films, theatrical works, and debates that address the power of cultural forms in a struggle to end violence. All of these programs use culture and art as a forum for constructive dialog, the first step toward creating meaningful change within any society.

Clearly, what AfroReggae does with and for youth in *favelas* is only the beginning of the effect their art has on the culture and future of the city. The art produced by participants demonstrates the great potential of the *favelas* as a space not just for the destruction seen in the news but for creation and innovation. That art is a testament to the value of their communities, in terms of both cultural and social capital. It also provides a vehicle through which those who have been historically silenced or underrepresented can voice their opinions, express their beliefs, defend their rights as citizens, and demand justice and accountability from the society that actively marginalizes and excludes them. Because the arts speak to the soul, they hold the greatest potential for reaching people across divisions of class, race, age, or gender. Like so much art and culture produced at the border between two worlds, AfroReggae's art—at the point of contact—reflects the creative capacity reached only in the midst of conflict through contestation and collaboration, through the negotiation of space, symbols, and meaning that defines culture and art. Most importantly, perhaps, AfroReggae's strategy to fight for justice through the arts rather than succumb to the violence inspires and informs other movements. The art created and presented through AfroReggae's programs and performances not only changes the lives of participants and challenges the preconceptions held by the rest of society; it also brings to light the universal social issues of human rights; children's rights; state violence; marginality; poverty; and race, class, and gender inequalities. The group's documentary work has carried a message of activism and social justice beyond the communities in which the art is produced to inform artists, students, and activists in other cities and nations across the world on the strategies employed by communities that work together to break down barriers and facilitate peace.

Figure 2. During my site visit, I was allowed to take this one photo of a street within the favela of Vigario Geral, with permission from an AfroReggae conflict mediator.

Third Visit to Rio

AfroReggae's struggle for peace and justice is far from over. In the months leading up to my third and most recent trip to Rio, traffickers shot down a military helicopter, raising the hysteria to new levels and provoking the onlooking world to question the Brazilian government's ability to contain violence in the city elected to hold the 2016 Olympics. Returning to Rio in January 2010 to conduct research on AfroReggae, and better informed of the nation's history and the context of the city's internal battles, I saw everything in a new light. Amid the ever-escalating tension, the city was bustling in preparation for Carnival, the one annual occasion during which *favela* culture has its official time to shine. The paradox of media portrayals, I had noted before, continued with headlines of the violence often sharing the same page as coverage of carnival madness. As a researcher working on my master's thesis, I was searching for the untold parts of the story, and I grew increasingly frustrated. It seemed that the city loved AfroReggae, devouring its music and concerts, praising its social justice efforts, and generally agreeing that the group was making a huge difference in the lives of a broad range of people. But was it?

One wouldn't have guessed it considering the carnage reported on the nightly news. I pivoted from interview to interview, discussing the issues with authors, journalists, academics, activists, and organization employees, and by the end of the second week of my visit, I was reeling from the oppositional perspectives I'd encountered. Some felt that the group, in spite of all the attention it was receiving, was really changing very little, while others claimed it was the best thing under the sun to happen to Rio. I couldn't figure out who was right, who was wrong, who was disillusioned, and who was ignorantly optimistic. I tried to "trust the process" as I'd been told by colleagues to do, but I was beginning to doubt the very foundations of all my previous observations and assertions about AfroReggae and the alleged impact it was making. It was a troubling thought that perhaps I'd been wrong, fooled by the glowing reviews, and I knew I needed to go see for myself what was really going on.

During this time, my focus was entirely on making connections, seeing the link between AfroReggae and other political movements in the history of music, both within Brazil and around the world. I tripped over an obvious connection: the positioning of AfroReggae within the global hip-hop movement. AfroReggae had come to have several bands, all of which incorporated traditional African drumbeats and Brazilian samba rhythms, but infused them with newer vocal styles and sounds typical of modern U.S. hip-hop. They also used some old U.S. funk music, sampling old songs while laying new rap verses over them, a technique borrowed from hip-hop. Well, that got me thinking about U.S. hip-hop and how political it was when it first emerged in the United States, that is, before it was attacked by the state and quickly co-opted by corporate entities. Similar to the case with Brazilian funk, hip-hop was targeted for its alleged connections to violence and was seen as offensive by the middle and upper classes. The genre was labeled by political and community figures as obscene and was banned from the shelves of many stores (Lipsitz, 2007). It was then snatched up by giant corporate record labels whose executives actively stripped the music of its political content—for example, commentary on police brutality, the absence of infrastructure, and the curious influx of crack in poor neighborhoods. What was left when the commercial machine was done with hip-hop was a distorted "art" that hollered about money, guns, and hos, but remained silent on the issues that had provoked its creation in the first place. Like Brazilian funk, hip-hop had been rendered a scapegoat. Then, in a surprising turn of events, it was adopted, adapted, and turned into a somewhat defining style that represented a new age of urban music and culture in the United States, much like *favela* samba had been adopted and adapted (i.e., depoliticized) in Brazil and transformed into a cultural icon that is marketed not as *favela* music but simply as Brazilian music. I wondered if that were happening to AfroReggae. When I dug deeper, I was surprised by what I found.

AfroReggae, unlike Brazilian funk, was not rejected by the state or banned from stores and radio. Nor was it completely co-opted and reinvented by the corporate world. But it was being co-opted to a certain extent; that much was clear by the sources of the group's funding and its steady presence in mainstream media. I began to see signs of a divergence from the historical paradigm reflected in AfroReggae's unique ability to turn the co-optation process inside out, using its resources and media connections as a vehicle to become more political rather than less so (Yúdice, 2001). It wasn't that AfroReggae was all progress with no bells and whistles, nor vice versa; it was the whole package: bells, whistles, social justice, and all. It had tapped into the perks of being a main-stage spectacle without losing the edge of political force that had defined the movement since its humble beginnings as a black culture newspaper. Now the ball was rolling, and I had to step back and rearrange my whole academic argument. It was no longer a debate about whether or not the group was making a real difference or simply providing a convenient photo op. Now it was clear that it was paving the way for a whole new approach to social justice through the arts by doing a little co-opting of its own. It had borrowed strategies of resistance from the very forces it was resisting, a political philosophy that echoed the sampling techniques evident in its music. Additionally, it was demonstrating to the rest of the city the ability *favela* residents had to produce art and culture, to make social critiques, and to transform their daily reality through acts of citizenship and activism. The key to my project would be documenting how, exactly, this thrown-together group of musicians, community activists, and *favela* youth was able to pull off a stunt of such great proportion and significance. So, spinning with newfound enthusiasm, I got back to work.

Limitations and Conclusions

AfroReggae has started an arts craze in the *favelas*, with emphasis on visual arts such as graffiti and comic drawing; performance arts such as dance, circus, theater, and, of course, music; and informational photo/documentary work. But there are obvious and inevitable limitations facing a movement whose primary strategy for change is creative production. Structural inequalities, state neglect, and frequent military intervention provide constant reminders that *favela* residents need more than a few songs and murals to create long-lasting change. Traffickers continue to control daily life in many *favelas*, recruiting young residents, and the staggering death toll has eased but not ceased. Yet with other organizations learning from AfroReggae's fundamental pillars of conflict mediation, anti-violence, and cultural citizenship, it seems that systemic change is also unavoidable. Granted, AfroReggae's creative youth aren't writing or enforcing public policies, but they

are influencing those who do, making way for alternative approaches and demanding a higher level of accountability from those in power. By making huge waves in the art/music world, the *favelas* and their residents prove that they're not going to quietly tolerate state neglect and social marginalization; they are refusing to be ignored.

Resources for Educators

There are several excellent websites that cover the work of AfroReggae in Rio de Janeiro and elsewhere in Brazil. A great place to start is, of course, the official organization webpage at www.afroreggae.org. Also helpful is the site www.favela-totheworld.org, which explores AfroReggae's partnership for social justice in the U.K. More information is available on the page for the first major documentary produced on AfroReggae, called *Favela Rising*, at www.favelarising.com. Education for Liberation offers a comprehensive lesson plan guide to accompany the film *Favela Rising*, which can be found here: http://www.edliberation.org/resources/records/favela-rising-movie-lessons. AfroReggae itself also produced a full-length documentary in Portuguese with English subtitles called *No Motive Explains War*, which can be ordered online through the organization's website. Authors Patrick Neate and Damian Platt wrote the first full-length book on AfroReggae, entitled *Culture Is Our Weapon*, which can be found on amazon.com. For legitimate studies on police violence in Rio de Janeiro, see official reports by Amnesty International, Justicia Global, and CESEC, the Center for Studies on Security and Citizenship.

Notes

1. This is a rough estimate. Numbers vary from year to year and depending on the source. However, the website, organization employees, and several outside sources use 2,000 as the official estimate of participants.

References

AfroReggae. (2010). www.afroReggae.org

Diegues, C. (2006). *Nenhum motive explica a guerra or No motive explains war.* Brazil: GegePro-ductions/Warner Music Brasil.

Lipsitz, G. (2007). *Footsteps in the dark: The hidden histories of popular music.* Minneapolis: University of Minnesota Press.

Neate P., & Platt, D. (2010). *Culture is our weapon: Making music and changing lives in Rio de Janeiro.* London: Penguin Books.

Yúdice, G. (2001). AfroReggae: Parlaying culture into social justice. *Social Text,* 19(4), 5–65.

Zimbalist, J., & Mochary, M. (2005). *Favela rising.* United States: All Rise Films.

Media Literacy and Social Justice in a Visual World

JACQUELYN S. KIBBEY

If children don't shape images, images will shape them.
—*BILL IVEY, CHAIR OF THE NATIONAL ENDOWMENT FOR THE ARTS, 2000*

The role of the visual arts in public education is not to prepare future artists, but rather to fully educate the public at large, everyone who is living and learning in a visual age and who needs to decode and encode visual images. In today's terms, that means not only educating all people about "high art" (that which is found in museums and galleries) but also our diverse visual culture, in order to develop visual literacy skills and knowledge. Now, more than ever, as the world population becomes dependent on technology and focused on creativity and innovation, 21st-century students should begin to understand how those technologies use visual images and how such images affect their lives. "In the 21st century 'texts' and 'literacy' are not limited to words on the page: they also apply to still and moving images such as photographs, television, and film. Today, being literate also means understanding wikis, blogs, nings, digital media, and other new emerging technologies" (Baker, 2010, p. 133). This is also commonly referred to as "mass media," the premise being, according to Robert Pelfrey (1996) in his book *Art and Mass Media*, that the major art forms in students' lives are the popular art forms of the mass media. He asserts that both Western fine art and popular art stem from a common artistic tradition. Thus this chapter will look at the foundations of visual

literacy, how it relates to social justice issues, and how teachers might incorporate this knowledge into a new and relevant curriculum to be employed in their classrooms. Visual literacy raises awareness of visual culture. Visual culture is perpetuated and invented via images used in the mass media. The use of visual literacy, media literacy, and technology literacy all converge to potentially influence citizens about social justice issues.

Confusion may exist over the use of an embedded term throughout the chapter: "Visual Literacy." Visual literacy is the overarching concept, the "big picture" into which we infuse media literacy. It is based on the development of a visual language, utilizing the elements and principles of art and design. Visual literacy teaches us how to see, communicate, and understand through visual means. Advertisers and marketers understand how to reach their audience far better than educators. Why shouldn't teachers enlist those same methods? According to Wikipedia (2010), the definition of visual literacy is "the ability to interpret, negotiate and make meaning from information presented in the form of an image." It is my belief that this is the heart and soul of art appreciation, the foundation for critiques, and the summative evaluation component of studio art classes. It is also pertinent to the study of art history. These are all the major components of the art education curriculum, but the world of advertising takes them well beyond the art classroom. Marketers include such visual components as maps, charts, graphic organizers, as well as body language, photos, and icons in their advertisements. In addition, many other areas of the school curriculum use these images as well to augment their own content areas.

The purpose of visual art education must be to serve the population at large. Everyone should be aware of the basic art (and psychological) principle that art is expression and expression elicits response from the viewer, consciously or unconsciously. Ultimately, citizens would benefit from the ability to analyze what triggered their responses! Next come the questions: Why and how would we want to educate the general public about art and media literacy? And how do we interpret mass media? What tools do we use to critique, analyze, and raise awareness? Many social justice issues are based on a personal awareness, or lack thereof. In their book *Art Education for Social Justice*, Anderson and colleagues (2010) state that the concept of social justice seems always to be tied to some notion of social equity: perceptions of equal access, equal opportunity, fair treatment, and respect. It becomes a power issue, periphery versus mainstream, both physical and personal. The mass media play a big role in social justice issues generally. Why should schools and the public want to include visual literacy and social justice in school curriculum? Because as Bill Ivey, the chair of the National Endowment for the Arts, stated: "If children don't shape images, images will shape them" (Ivey, 2000).

Justification for Inclusion across the Curriculum

There is certainly a multitude of reasons to demand the inclusion of visual and media literacy in all subject areas, not just in the art classroom. This type of literacy helps us understand bias and analyze marketing and advertising techniques (some of which have shaped history.) It also requires the use of critical thinking skills by forcing the use of comparison and contrast, categorization, and classification, all of which are ways to analyze social justice issues that we want future citizens to recognize and employ.

The focus of art education in public schools is on preparing future consumers of art. This is using the term "art" in the broadest sense. All citizens will need to make aesthetic choices for themselves as consumers and in the role of voter/taxpayer within a community.

Increasingly, every day each person is expected to make aesthetic choices, from choosing clothes to wear, to purchasing and decorating a home, to choosing a car, or selecting eyeglass frames. While the functions of the products are important, people also tend to be sensitive to the looks and design features of such items. This trend is noted in Daniel Pink's book *A Whole New Mind* (2006). As a result of automation, abundance, and outsourcing to Asia (India, the Philippines, and China), aesthetics is driving the global economy as well as manifesting itself as a major influence on young minds. Thus Pink's claim that the MFA (Master's of Fine Arts) degree will become the new MBA (Master's of Business Administration). He believes it is increasingly clear that all 21st-century citizens need to develop and nurture six new senses to be visually literate:

1. Design—create and appreciate human-made objects that go beyond function and may be perceived as beautiful, whimsical, extraordinary, unique, or emotionally engaging;
2. Story—communicate effectively with others by creating as well as appreciating a compelling narrative;
3. Symphony—synthesize ideas, see the big picture, cross boundaries, and combine disparate pieces into a meaningful whole;
4. Empathy—understand another's point of view, forge relationships, and feel compassion for others;
5. Play—creatively engage in problem-solving benefits personally and socially from flexibility, humor, risk-taking, curiosity, inventive thinking, and games;
6. Meaning—pursue more significant endeavors, desires, and enduring ideas with a sense of purposeful inspiration, fulfillment, and responsibility in making informed choices toward higher-order thinking skills and transformation. (Pink, 2008)

This definition, originally included on the 2008 NAEA (National Art Education Association) bookmark, stating that "Art teachers nurture six senses in developing visual literacy...," can now be found on http://distanceed.math.tamu.edu/tech-tools/valgebra/resources/definitions.html.

Now that we know that what is at stake is the global economy, it's obvious that we need to prepare future citizens to know how to balance their checkbooks and budget their incomes, but it is just as important to help them understand how to read images. Students should become aware of, as well as able to interpret/analyze and question why they desire certain personal images, or why they want to purchase certain brands, or why they desire objects that they do not need but that they want. Students should pause and question why they want to replicate behaviors that are viewed on TV or in films. People who can analyze and control visual messages are not always producing high art for the ages. Sometimes they use those skills to persuade or manipulate people into thinking they desire and need to purchase certain items, or encourage people to behave in certain ways through the development and bombardment of aesthetic icons and exposures in the popular culture's mass media.

This is also known as propaganda, subliminal messaging, and, more broadly, marketing. Technology is the perfect media to promote all of it! Whether the medium is film, television, or iPads and computers, images and messages are linked through expression and response. Where, in the school curriculum, does it indicate a standard stating that visual literacy should be taught? Elliot Eisner makes a strong case and points out in his book *The Kind of Schools We Need* (1998) that the term "literacy" goes far beyond the written and spoken word in today's world. Eisner states that meaning is the core of literacy. He questions how meaning is conveyed, and he raises the issues of justification and whose job it is to teach visual literacy.

Therefore, it would seem that visual literacy is applicable to all subject areas just as it is broadly utilized in the real world—not just compartmentalized in subject-specific courses and textbooks. In order to create/prepare literate consumers, visual literacy must be addressed in the formal education process. It should begin early in elementary school and continue through high school. It should be embedded within the visual art curriculum, but also with interdisciplinary links and applications to be reinforced in all content areas, much like certification requirements mandate that all content areas reinforce traditional reading, writing, and public speaking known as general literacy skills.

The tools needed to critically analyze and thoughtfully respond to any type of visual images are firmly rooted in the field of visual art. It is through the elements of art and design that visual images are created in all media. The fields of aesthetics and criticism as well as art history target the cognitive process and are therefore linked to the field of psychology. Thus, students must have solid exposure and in-

struction in all of these areas to be able to analyze and discuss what it is they are viewing. Utilizing higher order thinking skills to compare and contrast images while investigating how basic tools are used to elicit response from the viewer of high art or advertisements is imperative to understanding and raising awareness.

On a personal level, I remember how astounded I was as an undergraduate to learn that the interior color and design of restaurants was directly related to the prices on the menu and how long guests were encouraged (or not) to linger. Thus most fast food restaurants utilized orange and red interior colors to agitate the clientele and encourage them to eat and move on quickly. I had no idea I was being manipulated that way by the food industry and its use of color theory!

The above awareness led to further discoveries such as product packaging and design, and placement of products in grocery stores, which prey on eye-level as well as age-level components to encourage purchases. Again, these marketing techniques were derived from knowledge of developmental psychology and the utilization of the elements and principles of art and design, but it wasn't happening in a gallery. It was being viewed in the mass media in magazines, on television and films, and in local businesses. I remember when it became illegal for movie theaters to insert subliminal frames of popcorn images within the films that were too fast for the brain to register, but instilled a "craving" for popcorn. Additionally, I was amazed to find out that TV advertising spots are sold based on the gender and age of the intended audience of the program; thus beer and trucks were always advertised during televised sporting events, while soap and undergarments were advertised during daytime soap operas. These were all enlightening and amazing discoveries that shook my world and—in today's vernacular—had social justice implications given the use of gender, ethnicity, age, and culpability. Now our students, or, to use the new term "screenagers" (Rushkoff, 2006), can view themselves on a hand-held screen utilizing GPS technology and see where they are on a map. They regularly invade each other's lives on Facebook and Twitter. Technology has the clear ability to enable or disable us as we increase our reliance on it to provide us with answers. Ask any math teacher about the significance and impact of the use of hand-held calculators in the classroom.

The messages of TV and film are not always found in their scripts. They have discerning subtexts. The images and music play an important role in the interpretation of the show or image being viewed. Interpretation is not totally left to the imagination of the reader/viewer. This simple fact is affecting the current population of school-age (and younger) students. It is problematic because many parents do not view the same shows that their children view, and thus are not there to answer questions or insert comments on acceptability, and in general help with interpretation of what is being viewed. Mass media continues to have a major impact on the moral and social behavior of young students. This is becoming more of a

contentious matter as the issue of "respect" surfaces as a major problem in schools. One can posit that it may be due to parents' letting TV and film raise their children. They use these venues as convenient babysitters, assuming (incorrectly) that their values are being conveyed, or that their real-life situation will trump what is being viewed on TV. However, TV is a tough act to follow, and children cannot discriminate between fact and fiction. Just ask any kindergarten teacher who was working in that capacity when *Sesame Street* was introduced to the public. Children viewed this show and were told they would be learning just like they would learn in school when they get big enough to go there. Then, when the kids got old enough to go to school, they found the pace of learning was not what the editors of a television show could provide, and the learning was not nearly as entertaining. They had come to expect education to be equated with entertainment.

Furthermore, as children grew older and started watching adult programming such as sitcoms (not to mention adult-targeted commercials), they believed that this was how people did/should act in society. The line between reality and fiction became blurred, and if it was not noted and corrected, then inappropriate behavior and language walked right in the school door. Stereotypes that are fodder for sitcoms became acceptable and often sought after.

Similarly, images in fashion magazines started dictating what women should be attempting to look like as the photos of stick-thin females were prominently displayed and aligned with the concept of beauty. Again, without parental intervention, such images were never questioned. If parents were not going to assume the role of media critic, then who would?

While all of this was taking place, schools were becoming overburdened with test-driven data. Their focus was on the 3 R's and raising test scores so that they could be deemed accountable. Yet the driving force of Goals 2000 was to see that every school had access to computers and was connected to the Internet to accommodate the newest learning tool of the 20th century.

Meanwhile, almost no one was dealing with "new" and problematic issues such as media literacy and how the media was affecting our children and what implications that would have or how it would change the world. Teachers and parents were notoriously criticizing television and noting the influence on young minds, but no one was demanding inclusion in the school curriculum to address the issues. Television did not go away, but rather became more prevalent in society, expanding from three or four local channels to over 700!

Now, back to the question at hand: Whose responsibility is it to teach critical analysis of new media to develop media and visual literacy in all citizens? Whereas school districts tend to want to cut the arts, not increase the role of them within the educational structure, expansion is the obvious answer. This is particularly important when one considers the powerful and influential role that such media and

images, through advertising power, play in most students' lives, even affecting their career paths.

Career education seems to be gaining momentum, and most careers are inter-disciplinary in nature. Most careers also utilize observational and marketing skills. The job of the visual arts is to heighten observational abilities and enhance the ability to create and read images through the application of a variety of studio and art appreciation skills.

Schools must teach critical observation skills and utilize analytical and compara-tive methodologies. The field of art education has done this historically and is man-dated to do so through its national standards. Not only do the time-honored approaches of Bruner's Concept Attainment Model (Bruner, Goodnow, & Austin, 1956) and Feldman's Critical Analysis Theory (1992) function well in this venue, but the field of art education heavily utilizes the hierarchical format of Bloom's (1956) Taxonomy to target higher-level thinking skills. This has been augmented by the contribution of the identification of the 8 Studio Habits of Mind (research funded by the J. Paul Getty Trust), found in the book *Studio Thinking: The Real Benefits of Vi-sual Arts Education* (Hetland et al., 2007). Another example of a way to enhance cog-nition focuses on a balanced approach that addresses significance and relevance. Renee Sandell formulated the "Form+Theme+Context (FTC) Theory," which delves deeply into images (artwork) by helping the viewer understand the context in which the art form was created and valued (Sandell, 2009). The FTC Palette is a graphic or-ganizer that helps educators to teach the decoding and encoding of visual ideas, cre-ating greater learner access through open-ended exploration (Sandell, 2009). This model expands meaning while raising awareness of art styles, processes, and utiliza-tion, and most of all art's expressive force that confronts past and current civiliza-tions' social justice issues that have influenced artists and others throughout history.

The media literacy components that should be covered in any course can be found on the Center for Media Literacy (CML) website (Center for Media Liter-acy, n.d.). They have clearly established "5 Questions for Deconstruction" of viewed materials:

- Who created the message?
- What creative techniques are used to attract my attention?
- How might different people understand the message differently?
- What values, lifestyle, and point of view are represented by or omitted from this message?
- Why is this message being sent?

The above deconstruction of a viewed image is supported by the underlying 5 Core Concepts:

- All media messages are constructed.
- Media messages are constructed using a creative language with its own rules.
- Different people experience the same media message differently.
- Media have embedded values and points of view.
- Most media messages are organized to gain profit and/or power.

What would a course dedicated to teaching Media Literacy as its primary goal look like?

Case Study

A wonderful example of an application of infusing media literacy into a public school curriculum is a case study of a high school art teacher who recognized such a need and did something about it. Mary Ellen Shevalier, a high school art teacher at South Jefferson High School in upstate New York (close to Watertown and the Fort Drum army base), is an amazing woman who created, proposed, and was allowed to deliver an entire new media literacy course in the fall of 2008 entitled *I Am a Citizen of the World*. It was an interdisciplinary initiative that was team-taught and open to all students in grades 9–12 as an arts elective. The other teachers on the team were the district media specialist, a French teacher, and a health teacher.

The students were asked to brainstorm and identify an "issue" that was important to them and bothered them. They were asked to study this issue and look at it on three different levels: local impact (meaning their community and school), national impact, and global impact. They were to see how their chosen issue functioned at those three levels and utilize supporting evidence through media, visual images, and artwork. This was to raise their awareness of how visual media communicates as well as bombards people of all ages, all of the time. They were taught to recognize it, analyze it, and most importantly control it so as not to fall victim to it. Then they were asked to develop products and presentations as authentic expressions and catalysts of change.

One of their first choices was to target "stereotyping." The students used digital storytelling to voice their opinions about stereotyping in the media and in school. They then shared their media work by producing a middle school assembly on the topics of stereotyping and tolerance. It was very powerful and well received by the middle school students. The high school media literacy students had learned how to communicate effectively with images through film supported by public speaking skills and had become adept production teams in the process. This was a powerful testimony as to the potential such a course could provide in the education of all students. For many of the high school students enrolled in the course, it became a rea-

son to come to school each day. The course was offered during a double period at the beginning of the day, and the attendance was regularly high, with very few absences or lateness. One-third of the students were able to sign up and repeat the course the second semester. Those students became the first team leaders for new groups. It continues to self-perpetuate. For more information, examples, and pictures, see the course website (South Jefferson High School, 2008).

The experience culminated with well-received formal media literacy presentations (student-developed products) to parents, community members, school board members, local businesses, education leaders, and the superintendent of schools. Everyone was astounded at how professional the productions were and how effective the messages were. The students incorporated original music and scripts but also learned about and managed copyright laws and permissions for historical components of images and music that they wished to include. All agreed that this was an amazing experience.

Additionally, the teachers and student teachers presented this course along with an evaluation of it to the State Art Teachers Association (in Rye Brook, New York, 2009) and at the National Art Education Association Conference in Baltimore (2010). The course was introduced in the fall of 2008 and continues to grow and thrive. This is an excellent example of how such a course can be born, but it takes teachers and administrators with great insight to get it started. That wonderful combination was present at South Jefferson High School.

Concluding Thoughts and Powerful Applications

Flavia Bastos, in her editorial capacity for the journal *Art Education*, wrote in an issue dedicated to art education and social justice, "I am moved by the proposition that education is a vehicle of social transformation" (Bastos, 2010, p. 3). It is transformative education. Accordingly, in the same issue, Marit Dewhurst states: "If critical pedagogy is about learning to critically examine the world around us—to pull apart the structural factors that lead to injustice—then why stop at the obvious examples of inequality?" (Dewhurst, 2010, p. 7). She further indicates that there are three competing visions: "(1) how strategic the artistic and activist decisions are in relation to their potential to effectively change policy; (2) what constitutes activism or social change; and (3) if emphasis is placed on the process or the product of artmaking" (p. 7). All were found as content or process in the new media literacy course at South Jefferson High School. It was amazing to watch the students rise to the issues and become enlivened by them. All of a sudden, their schooling took on new significance. Brian Payne's observations that "issues of gender, race, sexual orientation, and intellectual disability are taboo among teens, as they are consumed with

their own struggle for identity and often unable to view the struggles of those around them who may not fit into the social majority in the overwhelming ecosystem of high school peer groups" (Payne, 2010, p. 52) could have been generated by watching the new course unfold. The South Jefferson students were no exception to his description of high school students, but once they walked through the doorway and learned to use a critical lens, they rose to the challenges and embraced them. They learned to be critical viewers and it opened up new worlds for them. No wonder it was their favorite class, the one they came to school for. And no wonder they wanted to repeat it. It was an amazing example of a relevant and challenging curriculum where applied learning as well as activism took place.

Art is a visual solution to a problem for which there is no one clear right or wrong answer. In the field of education this is known as developing critical thinking skills. In art, only a personal interpretation provides a solution. This develops a tolerance of differences, an important social justice lesson to be learned in schools today. Someone or their work is not "bad" just because it is different.

The need to create is powerful. Many adolescents are insecure and often low in self-esteem. This can block their receptivity toward studying art. Such a course as the one at South Jefferson High School overrides those fears. At the high school level in the United States, visual art is not a mandatory subject, but an elective. Even so, very few who study it do so with art as a career option in mind. Many enroll because they think it's relaxing and not graded hard. Many students are placed in art by well-meaning guidance counselors who want problem students busy in a class and not causing trouble in study hall. So many students are reluctant learners. However, once they show up in the art classes, the teacher's job is clearly to individualize at the high school level, guiding students toward rewarding and appropriate behaviors and outcomes. This means addressing social justice issues that are impacting their lives and helping them understand through their expressive abilities in art.

Elliot Eisner stated, "Diversity in education breeds social complexity and social complexity can lead to richness in culture that uniformity can never provide. What democratic cultures need is unity in diversity: both are necessary" (Eisner, 1998, p. 206). Thus we need to continue to assess the outcomes of schooling and continue to challenge and question our roles within the educational system. Schools need to change to meet the needs of society. "Schools have, as one of their important functions the development of multiple forms of literacy—that is, the development of the student's ability to secure meaning from the arts, the sciences, mathematics, and indeed, from any of the social forms from which it can be construed" (Eisner, 1998, p. 7).

The world needs men and women of vision. We need savvy consumers who cannot be easily manipulated by media. We need those who can imagine solutions to problems and create and market inventions and information. This will not happen

without the arts (including both visual literacy and media literacy). It is currently the most prominent subject matter that applauds and encourages innovation and personal interpretation and expression while de-emphasizing right or wrong answers. Art classes encourage and expect people to defend their choices and solutions to problems. The answers to questions posed in an art class do not come from a textbook and are not the correct answers written neatly, to be regurgitated later on a multiple-choice test. Individualization and differentiated instruction are the norm and not the exception. Independent and critical thinking skills are demanded and rewarded. Without such a subject matter firmly ensconced in the educational system, we would produce nothing but clones who are not very good thinkers, or problem solvers, or inventors. Just as art is a necessary and viable component of society and monitors the health of any given culture, so must it function in schools. If students are currently spending 7.5 hours each day (more than 53 hours per week with 24-hour access) surfing the web and blogging and watching TV, and children between 8 and 18 who use the media heavily are getting poorer grades than children who do not, and if more black and Hispanic children spend far more time with media than white children do (Kaiser Family Foundation, 2010), then clearly it needs to be an item of concern in the school curriculum. The future depends on it!

References

Anderson, T., Gussak, D., Hallmark, K., & Paul, A. (2010). *Art education for social justice.* Reston, VA: NAEA.

Baker, F.W. (2010). Media literacy: 21st-century literacy skills. In H. Hayes-Jacobs (Ed.), *Curriculum 21: Essential education for a changing world* (pp. 133–152). Alexandria, VA: ASCD.

Bastos, F. (2010, September). What does social justice art education look like? *Art Education,* 2–3.

Bloom, B.S. (1956). *The cognitive domain.* New York: David McKay.

Bruner, J.S., Goodnow, J.J., & Austin, G.A. (1956). *A study of thinking.* London: Chapman & Hall.

Center for Media Literacy (CML) (n.d.). Retrieved September 1, 2010, from http://www.media lit.org

Dewhurst, M. (2010, September). An inevitable question: Exploring the defining features of social justice art education. *Art Education,* 6–13.

Eisner, E. (1998). *The kind of schools we need: Personal essays.* Portsmouth, NH: Heinemann.

Feldman, E. (1992). *Varieties of visual experience.* (4th ed.). New York: Abrams.

Hetland, L., Winner, E., Veenema, S., & Sheridan, K. (2007). *Studio thinking: The real benefits of visual arts education.* New York: Teachers College Press.

Ivey, W. (2000, October 4). Riley and Ivey announce nearly $1 million in media literacy grants. U.S. Dept. of Education and National Endowment for the Arts. Retrieved October 25, 2010, from http://www.ed.gov/PressReleases/10-2000/100400.html

Kaiser Family Foundation (2010, January). Generation M2: Media in the lives of 8–18 year olds. Retrieved October 25, 2010, from http://www.kff.org/entmedia/index.cfm

Payne, B. (2010, September). Your art is gay and retarded. *Art Education*, 52–55.

Pelfrey, R. (1996). *Art and mass media.* Dubuque, IA: Kendall/Hunt.

Pink, D. (2006). *A whole new mind: Why right brainers will rule the world.* New York: Riverhead Books.

Pink, D. (2008). NAEA bookmark. Retrieved January 13, 2011, from http://distance-ed.math.tamu.edu/techtools/valgebra/resources/definitions.html

Rushkoff, D. (2006). *ScreenAgers: Lessons in chaos from digital kids.* Creskill, NJ: Hampton Press.

South Jefferson High School. (2008). Media literacy course. http://www.spartanpride.org/web-pages/citizen/index.cfm-

Sandell, R. (2009). Using form+theme+context (FTC) for rebalancing 21st-century art education. *Studies in Art Education*, 50(3), 287–299.

Wikipedia. (2010). http://www.en.wikipedia.org/wiki/Visual_Literacy. Retrieved September 1, 2010.

Enlivening the Curriculum Through Imagination

MARY HARRELL

Introduction

For me, an educator and imaginal psychologist, the work of social justice activism begins with the act of shining a light on that which lives in the shadows and the margins of cultural awareness. Though it is a function of the human condition to turn quietly away from the shadow, or repressed aspects of self and society, we know from Jung, Hillman, von Franz, and others that when we resist this urge to turn away, when we invite the invisible to become visible, we enter, individually and collectively, into relationship with our own substance and mass. In this way, imagination, like authentic art, renders the world richer by providing a language to speak its complexity.

In this chapter I use the terms *imagination* and *imaginal world* in the psychological sense, meaning that between one's mind and the material world of matter there is a third world. It is a *real* place of irrefutable and razor-sharp truth that can be entered through image. All artists have known this since the beginning of time. They know that images created through music, poetry, two- and three-dimensional art, song or dance, express truths that are undeniable and often revolutionary.

If we want to bring imagination to the schools, in other words to use image to know the experience of social injustice, it seems that the best way to start is with the teachers. I have an opportunity to do just that when I teach a popular graduate course entitled *Bringing Imagination to the Curriculum*. I would be cheating if I said

that the course was *designed by me*, because it wasn't really designed at all. It was *imagined through me*.

My graduate students who teach K–12 students of their own learn that the images created by music, literature, dance, and the visual arts bring about what analytical psychologist Carl Jung (1953/1977) labeled the transcendent function. He explains this function as the process of coming to terms with the unconscious, or rendering certain aspects of the unconscious conscious. Through the symbolic language of image, the unconscious—or Psyche, as she is called—has the capacity to create a curriculum that becomes more real and more alive, a curriculum where the past moves fluidly into the present, becoming relevant for our students, a curriculum that becomes its own vital world inhabited by imaginal beings. As we find ways to enter into the depths of school curriculum we find, at last, the many experiences of injustice that until now have been too often hidden, and finding them allows legitimate and authentic transformation of our students.

Corbin (1998), following in the tradition of 13th-century mystics, calls this vital world the *mundus imaginalis*, or the realm of imagination. Imagination is reclaiming its place in a modern view of teaching, learning, and scholarship. Richard Tarnas (2006), professor of philosophy and depth psychology, explains this reclamation as a participatory relationship among Psyche (the unconscious), matter, and mind. For Tarnas this is a time when culturally we are experiencing the intimation of a new worldview in which imagination serves as a creative act, allowing men and women and, I would add, young learners to enter into a more open-ended epistemological equation, one that transcends the limitations of intellectual rigor.

For further evidence of the vital place of imagination in teaching and learning, my students don't have to look far. Robert Romanyshyn's *Wounded Researcher* (2007, ch. 3) is a groundbreaking new text describing an imaginal approach to research. Within the book's pages Romanyshyn explains how exploration of the gap between conscious and unconscious experience, Jung's transcendent function, can lead to new epistemologies. Not surprisingly, the vehicle Romanyshyn offers for this exploration is imagination. Suggesting that a re-imagining of curriculum is both essential and timely, I offer my own teacher preparation course as one of several points of entry.

A Description of the Course Bringing Imagination to the Curriculum

Perhaps the best way to understand this class is to eavesdrop on the students and me during the beginning minutes of our first session. I want them to realize what they are in for and to have an opportunity to change their minds before they get in too deep. My introductory comments follow:

If you think that this course is about teacher creativity and imagination in its more traditional sense you may be in for a surprise. This class, as the word "imagination" might imply, is not about learning new art techniques, nor is it about creating material things out of art supplies for the sake of doing art. What I aim to bring to the class is an opportunity for each of you to go to a world that analytical psychologists refer to as the *mundus imaginalis*, a real world in which the human condition, yours personally and that of the broader culture, exists in symbolic image. Within this world lie deep truths about the topics you teach in school.

Using imagination, your students can explore the curriculum as they never have before. There is one catch, however. It is not enough for you to theoretically understand analytical concepts like archetypes, the collective and personal unconscious, or the idea of the complex—the stuff of the imaginal world—you must *experience* these things. So while one part of our coursework is learning about analytical psychology and its ideas, another part of the work is to experience the imaginal realm through two of its open doors: your personal dreams and the dreams of the culture in which we all reside (myths and fairytales). Once you personally interact with your own symbolic life, meet Her images, act upon them, be acted upon by them, then you will be ready to lead your students to this world. So get ready for the ride of your life. (Harrell, 2007, n.p.)

I'd like to continue with a description of the four components of my course, followed by a glimpse of an illustrative project that one of my students did with his own 10th graders.

Part One: A Foundation in Jung's Analytical Psychology

The first segment of the course involves 20 hours of analytical psychology. The following questions are answered: Where is analytical psychology situated within the field of psychology? What is the anatomy of the psyche as explained by Edinger (1996)? How does individual and cultural unconscious material affect what occurs in school cultures? Why is it important to tend to the unconscious in school curricula as well as in classroom or school cultures? What happens when teachers and other school leaders fail to address unconscious issues?

Students focus on four Jungian, or analytical, ideas in *Two Essays on Analytical Psychology* by C.G. Jung (1953/1977): first, individuation, or psychological growth; second, the transcendent function—the psychological function by which the conscious mind bridges the unconscious; third, imaginal figures—dream images, feelings, perceptions, etc.; and fourth, the archetypes that are defined as infinite patterns of human experience, such as mother, father, life, death, teacher, engulfment, and

erotic love. All of these ideas play out in individual psychological life. More importantly for educators, they play out in the world of school cultures and curriculum treatment.

Part Two: Experiencing the Realm of Imagination

The second aim of the course is to give graduate students direct experience with unconscious reality. We know from Mary Watkins (1984) that the unconscious, or "Psyche," as she is called in the frame of analytical psychology, speaks in dream images, fairy tales, or active imagination, a process by which one "dreams" while in a waking state; students begin recording dreams and "working" them. In other words, students receive dream journals on the first day of class and begin writing dreams, listing images, making associations, and noticing current life situations that may be linked to the dreams. Students learn of the structure of dreams, types of dreams, and the central psychological process that dreams tend to address. Some examples of these processes are those that the societal consciousness and the individual tend to repress, such as greed, sexuality, aggression, power, shame, anxiety, and especially issues of death or destruction. There is an emphasis on dream analysis because one *experiences* dreams as reality, and to feel the resonance that comes when a dream is successfully interpreted tends to be a most powerful experience of the imaginal realm. Students develop an understanding of Corbin's (1998) view, that imagination is the unconscious space between the domains of matter and mind; they understand this domain as real, as vital to well being as breathing is to the material body.

Part Three: Using Imagination to Make the Invisible Visible

The third focus of the course is to explore the many ways in which schools, in their tendency to overvalue rational intellectual knowing over instinctual knowing, contribute to a marginalization of the unconscious, in both curricular and socio-emotional arenas. Issues of race, gender, sexual preference, disability, class, and the minimizing of the inner world of our students are all implicated. Unfortunately, too little is said in schools about how such marginalizing of reality unwittingly links to social injustice. By example, students learn about the many positive features brought to the culture through industrialization, but too little is said about the cost to waterways or the pollution of the air. More importantly, little is said about the exploitation of the poor and how such exploitation continues by those in power today.

While these types of justice issues are taught and often grasped in teacher preparation institutions, the public school culture itself tends to prevent those

intellectual understandings from manifesting in a more balanced school environment. A central aim of my course is to correct this problem by inviting imagination to speak on behalf of the invisible.

Part Four: Graduate Students Bring Imagination to Their K–12 Classrooms

As a fourth and final focus, my graduate students are required to explore a particular unit of study, a classroom dynamic, or a single concept in terms of bringing its imaginal aspect to light in a more real way. They are required to create developmentally appropriate projects utilizing image as the primary means of exploration, the idea being that schools will move toward a mediation of a historical tendency to overvalue intellect, reason, and linearity. Image is defined as literature, rhythms, dance, theater, three-dimensional art, and so forth. At this point in the course my students are beginning to fully understand imagination as an avenue to a more real experience of classroom curriculum through a balanced union of intellect and instinct (mind and body).

Some of their more successful projects include poetry, personification, collage, murals, and three-dimensional art, as well as the imagery of literature, song, and rhythms. It is through the projects that my graduate students experience their "aha!" moments. As they witness the energy and excitement of their K–12 students, my graduate students are able to let go of vestiges of doubt about the ability of imagination to successfully partner with intellectual ways of knowing.

Learning Through the Creative Act of Imagination

It is important to note that in my course I make the distinction between real imagination and imaginary activities. To explain: real imagination as understood by Coleman (2006) and by me involves the ability to engage in symbolic thought, in other words, the ability to play with reality without denying it.

Real imagination, unlike the imaginary activity of fantasy, does not attempt to negate or repress reality. In imagination (or the imaginal realm), the symbol or the symbolic figure points to something other, something that is not present and yet is a new, ambiguous third. By example, in the learning project I discuss herein, students create an image of hunger. While hunger is not *literally* present, students' visual and poetic images render Her more alive than the mental construct that might define Her; in this sense hunger is *both* present and absent in the student project because imagination renders Her ensouled. Rather than being experienced as dark and dreary, the curriculum illuminates the learning space with deepened reality and vitality.

One Student Project: An Imaginal Approach to Learning

Perhaps the work of Jim, one of my graduate students, and some of his 10th-grade students might help us better understand a curriculum that is experienced through the lens of imagination. Jim teaches in a transitional high school program in Oswego, New York. (All names and places in this example are fictional for purposes of privacy.) Jim's students tend to have difficulty being successful in mainstream classrooms. They are known to be poor achievers with marked behavior problems or learning disabilities. Unfortunately, in some ways they are the "underside" of the educational system, those in the margins, the ones often unnoticed by many in the broader school culture. Yet for the imaginal project entitled Imagining Global Issues, each student shows a remarkable understanding of his or her chosen world issue and brings it to light in a dramatic and moving way.

For 4 days Jim's students work on a global issue of choice. Some examples are poverty, racism, world hunger, teen pregnancy, and global warming. The students research their issue, find three to five websites that address the issue, and develop what Jim calls a "Significant Statement" including examples of the impact of the world issue. Their reports include history of the issues, causes, and the way in which each issue is currently being addressed. To communicate the deepest level of reality found in their research, they employ their own organs of imagination, creating original poetry and visual art through which the issue is personified.

Finally, the 10th-grade students present these images, their symbolic pictures if you will, to the class. What matters to Jim is that formerly reluctant students become captivated by the project. Imagination at work can be fully appreciated in a reflection of a particular group's student-rendered image—a large poster depicting world hunger. At first glance one sees to the right of the drawing a rather expressionless, obese man, mouth open wide, gorging himself on a slice of dripping, cheese-laden, pepperoni pizza. His image fills the right side of the poster, from bottom to top. Beside him students have drawn a large, high table topped with an oven-roasted turkey and a bowl of fresh homemade bread. What one might miss because of its tiny dimensions and position at the very bottom of the sketch is a group of three starving figures, emaciated and too weak to stand. One is captivated by the sketch and is compelled to take a moment to study the attitude, size, movement, and gestures of the several figures within the poster rendering. The poignancy of these figures evokes the desperate reality of hunger and the powerless stance of its victims as students' written reports alone cannot.

The image is powerful, showing both the marginalized nature of the victims of hunger and the large capacity of greed to continue feeding itself. This image is an example of intuitive as well as intellectual intelligence at work in the learning process. The skeleton-like bodies, tiny and abandoned, show as words alone cannot

that the students explore the issue deeply. Both the students and the figures themselves expose the crime of starvation within bounty, and in doing so they bear witness to a reality that cries for awareness and can only be mediated through conscious regard. These figures are, of course, symbols for hunger; they are not concrete literal skeletons, yet paradoxically they are real. These are the ambiguous inhabitants of imagination. Though they exist in a neither/nor reality, they do exist.

Jim and his students know that hunger is much more than a concept to be learned. Hunger is an archetype, a pattern of human experience. The act of focusing on its imaginal figures in art is the transcendent function that Jung talks about, the act of living consciously in the tension between what is and what is not.

But hold on: these 10th-grade students are not finished yet. They have written a powerful poem, for the second part of their presentation, allowing hunger to exercise Her own voice, in essence creating another layer of imaginal reality. With a dialogue between hunger and Her audience, she once again transcends Her existence as an abstract concept and becomes more real. Hunger, in Jung's (1990) *mundus imaginalis*, becomes an autonomous liminal being, a shift changer existing as a subtle body between the sensible world of matter and the reasonable world of mind.

The poem vibrates with the wish for a dramatic reading? In my mind's eye, I'm already seeing Sharon Kane, author of *Literacy Learning in the Content Areas* (2007), smiling, knowing that Jim may lead his students to create a two-part choral reading from their poem, as suggested in *Joyful Noise: A Poem for Two Voices* (Fleishman & Beddows, 1988). He would thereby move the student poem a step further. Jim's students have created a student-authored, two-voice poem to illuminate the issue of hunger in a deep and meaningful way. Performing the poem is a natural next step. The poem tells us that Jim and his students understand that a world abundant in food holds at its underside a devastating hunger. Jim's students are no longer disengaged learners but part of a curriculum that has erupted with vitality.

From a more traditional intellectual standpoint the students meet two learning goals. First, they find meaning in the problem of world hunger, and second, their work demonstrates an integration of analysis and real-life drama. The current world concepts that Jim wants his students to learn have become real, just as imagination in its truest sense is real.

Conclusion

We learn from Zabriskie (2004) that artistic creations, like the one discussed in Jim's classroom, might best be seen as both "inquiries and responses to the world" (p. 235). Cast in this light, they become legitimized in a world that otherwise might consider the *hard* sciences as somehow more essential. In recasting the unconscious

(Psyche) as image-maker, the symbol becomes important; it becomes the pathway to multiple layers of reality. Subsequently, imagination and Her infinite symbolic figures become the birthing place for truth for our students.

To underscore my claim that imagination in the schools is a necessary vehicle for enlivening our classrooms, I quote Zabriskie: "Imagination is then a laboratory, not a fantasy, a flight, avoidance, or defense, but a vector toward actualization, a way station between what is and could be" (2004, p. 236). Poetry, images, rhythms, paintings all become metaphors for individual and universal processes, just as the grand formula e=mc^2 was first imagined and even now continues to undergo testing against the wall of the physical world. Imagination not only reflects the world, but creates and recreates Her.

References

Coleman, W. (2006). Imagination and the imaginary. *Journal of Analytical Psychology*, *51*, 21–41.

Corbin, H. (1998). *Alone with the alone: Creative imagination in the Sufism of Ibn Arabi*. Princeton, NJ: Princeton University Press.

Edinger, E.F. (1996). *Anatomy of the psyche: Alchemical symbolism in psychotherapy*. Peru, IL: Open Court.

Fleishman, P., & Beddows, E. (1988). *Joyful noise: A poem for two voices*. New York: Harper-Collins.

Freire, P. (1970/2002). *Pedagogy of the oppressed*. (M.B. Ramos, Trans.). New York: Continuum. (Original work published 1970)

Harrell, M.H. (2007). Personal journal. (Unpublished).

Jung, C.G. (1953/1977). Two essays of analytical psychology. In R.F.C. Hull (Trans.), *The collected works of C.G. Jung* (Vol. 7). Princeton, NJ: Princeton University Press. (Original work published 1953)

Jung, C.G. (1990). The archetypes and the collective unconscious. In R.F.C. Hull (Trans.), *The collected works of C.G. Jung* (Vol. 9. I). Princeton, NJ: Princeton University Press. (Original work published 1959)

Kane, S. (2007). *Literacy and learning in the content areas.* (2nd ed.). Scottsdale, AZ: Holcomb Hathaway.

Romanyshyn, R.D. (2007). *The wounded researcher: Research with soul in mind.* New Orleans, LA: Spring Journal.

Tarnas, R. (1991). *The passions of the western mind: Understanding the ideas that have shaped our world view.* New York: Ballantine Books.

Watkins, M. (1984). *Waking dreams.* Woodstock, CT: Spring Publications.

Zabriskie, B. (2004). Imagination as laboratory. *Journal of Analytical Psychology,* 49, 235–242.

Photography and Social Justice

Preservice Teachers and the Ocularized, Urban Other

DENNIS PARSONS

What makes photography photography is not its capacity to pres-
ent what it photographs, but its character as a force of interruption
—*EDUARDO CADAVA (1997, P. XXVIII)*

Six preservice teacher candidates who were enrolled in a course on schools and
urban life designed a final "giving back" project, a collaborative scrapbook they
worked on, photographing and interviewing middle school students in a Lower
East Side middle school in Manhattan. The course, *Schools and Urban Society*,
draws preservice teachers predominantly from semi-rural and suburban back-
grounds and is designed to help teachers have an urban experience as they grapple
with their personal and professional identities in an urban context. One of the
course goals is to have them name and critique how they construct knowledge, and
how knowledge constructs them in their autobiographies, their narratives, and—
with this particular group of students—their use of non-discursive and multimodal
symbolic forms: assemblages of photographs and print text. The conversation pro-
ceeds with preservice teachers on their photography project and use of images with
print text, alongside historicizing and critiquing the role of photography in urban
portrayals and contemporary theorizing on photography.

What interests me is the role of aesthetic education in teaching for social jus-
tice. With this project I inquire about how photography and the interplay between

image and print might be used to teach for social justice. Through this inquiry I wonder how photography might be used as a text through which teachers can begin to name, examine, and describe the tensions and conflicts that arise in their own constructing of themselves in relation to an Other. For this to happen, I argue that a shift must occur from a modernist notion of the photograph as a representation of reality, toward postmodern photography as "interruption." Through my discussion with students, I hope to illustrate how it is that we must adjust to the liminal, in-between spaces of modernist and post-modernist stances (which exist in us all) where these interruptions might occur. It becomes crucial to then reflect on a bit of the history of photographic truth, to raise questions about the cultural construction of photographic reality in general, and how it frames preservice teachers' particular readings of their texts.

Historically, the camera has long had its gaze set on the bodies of the indigent poor and working-class immigrant populations. While there has been a recent worldwide increase in surveillance through video, photography, and other monitoring technologies, a historically significant location for surveillance and amassing bodies of evidence has been the Lower East Side of New York City, where the school is located. A gateway for U.S. immigrant populations—Irish, Jewish, Latino, Chinese—the Lower East Side and its inhabitants have been photographed, as by Jacob Riis ("Bandits Roos," 1888) and Lewis W. Hine, often with the best of intentions, tugging at the heart and purse strings of the philanthropic wealthy, and yet romanticizing and objectifying the lived experience of the poor, working class, and/or darker-skinned Other. Against the backdrop of this historical and cultural landscape, the history of urban education and the role of media culture often reinforce rather than challenge and critique urban stereotypes and narrative portrayals of students of poverty and/or color. So it is no wonder that in the school year following this project, one teacher would balk at future photography or video projects, reminding us that "these kids have been photographed enough."

Lalvani (1996), Tagg (1993), Foucault (1977), Elkins (1996), and Benjamin (in Cadava, 1997; in Rosenblum, 2008) all argue how photography has been used to highlight the grotesque, the downtrodden, and the marginal in ways that sustain dominance, control, superiority. These portrayals and how they continue to be used reifies preconceptions of the Other. Tagg's project in particular dwells on the problem of photographic realism—photography as a mirror free of distortions, revealing uncompromised, essential truths—that works to equate urban with decay, its poorer, immigrant inhabitants as uncivilized. So it makes perfect sense that our urban partner schoolteacher in this very setting might shudder whenever the lens cap comes off: her words speak the history of concern for urban poor and/or people of color, who have been overly examined, scrutinized, made into exotic objects, and who ultimately had judgment passed on them by the photographic event. She

is concerned with how these and other images of the schoolchildren will be read and interpreted once in the hands of an Other.

Position this one teacher's response within a postcolonial framework (Gandhi, 1998). Writing about the ways photography has been used to subject black bodies, for example, Pacteau (1999) relates how "sociality and subjectivity are premised on the exclusion of the disorderly, the unclean, the improper—an exclusion that defines them, in Julia Kristeva's words, as *non-objet du désir*" (p. 92). McCarthy, Giardana, Harewood, and Park's (2003) use of Nietzsche's *ressentiment* is also reflected in this one teacher's local critique. *Ressentiment*, from the word resentment, is a product of the industrial age, a moral framework or "the practice in which one defines one's identity through the negation of the other" (p. 456).

Photographic Truth: Surveillance and Evidence

Tagg (1993) argues that technologies such as the camera are never neutral and have material, historical uses. Benjamin (quoted in Cadava, 1997) challenges the realist assumptions underpinning how, historically, photography, art, and technology were used—and continue to be used—to maintain positions of power and status. Bourdieu (1990) challenges the photographic claims to truth, a "model of veracity and objectivity," arguing instead that "photography captures an *aspect* of reality" (p. 73; emphasis added). For Bourdieu, "photography is considered to be a perfectly realistic and objective recording of the visible world because (from its origin) it has been assigned *social uses* that are held to be 'realistic' and objective'" (p. 74). Tagg and Bourdieu each emphasize how photography is used as an apparatus of power to persuade, to create truths, to narrate history.

What the photograph reveals it also conceals, even erases. Citing David Bate, and consistent with McCarthy and colleagues' (2003) use of *ressentiment*, Lalvani argues that photography is "complicitous with . . . a colonialist gaze" (Bate, as cited in Lalvani, 1996, p. 69). As an extension of the colonialist gaze, the camera is used to position subjects by class, race, or other identity markers, by appearing to erase the significance of these markers. In turn, Lalvani (1996) traces the popularization of photography through its accessibility to the middle and working classes; analyzes the socio-cultural, historical context in which the instrument has become democratized; and challenges the illusion of the democratizing effects of photography. By the late 19th century, Lalvani argues, the availability of the camera to all classes "enable[d] individuals to momentarily conceal their working-class backgrounds and be made visible in the light of their aspirations" (p. 69). Such proliferation across social classes sustains the possibility of upward mobility while removing class markers through the illusion of class assimilation. Vision pre-

dominates and, as a dominant means for surveillance, is significantly tied to regulating bodies.

For his project, Lalvani (1996) brings together work that critiques the "modernist privileging of vision." Heidegger's work on "ocularization," Derrida's "hegemony of modern vision as an attempt to establish a metaphysics of presence," and Nietzsche's critique of the "progressive endeavor to subjugate reality, to overcome otherness and difference, and to make everything present to the inspection of an imperial Gaze" justifies the "necessary production of a seductive illusion" (pp. 1–2). Unmoored from its historical and political context, the photograph conceals regimes of truth by eliding how it is that, for subjects, "representational systems discursively produce them as objects" (p. 69). "As Tagg has observed, the realism of the photograph, its ability to record, reflects the power of the apparatuses of the state which invest and guarantee the images it constructs as evidence" (p. 172). In this light, the assumption of the photograph as a "moment in time" snapshot of reality helps sustain modernist notions of truth, concealing the ways in which the camera perpetuates ideologies of racism, classicism, and norms of gender and sexuality.

Photography as a Moment of Truth

Soon after their return from New York City, participants gathered in my office to share their final reflections on the class and their thoughts and feelings about the scrapbook. Their responses reveal their stances on truth, representation, and visual texts:

> NADIA: The way they answered those questions each person will have a different answer.
>
> THURMAN: I think like the *physical representation* of what we took away because we had this amazing experience and that is onto sort of this physical representation of each of our experiences sort of mushed into something we can hold onto.
>
> MARIA: [Referring to their student interview questions] "If you could change anything about where you live?" "The rusty-assed buildings."
>
> MARIA: I think the black-and-white photographs do more justice to the photos than the color.
>
> THURMAN: More attention to the individual than what they're wearing.
>
> MARIA: If they were colored there'd be too much to look at....What are you paying attention to? The faces or all the colors?

Immediately, their conversation suggests the transaction between subject and photograph, and ways in which texts mediate the world. Together they grapple with

the modernist notion of whether or how photographs *convey* reality in their representations. They wonder if the combination of image and print provides *more*, or whether visual images merely outweigh the sluggishness of the printed word in representing lived experience. These notions suggest a modernist perspective on knowledge construction, while at the same time their talk demonstrates moments of continuing to grapple with the slippery complexity of these ideas. Nadia relates how "each person will have a different answer," a perspective that privileges individualism, while eliding how it is that knowledge is constructed socially and politically, but also shows how their structured interviews provide a valuable constraint for student responses. Still, their question assumes a world that needs changing, and reinforces individual responsibility without exploring the political and economic, material conditions that sustain economic differences and perpetuate "the rusty-assed buildings."

Thurman's response alludes to the Derridean "metaphysics of presence" (Derrida, 1974), and the crisis between representation and the excesses of lived experience— the endless deferral, the details that escape or resist representation through words and images. He connects with these crises through tensions that arise from the creative act of making the scrapbook, tensions that involve individual, as well as collective, collaborative constraints. And while it seems that Maria is ignoring Thurman's point to make a point of her own—that students' responses were frank and not overly self-conscious—she comes back to this idea of the scrapbook as an artifact, extending his idea with the ways that the text represents knowledge and their experiences working with these students. Perhaps somewhat fleetingly, Thurman's response calls up Barthes's (1981) sentiment toward images of his own mother. Similarly, with Thurman, the scrapbook exists as evidence or proof of something that had once existed, thus binding representation to experience through memory, as a physical text to "hold onto." Desire for the tangible artifact pushes the scrapbook (as perhaps befits the genre) into the realm of deadening nostalgia.

In this same excerpt the group members begin discussing the results of their choosing to shoot in black and white, a topic they often return to in our conversation. Relevant to their decision and response to the black-and-white photographs is Elkins's (1996) discussion of the physiological, political, and psychological process of seeing as vision. Elkins's project, although a discourse on sight and vision, relates directly to photography and its uses. Elkins describes the inconstancy of sight as "a way of looking that skips over some parts and emphasizes others in the service of some unrecognized anxiety or desire" (p. 92). For the group, according to Maria, this service was for the individual subject—she was aware of how black and white throws certain objects into background relief, while emphasizing other elements. Yet Thurman's comment skips over the material emphasis on clothing that is so crucial to many of these students, inserting a familiar middle-

class, predominantly white reading of their culture, ignoring the local culture, which is there "in black and white." This reading of the images, as a Lacanian "desire to ignore" (Felman, 1987), runs the risk of displacing their urban cultural capital with middle-class, white values, while at the same time validating values of education, traditional literacies *through* the elision of cultural capital.

Also relevant to Thurman's and Maria's comments is Barthes's (1981) insistence that color is a "coating applied *later on* to the original truth of the black-and-white photograph What matters to me is not the photograph's 'life' (a purely ideological notion) but the certainty that the photographed body touches me with its own rays and not with a superadded light" (p. 81). In terms of aesthetics of photography, the ideas of Elkins and Barthes come out in the previous group discussion. Barthes and Maria share views on the use of black and white as a conscious choice. Maria explains the group's decision so that the viewer will not be distracted by extraneous materials, so that the focus will be on the truth and the essential and existential being of the photographed.

Throughout the group discussion, there is back-and-forth movement around notions of photography as representing reality. For example, Thurman's reference to the text as a *physical* representation belies the excess of experience and the limitations of the medium of photography and the scrapbook in its inability to totalize the lived experience. Meanwhile, Tagg (1993) and Lalvani (1996) each has a go at critiquing the modernist underpinnings of Barthes's theorizing of photography. Perhaps a more pressing contradiction in studying Barthes's *Camera Lucida*, however, is not so much the criticism of his reliance on the objective truth of photography, but in his use of the photograph as evidence leading to the essence of the subject. And Thurman and Maria make allusions to this Barthesian idea when talking about the insignificance of students' clothing and background as compared to their faces. According to Barthes (1981), "To 'enlarge the face' of his mother is to 'see it better, to understand it better, to know its truth'" (p. 99). Even Barthes concedes that such a way to truth is uncertain; what is significant is the "hope of discovering truth" (p. 99), made possible by desire through photography. He writes:

> All I look *like* is other photographs of myself, and this to infinity: no one is anything but the copy of a copy, real or mental (at most, I can say that in certain photographs I *endure myself*, or not depending on whether or not I find myself in accord with the image of myself I want to give). (Barthes, 1981, p. 102)

In another excerpt from our conversation, Thurman comes back to the contradictions between middle-class values and faith and the violability of culture by education, referring back to this use of photography to highlight and emphasize, while throwing extraneous parts into background relief. Somewhat common to the

group is a willingness to ignore students' desires and emphasis on dress, which they overlook for the sake of a greater good. This is the idea of education as a stepping stone or way out, but, again, a way out from where? This stance continues to ignore the local capital of dress for the cultural capital of upward mobility by erasing, pun in place, the material significance of clothing. While this is a tension that arises both within and across the community, here photography is being used as an instrument to gloss over the tension and create a counter-posing reality. I wonder, as does Elkins (1996) with vision/sight, whether in photography perhaps we seek to reveal only that which is not too uncomfortable, affirming traditions about mainstream education as opportunity, ignoring the students' emphasis on dress, and also sidestepping the limits that formal education might have on and the tensions it might have with the identities of students who are poor and/or of color.

Yet I hold that viewing and discussing photography, from the perspective of the photographer and the photograph, has rich potential for critiquing relations between self and Other (Parsons, 2004). That photography seeks the essential/existential and is also used as an instrument to ignore, to turn away from, makes visual/media studies crucial. How might photography make a place in which we are willing to explore our own discomfort? How might aesthetic response to photography allow us to sit with our less-tolerable self-images? Or, like any other mode of discourse, is the use of photography merely, perhaps even more vigilantly, for protecting us from what we loathe or fear most about ourselves? This last point, of course, depends on how each of us is positioned before the photographic lens, crucial to exploring, in this context, issues of race, ethnicity, and social class through critical visual/media literacy.

Photographic Framing—Material/ Social Context

With a sense of audience and purpose in mind, both Maria and Thurman make it clear that the identity of the student/subject is most significant to their project. They are also using photography to persuade: using it to reach into the future, to make that future preteacher audience care about these urban kids, to get them involved by enrolling in the class. I introduce a discussion about framing in photography and its contextual, political, albeit structural implications. I talk about two photographs of a Latino boy reading, and how the meaning for me is so different from one image to the next, when the photographer widens the lens. In the one, the boy is shown in isolated solitude. But in the other, he is sitting among the traffic of taller adolescent girls, either standing or walking by unaware of him or the camera. When I brought this example to their attention, I was thinking about the differences between representation and photography as a re-presentation, a

re-contextualization. But instead the conversation returns to the totalizing poten-
tial of the scrapbook:

> DENNIS: I think the picture of the boy reading the dictionary...you're catching
> something of him and wider contexts, the girls around him...lost?...neat
> juxtaposition.
>
> MARIA: If we *didn't* do this...I like the idea. I remember when we decided to
> do it. What we would have handed in like another paper with our ques-
> tion typed in it, what does that do? You can read it but I think the pictures
> show so much more together that they kind of paint the picture we
> wanted people to see of the students.

My goal here—though cast in a modernist metaphor of the ocular lens, and
steeped in structuralist notions of "framing"—was to interrupt the photographs by
sharing my response to the framing and the background of a young male student
of color, reading the large book, possibly a dictionary. Here I wanted to engage in
a discussion of the potential for photography to make reality problematic, and any
type of conclusions, inconclusive. Instead, Maria shifted the conversation back to
Thurman's dilemma, arguing for the merits of both discursive and non-discursive
texts, and how their choice was rhetorical and persuasive. For her, they greatly
minded how their representations of an Other has an effect on an audience, which
challenges modernist notions of representations as a mirror of reality.

I don't come back to qualify my own position in how I want the group to ex-
amine its relationship to viewing practices and the photograph as evidence. My in-
tention here was to challenge notions of a discrete, autonomous self through
meanings that are contingent on social relations and practices through these two
photographs. I am confident that they grasp the idea, because they talk about dif-
ferences among their photographed subjects, differences in power relations, differ-
ences in establishing trusting relations, and how they came to know that such
intimacies had been created. My probing, however, gets us stuck in the language of
binaries and essences:

> DENNIS: Well that's what I am asking about, what does that image show you
> now? It's not re-representing them, factually or literally. It's *a* representa-
> tion of them.
>
> THURMAN: It's them.
>
> DENNIS: But it's not them.
>
> THURMAN: But it's them. When I read this [scrapbook], it's not them, wholly,
> but I think we got the best representation we could have had with the
> time we had allotted. You could get a feel for each person.

NADIA: Those are their words. Like nothing was changed, added, and I think everything was the same, so together you have the picture and you have the words and you can *see* how that they *are* students just like here [Oswego], and these are things that we made them think about…like we asked them a question. They weren't like, "we don't care," these are their opinions and their thoughts and a lot of times up here we might forget that they have opinions about what goes on in the world. That's what I thought about.

Thurman may have felt that I was critiquing their project rather than opening up questions about the medium of photography and representation of the Other. Still, the exchange demonstrates some different feelings and ideas about the realism of photography, the power of multitextual modes of representation, but nonetheless a modernist privileging of essentializing discourses.

One Photograph

At the very beginning of our conversation that evening, they turn their attention to a section of the scrapbook entitled "After a dark day," which includes photographs they had taken of Ground Zero and interviews with students about what they re-member or where they were when the planes hit the towers. (The twin towers were directly in the line of sight from many of the classroom windows.) Thurman de-scribes how the "whole section, September 11th had a close-up of their faces." He begins by discussing a photograph taken during a classroom project in which stu-dents collaborated to make an American flag that was to be donated to a local fire-house. Patches of blue jeans glued together to make up the square of stars, and a collection of single-file, white, individual handprints trail across the cloth, inter-rupting the red fabric. Thurman explains how their words describe "what they saw on that day and the picture of Ramón [pseudonym], his hand [making the] print." He looks at the photograph and wonders "what their faces looked like on that day looking out the window" and then "to see the hope in the picture of Ramón and that amazing hope in his eyes." Thurman's recounting of a tragic history works to help imagine the sense of a positive future, a past making the future. And then there's that flag. There is Ramón looking up and staring right into the lens.

Ramón, with his brown hand covered by a whitewash of paint, about to use his handprint to literally represent the white lines of the flag, creates a tension for Thurman between what it might have been like to experience the towers falling, and the sense of joyfulness, or at least serenity, in this photograph.

Elkins (1996) writes how "sometimes the desire to possess what is seen is so in-tense that vision reaches outward and *creates* the objects themselves" (p. 29). While

Thurman's sentiment is not an outright reinscription of *ressentiment* and urban decay, as suggested by Nietzsche and Pacteau respectively, there is a subtle imposing of middle-class values, which could possibly work to negate their realities. Reading Ramón's expression as looking forward and aligning with patriotic values, even if accurate, is a position that ought to be questioned: Who benefits from this allegiance? Who has much to surrender? And what does this do to the narrative, to the telling and shaping of a small piece of history, as micro practice? As I view the photo, I read in my own directions, disturbed by the metaphor of him whitewashing his brown skin—reverse minstrelsy—because it calls to mind the history of assimilation through one's own subjection and subjugation of ethnicity. The discourse of vision as the real is undermined by the ways in which the scrapbook, as a whole, unites us, under the flag and the guise of an agreeable, sovereign soldier (Anderson, 1991). I cannot refuse how perhaps Ramón was elated about fitting in and belonging, particularly in the absence of representation of brown people, while also questioning how patriotic rituals simultaneously connect with and conceal tensions of race, ethnicity, gender, sexual orientation, and class struggle. I wonder what missed opportunities I might have used during these moments of dialogue to raise questions about how we were talking about Ramón, about how, perhaps, we were imposing a sense of orderliness on the narrative and projecting the calming salve of assimilation. That the same teacher who was skittish about students being photographed was also proud that these students offered up pieces of their most prized and scarce possession—square patches from their favorite jeans—to make up the starred portion of the flag. While she acknowledges what her students value, threads of cultural capital are nonetheless sewn into the weave of assimilation.

Nietzsche, according to Lalvani (1996), sought alternatives to assimilation in the concept of multiplying perspectives, "in which it is not the violence of the light that dominates but an illuminating vision that flickers between presence and absence, concealment and disclosure" (p. 2). This space of ambiguity and contingency is where I aspire, and I seek to engage other readers and viewers. Yet I know that I struggle with the persistent lens of modernism. I see the contradictions with my critique of Thurman and other group members, who suggest that photography "captures a moment," an essence of experience. And yet as I engage with the group, we begin at least to examine some of the myths and subjugations that are at work. We talk about the constraints of the photo-ethnographer, the tensions between immersing oneself in the lives of these urban schoolchildren instead of documenting experience. Meanwhile, Thurman celebrates the joys of being in the world, sharing and engaging:

> THURMAN: But I wish like we had a page "Building relationships" or "Crossing bridges" of us in in-depth conversations, pictures of us, like having

conversations with them…we were just in the moment with them and trying to take their whole being.

NADIA: Soak it up.

THURMAN: Soak it up, that the last thing we were thinking about was, ok, go get Estela so she could get a picture of us talking.

DENNIS: Kodak moment.

THURMAN: Yeah, you know, somewhere like in the back of your mind, what's going on is amazing but the last thing you're thinking about is trying to find some way to *artificially* preserve it.

In this exchange, Thurman ventures toward a critique of photography, or the scrapbook as a whole, as a static artifact, but his remarks also suggest a modernist notion that real, lived experiences can be captured and preserved, although somewhat problematically, as a moment in time. Thurman offers a resolution, but without any accompanying critique of experience, along the lines of Britzman (1991) and Scott (1991), who demonstrate how knowledge constructed "from experience" is never ideologically free or politically neutral:

NADIA: Even if you say, "Hold on let me get a camera." it's still…'cause you're posing, you're smiling.

DENNIS: Certainly I don't want you to answer these questions with what you *could* have done.

THURMAN: I think it's good for us to do that.

…

COLLEEN: I thought the book was more about the kids and the board (bulletin board) was more of us. We wanted to represent the children…I agree it should have been us.

THURMAN: I don't think any of us don't love this…hindsight. I wish we had put in that extra piece…show that we have rapport with them.

MARIA: You can't help but think of what you could have done….

There is truth and contradiction in Thurman's response. From an existential perspective, yes, to be in the world one cannot also "capture it" or at least self-consciously look for ways to preserve it. The group agrees on the pleasure of its aesthetical choices of the scrapbook, the progression from black and white to color, the rhetoric from "One dark day…" to "And then…," a teleology that culminates with the U.S. flag. However, the potential for the technology of the camera to rupture—visual images have the potential to stir interruptions—is evident in their response to the photographs in the scrapbook.

There are also problems with my own critique. I challenge the inferences of quasi-religious and patriotic symbolism suggested by the transition from black and white to color, a coming out of darkness to light, toward unity, toward equality. I critique it in the same way that Nietzsche saw the predominance of vision as "seductive illusion." I prefer the dynamic potential of multiplying perspectives, arguing for a democracy of discensus, rather than consensus. I notice this in my desire to get them to look at the two different photographs of the boy reading, how the camera frame withholds and, in an alternate photograph, supplies context, through a narrow or a wide focus. I am forthcoming with my own desires and my own interests with regard to literate practice. I want to explore the literacy of photography, other visual modes, and print text for its violent consequences. In the example of the Latino boy reading, there are ways to read these images as intersected by gender, masculinity, ethnicity. As the young women are standing or walking around him, he appears invisible to all but the camera, whereas the alternate photo shows only the experience of literacy as a safe haven, a refuge. This narrative of solitude is interrupted by the other image, which reveals potential risks for how he might be viewed by others, a young Latino, sitting, reading.

Photography, Self, and Other

I ask the group to reflect on the ways in which creating or viewing the completed scrapbook may have helped them to think about their relationship with the Other. Thurman identifies with his own Otherness as being a gay man, although from a middle class family. Jhonary relates that she is both and not the Other: "I could not see the Other because I am not…because I've been there. I lived in a pretty run down building [where people were] sniffing coke on the stairway, it doesn't matter how much education I get. I will still be a Latino woman," and contends that "they're living in the moment which is dead but I hope they see that there is so much out there." In this sense, from a position of parents who value education as "a way out," she is expressing conflicts within her own otherness, between herself and the schoolchildren with whom she identifies:

> JHONARY: My parents have stressed it [education], always stressed it. I just
> want to say some people stress it and others, "Don't worry your husband
> will take care of you."

Thurman agrees, calling up the ambiguous messages that students must be experiencing:

THURMAN: So how do you get to the issue? There are parents out there like that who will help you [the teacher] get where you need to go, but if the student has parents that *don't* understand the value of education, and so you're trying to get them motivated and then they go home and they're hearing that message from the people they care about that says "Don't listen to the teacher, that's not going to get you anywhere, you got to worry about getting a job," and so when they hear that constantly they hear the teacher and parents give them opposite messages, and so obviously they're going to trust the parent more than they trust some teacher, and so it's hard because you want to get them out of the situation, but you can't tell if their parents are educated, but the parents had the same situation that the kid did, didn't go anyway, so you have this cycle you're trying to *fight* so you don't have any *allies*.

In these moments, I wanted to explore how they relate to the Other through the images, and what, perhaps, these images tell them about how they are constructing the students. In turn, Thurman and Jhonary complicate Otherness. For the most part, however, the group members attended to their role as textual producers. The experience of having an aesthetic response to their own text was either less prominent, or perhaps too immediate. Instead, they reiterate how the purpose of the artifact put them on a certain trajectory:

MARIA: I feel like we made it a scrapbook of them [for a reason].
THURMAN: [For a reason]
MARIA: We just stuck to that.

They wanted to make scrapbook readers care enough to get involved in New York City classrooms. Photographic and multitextual images can be used mono- or dialogically. The difference involves making objects out of subjects.

Forgetting/Remembering: "A picture is worth..."

How might one play about the differences between photographs as referential symbols of the subject/object of an Other and still hold to contingency of the artifact, as well as how we position ourselves in relation to the image? We may challenge photographic truth, but dividing practices underscore the belief that photographs don't lie. In this project, student participants relate their own ambivalent relationship with the photograph as a medium of truth. Such conversations make for a useful groundlessness by opening up potential questions around the re-

lationship between language, thought, and the perceptions of reality. In our conversation we dwell on this very issue:

> MARIA: If you don't have a picture you can't remember certain features.
> THURMAN: Personality.
> MARIA: With pictures and words together, I think they represented very well where you can't forget.

A point of intense discussion with the group has been over the photograph as a snapshot of reality, which has implications for a range of philosophical debates. As a heuristic for teaching social justice, this debate turns out to be useful, in that "*every* photograph is the result of specific and, in every sense, significant distortions which renders its relation to any prior reality deeply problematic and raises the question of the determining level of the material apparatus and of the social practices within which photography takes place" (Lalvani, 1996, p. 2).

According to Barthes (1981), the photograph is evidence of the existence of a world through its correspondence between the viewer and the world. Photography is objective evidence. These ideological leanings were revealed through participants' expressions of their own views on photography. Participants express their desire to use the photographs to "call up the past," to prove the existence of a history between themselves as viewers and their subjects. They relate a willingness to grapple with their own intersubjective transactions with these texts. They grasp the ways in which photographic acts—picturing Others— makes power dynamics more obvious. In these acts, they see the potential for exploiting Others. Yet they also see liberating possibilities in the narrative of their print and image constructions of the Other. However, they are prone to downplay, ignore, erase, or resist the larger political, material concerns, the technologizing of photography.

Image and Embodiment: Toward a Curriculum of "Image-Text"

Through engaging with the photographs, one of the pragmatic outcomes of this project has been the heuristic potential of juxtaposing binaries. Toward the end of our conversation, for example, we were discussing the two different photographs of Shauna [pseudonym], one in a cool gangsta pose, and the other in a warm embrace with her school friend. I confessed to them that I did not know these images were of the same young woman. The group proposed that we share photographs of Shauna, so that we could discuss how photographs "lie" and create a partial truth, which stands as *the* truth, create a partial story, which stands as the whole story.

During this discussion, I draw their attention to the juxtaposition of the images of "Afghan Girl," the famous image that won the photographer the Pulitzer, and the more recent photograph of her taken during the early days of the U.S. war in Afghanistan. In the aftermath of the U.S. invasion, the caption in *National Geographic* read: "Afghan Girl Found?" Was she ever missing? She did not know how her images were being mediated and consumed by the West, although the article reveals some of these tensions, including her memory of how angry she felt while yielding to the power of the photographer. He recounts cutting a wide swath, photographing others before coming closer to the prize (I would call it circling one's prey); she recalls the embarrassment of being photographed with the burn marks captured on her robe, from her cooking.

The rediscovery of the "Afghan Girl" and unveiling her identity to the world opens up and allows me to revisit some complicated questions that involve photography, representation, literacy, the nexus of print, and the photographic image. The phrase that strikes me in this portrayal of "Afghan Girl" and the adventure of finding her is the assumption that she is made whole by such an encounter. The media has completed her life with the coming to full circle of this story. How can we confront her, face her, when we exert so little to understand what her life might be like, yet assume that we have had a connection, no doubt through the photograph? The story, particularly the initial quest to photograph, shows how photography tramples and invades. Through the narrative, we find out some of what she was going through during the time, and her suppressed anger, but even these comments seem to be shared un-self-consciously. The group merely wanted to talk about how much her difficult life has aged her.

After we discussed "Afghan Girl," the differences between the two images, the tensions between image and print narration, and the photographic event as a site of power and subjugation, I show other examples from professional photography. After pausing over Dorothea Lange's "Migrant Mother," we view an image of the same family by Bill Ganzel (1984), whose project it was to locate and photograph dust bowl survivors. In the one image, some 43 years later, Thompson, the central figure, then in her mid-70s, is shown with the same three of her children gathered around her. Thompson is shown sitting in a backyard somewhere, on a lawn chair, her hand pressed to her face, as if to reenact the famous dust bowl era image. Besides the obvious expanse of time between these two images, there is a juxtaposition of aesthetics, between high art, iconic images, and lower-brow, closer to drugstore photography.

Leonard (1994) uses these two very different images of the Thompson family in her art making, employing multiple images and collages of a subject autobiographically to engage the audience in critical discussions about identity, gender, and subject making, memory and loss. In several images, Leonard's mother is "ab-

sent," gesturing simultaneously toward the loss of her mother, and her mother's own loss, having suffered from Alzheimer's. Upon absorbing these images, the group proposes to use the "incongruent" photographs of Shauna to engage an audience in ways that will allow them to confront their own biases and preconceptions when they enter into a dialogue with a photograph.

I purposely use the story of the photograph, such as the narrative surrounding "Afghan Girl," not as addition to the totality of the image, but to make complex the tensions and colonial narrativization of events. I also want to bring in the work of Lincoln Center Institute in New York City as a way of creating a dialogue, of having students embodying their own works through positioning themselves in photographs or video streams. After asking students to describe what they see in the painting, or the movement, John Toth (2002), in the Lincoln Center tradition, might "Ask people to get into the same positions of the sculptures," "What kind of lines do your arms, legs, fingers, torso make?" or have participants render the objects/symbols through their own drawing. Such practices in mimesis also acknowledge, quite literally, embodied knowledge, connecting thought and feeling, mind and body.

With such prompts as "get into the position ...," I would further extend the dialogue to include questions that raise issues of power, knowledge, identity, and position. What is it like to see the world from their perspective? How does the camera work to capture a sense of this person's life world? How might we begin to disrupt the narrative that this photograph (or video) tells? Finally, who benefits from this representation? This last question reflects what Berger (1980) emphasizes as a crucial distinction: "For the photographer this means thinking of her or himself not so much as a reporter to the rest of the world but, rather, as a recorder for those involved in the events photographed" (p. 62).

Such dialogue encourages the use of the photograph as location, as the nexus of self and Other. The shift of the location from consumer to producer changes the meaning of the prompts and the dynamics of the conversation, perhaps shifting and potentially oscillating emphases: from the photograph, to the photographed and the photographer. By engaging in this dialogue within the classroom community, I aim for the spaces in between. Such a dialogue might begin to destabilize traditional notions of self/Other as it "troubles" the medium of photography. Giroux and Simon (1994) cite the work of Solomon-Godeau's critical practice of photography as "multilayered, mobile and self-conscious" (p. 95). Moreover, Solomon-Godeau firmly believes that photography is a discourse "whose aim is to disrupt, rupture, and render visible how power works to promote relations of domination through the establishing ordering of institutional forms, representational practices, and social relationships" (p. 95). Perhaps most crucial to my project is Solomon-Godeau's conviction, according to Giroux and Simon, toward making the "politics of the photographer/cultural worker as much an object of critical

scrutiny as the texts and subject matter that traditionally come under critical analysis" (p. 95). Solomon-Godeau's stance toward viewing challenges the notion of inherent authenticity in photographic representations by examining the position of the photographer and how she identifies with the subject/Other. Moreover, this kind of dialogue with the photographic event challenges the modernist stance of reproduction of the subject/object dichotomy of the event. The photographer, according to Giroux and Simon, does not "*work on* subjects, but rather *through* them" (p. 99), and must "ask questions about their own complicity in the specific ways the 'truth' of a photograph is written" (p. 99).

The photograph, I argue, obviates both the separation and the blur between self and Other, each of which needs tending. Truth is not out there, discovered and recorded by the author-photographer, nor is it merely a reflection of his or her own fantasies. The photographer must consider the constructedness of the photographic text *in relation to* the Other. The photographer must confront his or her own colonizing gaze. For this to occur, one must historicize the photographic event, which "requires attention to its intervention in the narrativization of the past, an intervention most often characterized by the erasure of the marks of its own 'making and maker'" (Giroux & Simon, p. 94). The photographic event, then, both allows readers of the image to explore multiple entrance points into the "reality of the event" while it works on our presumptions about the text as a true rendering of the event. Then, perhaps, the need for critical dialogue concerning the photograph, the photographer, and the photographed will be even more imminent.

References

Anderson, B. (1991). *Imagined communities: Reflections on the origin and spread of Nationalism.* London: Verso.

Barthes, R. (1981). *Camera lucida.* (R. Howard, Trans.). New York: Hill and Wang.

Berger. J. (1980). *About looking.* New York: Vintage.

Bourdieu, P. (1990). *Photography: A middle-brow art.* (S. Whiteside, Trans.). Stanford, CA: Stanford University Press.

Britzman, D. (1991). *Practice makes practice: A critical study of learning to teach.* Albany: State University of New York Press.

Cadava, E. (1997). *Words of light: Theses on the photography of history.* Princeton, NJ: Princeton University Press.

Derrida, J. (1974). *Of grammatology.* (G.C. Spivak, Trans.). Baltimore: The Johns Hopkins University Press.

Elkins, J. (1996). *The object stares back: On the nature of seeing.* New York: Harcourt.

Felman, S. (1987). *Jacques Lacan and the adventures of insight: Psychoanalysis in contemporary culture.* Cambridge, MA: Harvard University Press.

Foucault, M. (1977). *Discipline and punish: The birth of the prison.* New York: Pantheon.

Ganzel, B. (1984). *Dust bowl descent.* Lincoln: University of Nebraska Press.

Gandhi, L. (1998). *Postcolonial theory: A critical introduction.* New York: Columbia University Press.

Giroux, H., & Simon, R. (1994). Pedagogy and the critical practice of photography. In H. Giroux (Ed.), *Disturbing pleasures: Learning popular culture* (pp. 93–106). New York: Routledge.

Lalvani, S. (1996). *Photography, vision, and the production of modern bodies.* Albany: State University of New York Press.

Leonard, J. (1994). Not losing her memory: Stories in photographs, words and collage. *Modern Fiction Studies, 40*(3), 657–685.

McCarthy, C., Giardana, M.D., Harewood, S.J., & Park, J-K. (2003). Contesting culture: Identity and curriculum dilemmas in the age of globalization, postcolonialism, and multiplicity. *Harvard Educational Review, 73*(3), 449–465.

Pacteau, F. (1999). Dark continent. In L. Bloom (Ed.), *With other eyes: Looking at race and gender in visual culture.* Minneapolis: University of Minnesota Press.

Parsons, D. (2004). Masks of desire: Autobiography, self, and Other. *Journal of Curriculum Theorizing, 20*(3), 77–92.

Rosenblum, N. (2008). *A world history of photography.* (4th ed.). New York: Abbeville Press.

Scott, J. (1991). The evidence of experience. *Critical Inquiry, 17*(4), 773–797.

Tagg, J. (1993). *The burden of representation: Essays on photographies and histories.* Minneapolis: University of Minnesota Press.

Toth, J. (2002). *Inner eye.* Retrieved September 8, 2010, from http://www.innereye.net/schools/Montessori/Montessori2001.htm

Creating Student Activists Through Community Participatory Documentaries

JANE WINSLOW

Documentaries have been used as tools for community building and social activism practically since the start of non-fiction filmmaking. Many filmmakers such as John Grierson, Pare Lorentz, John Huston, and Barbara Kopple have tackled issues of poverty, the environment, the human cost of war, and other social injustices while creating documentary works of art, expanding the rhetoric of this medium in the process. In the late 1960s Canada's Challenge for Change (Hutcheson & Schugurensky, 2005) produced community-controlled video projects such as *VTR St. Jacques* (1969), which "stimulated and improved intra-community communication as well as serving as a bridge to officialdom outside the community" (Barnouw, 1993, p. 260). Although there has been debate as to whether Challenge for Change's community-based films actually brought about the social change it had hoped to (Marchessault, 1995), it was successful in laying the groundwork for a documentary style that included a community's voice. During the last decade, more and more social activism documentary projects have changed from an exclusively observational vision of the producer/director to projects created by a multiplicity of voices from the community or group represented in the program.

Cinéma vérité, participatory, and observational-style documentaries have evolved into community participation documentaries, expanding the authorship to the people whose lives and issues are actually being represented. Now more than ever, artist/activists and educators can take tools such as digital cameras and computer-based editing equipment to groups who will in turn create documents of their world.

Globally, people are producing digital video programs that not only document parts of the world different from their own but also work together with the communities to create social change through the creation of a documentary film. Individual filmmakers; non-profit organizations; university and college programs around the country such as Georgetown, the University of Washington's Native Voices Center, Alaska Native Heritage Film Project, Village Earth, Reel Grrls-Seattle; are doing this type of work. These films have been broadcast on stations and screened at film festivals around the world, furthering the reach of these works and thereby the issues they discuss.

Digital documentary filmmaking has empowered many students to reflect their own personal visions. By using the community participation style of documentaries, students have also collaborated with members from diverse communities to express social issues of primary importance to them.

Teaching Community Participatory Documentaries

As an educator, I have found community-based, participatory-style documentaries the most powerful for engaging students in both the artistic process of digital filmmaking as well as in creating socially conscious art. Many college students think of the documentary as a very long TV news story, not necessarily as art or social justice work. Although at times documentaries are seen as discussions or observations of very political and socially relevant issues, the process is passive and more reportage. The exposure of the audience to a balanced perspective of subject matter is the point of the program. Whether or not it inspires social activism is dependent on the viewer. The filmmaker is not the social activist, and the project is an observation of the issue rather than an expression of a particular group's viewpoint facilitated by the filmmaker, as in a community-based, participatory-style documentary.

In the college classroom, students learn the techniques of digital filmmaking such as camera use, lighting, and field audio, as well as post-production skills such as video and audio editing. Through collaborations between the student and a community group, documentary production can become more than just an exercise in video production. Instead, by using an amalgamation of scholastic, academic endeavor and digital filmmaking skills, artist/activist students can become the bridge between their community and the larger social communities.

By producing an actual community-based documentary project, instructors can facilitate the students' understanding of their responsibility within the community at large and their relationship to a variety of groups or communities of which they know very little. In addition to using the technology of digital filmmaking, the student artists learn how to develop and research a project as well as develop ethics

and a sense of respect and responsibility in exploring communities and societies that are different from their own. They become socially active and conscious of the issues beyond their ken. Through the art of documentary digital filmmaking, social activists are born.

Source: Women Writers

While getting my master's degree, I needed to find a subject for my documentary thesis project. I had been a founding member of a women writers group in Bloomington, Indiana, and had stayed involved as a member for many years even after moving away, making the trek from Cincinnati to Bloomington for meetings about once a month. We had a yearly retreat coming up, so I decided to use my Source: Women Writers group as the focal point of my thesis project to discuss the importance of women's circles and writing for women's lives.

For the research and literature review that I had done for my thesis project, I looked at filmmakers such as Barbara Kopple (*Harlan County U.S.A.*, 1976; *Dixie Chicks: Shout Up And Sing*, 2006) and Trinh T. Minh-ha (*Naked Spaces*, 1985; *Surname Viet Given Name Nam*, 1989) to inform the style of my documentary. Both filmmakers worked very differently style-wise, Kopple using a mixture of observational and participatory/cinéma vérité style and Minh-ha working experimentally. As auteurs, they both felt very "present" in their films and used a very personal voice. Though Kopple didn't have the mining community members do the actual filmmaking in *Harlan County*, she did give the feeling that the film spoke of the mining community's plight with their voice, stylistically similar to the community participatory style.

Since I was a member of the writer's group that was the subject of my documentary, I felt that my contribution to the project was going to come through not in an interview, as with the other seven members, but through the "lens" with which the viewer would see the documentary. Since there was only a crew of two, myself and one other non-group member, the intimacy and openness that the members of Source: Women Writers gave in their interviews was indicative of what one can capture through the use of the community participation style.

Community Participatory Production in the Classroom

Whether in a high school or college, in film- or video-specific courses or other classes that use digital video or film projects, instructors can use this type of project as the conduit to engage students in social justice. To help students develop as artists/activists, instructors can create two types of projects, one dealing with issues close to home and one that moves outside their ken and frame of reference.

The first project is on a topic or social issue with which they have a great deal of familiarity, perhaps a community or group of which they are already members. For example, the student might be an avid skateboarder who is working to keep the community skate-park from being closed down. Another might be a student who is a member of the Lesbian/Gay/Bisexual/Trans group on campus who wants to create a project on a friend who is transitioning male to female. From the position of membership within the group or issue, the student filmmaker will have the advantage of access, empathy, and firsthand information about a subject.

Students will tend to have the misconception with this type of project that they do not have to do any further research on the subject, a notion that the instructor will have to dispel. I find that as a documentarian, one must do as much or more delving into subjects that are more familiar than those one knows little about. Another difficulty arises with these projects: not having enough distance from the subject matter so that one might assume a knowledge base that the audience does not have. As a consequence, the filmmaker does not represent it in a way that is persuasive and compelling.

Once the students have tackled the Insiders assignment, the second project is with a group or community about which they know little or nothing. One team of students did a project on a homeless shelter in Seattle called *Tent City*. One of the student team members had just started volunteering for the organization and knew very little about it. In the process of making the film all the members garnered a greater understanding of the issues facing the homeless and working poor—a deeper, more poignant understanding, I believe, than they would have gotten if they were just "covering the story" in a reportage style in which they would have kept their distance from the subject. I will discuss this project in more detail later.

If the course allows for only one project, the instructor can still create a sense of activism by using either the "inside" or "outside the circle" project, or a hybrid of these projects. For the following discussion, I will presume the type of project to be an "outside the circle," community participation-style documentary.

There are several different structures or configurations instructors can use to employ these types of documentary projects in the curriculum, whether it is an actual digital video production or filmmaking class or a class that includes a video/film project component.

Small-Group Projects

The simplest implementation is through the small group documentary project within the scope of a field video/TV production class. The students will use these projects to implement the production skills learned within the class while

at the same time expanding their understanding of a particular social issue, developing connections with other communities and engaging in creative/artist social activism.

Typically these projects would be major productions after instruction and practice with production equipment and theories. Since they will possibly be training members of the community with whom they are working, they need some expertise in production before going out into the field. It is helpful for the students if the instructor has lined up some contacts with community groups who are interested or have a need for a video program. Many students, though, will have discovered their own project ideas that they will want to pursue.

Depending on the amount of time that can be allocated to this project, the instructor can structure the assignment in two different ways. The first way would be as a typical short documentary in which the students immerse themselves in the subject matter and explore from their point of view the social issue on which they are working. Another approach, though, is to ask the student teams to involve the subjects of the documentary as more than just interviewees.

The students would become collaborators with the community, for example, by teaching the members of a particular group to use the video cameras and then having them shoot the footage that will describe their issues or problems. During the editing/post-production process, the students will work with the community members to structure the program in a way that truly tells their story.

Although this type of collaborative project is not always feasible due to time constraints of the students and the project deadlines, the level of intimacy with the social issue and subjects that this type of project engenders can transform the student's and viewer's understanding of that community and the dilemmas it faces. Regardless of the level of technical perfection that student producers achieve on the project, the content will usually be outstanding in the depth of insight the program will reach, and the process of making the project becomes as profound as the final product for both the students and community members.

One problem that a digital filmmaker sometimes encounters with this type of project is the concept of "ownership": who actually has the final say on what's in or out of the fine cut. As a digital filmmaker, I can facilitate a group's documentary by offering technical assistance and training as well as help with structuring and crafting the story to be the most compelling story it can be.

In this case, though, I am only the aide-de-camp for the project, and the group or community members are the producers and have the final say as to content. It has been argued that if a filmmaker is providing funding in terms of access to equipment, considerable production expertise beyond basic technical training/support, and distribution and marketing, then the filmmaker should be considered the executive producer (EP) and as such will have the right to influence the direction

of the project in a major way. This type of control would certainly defeat the main purposes of initiating a community participatory-style documentary project.

The student producers, on the other hand, are typically relying on the project for their grade, and therefore I believe the student has ultimate responsibility for the final product. The instructor can create ways in which students working in this style of community participation documentary can still have the flexibility they will need to succeed as artists and as students.

One way to facilitate the project's successful completion, if there are difficulties in this arena, is to have the students weave together parallel stories of their experience of exploring the subject matter alongside the community's experience producing the documentary. This can be very powerful since at minimum, even if the students' footage is not needed to create the final project, the community can have a reflection of itself from the students' "outside eye." This input can be invaluable for the group to ascertain how both the subject matter and they themselves are coming across to an audience. The information gained can help the community group more accurately and succinctly frame its story for the target audience.

For their part, students become both members of sorts and observers of the group. This can support the students in experiencing the subject matter more intimately and deeply, while as a practical measure allowing students to maintain control over the production of a portion of the material. In the cases where the community members do not generate their portion of the project in time for the class deadline, the students can utilize their own footage to finish the program within the course time frame.

BeComing: Women's Circles, Women's Lives

A few years ago I directed and co-produced a documentary called *BeComing: Women's Circles, Women's Lives*, which examined the therapeutic benefits derived from women's circles. The project was initiated by a women's circle that had been in existence for a long period of time and was spearheaded by three women from the circle. These members brought me in as a co-producer, and though I had been a member of several women's circles myself and understood the subject matter, these three members of the circle appropriately identified the direction and tenor of the program: they were the voice of this community and as such they were to define how this program explored the subject matter.

On the last day of shooting, the women asked our very small crew of four women and one man to join the circle in front of the camera to reflect on our experience of being part of this circle (albeit a concentric circle) for the weekend retreat. The crew and circle members were struck by the depth of emotional connection we had formed within the processes of shooting the project. As producers, we didn't know if we were

going to use this footage in the final program, but we did believe that it would be an important aspect of the process for us as a new temporal community. At the end of the women's circle documentary, we did choose to use this moment as a reflection on the power that circles can have for individuals who are touched by their intimate, safe space as they radiate out to form circles within circles within circles.

My assistant director, a former student who had worked with me on many projects and who also was a member of a women's circle, felt that the experience of becoming a circle through the intersection of crew with women from the circle was exceptionally profound.

The process-oriented style of documentary takes the emphasis off the final product itself and places it on the process as a whole. This not only changes the quality of the experience felt by all who are touched by the production but can create, I believe, a more profound and resonant documentary in which the social action/interaction is made personal, and the social action/interaction is made art.

Tent City

One spring quarter while I was teaching at a community college in Seattle, a student from my Field Video Production class decided to produce as her final project a promotional, fundraising video program for Tent City, a homeless shelter where the residents live in tents on property provided by various churches and organizations. She had heard about the shelter and wanted to do some sort of social activism to help it continue its work, and a promotional video was one thing it needed that she could give. She pitched her project idea to the class, which is what the students do in my production courses, and several students were interested in joining her production team.

The original student/activist and one of the other team members stayed several nights at the shelter to get more of a sense of what it is like to be a member of the homeless community. Though they didn't do any videotaping during their stay, they did develop a more visceral understanding of the problems and issues of being homeless as they worked in the kitchen and did various other tasks that residents were required to do. They also developed a sense of trust with some of the residents at the shelter whom they would later interview. After producing the promotional piece, these two students worked into the summer quarter to edit a more in-depth documentary program on Tent City, and the original student continued beyond that as a social activist for Tent City and the homeless.

The students were very impacted by certain statements that the residents made, even though they had joined the community in this limited and cursory manner. In a section of their program that deals with the question "Who are homeless people?" one of the interview subjects made this comment:

People are battling and we have a right to be cared for too in this society…it's everybody and anybody…they don't want a handout they want a hand up.

In the section that describes how Tent City came about, one of the residents recalls its history with a tinge of his own experience.

It was important for people to band together…there's safety in numbers… people were tired of living in doorways…it had worked in other parts of the US.…Seattle thought it was time to curb the homeless problem.

Though the project was not a community participatory documentary, the brief stay within the community and the work with the members in crafting the promotional piece allowed a deepening of the comments garnered from the interviews and a better understanding of the subject matter by the producers, which then translated into a stronger, more persuasive project. It also energized the artist/social activist part of the students.

Full-Class Production

Another way in which to incorporate this style of community-based documentary into the curriculum is by developing a partnership with a community-based group or governmental organization and developing a full semester/quarter or several semester/quarter courses in which to produce the project. Using this group or community as the focal point, the instructor uses this advanced video production class as the production company. The outcome of the class is to provide the student with professional and technical training, expand the student's understanding of the issue, and produce a program for the organization.

The students interview to get into the class for the various crew positions and are then "hired" into the positions for which they are most suited. As class members, these students must fulfill their crew assignment responsibilities fully and professionally or get fired from the project, which for all intents and purposes fails them in that class. Positions on the crew are extremely sought after, so this is not typically a problem.

More of an issue is the need to have variable credit hours for the course, since there is quite a discrepancy in hours required for the various crew positions. If the instructor uses a theater production course structure and assigns the hours based on the crew position requirements, the students, when hired for that particular job, will know what credits they will receive as well as the job functions they will be fulfilling.

Many groups approach colleges to produce programs for them. For full-scale programs, I have asked the organization to supply partial funding for the production

expense, for example, videotape stock or capture hard drives, transportation and meals for crew, and in some cases higher-quality equipment rental.

This type of course is more successful if the production and post-production processes are separate. If the course can be constructed so as to spread over two semesters/quarters as two consecutive classes, or if the post-production can be used as a special project for one or two advanced editing students and the producer/directors, the course will flow much better, and the product will also turn out to be of higher quality.

Awareness, Options, Control: A Program on Truancy

One Fall semester, members of the County Prosecutor's Office approached my college to produce a video to go along with its truancy education classes. They wanted a program for high school and junior high school students that explained the consequences of being truant and skipping school while encouraging the youth to stay in school.

At first I gave the project to three of my strongest production students to produce, but it turned out to be too overwhelming and complex a project, so I took it on as producer/director and retained them as associate producers. Since this project was going to be used statewide with quite an extensive scope, I decided to use it as a full quarter video production class based on our theater production model. The Prosecutor's Office paid to rent a broadcast-quality, professional camera and for some additional production and travel expenses.

Additionally, I brought in two alumni, one as a director of photography (primary camera) and one as my co-producer/director. Students who interviewed for the positions as part of their admission into the class filled the rest of the crew positions, as they would have for parts within a theatrical production.

Every student who interviewed got "hired" for the project, though not always for the position he or she had wanted. All students learned the particular duties of their crew position in depth as well as the basics of all the other technical crew positions, in the event that they needed to fill in for one of the other crew members.

Some crew positions rotated based on the availability of students for the shoot times and location trips. Because of these two factors, students completed the class with a full understanding of the technical aspects of each area of production. Equally important, though, was the knowledge and understanding of the content gained by the deep, personal involvement in exploring the subject of truancy.

Many of the youth who were interviewed struck a chord with the students in the class. Quite a few of the students, it turned out, were themselves truant during their high school and junior high school years and had finished their education using alternative methods. Students drew on personal experience to develop the approach

we used for the program content. As a team, the producers and other production members decided on the approach of the program, which was not just to delineate the laws and consequences of being truant but also to recognize the myriad reasons that youth are truant. We wanted to give concrete alternatives to the traditional high school experience so that the youth watching would see ways in which they could fulfill their educational and legal requirements.

This did not start as a community-based documentary/educational project. However, with the amount of production work done by team members having direct experience with this issue, the effect was very similar to that of having gone out into the high school and junior high community and asking them to document their ideas on this subject. One of the associate producers ended up being interviewed for the project, since his experience with truancy was so germane and poignant within the subject matter we were exploring, and he was there at a college successfully working on a degree.

The interview subjects we garnered ranged from high school and alternative high school students, community college students who were pursuing or had received their GEDs, all the way to the youth who were in the juvenile detention center. Several times during the production students would come to me to talk about the impact the project was having on them. Sometimes it was due to the proximity of their life experience with that of one of our interview subjects, and other times it was just the power of the stories that were being told to us through the preliminary or on-camera interviews.

On one of our visits to the detention center, a student crew member asked if I would take over for him while he took a break. Later he told me that he needed a moment to regroup, since the stories of the youth could have been his own had his life deviated just slightly from the path it had taken. As he connected his past with the subject matter, his creative input to the project became more potent and substantive.

Because of these personal connections and parallels that the students made with the content, the program, I believe, gained an immediacy and spoke directly to the target audience in a more powerful way, allowing the junior high and high school audience to actually receive and access the information on truancy that under other circumstances would certainly have been ignored.

When we received the notes on the rough cut from the deputy prosecutor and a high school counselor, we were asked to cut out one of the interview subjects from the program, since to them he looked too much like a drug dealer. I felt that this particular person was one of the most important interview subjects of the program precisely because he was someone who spoke directly to the high school audience and therefore had its ear.

The opening of the program ends with a statement from this young man's interview: "I don't know what to say to someone like me 'cause I wouldn't have

listened to me." I did not want to take out this bite (or any of the other sections of his interview we had used), since in my professional opinion this statement alone would make the students' ears prick up and give the program credibility.

As a production team, we deliberated on all the notes, deciding that most of the items they had objected to could be fixed or changed with no detrimental impact on the program. The removal of this particular interview subject, though, was not going to be doable. We came up with the rationale for the inclusion of this person and met with the client to explain our position. Through the explanation by the students themselves, the client could see how this interview subject actually would help the junior high and high school students receive the information the client intended for them. By having to defend the choices of content, the students gained a more profound understanding of all sides of the project's issues—their own and that of the clients.

Awareness, Options, Control: Take Control (Winslow, 2000) is now a large component of a nationally recognized truancy program, Keeping Kids in School. It has won many awards, not just in student media festivals, but also in regional and national professional media and film competitions where it went up against professional, full-budget productions. To me, though, the success and import of this project lies as much in the experiential process and the personal connection to the content that inspires personal growth and social awareness as in the professional experience and accolades it brought to the students.

In The Community: Students Become Teachers

In 1967, Canada's National Film Board started a program called Challenge for Change, which developed into a community-based participatory media that provided an outlet for dialogue between the communities and the Canadian government. In Michelle Stewart's article "The Indian Film Crews of Challenge for Change: Representation and the State" (2007), she states:

> Contributing significantly to a national debate over the politics of representation, the dialogue films convinced many of the need for community-controlled media and led to the establishment of two national Indian training crews (1968–70, 1971–73). The Indian dialogue films and the Indian training crews underscored the potential of film/video technology for community self-definition, shaped the way direct cinema developed within CC, and influenced many who worked at the NFB. (p. 49)

Currently, this practice has re-emerged with community-based media organizations, school visiting artist programs, and local museums' and libraries' educational

programs utilizing media productions to inspire creative social activism. At the Pratt Museum in Homer, Alaska, community-based video collaboration projects have been strongly infused into a mission of community museum-making. As one of the winners of the 2005 National Awards for Museum and Library Service, the award's program discusses the Pratt's commitment to the inclusion of this style of video program as part of its participatory exhibit structure:

> The Pratt's series of community-based videos are another way the people of the area participate in museum-making. With a small budget, a participatory process, and an open mind for the direction of the final product, the museum loosely guides the development of these videos, which are presented throughout the museum's exhibits. Examples include "Rich and Simple Life," about the homestead life of Ruth Kilcher revealed by readings of her diary and memories of her eight children; and "Bringing The Stories Back," about the remembrances of Alutiiq ancestral homes on the outer coast of the Kenai Peninsula. The newest video, "Kiputmen Naukurlurpet—Let It Grow Back," was developed with elders and youth from the Native village of Port Graham who discussed their Alutiiq Sugpiaq language. They described how their language was taken away and how it is currently used in the village. (Institue of Museum and Library Services, 2005, p. 12)

Reel Grrls at 911 Media Arts, a community-based media organization in Seattle, is a program that provides filmmaking workshops for teenage girls who come from diverse communities.

> Our mission is to cultivate voice and leadership in girls at a vulnerable age in their development. What distinguishes our program is the high level of support that our female mentors offer and the high level of commitment that we ask for in return.
>
> Our participants don't just drop into a computer lab after school—they develop lasting relationships with women filmmakers and learn skills that propel them to leadership roles in their community, college scholarships, and careers in the media industry. (Reel Grrls, 2010)

Reel Grrls starts with a video training program where the young women learn video production, which empowers them to find their voice through which they can document their lives. The advanced Reel Grrls then can go on to produce outreach videos for non-profit organizations through the Summer Apprentice Program. The Reel Grrls community uses the model of training the filmmaking artist/activists who then train the next wave of artist/activists.

Internationally there are many programs that get started because filmmaker/activists become aware of a social issue and then set out to document the issue. In the process they realize that the best voice for this project is not the filmmaker's but the community itself. This is what inspired London-based Danielle Smith, founder and director of Sandblast Foundation and a documentary photographer/filmmaker, whose arts and human rights projects help to raise awareness about the Saharawis of Western Sahara, a dispossessed and marginalized refugee community living in desert camps in southwestern Algeria.

During her work creating documentaries and photo-essays in the camps, Danielle realized that the Saharawi peoples' rich arts culture could also be expressed through filmmaking if they were given the opportunity to get training in the film arts.

> Over the years, numerous outsiders have sought to tell the story of the Saharawi plight to the world but it has not been told by the Saharawis themselves.
>
> This situation is likely to change soon as a result of increasing inputs and training being provided by Spanish-led initiatives like FISAHARA. Since 2003, FISAHARA has been staging international film festivals in the camps to develop the population's exposure and appreciation of film. They recently got funding to build an audiovisual centre to train future Saharawi filmmakers. It was inaugurated during the 7th film festival in May 2010. The seven years of holding the festival and running short audiovisual film workshops each time has already borne fruit. Small but slowly growing numbers of young Saharawis are forming cooperatives in the camps to produce films independently and tell their stories with whatever means they can find. (Sandblast Arts Organization, 2010b)

Although this is a new type of medium for this oral-based culture, the development of training workshops and media creation opportunities can help this community to develop its own projects to use as vehicles for social activism. On the Sandblast website, there is an invitation to contact this arts organization if you are "a filmmaker wanting to collaborate with the Saharawis to either help train or collaborate with them in producing their stories" (Sandblast Arts Organization, 2010a). This is the community-based participatory documentary in action—the facilitation of a community's voice through artist/social activism.

One can adapt this model within the high school or college programs, as I discussed earlier. The college students can train the specific group, for example, high school teens or low-income seniors, on how to use digital video equipment and then help this group produce a documentary. In the process, members of the group

or community teach the college students about their life experiences. This solidifies the college students' knowledge and skill of the digital video equipment through the instruction process while deepening their understanding of the group with which they are working.

The process empowers community groups by giving them a positive outlet for their voice and the skills to express it. Both groups are at once students and teachers. Both are learning ways in which to be interconnected. Both groups become stronger through building bridges between communities by developing understanding of social issues and working as a team to create a program that reflects that. The emphasis is on the student teachers and the community members becoming a coherent production team speaking with one voice.

This type of program can be used for adult extension or life-long learning programs extending the outreach of a college into the larger community. It can give all involved an understanding of community ownership, responsibility, and social activism. In any of the earlier, above-mentioned student productions, the process could be adapted to have the students become the trainers for the community members who then document the topic being explored.

Ethics and Content Responsibilities

For all documentary and non-fiction production classes there must be a discussion of ethics and responsibility to represent the subjects and issues of the program as authentically as one can. This is especially true with these types of projects.

In documentary productions, there can be a temptation to make assumptions based on one's own attitudes and ideas. Intentionally or unintentionally, the digital technology can then be used to manipulate the original ideas expressed in an interview by changing the content to express instead the filmmaker's point of view. The ethics of respectfully and accurately representing the subject's ideas is of paramount importance. If the interview material doesn't support the idea a filmmaker is depicting within that program, then he or she must leave it out and go find the material that does. The artist/instructor must stress this point to the students and make ethics an essential part of this curriculum.

A video producer must always approach the people who appear in front of the camera with respect, even when they have ideas different than one's own. Class discussions in listening skills, respect for differences and diversity, and an emphasis on the responsibility to represent others' ideas truthfully and accurately must take place before the students go out into the field to work with communities and groups. This style of documentary production gives the students an opportunity to apply ethical theories and practices in direct and active ways.

Conclusion

Whether as a full-class production, an individual or small-group project, or out in the larger community, the community-based participatory documentary process can engage student filmmakers in becoming community activists and socially conscious artists. By gaining technical skills and an understanding of citizenship, diversity, community building, and ethical responsibility, many students will emerge as artists/social activists, and their work from these projects will continue to influence their future creative output. They will in turn reach out to teach and inspire diverse community and social groups to find their voice. Students learn to create art, and to teach this art, through which they learn about building community, and the community will in turn create and educate as well. The circle of connection continues, and social activism is borne out through the arts.

References

Barnouw, E. (1993). *Documentary: A history of the non-fiction film.* New York: Oxford University Press.

Trinh, T.M. & Bourdier, J.P. (Producer). (1985). *Naked spaces* [motion picture]. United States: Women Make Movies.

Trinh, T.M. & Bourdier, J.P. (Producer). (1989). *Surname Viet given name Nam* [motion picture]. United States: Women Make Movies.

Hutcheson, M., & Schugurensky, D. (2005) Challenge for Change launched, a participatory media approach to citizenship education. The Ontario Institute for Studies in Education of the University of Toronto (OISE/UT). Retrieved from http://fcis.oise.utoronto.ca/~daniel_sc/assignment1/1966cfc.html

Institute of Museum and Library Services. (2005). 2005 National Awards for Museum and Library Service Program. Washington, DC. Retrieved from http://www.imls.gov/pdf/2005 awards.pdf

Kopple, B. (Producer/Director). (1976). *Harlan County U.S.A.* [motion picture]. United States: First Run Features.

Kopple, B., & Peck, C. (Producers/Directors). (2006). *Dixie Chicks: Shout up and sing* [motion picture]. United States: The Weinstein Company.

Marchessault, J. (1995). Reflections on the dispossessed: Video and the "Challenge for Change" experiment. *Screen, 2,* 131–146.

Reel Grrls. (2010). Overview: Our mission. Retrieved August 26, 2010, from http://www.reelgrrls.org/about/overview

Sandblast Arts Organization. (2010a). Who we are: Danielle Smith. Retrieved August 8, 2010, from http://www.sandblast-arts.org/about-us/who-we-are/danielle-smith

Sandblast Arts Organization. (2010b). *Voices and visions: Film.* Retrieved August 26, 2010, from http://www.sandblast-arts.org/voices-and-visions/film

Stewart, M. (2007). The Indian film crews of Challenge for Change: Representation and the state. *Canadian Journal of Film Studies, 16*(2), 49–81.

Winslow, J. (Producer/Director), & Levin-Delson, T. (Co-producer/Director). (2000). *Awareness, options, control: Take control* (part of the Keeping Kids in School program) [video]. United States: King County Prosecutor's Office, Seattle; Washington/FireDancer Productions, Oswego, New York.

Art Class at the Onondaga Nation School

A Practice of the Good Mind

JENNIFER KAGAN AND CHRIS CAPELLA

Take highway 81 South to exit 16, "Onondaga Nation Territory," and then take 11A, which is basically a hidden road to those uninitiated, only marked by a flower bed. Sometimes there is a truck parked along the entrance to 11A. I believe that the Onondagas patrol this road, and the people in the truck mark your comings and goings. Down this road you will look to the left and right and see houses, buildings, and trailers; some property is very neat with landscaped lawns, and other areas have a closer-to-nature look. You feel a sense of reverence, a visceral respect as you sit up more alert in your car. Attention. You slow your speed and look left and right, not to miss anything at the stretch of land that is clearly Nation grounds. Maybe that's why it isn't clearly labeled, because it has to be felt. Dorothy, you're not in America anymore! You're in the Onondaga Nation on the way to the Nation School.

This chapter explores the idea of community in its largest and smallest sense. It explores community at the Onondaga Nation School, which mirrors the sense of community of the Onondaga tribe and reflects the notion of the smaller community (of learners) in Chris Capella's art class. I examine Chris's role as art teacher/leader that enhances learning about one's heritage through arts-based education.

Onondaga Nation School is often called a *community* school, in that it is a hub of activity for the Native American community. There are arts and crafts fairs during the year, meetings, harvest dinners, and spring dinners where the kids prepare the food and the community comes to partake. Tibetan monks have visited the school, musical groups such as Ulali, Native writer Joseph Bruchac and Native

actor Adam Beech from *Smoke Signals* have stopped by, as well as film director Chris Eyre. There are monthly moccasin dances; language and culture classes for the kids; the Community Give, where children bring boxes full of items that they have made and go to the Elders' homes and ask if they can do any work (like raking) for them; and an academic fair where some community members judge the students' work. Even the school architecture is symbolic of Onondaga culture. From the sky the school looks like an eagle. A recent addition to it is the pre-kindergarten for 4-year-olds. The preschool takes place in a building next to the school and is called Ohahiyoh, or The Good Path. There the teachers immerse the students in Onondaga language, and they learn by doing small projects. So, students at a very young age are taught about the community. Elders often come into the building and serve as an inspiration. In the hallways there are pictures of families and Elders, and the Elders' presence is still felt even though they may be gone. Thus individuals from 4 to 84 are represented in the building. And we are one.

Community is survival to the Native Americans (Brayboy & McCarty, 2010). Instead of Descartes's philosophy of knowing and being "I think therefore I am," Burkhart came up with an Indigenous version: "We are, therefore I am" (Brayboy & McCarty, 2010, p. 187).

There is the belief out there (by some non-natives) that "…Native Americans today should either live like 'authentic Indians' off the land, or concede their status, to finally join and contribute to America like 'everyone else'" (Holloman, 1996, p. 51). This idea that you have one choice—either you choose to be a Native or follow white people's ways—is a false dichotomy at Onondaga Nation School. Children seem adept at navigating through the worlds, and thus are bicultural. They show they are fluent in both mainstream culture and Native culture.

When you arrive at the school, there are two monitors there to greet you and have you sign in if you're not on faculty. One of the monitors is always doing intricate beadwork or sewing traditional regalia on her sewing machine at the entrance to the building. The other monitor is working diligently on her computer. Side by side, these two Native women juxtapose the two worlds, traditional and contemporary. And somehow, like the wampum beadwork that has two parallel lines that never touch, one line representing Native ways and one line representing Western ways, it works.

I've worked in various capacities at the Onondaga Nation School (ONS) for 9 years. I am a full-time assistant professor of literacy in the School of Education at Oswego State University. I teach a 6-week summer course entitled LIT 509: *Evaluation for Reflective Instruction at the Onondaga Nation School*. This course has a tutoring component, so that the graduate students in the master's program in literacy at Oswego will have the opportunity to work one-on-one with ONS students. I was asked by the former principal at the school to be a full-time English-Language

Arts staff developer for the Lafayette Central School District for the year 2003–2004. That year I was on a reduced course load at SUNY Oswego while working for the district. For 2 years I brought creative writers from Syracuse University's Masters of Fine Arts Creative Writing Program to the fifth and sixth grades so that the ONS students could have the opportunity to apprentice with "real" writers. For 5 years I have worked with an inquiry group of ONS teachers, one evening a week, and we study best practices in literacy. I am also passionate about bringing the game of tennis to the Onondaga kids. I run a summer tennis program and have secured equipment and travel monies from grants I have arranged for buses to travel to New York City in order to visit the U.S. Open's day for kids (Arthur Ashe Kid's Day) at the end of August. Last year we traveled to a Quick Start tournament for kids ages 8–12 in Batavia, New York. Onondaga Nation School won the tournament and was awarded a trophy, which sits in a showcase at the Tsha'Hon'nonyen'dakwa Arena (a big ice hockey/box lacrosse building on the Nation's grounds where they play games).

I am fairly well recognized at the school because it is small (only 95 children, K–8) and because I wear so many hats. This doesn't mean I take this for granted. Every day, out of respect, I walk up to the hall monitors and say hi to them by name and look for the sign-in sheet and a pencil. Every day. I sign in and say I'm going to Chris Capella's room. I walk through the cafeteria, down a back hallway (the end of which is considered to be haunted), and enter the classroom that used to be the cafeteria. It is a large space with lots of long tables and stools for the students to work on. In the back of the classroom is a kiln for firing clay. The classroom has many computers and looks neat and tidy for an art room. There is a sense of calm.

I've known Chris for several years because she has played a major role in the inquiry group, and she has played a significant role in the tennis program as well. I consider her to be a close friend. I've stayed with her multiple times in hotel rooms for tennis conferences, I was at her wedding and baby shower, and I have been to her parents' house. She has never formally learned how to play tennis, but this doesn't stop her from learning the sport by watching. She has a natural athletic ability and great eye-hand coordination from softball. She teaches the techniques of tennis to the kids.

She exhibited her fearlessness as she put us all on a Blackboard site so that the inquiry group members could have threaded discussions. Chris embraces technology and uses it as a tool for her benefit. She put together a forceful PowerPoint program and presented it to the head of the Arena at the Nation, so that we could continue having tennis there. If Chris has an idea, she thinks it through from beginning to end and executes it; nothing seems to get in her way, and the impossible suddenly becomes possible with her in charge. She is a learner as well as a teacher, or what I would call *a reacher*, in that she actively reaches out for knowl-

edge. "Pedagogy is more than simply the act of teaching; it too is an active and critical engagement with the world. Thus, teaching and learning are coterminous; one cannot truly engage in teaching without also being a learner" (Brayboy & McCarty, 2010, p. 184).

Chris typically exudes a sense of calm, and it is contagious; she never raises her voice. She doesn't speak loudly, but you know when you've created something that she thinks is top rate, or when you've disappointed her with your behavior. She laughs a lot. It's a bit of a chuckle and giggle. The students laugh along with her. I have observed Chris's classes many times, and the vast majority of the students are engrossed in their projects. I have tried to engage them in discussion while they are working on pieces, and they are polite, but typically their level of concentration is too keen for the interruption.

There are few, if any, classroom management problems due to the engaging work and Chris's style of teaching. Starko (2005) states, "Encouraging a personal connection in students is the key to their motivation. Arts-based as well as core curricula teachers can build classrooms that enhance student motivation, creating an environment where students aren't afraid to experiment, create new plans and ideas and explore new avenues in their learning" (p. 7).

The art room is a safe haven for kids. It is a secure space, rather than just a place. A *place* is considered to be a geographical location, like "the art room," devoid of any feeling. A *space* is the place along with all of the perceptions that go with it. Here the kids feel they can be who they are. They listen to Native music and sing the chants that are piping out of the CD player but are also allowed to listen to any music they want with their iPods. In "Indigenous Knowledges and Social Justice Pedagogy" (2010), Brayboy and McCarty state: "The landscape—the places where teaching and learning take place—is not just a blank backdrop for the journey, but the locus of the power to move through a knowledge-seeking journey. It is an active space, not a neutral insignificant one" (p. 187).

Kids are taught that they are artists from pre-kindergarten on. Chris tells them as they enter the art room as pre-kindergartners, "you are artists," and this identity sticks. The youngest ones are given 2-day projects to do and are told routines and expectations. Sometimes they are given sponges to add water to, and they watch them grow; they are also given stamps to stamp designs on paper. One assignment for the preschool kids was the "wacky watch," where the students were given a textured band of a watch and they decorated the watch face. They were asked to use their imagination when decorating it. One little boy loved his watch so much he would put it in a "special spot." They also made some shapes like hearts to give away to their families.

You can tell from the older kids' work that they are serious about technique, diligent in their sketches, and open in their conferences with Chris. She wants these

students to be "investigators" and look deeper into objects for what stories they may tell. She wants her students to be creative and "step out of their box." She comes from the mindset that everybody has skill and talent, and she does what the best teachers do for their students: she *evokes* their talent.

Chris also feels that you not only have to understand the art that you are making, but you also have to understand its history. She recently went to a national convention in Baltimore in April 2010 entitled "Art Education and Social Justice." She decided to attend a lecture that was about Native American art, and she was disappointed with the lack of background information presented during the talk. She said, "I know my P's and Q's about Haudenosaunee (translated: People of the Longhouse meaning: Iroquois Confederacy) culture." Chris explained that people (Native and non-Native) are eager to learn about Native art and that it is the responsibility of artists to let others know their history and culture.

Chris often bridges what the kids learn in art class with what they learn in life—not only in her classroom, but also in a program called Bridges. The Bridges program is made up of Onondaga Nation School (ONS) kids (the school is a K–8 building) who are in the later grades and are going to be going to the Lafayette Junior/Senior High School (a 7–12 building). Sometimes the transition to the high school is rough, due to the fact that ONS is 100% Native, and when you get to the high school you have a 25% Native population. There is less support, and in coming from the homey feel of ONS to the more regimented feel of the high school, students can get lost. At the Nation School it's OK to be in school and a strong Native person, whereas when students get to the high school, it's not always perceived to be OK. Students in Bridges go on ropes courses at Orenda (Pronounced Olenta) Springs, an experiential learning center close by, and camp on Racquet Lake in the Adirondacks. In both places kids are inspired by nature and the positive energy to do good. The ropes courses challenge the students to conquer their fears and work together. There Chris will talk to them and explain that it is OK to be a good student and it is OK to be a good artist.

There was one sixth grader who did not believe in himself as an artist, nor did his mother believe that he could do art. This overarching viewpoint colored his outlook more than anything he actually did. He excelled at sports such as hockey and lacrosse, which he found easy, but had a negative attitude toward art class. Chris felt that his sketches were very good and that he definitely had potential, which she conveyed to his mom and him. Initially, he refused to believe her. Not willing to give up, she kept on coaxing him to keep drawing. It wasn't until he completed two projects—a cradleboard and a mosaic piece—that he understood that he had some talent. His mom was pleasantly surprised by these final projects as well. He understood that to do the right thing in art class meant he had to become

diligent and have a good work ethic. Chris believes that *everyone* has skill and talent, but sometimes it's just untapped, or maybe a bit raw, or perhaps clouded by an attitude.

Observing Chris's sixth-grade class gave me insight as to how her classes with the older kids in the school are typically run. There are Haudenosaunee social songs in the background, and students will intermittently sing the chants on cue. It's amazing to hear. The undulations of the singer's voice seem so difficult to replicate, but these students know the nuances. There were some social songs that were sung in my presence, but the ceremony songs stay among the Native people. One student has a t-shirt on that has four prominent Native Americans staged like Mount Rushmore with the caption, "The Original Americans." While they are singing, some students are wiping grout from their mosaics and polishing the tiles. Some mosaics are of clan animals like a turtle, while others are foxes and snakes. Some students are done with their mosaics, so they are doing wood burnings of animals such as horses and birds.

A random reference to the 1980s rapper Vanilla Ice creeps into the conversation and is a source of laughter. Students in the class chant "Ice, Ice Baby" softly and get the giggles. The middle school students' boundless energy reminds me of the fictitious character Junior, who is 14 years old in the book *The Absolutely True Diary of a Part-Time Indian* by Sherman Alexie (2007). Junior is a cartoonist who grew up on the Spokane Indian reservation, and it is through his prose and pictures that we get a sense of the culture clash over being in the white world and the Indian world. Especially poignant is when he draws a cartoon of a person divided down the middle who is, on the left, white, and on the right, Indian, with stereotypical characteristics. He says, "I realized that, sure, I was a Spokane Indian. I belonged to that tribe. But I also belonged to the tribe of American immigrants. And to the tribe of basketball players. And to the tribe of book worms" (Alexie, 2007, p. 217). Junior is multifaceted, like the kids in Chris Capella's art class, navigating through dominant culture and the influences on their own cultural identity.

Mr. Jeff Capella (the MST—math, science, and technology teacher) often team-teaches with Chris and is overseeing the wood burning. Chris and Jeff model working together; he and another student are quoting lines verbatim with the correct accents from a film that they have both seen. Chris is "working the room" by talking to those who need a bit more direction. She's helping with the application of grout, saying to one student, "I think we're ready for a paper towel." By saying "we're" instead of "you're" to this struggling student, she is scaffolding the instruction for her, letting her know that she will show rather than tell her what to do.

Sometimes Chris's classes resemble "three-ring circuses" in that there are multiple projects at multiple stages, and so Chris has to be on her toes and be able to

switch gears with the multiple projects. Sometimes students are at a different stage, so she has to meet with them in short meetings to make sure they're on the right track. She was talking to one of her classes about making a jar out of clay by four techniques: (1) pinch pot; (2) slab; (3) wheel throwing; and (4) coil. She was teaching via lecture or direct instruction and writing information on the board. Out of the corner of her eye she saw a student put his sketchbook on his head. She walked over to the student and said matter-of-factly and without irritation, "Could you stop that?" He promptly did. Chris asked another student if he would be distracted sitting over "there," to which he straightened up and said "No."

Somehow Lady Gaga is thrown into the mix of the conversation, as well as the idea that it would be weird to marry your cousin and marry in the same clan (Onondagas have a matrilineal society and have to marry outside of their clan). They riff a bit more on random topics, such as how the fifth-grade teacher Ms. George is the cousin of one of the students, and the cousin says of her as a teacher, "I like her." Conversations typically progress from popular culture to school culture to talking about family life. "My gramma has fourteen grandchildren," someone will boast. "My mom has eight children," someone will counter, and then there is the audible counting of cousins by a group of students. One boy talked about living in other places, like on casino grounds, which he liked. Then there are the more personal conversations that are covered: how a boy's dad went to jail for beating up a cop (although the boy explained that the cop was beating up a woman), or how another person was known for setting cars on fire. "Let the rez deal with him," was the answer agreed upon. This shows the comfort level the students have in the room; they can talk about anything and know they are supported and safe.

A boy walks into the art room at the end of the period wanting to fix the beadwork on his moccasins on his own time. I have known this boy for a while, and when he was younger he had a lot of difficulty focusing on schoolwork. He was the fastest runner in the grade and an amazing athlete, but had much difficulty staying on task and would often interrupt students and the teacher. Chris relayed to me that he was incredibly helpful in assisting with art projects in the younger grades, and she was going to give him an art award at graduation. I witnessed a humility and maturity in this young man that I had never seen before. I would say that the life lessons Chris overtly and covertly taught were rubbing off on him, and he took solace in coming to her room perhaps to get away from his reputation and start anew without judgment.

Another class comes in making graduation presents for the graduating classes. They are making medicine boxes and drawing the sketches for the tops of the boxes on the computer. Chris is helping some students graph out their design, and one student wants to include the Hiawatha belt on the top of her design but is vis-

ibly stressed over how to do this. Chris takes the pencil from her and gently shades part of the design on the medicine box, leaving off where the student can continue the design. Chris says gently, "You're too hard on yourself," and the girl nods. In these medicine boxes they can put a variety of items: Indian tobacco, dried plants, and so on. Students are very invested in making these boxes because they will go to the members of the graduating eighth-grade class.

Chris admits that there are many students like the one previously mentioned who stress about their work and get a little "frazzled." The students want their art pieces to turn out perfectly, because their work often gets displayed. They are concerned about the family/community reaction. There is also an opportunity to exhibit pieces at the New York State Fair. The students have incredibly high expectations of themselves because of this, which is both a good thing and potentially a bit negative. These students have an authentic audience to view their work, so they feel they must do a superior job. They must *represent*. This pushes them to do their best, but it can also paralyze them into thinking nothing is ever good enough. Chris explained that it's almost like having an inferiority complex, and the kids are very hard on themselves. They want to please their parents so badly and search for approval. Chris has a way of nurturing them that allows them solace (if only temporary) from the destructive *nothing's ever good enough* loop. Kids are going through puberty, and the pressures to do everything extremely well (be good dancers, singers, and artists) are increasing.

Chris has decided to combat this with "critiques" of artwork by starting early on in the primary grades, so that students will understand that artists often work with feedback from others. There is a way to give constructive feedback to the artist that is empowering rather than demoralizing. Their "inner critic" must also be silenced, and typically students feel that these critiques are a positive experience rather than a negative.

There is the philosophy of the Good Mind (Ganigonhi:yoh) that pervades Onondaga thinking: "It is a realization that we are connected to the good, that we have access to a loving source of good thoughts" (Jacques, 2000, p. 1). One has a choice to follow thoughts based on a loving purpose. Chris is a good example of modeling the Good Mind discipline. She is so positive and caring that it rubs off on the kids. It doesn't matter if the conduit is clay, paint, sketching, or wood burning. You learn how to be a contributing member of the classroom community, school community, and Native community. As Jacques (2002) states, "If you want change to happen, begin by changing yourself" (p. 2). It is through conscious thought and reflection that we can be positive role models, which is what Chris wants most from these students. "Social justice must be lived" (Brayboy & McCarty, 2010, p. 184). These students are the living, breathing community of the next

generation, and Chris is helping them to live it. To end with the beginning: and we are one.

References

Alexie, S. (2007). *The absolutely true diary of a part-time Indian.* New York: Little, Brown and Company.

Brayboy, B.M.J., & McCarty, J.L. (2010). Indigenous knowledges and social justice pedagogy. In T. Chapman & N. Hobbel (Eds.), *Social justice pedagogy across the curriculum: The practice of freedom* (pp. 184–199). New York: Routledge.

Holloman, M. (1996). A Native American identity in art education. In S. O'Meara & D. West (Eds.), *From our eyes: Learning from indigenous peoples* (pp. 47–58). Ontario, Canada: Garamond Press.

Jacques, Frieda. (2000). *Discipline of the good mind.* Unpublished manuscript.

Starko, A.J. (2005). *Creativity in the classroom.* (3rd ed.). Mahwah, NJ: Lawrence Erlbaum Associates.

Indigenous Activism

Art, Identity, and the Politics of the Quincentenary

LISA ROBERTS SEPPI

The 1992 Columbian Quincentenary bore witness to a historical crisis involving memory and identity described by Victor Zamudio-Taylor (1992) as a "cultural emergency" regarding the "failed project of national identity" (p. 14). In the years preceding the Quincentenary, multicultural programs in education and the arts sought to recognize and integrate the contributions of all cultures within the United States on the basis of equality. However, as the official Christopher Columbus Jubilee Commission (established in 1985) made plans to uncritically commemorate the 500-year anniversary of the Admiral's "discovery" and conquest of the New World, it did so without input or significant participation from North America's indigenous populations. Galvanized by the prospect of being further marginalized and misrepresented within the historical narrative of 1492, indigenous Americans had no other recourse but to plan their own events (Barreiro, 1990; Gentry & Grinde, Jr., 1994). The Native American artistic community saw the Quincentenary as an opportunity to re-examine the ethics of colonialism and address problems in the tautology in which European-American representations of the Native "Other" are engaged. They organized exhibitions and events to demystify the myth of Columbus and to reinterpret the meaning and significance of his voyage. In order to correct historical misunderstandings that foster racism and stereotypes, a concerted effort was put forward to promote awareness of distinctly indigenous values and belief systems that reaffirmed positive concepts of collective cultural identity and historical continuity. Many artists and curators identified and

valorized what has been termed the Native perspective—a shared worldview that, despite its expression through a vast range of experiential and aesthetic tendencies, is rooted in a common colonial history and ethnic background (Alfred Young Man, 1992). However, the subtle language of protection and victimization, along with the desire to affirm positive concepts of collective cultural identity and historical continuity, resulted in numerous exhibitions conceived without adequate individual artistic contextualization. Consequently, monolithic constructions of ethnic art and questions of homogenized Indian identity, along with their attendant exotic signifiers, remained relatively untheorized and unhistoricized. This has been a persistent problem for artists of Native American descent because, despite the more than 300 distinct American Indian cultures residing in the United States today, there has long been a homogenized identity and corresponding category of art referred to as American Indian. As the anthropologist and art critic Charlotte Townsend-Gault has repeatedly argued, Native American art is not in and of itself an "art category" but rather a "sociopolitical situation constituted by a devastating history" (Nemiroff, Houle, & Townsend-Gault, 1992, p. 81).

This chapter looks at indigenous involvement with the 1992 Quincentenry to examine the ways in which artists used visual work to generate awareness about contemporary Native American and First Nations art, identity, and culture and revise the historical record. Although this chapter will discuss a variety of artists' work, in order to avoid reiterating the impression of a unified, singular identity called "Indian," the life, work, and experiences of the Cherokee Kay WalkingStick will be used as a case study. In addition, three recurring themes dominate the artistic body of work produced for the quincentennial celebration, including the work of WalkingStick: land, memory, and culture/identity. Implicit in all three themes are ideas about home, history, and family. These themes and ideas will be further used to frame the discussions herein.

Due to the controversy generated by competing historical narratives—narratives that offered contradictory assessments of the colonial system and posited Columbus as either a heroic explorer or the progenitor of cultural and ecological destruction—"1992 was," in the words of historians Stephen Summerhill and John Alexander Williams, "over before it even began" (2000, p. 119). The anti-Columbus stance received public attention through myriad events ranging from indigenous and student activists protesting the *First Encounters* exhibition at the Florida Museum of Natural History, to American Indian Movement (AIM) representative Russell Means pouring symbolic blood on the Columbus statue in Denver, Colorado, to the publication of Kirkpatrick Sale's book *The Conquest of Paradise: Christopher Columbus and the Columbian Legacy*, the first anti-Columbus book to garner significant public recognition (Summerhill & Williams, 2000). However, according to Summerhill and Williams in their 2000 publication *Sinking Colum-*

bus, the 1992 Quincentenary succeeded precisely because it "failed." Its failure to generate unequivocal public support and its inability to forge a unified response capable of speaking on behalf of a collective cultural consciousness and national identity are what gave the Quincentenary its "enduring positive value" (Summerhill & Williams, 2000, pp. 4–5). The failed Quincentenary celebration gave rise to alternative events that "increased public recognition of the importance of nature, native peoples, and human rights" (Summerhill & Williams, 2000, pp. 4–5). That Columbus could not serve as a symbolic national hero underscored the truly fragmented and culturally diverse composition of contemporary American society. The metaphoric melting pot was similarly exposed as an erroneous myth. In place of its seamless blending of cultural pluralities existed an ethnic cauldron boiling over with unresolved tension and resentment. No longer capable of functioning as "an innocuous ethnic celebration," Summerhill and Williams argue that the Quincentenary had become instead a "battleground for our entire view of Western culture" (Summerhill & Williams, 2000, p. 119).

The Columbian anniversary had been celebrated twice before in United States history—in 1893 at the Chicago World's Columbian Exposition and 100 years earlier, in 1792, when Columbus became an important figure in the creation of a narrative of identity and in the birth of American nationalism or American national identity. According to Benedict Anderson, the birth of nationalism in the late 18th and early 19th centuries represents a new form of consciousness that came into existence when the nation could no longer be experienced as something new. This profound change in consciousness required that a certain amount of historical amnesia occur so that a narrative of collective national identity could be fabricated. However, unlike personal or autobiographical narratives, nations have no clearly identifiable birth and "cannot be written through long procreative chain of begettings." Instead, narratives of national identity are assembled from the present backward, a "fashioning" which Anderson states is "marked by deaths"—deaths that must be structured as anonymous events that can be aggregated and averaged into statistics charting the changing conditions of life experienced by masses of anonymous human beings whose only commonality is that of this newly defined nationality (Anderson, 1991, p. 205).

Historical accounts charting the "discovery" of North America and the subsequent creation of the United States of America have, until recently, responded to the presence of pre-contact indigenous peoples in several ways: by discounting their presence as original occupants and thus as "owners" of the land now comprising the United States and Canada; minimizing the contributions made by indigenous populations in the colonial process itself; failing to acknowledge the legitimacy of the contemporary Native American and First Nations cultures as heirs to the indigenous sovereign nations that populated North America well

before 1492; and ignoring the harsh realities of conquest that led to, more often than not, widespread death and the destruction of indigenous cultures throughout the globe. By refusing to remain silent or be rendered anonymous during the 1992 Quincentenary, and by insisting upon asserting their physical presence and their voices within both America's past documentary record and postcolonial present, contemporary Native peoples disrupted the narrative of American national identity and forced Americans to acknowledge their historical past. Writing from an indigenist perspective for the *Counter-Colonialismo* exhibition catalog, Victor Zamudio-Taylor proclaimed, "We are the demographic revenge, walking signifiers of a past to be dealt with, as well as the living blind spots of a failed project of national identity....1992 challenges us to remember our dead....A memory of absence has been proposed for the fin de siècle: the aesthetics of the living dead" (1992, p. 13).

With these precedents in mind, let us discuss two bodies of work from WalkingStick's career that specifically treat themes of Native American art, history, and ethnic identity. The first group was made between 1975 and 1978 while Walking-Stick was enrolled in the MFA program at Pratt Institute of Art in Brooklyn, New York. Comprised of well-known works such as *Message to Papa* and *The Chief Joseph Series*, these artworks function as personal acts of self-discovery generated by Walk-ingStick's attempt to reconnect with her Cherokee ancestry as well as more generalized concepts of American Indian identity. The second body of work was made between 1991 and 1995. In these works of art, most of which were made to occasion the events surrounding the 1992 Quincentenary, WalkingStick uses depictions of the earth to bring attention to themes of genocide, historical loss, the sacredness of the earth, and postcolonial identity.

The youngest of five children, WalkingStick was born to a Scottish-Irish mother, Emma McKaig, and a Cherokee father, Ralph WalkingStick, Jr. (a descendent of the Ridge family lineage). Before her birth, WalkingStick's mother left her abusive, alcoholic husband and moved with the children from Oklahoma to Syracuse, New York, where the artist was brought up in a white, urban, Protestant environment. "Although I never knew my Cherokee father," explains WalkingStick:

> I have a Cherokee name, and my mother reminded me daily, with pride, that I am an Indian. There were no other Indians that I knew in Syracuse, but my mother talked often about her experiences in Oklahoma and our Cherokee relatives there. I was not raised in Indian culture, so I'm not bicultural, but I do think of myself as a biracial woman. (Swenson, Smith, & Arbeiter, 1999, p. 213)

Throughout WalkingStick's upbringing, her mother sought to instill a sense of pride in her about her absentee father as well as her Cherokee ancestry. Although this had a tremendous impact upon WalkingStick's self-conception, as she recalls

always being aware that she was Indian, she did not have an experiential basis to inform her views about what it meant to be an American Indian.

In 1969 a group of approximately 78 Native American urban leaders and college students took over and occupied the abandoned federal prison on Alcatraz Island in the San Francisco Bay for a period of 19 months. Adopting the name Indians of All Tribes, the group drafted a public proclamation demanding title to the land for a proposed five-building complex containing a Center for Native American Studies, an Ecology Center, a Spiritual Center, a Training School, and a Museum. Although the participants in the seizure of Alcatraz failed to secure the terms of their stated agenda, the occupation became, in the words of one historian, "a fulcrum, a turning point" for Native American activism and cultural renewal (Smith & Warrior, 1996, p. 37). This event caused an upsurge in American Indian activism (known as the Red Power movement) and helped inaugurate a rebirth of Indian nationalism rooted in concepts of inter-tribalism, or what Stephen Cornell (1988) has termed "supratribal" identity, especially among the younger generation of urban, college-educated Native Americans (pp. 106–127). Although disconnected from her Cherokee heritage at the time, WalkingStick was, nonetheless, moved by the growing litany of Native leaders whose voices helped foster a renewed sense of pride in being Indian. After Alcatraz, WalkingStick recalls that working artists such as herself decided "it was time to take a stand and to address our Indian heritage in our work and lives" (WalkingStick & Marshall, 2001, p. 40). This, in conjunction with the 1969 death of her father, prompted WalkingStick to investigate and reconnect with her ethnicity and Cherokee family history in order to garner a greater sense of what it meant to be Indian—filling what sociologist Joane Nagel calls the "ethnic void" by reestablishing a connection with one's ethnic ancestry and one's tribal community (Nagel, 1997, p. 10).

Initially, WalkingStick's quest for self-discovery and cultural renewal was part of a drawn-out, painful process of atonement and reconciliation with her father that began in 1974 with the creation of *Message to Papa*. She constructed *Message* from pieces of canvas sewn together by hand and draped over wooden supports in a conical shape, forming a small tepee in which she alone could sit. Aware of the indexical potential of Indian imagery, WalkingStick chose to work with a tepee, a generic symbol of "Indianness," for the purpose of confronting Indian stereotypes, addressing her status as an "outsider," and reconnecting with her ethnicity. Although the Cherokee did not live in tepee dwellings, the image of the tepee is the ubiquitous icon that WalkingStick identified with outside "white views" about Indian identity and lifestyles—views that she shared having been brought up without an experiential basis to inform her concept of Cherokee identity (Abbott, 1994, p. 272). The outside of the tepee was stained and spattered with blue, hot pink, and purple acrylic paint and encircled with two large bands of black fabric, symbolic of the

black armbands worn by mourners or funeral attendants. The interior of the tepee contained feathers, strips of paper inscribed with repeating lines from a Christian prayer called The Lord's Prayer, and segments of a letter written by the artist to her deceased father. The entire sculptural installation was produced in a manner described by WalkingStick as ritualistic, "a personal rite of passage" through which she expunged the pain and anger of her childhood and confronted the tension surrounding her families' history, her father, and her heritage. *Message* is a symbolic burial ritual, an altar commemorating her father's memory, and a peace offering.

Message to Papa addressed WalkingStick's mixed feelings toward her father as well as her own beleaguered sense of Native identity. The internal conflicts WalkingStick initially experienced regarding her identity set her on a path of self-inquiry and made her sensitive to debates about Native American art and identity, as well as questions about the authenticity of that identity, often disputed on the basis of blood quantum, residency (were you born on or do you live on a reservation), or degree of knowledge and experience with tribal practices (Fisher, 1992, pp. 44–50). As a result, WalkingStick has always been careful to maintain that she is biracial and not bicultural, thereby acknowledging the importance of experiential components in the fabrication of a specifically cultural or ethnic identity. In the process of reconstituting her ethnic identity, WalkingStick also acquired a sense of responsibility and commitment to the Native American community at large, a purposeful and political decision that would have a lasting impact on her career. As WalkingStick stated, "I made a political choice to show with Native people and paint about Native people. I didn't just fall into it. I chose to deal with this Native heritage…" (K. WalkingStick, personal communication, July 18, 1999). As WalkingStick became active within a larger collective of Native American artists, she participated regularly in exhibitions and symposia focusing solely on American Indian art in the years leading up to the Quincentenary. By the early 1990s WalkingStick was recognized as a leading artist within the contemporary Native American art scene and the academic community at Cornell University where she was a professor of Art.

For most European Americans, the Quincentenary unproblematically commemorated Columbus's discovery of the Americas and thus the beginning of North America's history (Summerhill &Williams, 2000). For the Native American community, however, it was time to politicize and publicize the devastation and destruction that the last 500 years had brought to the indigenous populations in the land colonized by Columbus and consequently Europe. An enduring legacy of the colonial process inaugurated by Columbus with the birth of the misnomer "Indian" is the concept of fixity in the ideological construction of otherness. The desire for an original, autonomous idea of "Indianness" within a pure context requires that an exclusive set of selective criteria be maintained; these criteria are often prone to

idealization and narrative utopia or nostalgia. The nostalgic myth of contact and authentic presence is a "social disease," claims Susan Stewart (1993), a "sadness which creates a longing that of necessity is inauthentic because it does not take part in lived experience" (p. 23).

Message to Papa is a work that confronts and ultimately resolves the tensions surrounding WalkingStick's biracial identity, her distance from tribal or cultural practices growing up, and the impact of non-Native romantic and stereotypical views upon conceptions of "authentic" Indian identity. Countless artists such as Fritz Scholder, Jimmie Durham, Richard Ray Whitman, and James Luna, to name a few, have dealt with similar issues in their work, using art making as a performative act of self-identification. As the Cherokee artist, activist, and poet Durham states, "One of the most terrible aspects of our situation today is that none of us feel authentic. We do not feel that we are real Indians…. For the most part we feel guilty, and try to measure up to the white man's definition of ourselves" (Durham, 1983, p. 84; Fisher, 1992, p. 46). James Luna's 1992 photographic essay in *Art Journal* entitled "I've Always Wanted to Be an American Indian" challenges the Noble Savage trope with images and statistics that force viewers to look at who real Native people are today. In Luna's work he presents a detailed account of life on the La Jolla Reservation in southern California through photographs depicting the everyday (ranging from images of children to that of dilapidated buildings) and a barrage of statistical facts such as the size and population of the reservation, the number of murders and cases of disease, and the description of the education levels and jobs of the residents. The facts paint a grim if not sobering portrayal of life on the reservation. In closing he states:

> There is much pain and happiness, there is success and there is failure, there is despair and there is hope for the future. Still I would live no place else because this is my home, this is where my people have come. I also know that this place, like other places, is the reality that we Indians live; this is it. This isn't the feathers, the beads of many colors, or the mystical, spiritual glory that people who are culturally hungry want. Hey, do you still want to be an Indian? (Luna, 1992, n.p.)

In similar ways, the constructions of national or cultural narratives seek as their end goal to inculcate a sense of communal identity through the idea of shared histories, values, and knowledge. Memory, both the process of remembering and forgetting, plays a critical role in the definition of any collective (Anderson, 1991, pp. 187–206). Unwilling to forget the past or ignore the process of mythmaking, both of which are intricately connected to the definition and self-understanding of American Indians today, an elaborate ceremony of memory was proposed by the

1992 Alliance. The 1992 Alliance, created under the auspices of the national Circle of Elders (a network of traditional people from over a dozen Native nations), was a network of Native American organizations and individuals organized in 1990 to ensure that there would be a Native American context during the Quincentenary. The 1992 Alliance met in Washington, D.C., in September 1990, at which point Suzan Shown Harjo, National Coordinator of the Alliance, stressed the "need for Indian people to have a contemporary identity in the public consciousness of this country" (Barreiro, 1990, p. 16). At a 1991 conference the group identified one objective as being the need to develop a "national media campaign that will create awareness of Native values, change negative stereotypes about Indians, and encourage people to act to perpetuate Indian values" (p. 15). Other concerns such as religious freedom and environmental issues were also part of the Indian response to the Quincentenary (Barreiro, 1990, p. 16). In addition, organizations such as the Submuloc Society (Columbus spelled backward), founded by Susan and Kathryn Stewart and Corwin Clairmont in Bozeman, Montana, organized an exhibit to present the Indian response to the "landing of Christopher Columbus" (Roberts, 1992, p. iii), a response that was made strikingly clear in the opening curatorial statement by Jaune Quick-to-See Smith, who wrote, "Columbus personally began one of the world's major holocausts.... Conservative estimates are that 11 million people died brutally in the mass genocide in the New World.... American Indians are alive and well. May their voices ring throughout the land!" (Roberts, p. iii).

For her part, WalkingStick created several works of art that memorialized the past by honoring the dead as well as the contemporary realities of the living. She specifically treats the subject of genocide in three works of art, a 1991 painting and a sculpture called *Where Are the Generations?* and *Tears* respectively, and the 1992 artist's book entitled *The Wizard Speaks, the Calvary Listens, December 29, 1890.* *Where Are the Generations?* a large, two-paneled painting in which WalkingStick combines a representational landscape image with an abstract form. On the right half of the painting WalkingStick depicts a barren landscape comprised of rugged mountain ranges above arid passages of earth, in this case a dry riverbed containing little vegetation. The ominous appearance of the black sky is contrasted by the luminous glow emitted by the moon above, which appears to illuminate a pathway along which viewers may conceptually enter the landscape stretched out before them. WalkingStick's loose, gestural paint-handling style accentuates the formal properties of oil paint, both the fluid material properties and liquid surface sheen, and thereby communicates an eerie sense of calm and serenity that belies the harsh reality of the environment depicted.

Meanwhile, the dry, coarse, minimalist character intrinsic to the desert lands is physically transcribed in the opposing non-objective panel, which contains an oxidized copper disc set within a dense field of tactile cobalt blue, black, and red

acrylic paint mixed with cold wax. The iconic circular form is surrounded by heav-
ily worked layers of thick, viscous paint, the surface of which is agitated by scratch
marks that radiate around the circle and produce a visual, kinetic energy that pul-
sates outward from the circle. Across the upper half of the copper circle is a re-
poussé text that reads: "In 1492, we were over 20 million. Now we are 2 million.
Where are the children? Where are the Generations? Never born." *Tears*, the small
sculpture made to accompany *Where Are the Generations?* is fashioned to look like
a corpse resting upon a funeral scaffold. The corpse-like bundle is comprised of
corn, lithic tools, turquoise, and pieces of pottery made by the ancient Anasazi cul-
ture, wrapped in deerskin. Thin strips of leather ornamented with feathers and
beads hang from the wooden scaffold, which rests upon a wooden base covered
with black suede and a copper plate. The copper plate contains the same text used
in the painting described above; both contain WalkingStick's name written in
Cherokee below the inscription.

Between 1975 and 1978 WalkingStick produced a series of paintings dedicated
to deceased, historically significant, male Indian leaders such as Chief Joseph and
John Ridge. *Message to Papa* and *The Chief Joseph Series* demarcate WalkingStick's
attempts to reconnect with her ethnic heritage by memorializing and mourning
the death of her biological father as well as the cultural heroes—surrogate fa-
thers—of Native American history. If mourning represents an active process of
working through the pain of loss in order to overcome melancholic longing for the
lost object of love, then WalkingStick's early artworks, symbolic conversations
with the past and the dead, allow her to come to terms with a sense of personal
loss, as well as a larger cultural loss, thereby making it possible for her to recuper-
ate a heritage otherwise lost to her through time and circumstance. Now, more
self-assured and more comfortable with her Cherokee identity, WalkingStick
memorializes the past and the dead, while simultaneously projecting herself into
this larger history and heritage. "If the native people of the Americas had multi-
plied as the people of other nations have we would now still fill this continent,"
explains WalkingStick, "but we do not. Genocide happened here and this paint-
ing made on the eve of the Columbian Quincentenary is about that horrific fact"
(Broder, 1999, p. 268). In *Where Are The Generations?* and *Tears*, WalkingStick
mourns the dead as well as the unborn.

In many of the works of art made for the Quincentenary, WalkingStick medi-
ates death and loss, both the losses of life and land, as social acts. She focuses upon
land in order to underscore the fact that the fight for land and natural resources
shaped the history of Indian-white relations, and still does to this day, providing the
justification for the deaths of over a half million American Indians (Thornton, 1984,
pp. 500–502). One of the reasons WalkingStick uses copper in *Tears* and *Where Are
the Generations?* as well as in other paintings, including *Night* (1991), *Ourselves/Our*

Land (1991), and *Magical Day* (1991), is to serve as a reminder that the exploitation of natural resources was a motivating factor in the appropriation of tribal lands by the United States, and ultimately caused the death of many American Indian people. She has also written that another reason is that many children in public schools make copper cut-outs of Indian heads as part of their education about American Indians, which contributes to stereotypical views of Native peoples (K. Walking-Stick, personal papers, n.d.). In the text incorporated in *Where Are the Generations?* cited above, WalkingStick verbally identifies the existence of cultural genocide in America's history by citing the staggering number of deaths that occurred as a result of European contact, as well as the contemporary consequences of genocide, so that the loss can be properly worked through and overcome. Alongside the textual account, WalkingStick depicts an arid, desolate landscape in order to underscore the grim reality expressed by the statistical facts. However, this image is not entirely devoid of life, either. Although the sagebrush dotting the landscape read as tombstones, they also represent life and the earth's as well as human cultures' remarkable ability to sustain life even under the harshest of conditions.

Where Are the Generations? is also part of a larger aesthetic project that WalkingStick has been involved with for over a decade concerning the complex interrelationships among time, the earth, human existence, and spiritual transcendence. When WalkingStick first began using the diptych format in 1985, she combined two apparently unrelated aesthetic styles, realism and abstraction, in order to initiate a dialogue between different forms of cognition and existence, which she saw as interconnected. WalkingStick compared the relationship between the panels to short- and long-term memory. The naturalistic images represented immediate visual perceptions, like snapshots that the artist equated with ephemeral, time-bound mental pictures inscribed through memory. The non-objective panels were considered commensurate with long-term memory, something that spans time and is therefore enduring and all encompassing. Despite the stylistic differences, the panels were understood as equal parts of a whole, extensions of one another that, when viewed together, treated the earth, history, time, and life as existing along a continuum. In the paintings made for the Quincentenary, WalkingStick uses circular motifs to express this idea of a continuum.

In *Where Are the Generations?, Night,* and *Ourselves/Our Land* the circles and oval depicted in the left panels, in addition to the portion of a circle rendered in the left panel of *Magical Day*, symbolize concepts of cyclical time where past, present, and future overlap and are compressed, as does the continuum of life epitomized by the cycles of nature, birth, death, and rebirth. These paintings express "the long term importance of the earth to us, to our ancestors, our progeny and ourselves," explains WalkingStick (K. WalkingStick, personal papers, n.d.). "It is the earth that I want to be everlasting" (Nilson, 1991, p. C1). In *Night* the abstract panel also con-

tains a vertically aligned, almond-shaped form superimposed over the circle. The oval or almond-shaped form is a mandorla symbol, which WalkingStick identifies as related to both Native American concepts of Mother Earth and Judeo-Christian images depicting the Virgin Mary (K. WalkingStick, personal papers, n.d.); it, too, alludes to fertility, the life-giving properties of the earth and its importance for human survival. "The key is that the Earth is sacred," explains WalkingStick. "Those of us that are Native American talk about it. Those who are not don't talk about it, but believe it anyway" (Nilson, 1991, p. C1).

During the Quincentenary numerous American Indian and First Nations artists made works of art dealing with the subject of land loss and the forced removal of indigenous peoples from tribal homelands, a routine event throughout colonial history (Jaimes, 1992; McDonnell, 1991), and more specifically the connection between place/land, historical memory, and cultural identity. In Metis artist Eric Robertson's 1990 mixed-media installation entitled *Bearings and Demeanours*, ravens' beaks and potlatch hats made of copper are mounted on a wall in the top half of the work; they illustrate the inseparability of land from place, events, religion, and social identity in Northwest Coast Indian culture. Below them appear pinching collars and a surveyor's table etched with the surveyor's measures (1 Square Chain = 66 Feet). The comparison is meant to highlight the "contrasting structures and dynamics of land use" between non-Western and Western culture, writes Robertson (McMaster & Martin, 1992, p. 178). In the one we see land as a place connected to lives and events in tangible ways that reinforce the union between land and people. This connectivity between land and people epitomizes "landbase," what Seneca/Tuscarora artist George Longfish and critic Joan Randall defined as "the interwoven aspects of place, history, culture, physiology, a people and their sense of themselves and their spirituality" (Ward, 1990, p. 10). In the example denoted by the collars and surveyor's measures, land does not imprint a people with cultural identity, but rather is molded and stamped by that culture. Land is, in Robertson's words, a "container" that can be "emptied and filled" (McMaster & Martin, 1992, p. 178). In the latter, land is—as Robertson states—removed from the "experience of time, space and events" (McMaster & Martin, 1992, p. 178). It is merely a resource for human use. Visual artists are not the only ones to have commented about this link between people and place. Native American author N. Scott Momaday drives the point home when he writes, "The events of one's life take place, *take place*...they have meaning in relation to the things around them" (Ward, 1990, p. 10).

Cheyenne-Arapaho artist Hachivi Edgar Heap of Birds has also expressed his personal relationship to land—beginning with the homeland near his Arapaho great-grandmother Nancy North's house, in Oklahoma—in an ongoing series of abstract paintings entitled the *Neuf* Series (Heap of Birds, 2008, p. 31). Perhaps

more noteworthy, if anything because they are more blatantly political, are his textual drawings/paintings and his site-specific public signage works that force viewers to remember that white culture dominated American Indian culture through land dispossession, forced relocation, and assimilation. Of his political art, Heap of Birds states that the primary function is protection. In the same way a Cheyenne cradle board's key purpose is protecting the child (everything from the shape to the symbols), so too his text offers the same protection for Native peoples (Otis College, 2008).

Born in Wichita, Kansas, Heap of Birds is a headsman in the Elk Warrior Society of the Cheyenne-Arapaho nation. After studying at the Royal College of Art in London, he received his MFA in Painting from the Tyler School of Art, Temple University, in 1979. Like WalkingStick, some of his earliest and most significant work was inspired by his relationship not only to Native history, but also to family history. In 1979 he created *Fort Marion Lizards* as part of his MFA thesis show. Inspired by the ledger art created by the Arapaho and Cheyenne warriors incarcerated at Fort Marion, Florida, in the 1870s, *Fort Marion Lizards* is comprised of both English and Cheyenne words. A key step in the assimilation process was the eradication of tribal/cultural identity through language, oftentimes beginning with the imposition of English names. The image contains a list of the names of the prisoners of war and the four principal chiefs, whose names appear in red, like his great-grandfather Chief Many Magpies. Colonel Richard Henry Pratt, the man in charge at Fort Marion, changed Heap of Birds's family name from the Cheyenne Hachivi (Many Magpies), which he could not pronounce, to the English name Heap O' Birds and later Heap of Birds (Otis College, 2008; Rushing, 2008, p. 70). Superimposed over the list of prisoners' names, the words "English Words" and "Indian Prisoners" appear in bold, large text. As Heap of Birds points out, these Cheyenne and Arapaho men were given English names and yet they could not speak English; they were trapped and imprisoned by language (Otis College). Heap of Birds's work symbolically reclaims, as he states, the power of language.

In the 1989 serigraph *Telling Many Magpies*, Heap of Birds further demonstrates the influence of language to not only naming, but also ideas about cultural identity and ownership. In this work the artist derides popular cultures' appropriation of Indian names and images (as is the case with sports team mascots) at the expense of acknowledging and respecting living Indian people. To underscore this point Heap of Birds places the word NATURAL spelled backward across the top, as if to say the whole process of commercializing American Indian culture through racial stereotyping is unnatural.

Elsewhere Heap of Birds incorporates words spelled backward to encourage viewers to read backward in history, as is the case in the 1988/1997 *Reclaim New York* sign installation project where state names, spelled backward, are followed by text

acknowledging the indigenous owners from whom the land was coerced. All of these issues (the impact of language/naming, cultural appropriation, commerce, and land loss) come together in the 1990 signage project *Building Minnesota*. Commissioned by the Walker Art Center in Minneapolis, the installation was comprised of 40 metal signs with red letters bearing the names (in English and Dakota) of the 40 Dakota men, prisoners of war, who were hung by executive order for the role they played in the Dakota-U.S. conflicts of 1862 and 1865. Initially installed in the commercial district along the Mississippi River in Minnesota, this work uses language to honor (literally with the words HONOR) and memorialize the dead, and by implication the living, in public signs whose presence in a public economic space intervenes in our knowledge of and recollection of history in general, and also the specific history of Indian-white relations in that locale.

In 1992 WalkingStick produced a book entitled *The Wizard Speaks, the Cavalry Listens, December 29, 1890*. It, too, underscores languages' ability to shape peoples' attitudes and their perceptions about people, events, and history. WalkingStick's book refers to the tragedy known as the Wounded Knee Massacre, which occurred at Wounded Knee Creek near the Pine Ridge Reservation in South Dakota in 1890, where soldiers from the Seventh Cavalry killed 340 members of Big Foot's band of Minniconjou Sioux (Joesephy, Jr., Thomas, & Eder, 1993; Brown, 1970, pp. 439–450). WalkingStick's book is constructed of four wood panels measuring 11 by 12 inches each. The panels are connected by pieces of a fabric belt stained red. On one side of the panels black, blurred figures are depicted against sullied white backgrounds. Rendered in oilstick on canvas, the images are based upon historic photographs taken by photographers George Trager and Clarence Grant Morledge in the aftermath of the massacre (Fleming & Luskey, 1986/1992, p. 48; Carter, 1991, pp. 38–60). Their photographs document a gruesome scene wherein the majority of unarmed Sioux, mostly women, children, and the elderly, lay dead, killed indiscriminately by soldiers who fired upon them with guns and four hotchkiss canons as they fled for safety. In the days following the event a heavy snowstorm blanketed the area, creating an eerie frozen scene as the wounded and dead Sioux were left lying in the field until January 1, 1891, at which time they were buried in a mass grave (Carter, 1991, p. 49). Although two of the four images depict non-descriptive shadowy black corpses, the central two images are more specific: they represent the majority of Sioux victims—women, children, and elderly men. The panel left of center depicts what is presumably a female figure lying with her arm around the bundled body of a small baby. The other image, rendered in the panel to the right of center, is clearly based on well-known historic photographs taken by both Trager and Moreledge, depicting Chief Big Foot lying dead in the snow wearing a scarf tied around his head and a tattered overcoat (Carter, 1991, pp. 38–60). The reverse sides of WalkingStick's four panels are covered in copper and stamped with text drawn from an

editorial statement by L. Frank Baum, author of *The Wonderful Wizard of Oz*, which was published in the *Aberdeen Saturday Pioneer* newspaper in South Dakota 9 days before the massacre took place. In Baum's essay he argues against assimilation, calling instead for the "total annihilation" of all Native Americans:

> The Whites, by law of conquest, by justice of civilization, are masters of the American continent, and the best safety of frontier settlements will be secured by the total annihilation of the few remaining Indians. Why not annihilation? Their glory has fled, their spirit broken, their manhood effaced; better that they should die than live the miserable wretches that they are. History would forget these latter despicable beings, and speak in latter ages of the glory of these grand Kings of the forest and plains that Cooper loved to heroism [sic]. (Baum, 1890, n.p.)

Using language, both written text and oilstick paintings loosely based upon the photographs taken of the massacre site, WalkingStick revises the narrative of conquest and raises questions regarding the documentary truth inscribed in the historical record. The photographs taken by Trager and Moreledge were made for commercial purposes, created and mass marketed to satisfy a nation craving news about the "Indian crisis" of 1890–91 (Carter, 1991, p. 44; Fleming & Luskey, 1986/1992, p. 48). Often published and sold as a narrative series, photographs like the ones taken at the Wounded Knee massacre site, along with photographic portraits of well-known military figures and Indian leaders, transformed tragic events like Wounded Knee into historical memory. Brief captions identifying the contents of the photograph were frequently added in order to condense narrative and assert direct linguistic controls that would influence the process of reading and interpretation (Edwards, 1992, pp. 8–11; Sandweiss, 1991, p. 117). Trager's captions are simple and to the point; they read "Burial of the Dead at the Battle of Wounded Knee S.D." or "Bird's Eye View of Battlefield at Wounded Knee S.D. Looking North." Trager's text places his images within the context of Indian massacres and white battles scenes, events that the art historian Julie Schimmel argues were considered standard for representing the invented Indian so important to the mythology of western expansion and settlement. Understood in this context, frontier photographs like the ones WalkingStick appropriates functioned as metaphors for the struggle between civilization and savagery (Schimmel, 1991). However, WalkingStick does not include Trager's more benign text. Instead, she incorporates the inflammatory editorial passage written by Baum, whose callous comments inciting murder and genocide now offend our contemporary sensibilities, in order to instigate a critical re-evaluation of the civilization-savagery metaphor as well as the social attitudes and government policies it represents. She also raises questions

regarding the ideology of social progress, which supported the colonial enterprise and provided justification for such tragic events. By reproducing historic photographs and juxtaposing them with Baum's historic text, WalkingStick also interrogates the paradox of reality involved in the equation between photographic representations as documents of historical truth. In comparison to the photographs, which freeze the victims in place and time and compel sentimental reverie and melancholy through distance, WalkingStick's illusory representations bring them back to life while simultaneously canceling nostalgic desire. The physicality of paint and the look of handedness present in this work of art evoke a palpable human presence not found in the cool-objective, documentary eye of the journalistic photographs and text that identifies these images of death and absence.

WalkingStick was not the first or the only artist to confront colonial history generally, and more specifically the events of Wounded Knee. The Kiowa artist T.C. Cannon (1946–1978) was haunted by the same Trager photograph of Big Foot lying dead and frozen in the snow; he reworked the photograph in more than a dozen drawings, an oil painting, and one sculpture (Wallo & Pickard, 1990, pp. 94–96, 103). Metis artist Rick Rivet also produced several gestural figurative paintings in 1991 entitled *Wounded Knee #1* and *Wounded Knee #2*, which were exhibited in the 1992 *Indigena* exhibit. In the latter work of art Rivet reworks Trager's photograph depicting the burial of the Indian dead in a mass grave surrounded by civilian and U.S. military figures by adding Nazi officers, Spanish conquistadors, Canadian Mounties, Rough Riders, and Ku Klux Klan members to the gruesome scene of onlookers. In Rivet's painting only some of the figures address America's colonial past, but all represent perpetrators of racial intolerance and oppression, which has been the foundation for many nationalist and colonialist projects. He states:

> The U.S.A.'s policy of Manifest Destiny in the early nineteenth century implied Europeans and descendants were ordained by destiny and God to rule all of America. This was further justification for encroachment on Native life, land, and culture based on the tradition started by Columbus, and followed by the Spanish, English, French and Dutch. The Americans, like their predecessors, used this logic to justify the destruction of Aboriginal peoples. (McMaster & Martin, 1992, p. 175)

Rivet's and WalkingStick's paintings further identify the loss of life that occurred among aboriginal peoples as a result of colonialism and the Columbian legacy as genocide, comparable to the Holocaust.

If revising history has remained high on the list of topics addressed by today's indigenous artists, the identity of American Indian and First Nations art remains a close second. What is at stake are the classifications and standards (epitomized

by terms like traditional versus modern and questions of authenticity based upon one's blood quantum, relationship with a reservation, and degree of "traditional" elements in the work) that have come to define Native art by the non-Native outsider, and their continuing impact on the production and reception of contemporary indigenous art. Any artist of European-American descent can produce work about their ethnic heritage without having to prove it is authentically Irish or Italian. For this reason it was equally important for artists involved in the Quincentenary to remind viewers that not only were Native people still here, but they are living descendents of vibrant, active cultures.

In 1993 WalkingStick made an 18-page book entitled *Talking Leaves*, which deals with stereotypes and prejudicial attitudes regarding American Indian art and identity. Throughout the book WalkingStick pairs portraits of herself, shown at different times in her life, along with racially biased or culturally insensitive statements. The content of the remarks ranges from those questioning the authenticity of her Cherokee identity to those that ridicule her ethnicity. Behind and below the portraits exist horizontal friezes containing depictions of corn, water serpents, and rainbow motifs, images of Cherokee clan symbols, and WalkingStick's paintings. Together the symbolic motifs, paintings, and portraits communicate a narrative of WalkingStick's life, addressing in particular her identity as an artist of Native American descent.

The imagery contained in the friezes and the self-portraits is rendered in a well-known type of painting, the "Santa Fe Indian Style." That style was introduced in the Santa Fe area around 1910–1930 by a handful of artists from the pueblos of Cochiti, San Ildefonso, Zia, and Hopi working in a manner referred to as modern Pueblo Indian easel painting. Artists like Fred Kabotie, Velino Shije Herrera, Julian Martinez, Tonita Peña, and Alfonso Roybal were some of the first Pueblo artists to work in a new mode of watercolor painting, developing a distinctive, common style characterized by the use of outlined figures, flat colors, extensive detail with some modeling, and a lack of ground lines and atmospheric perspective. Their stylistically similar works of art depicted scenes of daily life and ceremonial dances, decorative compositions of animals and figures, and scenes of abstract, stylized landscape motifs. Throughout the 1940s and 1950s this style of painting became institutionalized through the government-sponsored arts education program at the Santa Fe Indian School, also known as the Studio, run by European American teacher Dorothy Dunn (Brody, 1971, 1992; Dunn, 1968). This style of painting was considered the standard aesthetic model for modern American Indian painting well into the 1970s. Indian artists whose artwork diverged from this model/style, like Oscar Howe, were often labeled inauthentic or not Indian artists (Archuleta & Strickland, 1991; Brody, 1971, 1992; Dunn, 1968; Gritton, 2000). WalkingStick copies the look of the Santa Fe Indian style and appropriates the symbolic motifs in what

she terms a "gentle parody" of the aesthetic as well as the era that produced it (K. WalkingStick, *Talking Leaves* book, a statement, n.d.).

The title of WalkingStick's book pays homage to a pivotal figure in Cherokee history, a man named George Geist, also known as Sequoyah, whose translation of the Cherokee language into an 85-symbol syllabary contributed to the rapid spread of literacy among the Cherokee Nation in 1821 (Fogelson, 1996, pp. 580–582). "Talking leaves" is the term Sequoyah used when referring to English written texts. WalkingStick's use of this term, as well as her incorporation of both the written English language and the Cherokee syllabary in *Talking Leaves*, engages the power of language and linguistic inscription in her interrogations of postcolonial subjectivity. WalkingStick's book of "talking leaves" offers subtle parodies of both the visual and verbal languages employed and, as a consequence, also addresses the misconceptions they have fostered and continue to communicate regarding contemporary Native American art and identity.

Talking Leaves is comprised of three types of imagery: equal-armed crosses embedded within thick encaustic, the verbal statements written or etched into dense layers of oilstick, and self-portraits rendered in gouache on paper. The portraits are shown on the right, surrounded by motifs with autobiographical significance through which the artist engages in an ethnic and artistic (re)presentation of self. On the left, WalkingStick records comments people have made to her over the years reflecting the misconceptions widely held about American Indian people in general. For instance, on page 8 a yellow text, which reads, "You're not an Indian. You weren't born on a reservation," is incised into a bright red background. The text is juxtaposed with a portrait of WalkingStick shown with her long black hair pulled back into a ponytail, wearing a black cowboy hat ornamented with a beaded headband, a turquoise necklace, and feather-shaped earrings. Behind WalkingStick's image, she depicts a variety of dwellings that include a row of geometrically simplified tepees below a slightly larger frieze in which she portrays four houses representing a pre-contact Cherokee dwelling, the old WalkingStick family cabin near Talequah, Oklahoma, the house in which she raised her family in Englewood, New Jersey, and her residence in Ithaca, New York, near the campus of Cornell University. WalkingStick's depictions of various homes that either she or her siblings inhabited, and that the Cherokee people in general would have lived in, challenges the stereotypical assumptions asserted by the statement quoted on the left—that all Indian people live in tepees and were born on reservations.

In the image shown on page 10, WalkingStick provides a portrait of her mother along with symbols denoting the seven Cherokee kinship clans (bird, wolf, red paint, wild potato, deer, blue, and twister). She also includes two Zuni-style bears, cultural symbols specific to the Zuni Pueblo Indians from New Mexico. She incorporates the bear images out of respect for her mother, who mistakenly believed

that the WalkingSticks were members of the bear clan, which is not actually part of the Cherokee clan system (K. WalkingStick, *Talking Leaves* book, a statement, n.d.). In conjunction with the image of her mother, who was instrumental in instilling her children with a sense of pride in their American Indian identities despite a cultural climate that insisted otherwise, WalkingStick includes this statement: "You're an Indian? So what can you say in Indian—'Where's the nearest bar?'" In another self-portrait, WalkingStick is shown wearing a cowboy hat and turquoise jewelry while behind her hang three of her paintings that are part of major museum collections. These paintings testify to WalkingStick's role and status as an artist and also reveal her stylistic and conceptual engagement with modern and postmodern art strategies as well as her training and participation in mainstream art institutions. The final self-portrait, which appears on page 18, is a contemporary image of the artist. In it WalkingStick gazes out from beneath a wide-brimmed hat, staring with an air of confidence and self-determination that is corroborated by the text surrounding her portrait. In her own words written in the Cherokee language, WalkingStick proclaims, "I am the Grandmother. I am Kay WalkingStick. Of the people Cherokee." Unlike the other self-images, this portrait is not rendered in the Santa Fe Indian School style but handled naturalistically using conté crayon. The defiant stare with which WalkingStick looks out at the viewer summarizes her stance on many issues pertinent to racist stereotypes about Native American art and identity raised here, to which she emphatically declares in the statement written on the facing and final page, "Enough."

To some extent one could argue that all Native American and First Nations art is activist. Whether or not indigenous artists use their work to treat issues pertaining to their native heritage or pointedly avoid creating work that announces racial ties (an attitude often verbalized in phrases like, "I'm an artist first"), the work engages with the politics of representation and as such challenges stereotypes about cultural identity and art. At the same time the work often addresses a long history of protest and resistance involving self-determination and tribal sovereignty, economic rights to land and resources, and spiritual or religious freedom. The 20th century is marked by numerous events and legislative policies concerning education, fishing rights, land claims, art, and culture. These have included but are not limited to the Indian Self-Determination and Education Assistance Act, 1975; the Alaska Native Claims Settlement Act, 1971; the Native American Languages Act, 1990; the American Indian Religious Freedom Act, 1978 and 1994; the Native American Graves Protection and Repatriation Act, 1990; the Indian Arts and Crafts Act, 1990 (Jaimes 1992; Josephy Jr., Nagel, & Johnson, 1999; Smith & Warrior, 1996); and the 1992 Columbian Quincentenary, possibly one of the most significant events in the last two decades because of its far-reaching impact on Native and non-Native peoples alike.

The activities, publications, and exhibitions organized for the Quincentennial highlighted the current conditions under which American Indian people struggle to live. They also served as a means of revising the past and reclaiming identity (artistic and cultural) in a postcolonial era. However, to accept any of the artists' work discussed here as emblems of Native American subjectivity is to risk validating the construction of idealized narratives of both ethnic art and identity. As Theodor Adorno warns, "the ideal (national/cultural) suffers at the expense of the idealization. The fabrication of national collectives…is the mark of a reified consciousness hardly capable of experience. Such fabrication remains within precisely those stereotypes which it is the task of thinking to resolve" (Rogoff, 1991, p. 197). Any discussion of contemporary Native American and First Nations art entails a tricky maneuver, requiring the insertion of greater specificity so that the artists can be seen as more than ciphers for American Indian cultural identity, while simultaneously acknowledging the appeal and weight of concepts of "Indianness." Individual artistic contextualization foregrounds the ideological and aesthetic complexity of contemporary Native American art and, in particular, the empirical realities and hybrid histories of its practitioners, which are very often already hinted at in the way artists assess and negotiate their identities as WalkingStick did in stating, "I am a Christian, but I pray to the four directions" (K. WalkingStick, personal communication, July 17, 1999).

References

Abott, L. (1994). *I stand in the center of the good: Interviews with contemporary Native American artists.* Lincoln: University of Nebraska Press.

Anderson, B. (1991). *Imagined communities: Reflections on the origin and spread of nationalism.* London and New York: Verso.

Archuleta, M., & Strickland, R. (1991). *Shared visions: Native American painters and sculptors of the twentieth century.* Phoenix, AZ: Heard Museum.

Barreiro, J. (Ed.). (1990, Fall). View from the shore: American Indian perspectives on the quincentenary. *Northeast Indian Quarterly,* 1–109.

Baum, L. Frank (1890, December 20). Editorial. *Aberdeen Saturday Pioneer,* Aberdeen, South Dakota.

Broder, P.J. (1999). *Earth songs, moon dreams: Paintings by American Indian women.* New York: St. Martin's Press.

Brody, J.J. (1971). *Indian painters and white patrons.* Albuquerque: University of New Mexico Press.

Brody, J.J. (1992). *A bridge across cultures: Pueblo painters in Santa Fe, 1910–1932.* Santa Fe, NM: Wheelwright Museum of the American Indian, 1992.

Brown, D. (1970). *Bury my heart at Wounded Knee: An Indian history of the American West.* New York: Henry Holt.

Carter, J.E. (1991). Making pictures for a news-hungry nation. In *Eyewitness at Wounded Knee.* Lincoln: University of Nebraska Press.

Cornell, S.E. (1988). *The return of the Native: American Indian political resurgence.* New York and Oxford: Oxford University Press.

Dunn, D. (1968). *American Indian painting of the Southwest and the Plains areas.* Albuquerque: University of New Mexico Press.

Durham, J. (1983). *Columbus Day.* Minneapolis, MN: West End Press.

Edwards, E. (1992). *Anthropology and photography.* New Haven, CT: Yale University Press.

Fisher, J. (1992). In search of the "inauthentic": Disturbing signs in contemporary Native American art. *Art Journal, 51*(3), 44–50.

Fleming, P.R., & Luskey, J. (1986/1992). *The North American Indians in early photographs.* New York: Barnes & Noble. (Original work published 1986)

Fogelson, R.D. (1996). Sequoyah. In F.E. Hoxie (Ed.), *Encyclopedia of North American Indians* (pp. 580–582). Boston and New York: Houghton Mifflin.

Gentry, C.M., & Grinde, D.A., Jr. (Eds.). (1994). *The unheard voices: American Indian responses to the Columbian Quincentenary, 1492–1992.* Los Angeles: American Indian Studies Center, University of California.

Gritton, J. (2000). *The Institute of American Indian Arts: Modernism and U.S. Indian policy.* Albuquerque: University of New Mexico Press.

Heap of Birds, E.H. (2008). Life as art: Creating through acts of personal and cultural renewal. In *Reinventing the wheel: Advancing the dialogue on contemporary American Indian art.* Denver: Denver Art Museum.

Jaimes, A.M. (Ed.). (1992). *The state of Native America: Genocide, colonization, and resistance.* Boston: South End Press.

Josephy, A.M., Jr., Nagel, J., & Johnson, T. (Eds.). (1999). *Red power: The American Indians' fight for freedom.* Lincoln: University of Nebraska Press. (Original work published 1971)

Josephy, A.M., Jr., Thomas, T., & Eder, J. (Eds.). (1993). *Wounded Knee: Lest we forget.* Cody, WY: Buffalo Bill Historical Center.

Luna, J. (1992). "I've always wanted to be an American Indian." *Art Journal, 51*(3), n.p.

McDonnell, J. (1991). *The dispossession of the American Indian, 1887–1934.* Bloomington: University of Indiana Press.

McMaster, G., & Martin, L. (1992). *Indigena: Contemporary Native perspectives.* Vancouver, BC: Canadian Museum of Civilization.

Nagel, J. (1997). *American Indian ethnic renewal: Red power and the resurgence of identity and culture.* New York and Oxford: Oxford University Press.

Nemiroff, D., Houle, R., & Townsend-Gault, C. (1992). *Land, spirit, power: First nations at the National Gallery of Canada.* Ottawa: National Gallery of Canada.

Nilson, R. (1991, September 16). Painting the Native soul, mother earth talks through artist's work. *The Arizona Republic.*

Otis College. (2008, September 23). *Otis visiting artist: Edgar Heap of Birds.* Retrieved January 13, 2011, from http://www.youtube.com/watch?v=KLRQsmB9PuA

Roberts, C.A. (Ed.). (1992). *The submuloc show/Columbus wohs.* Phoenix, AZ: Atlatl.

Rogoff, I. (1991). Double vision: Politics between image and representation. In *New Art: An International Survey.* London: Academy Editions.

Rushing, W.J., III. (2008). The prehistory of the wheel: Symbolic inversions and traumatic memory in the art of Edgar Heap of Birds. In N. Blomberg (Ed.), *Reinventing the wheel: Advancing the dialogue on contemporary American Indian art*. Denver: Denver Art Museum.

Sandweiss, M.A. (1991). Undecisive moments: The narrative tradition in western photography. In *Photography in nineteenth-century America*. New York: Harry N. Abrams.

Schimmel, J. (1991). Inventing the Indian. In W. Truettner (Ed.), *The West as America: Reinterpreting images of the frontier*. Washington and London: Smithsonian Institution Press.

Smith, P.C., & Warrior, R.A. (1996). *Like a hurricane: The Indian movement from Alcatraz to Wounded Knee*. New York: The New Press.

Stewart, S. (1993). *On longing: Narratives of the miniature, the gigantic, the souvenir, the collection*. Durham, NC: Duke University Press.

Summerhill, S.J., & Williams, J.A. (2000). *Sinking Columbus: Contested history, cultural politics, and mythmaking during the Quincentenary*. Gainesville: University of Florida Press.

Swenson, S., Smith, B., & Arbeiter, J. (1999). *Lives and works: Talks with women artists*. (Vol. 2). Metuchen, NJ: Scarecrow Press.

Thornton, R. (1984). Cherokee population losses during the Trail of Tears: A new perspective and a new estimate. *Ethnohistory, 31*(4), 289–300.

WalkingStick, K., & Marshall, A.E. (2001). *So fine!: Masterworks of fine arts from the Heard Museum*. Phoenix, AZ: Heard Museum.

Wallo, W., & Pickard, J. (1990). *T.C. Cannon: Native America (A new view of the West)*. N.p.: The National Cowboy Hall of Fame.

Ward, D. (1990). *Our land/ourselves: American Indian contemporary artists*. Albany: University Art Gallery, Albany State University.

Young Man, A. (1992). The metaphysics of North American Indian art. In G. McMaster & L. Martin (Eds.), *Indigena: Contemporary Native perspectives*. Vancouver, BC: Canadian Museum of Civilization.

Zamudio-Taylor, V. (1992). Memory, Identity, and Progress: Perspectives in 1992. In Lerma, P.C., & Orozco, S. (Eds.). *Counter colonialismo*. Austin, TX: Centro Cultural de la Raza MARS, Movimiento Artistico del Rio Salado MEXIC-ARTE Museum.

Activist Art and Pedagogy

The Dinner Party Curriculum Project

CARRIE NORDLUND, PEG SPEIRS, AND MARILYN
STEWART, WITH JUDY CHICAGO

Figure 1. The Dinner Party, 1975–1979. Photo © Donald Woodman.
Reproduced with permission from Through the Flower.

Introduction

As an icon of feminist art, *The Dinner Party* by artist Judy Chicago carries historical significance because it addresses the erasure of women's lives and achievement from the history of the Western world. Rooted in the second wave of the Women's Movement, feminist art has had a sustained presence in the dialogue for social justice as content for teaching in the field of art education (Garber et al., 2007). This chapter situates *The Dinner Party* within the context of teaching for social justice in K–12 settings. *The Dinner Party*, as content for teaching or as a catalyst for related learning, raises student awareness about important social and political issues with a goal of social change.

As a form of activist art pedagogy, feminist pedagogy is theoretically informed practice that positions women's issues and experiences in the forefront of learning. As teachers and students engage with the political and social issues that arise because of feminist course content, they can experience self-reflexivity and participate in the construction of knowledge, which in turn presents opportunities for transformation (Lewis, 1992; Luke 1994; Maher, 1987; Maher & Thompson-Tetreault, 1994; Speirs, 1998). Grounded in feminist theory, feminist pedagogy contextualizes learning in ways that intersect gender with power and social factors of difference. Feminist pedagogy, feminist theory, and feminist art are part of a larger collective identity known as feminist scholarship. We agree with some feminists who argue "that feminist scholarship is inherently linked to action" (Reinharz, 1992, p. 175).

In this chapter we examine *The Dinner Party* as feminist content in an overarching curriculum development project. We describe the process of creating *The Dinner Party* Curriculum, including the graduate institute held at Kutztown University of Pennsylvania that served as the foundation for its construction. In addition, we share ways in which the curriculum has evolved and our plans for its continued expansion. We highlight the curricular work of two art teachers, one who designed curriculum units for the elementary level and the other who focused on middle school students. In addition to the curricular content within these units of study, we present descriptions of feminist pedagogy in action, including examples of self-reflexivity, co-construction of knowledge, and transformation. All of the K–12 lessons mentioned in this article, and the K–12 curriculum we wrote from our experiences at the first institute, can be viewed online or downloaded from the website http://www.throughtheflower.org. We see curriculum as fluid and generative (Wiggins & McTighe, 2005; Stewart & Walker, 2005), with the contents evolving as new communities of teachers and students add layers of meaning to our understanding of women in relation to history, culture, and society. We begin with a special contribution by artist Judy Chicago to present, in her own words, an overview of *The Dinner Party* from its inception to permanent housing at the Brooklyn Museum.

The Story of *The Dinner Party,* by Judy Chicago

The Dinner Party is a monumental work of art, triangular in configuration, that employs numerous media, including ceramics, china-painting, and an array of needle and fiber techniques, to honor women's achievements. I created this work over a 5-year period (1974–1979). At first, I worked alone but slowly, people came forward to help me, some volunteer, others paid. Although there was a core team of 20 to 25, eventually 400 folks participated in helping to realize my vision.

I had certain definite goals with *The Dinner Party.* These included:

1. Recounting through art the unknown, overlooked, or forgotten history of women's contributions to Western Civilization.
2. Challenging the long-established hierarchies of art, which consigned areas of achievement open to women (for example, still-life and genre painting, china painting, and needlework) to a lesser status or the netherworld of craft.
3. Discovering whether a woman working at the same level of ambition previously reserved for men would garner support and recognition from the art world.
4. Permanently housing *The Dinner Party* so that women's achievements could never be erased again.

When *The Dinner Party* premiered in 1979 at the San Francisco Museum of Modern Art, it was a resounding success, at least in terms of its popularity with the audience. About 100,000 people stood in long lines to view the piece, the museum balanced its annual budget, and the bookstore made so much money that it bought a new, computerized cash register that it named "Judy." For months, I was presented with gifts from complete strangers, received notes and letters saying that *The Dinner Party* was life changing. I felt elated, believing that I had tested the art system and discovered that history had indeed changed, that women could in fact count on a favorable response if only we had the courage to challenge convention.

I was in for a shock. Beneath the surface of this recognition, a wave of resistance was building in the art community. At first, it was grumblings conveyed to me by sympathetic male artist friends. "Judy," they would say, "people are insisting that *The Dinner Party* isn't art." "And what did you say?" I would ask. "My response was that if Judy had wanted to do something other than art, she wouldn't have spent 5 years drawing, painting, carving and spending 17 hours a day in the studio." "Right," I replied, confident that such negative sentiments would be easily countered by the outpouring of enthusiasm that was evident everywhere, even in the mainstream press, including such national magazines as *Newsweek, Life,* and *People.*

However, my assessment was completely wrong. Those initial complaints gradually built until there was a wall of resistance. But this only became evident to me when all the museums scheduled to exhibit *The Dinner Party* abruptly cancelled without explanation. At the end of its successful premiere, *The Dinner Party* went into storage, and the artist went into shock. Not only was the piece consigned to crates and an entirely uncertain future, but also I had lost everything. My marriage had crumbled under the strain of my determination to complete the piece no matter the consequences to my health, my relationships, or my finances.

My previously dedicated staff scattered; they were as devastated as I was by the collapse of the exhibition tour and the prospect of unending storage fees. My dream of creating a porcelain room to permanently house the piece was in tatters, and the studio that I had rented in northern California sat vacant, a testament to my shattered hopes. Moreover, I was in considerable debt, having borrowed money to finish *The Dinner Party*.

Basically, I had to start all over again, while at the same time many people believed that I had enjoyed a huge success. Needless to say, this was confusing because outer appearances belied the truth of my situation. In the meantime, while I was trying to figure out how I was going to continue making art, which is what has always been paramount to me, Diane Gelon, *The Dinner Party* administrator, decided to take it upon herself to figure out a way to rekindle hope for an exhibition tour. The number of people who called—unaware of what had happened—to ask when *The Dinner Party* would be coming to their town, aided her in this effort.

When Diane Gelon explained that the scheduled museums had cancelled and that there would be no tour, callers were aghast. Not believing that this could be happening, they went to their local museums and requested that the piece be shown. When they were refused (usually with euphemisms like "There's no room in our schedule," or "It doesn't fit in with our exhibition program"), many people were educated about some of the biases of our art institutions.

A number of the people involved in these local efforts were engaged with their museums as members, docents, fundraisers, and, sometimes, as trustees. Many of them were women and, to them, the message was clear: you can support us but don't ask us to support what you are interested in. There were also some men involved, sometimes in pivotal institutional positions, who understood the message as well. They joined the women to do something about what they perceived as an obvious example of social injustice.

Thanks in large part to Diane Gelon's efforts, a grass-roots movement gradually developed. She traveled all over the country, and then around the world, meeting with groups that were organizing to exhibit *The Dinner Party*. People raised money, rented spaces, put together installation teams and staffs in order to show *The Dinner Party*. The first such exhibition was organized by Mary Ross Taylor in Houston.

Using her bookstore as the base of operations, she successfully mounted the first alternative showing at the University of Houston, Clearlake City, in a space donated by Calvin Cannon, a dean at the university.

Again, the exhibition was a huge popular success with innumerable art and educational adjunct activities. The impact in Houston demonstrated to Mary Ross the power of art to effect social change. In addition to becoming an advisor to subsequent groups attempting to organize exhibitions, she decided to work with me as the administrator of my next undertaking, the *Birth Project*, a series of 85 painted and needleworked images celebrating birth and creation. Many of the needleworkers who volunteered to work on this project did so after having seen and been inspired by *The Dinner Party*.

The Dinner Party became a springboard for action. It not only educated viewers about the historic erasure of women's achievements but also about the present-day resistance to women-centered art. Moreover, it stimulated people to stand up to the art world's censure of the piece in order to enable its exhibition and also to support me in my ongoing artistic career. Without this, it would have been exceedingly difficult for me to continue making art, because the art world resistance to *The Dinner Party* effectively shut off any other opportunities for me.

Over the course of the next decade, *The Dinner Party* made its way to Boston, New York, Cleveland, Chicago, and Atlanta, with stops along the way in Calgary, Toronto, and Montreal. In Boston, I was confronted with huge buses with my name emblazoned across them to publicize the show, which only added to the confusion that I was feeling about the discrepancy between my private reality and the public perception.

In Boston, the piece helped to fuel the gentrification of the area in which it was exhibited, and the space that housed it eventually became the Boston Center for the Arts. Similarly, in Chicago, the donated building where the piece was shown became a springboard for the development of the whole South Dearborn area. And in Cleveland, the profits from the show were used to create a non-profit organization for women.

In New York, a private group raised all the money for its showing at the Brooklyn Museum under the support of Director Michael Botwinick. However, in the Big Apple, *The Dinner Party* collided with the most powerful art critics in America, and they not only didn't like what they saw, they announced their negative opinions in the most widely read and influential forums (e.g., *The New York Times* and *Time* magazine).

Still, audiences were undeterred, lining up to see the piece in Brooklyn as they had everywhere else. In fact, for the first time, the museum had to institute a ticket system. But most museum professionals were undeterred in their collective opinion that *The Dinner Party* was not art. After all, they were the experts. What did the audience know?

Lady Ouida Touche, a woman who lived in both Calgary and London, provided the money to ship the piece overseas, where it was exhibited in Edinburgh, Scotland, London, and then Frankfurt, Germany. A woman named Dagmar von Garnier, who organized a widespread grass-roots movement all over Germany, spearheaded the Frankfurt effort. By the time the piece was finally shown at the Frankfurt Kunsthalle in 1987, there had been 300 articles about it in European newspapers.

After Frankfurt, *The Dinner Party* traveled to Melbourne, Australia. A grass-roots group that succeeded in making the show part of the Australian Bicentennial celebration brought it there after years of work. *The Dinner Party* was presented at the Royal Exhibition Center, where it was co-sponsored by the Victoria and Albert Museum.

On the opening weekend, there was a boisterous "Banquet for One Thousand Women" that mimicked an all-male event held 100 years earlier as part of the Australian Centennial celebration. Again, the exhibition proved extremely successful, though its censure by art critics continued. By this time, feminist theory had developed in the universities, and some of these theorists took it upon themselves to join the chorus of naysayers about *The Dinner Party*. It was entirely disconcerting to have thousands of perfectly ordinary women praise what was an obvious celebration of women while hearing academics insist that it "degraded women."

In fact, in 1996, when *The Dinner Party* was shown again in the United States for the first time in 15 years, at the UCLA Armand Hammer Museum, the Women's Studies Department at the university threatened to picket it. How, I wondered, had it come to this? How could a work of art, born out of the groundswell of activism of the 1970s feminist movement dedicated to overcoming the erasure of women's achievements, be so misunderstood by contemporary feminists? Did it reflect the power of the New York press? Were feminist academics so captivated by patriarchal writers that they could not think for themselves? I could not help but worry that the social justice movement that feminism represents had been sold out in academia.

Although I was greatly heartened by the fact that *The Dinner Party* had been exhibited in fifteen venues in six countries and three continents to a viewing audience of over one million people, still, if it were not permanently housed, I would have failed in my goals. By this time, the hopefulness that had fueled second-wave feminism had cooled, and it had become popular to claim that "feminism is dead" (as if the goals of a movement that believed in equality for women *all over the world* had been achieved). My small, non-profit organization, Through the Flower (http://www.throughthe-flower.org), which had overseen the worldwide tour of *The Dinner Party* and was responsible for its care, desperately wanted to see it permanently housed. However, the board of Through the Flower eventually came to recognize that we were not ourselves capable of accomplishing the permanent housing of *The Dinner Party*. What we *were* able to do was to keep the piece safe until permanent housing was achieved

through the vision of Dr. Elizabeth A. Sackler. In 2002, Dr. Sackler, a collector of my work and long-time social activist, informed me of her desire to acquire and gift *The Dinner Party* to the Brooklyn Museum where she intended to make it the centerpiece of the Elizabeth A. Sackler Center for Feminist Art.

In 2007, Dr. Sackler's vision became a reality. Now generations of young people will be able to visit *The Dinner Party*, thereby realizing my goal of ensuring that women's achievements will become a permanent part of our cultural heritage. But this would never have happened had my art not acted as a vehicle for social change and an instrument of realizing at least a modicum of social justice.

The Dinner Party Curriculum Project

So *The Dinner Party*, a product of and catalyst for social activism, finally has found its permanent home. Also, as Judy Chicago suggests, generations of young people will now be able to visit the artwork and learn of the achievements of women over time and throughout the Western world. The artwork is beautiful and awe-inspiring; many people talk about having something like a "religious experience" when encountering it. Some visitors leave determined to find out about the 1,038 women featured in the artwork and about other important women in history from around the globe. Some vow to be more vigilant, to never again allow for the erasure of women from history. This is as it should be. *The Dinner Party* is a powerful and evocative artwork.

Extending the Power

The Dinner Party Curriculum Project began in an effort to extend the reach of the artwork's power as a catalyst for action. Envisioning an audience of young people who might never have the opportunity to see the artwork in person, Judy Chicago and Through The Flower board member Constance Bumgarner Gee were determined to offer K–12 teachers a curriculum for guiding their students to investigate and learn from *The Dinner Party*. They reached out to curriculum writer Marilyn Stewart of Kutztown University, who saw an opportunity for collaboration with her colleagues who had long histories with feminism, feminist pedagogy, curriculum, and teaching about and through *The Dinner Party*. From the beginning, we worked as a team.

We knew that our mission was an important one. If we could create a curriculum to investigate *The Dinner Party* in a deep and substantive way, students engaged in this investigation would learn about women who have been erased from history. They would learn to question the official or widely accepted accounts of the past and to seek out stories of individuals who have been overlooked, ignored, or erased. Ultimately, because *The Dinner Party* stands as a reminder of the power of

activist art and the importance of addressing injustice and inequality wherever they are found, students engaged in its study would have the opportunity to understand and embrace what it means to have an activist stance toward their world.

In our initial weekend meeting with the artist to review and discuss our task, we talked about our shared belief that the best curricula are flexible and adaptable to different students, teachers, and settings. We agreed that with whatever we produced, we wished to honor the experiences of teachers and their knowledge and understanding of their own students. In addition, especially given the collaborative nature of the making of *The Dinner Party*, we wished to invite additional voices and perspectives to engage in our project. We were interested particularly in working with teachers from the K–12 classroom.

The Dinner Party is a highly complex artwork. Understanding and appreciation of the artwork requires careful and sustained attention to its various components, the role of symbolism and use of metaphor, and the multiple meanings generated by the range of important contexts within which the work can be viewed. Students generally have not been provided opportunities to seriously investigate the multiple layers of *The Dinner Party*. But then, neither have teachers. We quickly realized that if we were going to involve teachers in the project, we would need to construct an environment for sustained and intensive attention to *The Dinner Party*, where teachers could experience the same quality of learning we envisioned for K–12 students. This realization prompted us to begin planning a week-long professional development institute to engage teachers in a thorough investigation of the artwork. Our plan for the institute was to explore *The Dinner Party* in all of its complexity, engage participants in various inquiry-based experiences, model feminist pedagogy, and promote the creation of curriculum in which K–12 students might fully explore and learn from the artwork.

Transformation in One Week.

Titled "An Invitation to *The Dinner Party*," the institute was held for one week during the summer of 2007. This invitation to participants was to investigate *The Dinner Party* and, in the spirit of its creation, assist in the development of *The Dinner Party* Curriculum. The schedule during the week reflected these two aims. Judy Chicago opened the institute, welcoming all and sharing her excitement about the curriculum project. Throughout the week, activities functioned to introduce the artwork, to raise social consciousness, to build a context for understanding the artwork in terms of feminism and feminist art, and, finally, to explore the artwork's components, symbolism, metaphors, and multiple meanings. A highlight of the week was the day when, with the artist as our guide, we experienced *The Dinner Party* in its new home at the Brooklyn Museum.

Our institute sessions on curriculum development included an overview of what it means to teach for deep understanding using enduring or what we sometimes call "big" ideas to serve as the central focus for units of study (Stewart & Walker, 2005). We encouraged teachers to create curricula for their own settings and to share their work with us, the Curriculum Team, and ultimately with other teachers throughout the nation and beyond. Over the 12 months following the close of the institute, we received and reviewed curricular materials from most of the 45 participants who attended. All submitted curriculum plans and resources for teaching about *The Dinner Party*, but in addition, many provided documentation of the implementation of these plans with their students. We were pleased with the variety of ways in which teachers took the ideas from the institute back to their own classrooms.

That first summer institute proved to be a crucial component in the evolution of *The Dinner Party* Curriculum Project. We witnessed firsthand how easily teachers grasped the significance of the artwork within its social, political, ideological, historical, and art historical contexts. Through deep investigation of the artwork and these contexts, they quickly saw how its creation was necessary in order to address the erasure of the achievements of women from history. They also realized that *The Dinner Party* prompts questions about social equity at the time of its creation, but more importantly, they saw that it serves as a catalyst for these questions now and into the future. Expecting simply to come for a week to meet the artist and learn more about her iconic work, participants talked about the week as life changing. Many who had not considered themselves feminists upon entering the institute left with a profound understanding of their connection to feminism, feminist pedagogy, and the need for social activism. All participants left with a renewed commitment to vigilance in their teaching and in their personal lives, knowing how readily the story of women's achievements can be forgotten or dismissed. From their experience with *The Dinner Party*, several realized that this kind of erasure functions with other underrepresented groups as well. As the institute planners and faculty, we were delighted, if not stunned, by what had transpired during the week. Recognizing the transformative power of that one intense period of exploration and curriculum work, we turned to our institute schedule of activities, realizing that they should serve as the basis for what would become *The Dinner Party* Curriculum.

Mining Assumptions and Institute Experiences

In reflecting upon the institute plan, we realized that when we put the schedule together, we were guided by deeply embedded orientations to feminism and social justice, as well as certain important assumptions about art, how we engage with and interpret meaning in art, and how we approach teaching and learning. In our attempt to make explicit what was implicit in our planning, we identified 15 prin-

ciples that we had adhered to and that we believe might serve others who wish to create an environment and an approach to investigation of artworks for deep understanding (Nordlund, Speirs, & Stewart, 2010). We view these principles as foundational to *The Dinner Party* Curriculum.

The Dinner Party Curriculum consists of 14 "Encounters" that are adapted versions of the activities planned for our summer institute. Like those institute activities, the Encounters afford students opportunities to look deeply at an artwork beyond its formal elements and consider its rich contexts, including the artist's intention, time and place of its making, and connections to our lived experiences. The Encounters are grouped in a sequence with particular goals in mind. The first part, "Encountering *The Dinner Party*," introduces students to the artwork and the concepts of symbolism and metaphor. The second group of Encounters, "Raising Consciousness," guides students in an examination of gender and how it shapes them as individuals, as well as how *The Dinner Party* acts to raise consciousness of gender issues. With the third group of Encounters, "Creating Context," we provide students with the opportunity to situate *The Dinner Party* within the context of feminism, art history, and feminist art. The fourth and largest group of Encounters, "Exploring *The Dinner Party*," provides a multiplicity of modes of study of the symbolism and meaning of the components of the artwork, the use of metaphor in the piece, and the artistic intentions that underlie the form and structure of *The Dinner Party*. The Encounters engage students in art criticism, prompt art historical inquiry, provide opportunities for philosophical inquiry, and provide the basis for meaningful studio production.

The Encounters are accompanied by lessons, activities, and resources developed and implemented by the institute participants and submitted to us for review and possible inclusion. In selecting the lessons and activities to include with *The Dinner Party* Curriculum, we sought examples that most directly addressed the artwork and that we believed would assist students in approaching and understanding it in its complexity. While *The Dinner Party* Curriculum has been developed by and for art educators, it is also relevant for the study of history, social studies, English, and language arts.

Expectations for Change and Growth.

The Dinner Party Curriculum Project, spurred by Judy Chicago's idea that she could provide teachers with guidance for teaching about and with *The Dinner Party*, has grown. By far the most prominent component of the project is *The Dinner Party* Curriculum—the set of encounters designed so that teachers can access and adapt them for their respective needs, with sample lessons, instructional resources, and classroom strategies contributed by teachers who have implemented them with K–12 students. Even this component is expected to change and grow as increasing

numbers of teachers submit their curricular work for review for inclusion. The encounters and teacher-created lessons that make up *The Dinner Party* Curriculum are designed to engage students directly in the study of *The Dinner Party* in its various contexts. "Building on *The Dinner Party*" is another component of the larger project with the purpose of highlighting ways in which *The Dinner Party* can be a catalyst for investigation of topics, issues, and individuals related to but not directly addressed in *The Dinner Party*. The work by Hannah Koch, described later in this chapter, is an example of a unit of study that builds on the Curriculum as it considers the Suffragist Movement and some of the women who were involved.

The Dinner Party Curriculum Project also has a professional development component. In the summer of 2010, we held a second "Invitation to *The Dinner Party*" institute. Again held at Kutztown University, the focus of this one-week investigation was also *The Dinner Party*; thus the schedule of activities throughout the week was similar to that of the 2007 institute. However, the goal in this institute was to introduce *The Dinner Party* Curriculum and invite teachers to adapt parts of it for their own students and settings. We modeled most of the Encounters and showed participants where they were located online. Teachers were encouraged to review the activities, imagine incorporating them into their own settings, and adapt them for their own students. These teachers will, in turn, share their work with the institute faculty and other participants. Again, selected curricular units, lessons, and strategies will be added to the Curriculum and will be available to audiences worldwide. We expect to offer a professional development institute annually in the coming years as the project continues to evolve.

The Dinner Party Curriculum Project website (http://www.throughtheflower.org) and related social networking frameworks currently provide for continued dialogue among interested parties about the implementation of *The Dinner Party* Curriculum and other issues related to the artwork. As the technology for continued communication shifts and changes, we anticipate that we will adapt and change accordingly to allow for optimum interaction among those who have taught with the Curriculum and those who are looking forward to doing so. In this way, the legacy of activism—begun when an artist working alone to address injustice through her art was joined by hundreds of volunteers and continued as group after group organized to ensure that this artwork would be shown to and known by the public—will now move into the lives of teachers and students in K–12 classrooms and beyond.

K–12 Classroom Examples

At the close of the 2007 institute, participants designed curriculum with their students in mind. They contextualized learning within their respective teaching situ-

ations, resulting in a variety of responses that modeled activism with goals of teaching for social justice in K–12 settings. This section includes lessons that support learning about *The Dinner Party* and the social or political issues raised by the artwork. As well, we include examples of a curriculum that is not specifically attached to *The Dinner Party*, but for which the artwork has served as a catalyst. Rather than directly engage students in investigations of *The Dinner Party*, lessons such as these create opportunities for learning across the curriculum while having the potential to raise student awareness and, in effect, prompt social action. The website also makes available complete lessons and accompanying materials.

Art, Pedagogy, and Activism at the Elementary Level

At Muhlenberg Elementary School in the urban district of Allentown, Pennsylvania, art teacher Andrea Horn designed a unit of study for fifth grade entitled *Mothers of Mother Earth*. The first lesson of the unit encourages critical thinking about why men's contributions to the world are generally more recognized than women's contributions. After discussing the concept of "contribution," students generate names from those learned about in school or at home and give justification for their choices. As names are offered, the teacher categorizes them as men or women, which provides visual evidence of the issue and becomes a springboard for discussion, prompted further by questions asked by the teacher. As a second activity in the lesson, students identify images of important men and women in American history. Horn's students discovered they knew less about the women than the men. In groups, students then surmise why they know less about women's contributions, gaining critical awareness of why women have been excluded generally from the curriculum.

In the final phase of the lesson, the teacher introduces *The Dinner Party* and artist Judy Chicago through a PowerPoint presentation with vocabulary (such as "feminist" and "intellectual"), imagery, and information (definitions of feminist art and research). The teacher prompts discussion with questions about being an artist, social responsibility, and creating art about women and their experiences. As evidence of learning, students explain why they studied *The Dinner Party* and identify the links among the artist, artwork, and "great contributions."

The next lesson focuses on the written components of *The Dinner Party*, specifically, *Merger Poem*, written by the artist. Through the investigation of the artist's voice, students deepen their understanding of *The Dinner Party* and the women's contributions that have improved the world. Language arts and art criticism overlap in this lesson as each student group interprets two lines of the poem before sharing its findings with the class. As in the first activity, Horn encouraged co-constructed meaning making. She documented their ideas on large chart paper before

asking students to summarize the meaning of the entire poem. In the poem, Chicago imagines a world of equality, respect, compassion, and caring among all life. As formative assessment, students reflect on the idea that through our actions, deeds, and behaviors, we can improve the world.

Investigations continue with students comparing the poem with text woven into the entry banners leading into the room housing *The Dinner Party*. The text on the banners is written similarly to a religious decree. The artist envisions the world beginning anew when men and women can be treated with equality and fairness. To contextualize study of the individual place settings and the women they represent, students view age-appropriate segments of the DVD *The Dinner Party: A Tour of the Exhibition* (Through the Flower, 1976). They measure the distance of 48 feet, equal to one side of *The Dinner Party* table, to help them see and feel the immensity of the artwork they viewed on screen. The teacher adapts passages written by the author about the place settings to meet the literary needs of fifth graders. Also, the teacher provides color images and worksheets with questions to ignite discussion and teach students how to talk about works of art. The lesson concludes by asking students to imagine they could talk with the artist. What questions would they ask, and what would they tell her they have learned?

The final lesson involves an art-making activity that parallels the group process of making *The Dinner Party*. Students balance the challenges that arise when working in teams while allowing for individual strengths. Teams select a leader, and they consider each other's talents when dividing duties to accomplish their tasks. Students experience cooperation firsthand, and learn the importance of research when creating a multimedia artwork based on the contributions of a contemporary or historical woman. Following a series of prompts, each team presents a proposal for its design before executing it. As criteria, each visual art form includes symbols, the name of the woman designated as a Mother of Mother Earth, and a message for the audience to learn about this woman. In the process of making artwork about women scientists, artists, environmentalists, women's rights activists, conservationists, and authors, students learn about the lives and significant contributions these women have made to the world.

In Horn's unit, the teacher begins with what the students know before moving them to a new place in their understanding. Horn carefully constructed lessons and activities that supported the enduring idea, *Across cultures and throughout history women have made great contributions to improving our world*. Regarding the first lesson, Horn recalled that her fifth graders were appalled when they actually saw the list of men vs. women whom they listed as important people in history, and when they couldn't identify images of as many women as they could men. The fifth graders did not have a chance to participate in the studio component of the lesson, because they ran out of time. Horn said the students did not mind, because they

were so involved with the "preliminary" investigations. After participating in this unit of study, the fifth graders were assigned a language arts research project. Horn reported that a majority of them, including most of the boys, decided to do research on women. By studying activist artwork such as *The Dinner Party* and engaging students with activist pedagogy, Horn motivated her students to action by allowing them to discover apparent inequities on their own. Now that Horn has moved to teaching art at the high school level in her district, she intends to adapt the unit for her new students.

Art, pedagogy, and Activism at the Middle School Level

At the time of the institute, Hannah Koch was a graduate student at Kutztown University, soon to be teaching art at the middle school level. Koch's work in the graduate program had been particularly inspired by feminist and social reconstructionist pedagogy. Her research explored the life and work of Susan B. Anthony and the American Women's Suffrage Movement, serving as a basis for her thesis, which addressed the creation and use of an art education curriculum as a means for teaching the history of women. To exemplify ways in which teachers might build upon *The Dinner Party*, we included with *The Dinner Party* Curriculum a series of three lessons written by Koch for which the Susan B. Anthony place setting of *The Dinner Party* served as a catalyst. This series demonstrates how a teacher might move beyond consideration of *The Dinner Party* as such, and into an in-depth study prompted by a part of the artwork. Created in concert with and support from the Sewell-Belmont House in Washington, D.C., the lessons draw upon historical information and archival materials housed within the institution.

This series of lessons illuminates the life and work of Susan B. Anthony and the women of the American Women's Suffrage Movement. In addition, the lessons provide a larger context through which to understand feminist art such as *The Dinner Party*, feminist artists like Judy Chicago, the Feminist Movement, and the Civil Rights Movement. Studying the American Women's Suffrage Movement, Koch identified three main threads through which to learn about from this aspect of women's history: Collaboration and Relationships, Activism and Art, and Power and Empowering Women.

Collaboration and Relationships

Historically, expectations and responsibilities around the home and family, and limited opportunities for education and work outside the home, kept women apart. Collaboration strengthened women so they could do more than they could alone and served as a support structure for the first and second waves of feminism.

Inspired by the relationship between Susan B. Anthony and Elizabeth Cady Stanton, founders of the American Women's Suffrage Movement, Koch introduces the concept of collaboration in the first lesson as it relates to relationships in students' lives. The teacher asks for examples of when "two heads are better than one," the enduring idea of the lesson, as well as the challenges one faces when working alone. As students learn about the supportive partnership between Anthony and Stanton and how their strengths complemented each other, students reflect on how working with each other can change their participation.

Students consider the role collaboration played in the making of *The Dinner Party*. The teacher explains how the artist resolved technical issues in making the artwork with the help of experts. Also significant is the idea that many women believed in the artwork and wanted to contribute to giving women a place in history. Researching the collaborative relationship between Anthony and Stanton by examining multiple sources reveals the nuances in a relationship and, in turn, helps students cultivate better relationships with each other. The teachers supply print and online resources for students to read plus provide questions to help students make deeper investigations. Students experience a studio-based collaboration with peers and, in the process, have the space to express themselves and their relationship with another person while identifying and building upon their strengths.

Koch introduces a reflective letter-writing portion of the lesson, a direct link to language arts. She provides copies of letters written between Anthony and Stanton to illuminate the role letter writing played in their collaborative relationship. Students reflect on the readings by answering a series of questions before writing a letter to their partner about their collaborative art-making experience. Collaborative relationships such as the suffragists of the National Women's Party and the ratification of the 19th Amendment are other examples of how collaboration can help change society.

Activism and Art

The second lesson explores the concept of activism through the study of suffragists Susan B. Anthony and Alice Paul, and artists Judy Chicago and Nina Allender. Koch introduces the lesson with discussion questions about activism and activists in order to invite participation, find out what students know, and frame a definition. Koch identifies Anthony, Paul, and Chicago as three activists committed to the advancement of the status of women. She suggests creating information stations featuring each activist. Students travel in pairs to each station to read biographical information, view photographs, and fill out worksheets. As an informal assessment, students use the worksheets as a prompt to provide words to describe each woman, their shared characteristics, and their actions taken on be-

half of social change. This research prepares students for a large group discussion in which everyone can contribute.

The next activity shows students how Nina Allender used art to persuade and provoke audiences. Students work in groups to interpret Allender's political cartoons featured in *The Suffragist*, a weekly newspaper of the National Women's Party dedicated to the suffragist campaign. (A biography of Allender as a political cartoonist can be found at http://www.sewellbelmont.org/mainpages/collections_allender.html.) For the activity Koch made worksheets with questions and images that guide critical practice. This art criticism activity illuminates the use of art as activism in the Women's Suffrage Movement and asks students to make conclusions about the success of her artwork as a means of activism.

The studio portion of the lesson requires students to identify an issue or a cause about which they feel strongly and create a political cartoon that persuades or provokes thinking about the cause. Language arts plays significantly in this lesson as students are able to choose humor, satire, or irony to provoke and persuade their audience. Knowing the differences and combining imagery with text gives this lesson an integrated appeal and turns a drawing lesson into a multifaceted experience for students. The lesson ends with critique, giving each person an opportunity to talk about the issue, prompted by a questionnaire. Students offer reasons why some cartoons are particularly persuasive or thought provoking, and discuss the challenges of presenting an issue convincingly and accurately with imagery and few words. They compare their work with the political cartoons of Allender and walk away knowing art has the power to persuade and can be a powerful form of activism. Koch suggests submitting some of the most successful cartoons to the school newspaper.

Power and Empowerment

The third lesson in this series explores power and empowerment through different but related paths. Koch refers to *The Dinner Party* for examples of how women have used power in the past and how the artist portrayed powerful women in the artwork. The Suffrage Movement provides learning about how women envisioned the vote as a means to empowerment and how the movement used imagery to portray empowered women.

Koch opens the lesson with a discussion on power, asking students for definitions and examples of powerful people, things, images, and women before asking them to illustrate their ideas of power. Koch provides an information sheet that describes life for women before suffrage and includes questions for student reflection.

As the next activity, Koch introduces the studio project with a slide show of contemporary and past action figures, probing a discussion on the difference

between action figures and dolls. She provides examples of ways in which action figures have evolved beyond stereotypes and supplies images of suffragists in posed photographs. A critical discussion ensues as students first describe each image before making lists of commonalities and differences between action figures of the past and present, and images of women from the Suffrage Movement. Students are given a list of questions to encourage looking deeper at the figures through facial expressions, body, clothing, and by making connections to what they read, such as what ideas are represented and how the ideas are expressed. Students identify figures representing power and explain how the power was portrayed.

Attention moves to *The Dinner Party*, where students investigate the Susan B. Anthony runner to understand how Chicago represents a powerful woman in the artwork. Inquiry guides an exploration of colors, imagery, and symbolism. Biographical information provides a context through which to see the work and real-life examples of how women used power and for what end. Koch provides a list of suffragists for students to choose from, and students conduct their own research, looking for information and images related to their suffragist. Students visit the National Women's Party Digital Archives at the Sewell-Belmont House and Museum (http://www.sewallbelmont.org). This website provides prints, photographs, and informational essays about suffrage. In addition, students tour the National Women's History Museum website (http://www.nwhm.org/), where they can find images of suffragists along with banners, buttons, and other ephemera used during the movement as well as visual examples of the colors and aesthetics of the Suffrage Movement.

Students sketch their ideas for a suffragist action figure before making the figures out of polymer clay. As they make them, all students have an opportunity to share the identity of their suffragist action figure, her power, and how they plan to represent that power. By studying how artists visually communicate power, interpreting images of power and creating images of their own, students recognize that power has many faces, the enduring idea of the lesson. Becoming aware of the struggles women endured historically to achieve basic rights and privileges that people enjoy today fills a gap typically left empty by a standard school curriculum.

These classroom examples promote social justice in education through activist art and pedagogy. Creating opportunities for everyone to participate supports an education model more fitting to a democratic society. Creating learning environment where students discover and explore social and political issues and creative ways to address them encourages the development of a deeper social awareness and the inspiration to take action. Once we become conscious, the seeds of social change are planted. Education can give students the tools to cultivate social justice over a lifetime.

These two units of study illustrate some of the more ambitious ways in which *The Dinner Party* institute served as a foundation for moving forward. Many other

teachers left *The Dinner Party* institute determined to address the issues of social justice in their teaching, not necessarily as full-blown units of study but in smaller ways. What follows are some ways in which teachers took the content of the institute and a commitment to activism back to their respective settings. One teacher asked students to bring in examples of artwork made by women in their families, including handwork. Another made a feminist sock puppet video that addressed the injustices and inequities she witnessed in the school system. Still another had school-wide Dinner Parties to honor women. Two teachers transformed their art room to recreate the hushed and reflective environment of *The Dinner Party* installation in an effort to create an atmosphere of respect and for students to become a "part" of the work. A teacher had students become activists by writing letters to the U.S. Postal Service and their congressional representatives to feature women represented in *The Dinner Party* on postage stamps. Other lessons examined issues of gender identity and representation, silence and voice, and gender stereotypes. These examples of activist art and pedagogy can be found in the lessons posted on the website (http://www.throughtheflower.org). In addition, an evolving section of the website titled *From the Field* features lesson plans submitted by teachers who were inspired to take action after learning about *The Dinner Party* Curriculum Project.

Implications for Engagement with *The Dinner Party*

Designing and implementing K–12 curriculum around a feminist work of art such as *The Dinner Party* can be an act of social reconstructionism. In the curriculum examples provided above, activist art inspired activist pedagogy. Messages from the art spurred objectives of teaching toward social justice and social change. Both Andrea Horn's and Hannah Koch's curriculum focused on providing students with tools to become agents of change. Students critically analyzed the ways in which social phenomena emerged and were perceived so as to think about and create their new reality, one that was more just.

Activist Pedagogy

When educators choose to initiate activist pedagogy, there is accountability to our future. The curricula described above and found on http://www.throughtheflower.org contain models of activist pedagogy. Through students' analysis and interpretation of big ideas garnered from *The Dinner Party*, educators can activate students' skills and dispositions of recognizing conditions of power and empowerment. Educators can model critical thinking, reflection, social responsibility, and other tools necessary for students to identify inequities in power.

In both featured units of study, students are to critically examine and question power. The students critically consider: Why are men's contributions to the world and throughout history more recognized? Why do exclusions exist? How do artists and visual culture represent power? And so forth. By critically thinking about power in other times and places, such as during the American Women's Suffrage Movement, students can gain contextual knowledge that fosters feminist and activist dispositions.

Both Horn's and Koch's pedagogy modeled egalitarian classroom principles. Students were free to individually reflect and co-construct meanings. Through opportunities of personal reflection, students can consider how their actions, deeds, and dispositions can improve the world. Significant to seeing equitably and anew is reflecting on others' actions, such as when students assess the strengths and contributions of all members of a collaboration or learn to harness strengths of many individuals so as to complement and cultivate each other for a greater power. Reflection helps discover the overlooked.

The Dinner Party Curriculum Project illuminates Judy Chicago's social responsibility as an activist artist who exposes and acknowledges the overlooked history of women's contributions to Western Civilization. In the featured units of study, students also played roles of activists, where their art spoke to discrepancies in history and visual culture. As artists, students can recognize the power and contributions of visual voice. As increasing numbers of teachers embrace *The Dinner Party* Curriculum, the legacy of grass-roots activism, so vital to the creation, exhibition, and permanent housing of *The Dinner Party*, is sustained.

Reconstruction of Our Future

Teaching directed at social justice, as modeled in *The Dinner Party* Curriculum Project, consists of humanizing a community of learners to become agents of change. Change then emerges from building social capital with those who will act in ways that make for social justice in the future. By investing curriculum inclusive of activist art and activist pedagogy aimed at developing students' dispositions of critical thinking, reflection, and social responsibility, educators invest in a changing consciousness.

References

Chicago, J. (1996). *Beyond the flower.* New York: Viking.
Garber, E., Sandell, R., Stankiewicz, M.A., Risner, D., with Collins, G., Zimmerman, E., Congdon, K., Floyd, M., Jaksch, M., Speirs, P., Springgay, S., & Irwin, R. (2007). Gender equity in the visual arts and dance education. In S. Klein (General Ed.) & C. Kramarae (Ed., Part

IV), *Handbook for achieving gender equity through education* (pp. 359–380). Mahwah, NJ: Lawrence Erlbaum Associates.

Lewis, M. (1992). Interrupting patriarchy: Politics, resistance, and transformation in the feminist classroom. In C. Luke & J. Gore (Eds.), *Feminisms and critical pedagogy* (pp. 167–191). New York: Routledge.

Luke, C. (1994). Feminist pedagogy and critical media literacy. *Journal of Communication Inquiry*, *18*(2), 30–47.

Maher, F. (1987). Inquiry teaching and feminist pedagogy. *Social Education*, *51*(3), 186–192.

Maher, F., & Thompson-Tetreault, K. (1994). *The feminist classroom*. New York: Basic Books.

Nordlund, C., Speirs, P., & Stewart, M. (2010). Fifteen principles for teaching art. *Art Education*, *63*(5), 36–43.

Reinharz, S. (1992). *Feminist methods in social research*. New York: Oxford University Press.

Speirs, P. (1998). *Collapsing distinctions: Feminist art education as research, art and pedagogy*. (Unpublished dissertation). Pennsylvania State University.

Stewart, M., & Walker, S. (2005). *Rethinking curriculum in art*. Worcester, MA: Davis Publications.

Through the Flower (Producer), & Amend, K. (Director). (1976). *Judy Chicago's The Dinner Party: A Tour of the Exhibition* [motion picture]. United States: Through the Flower.

Wiggins, G., & McTighe, J. (2005). *Understanding by design*. (Expanded 2nd ed.). Upper Saddle River, NJ: Prentice Hall.

Acting Up In and Out of Class

Student Social Justice Activism in the Tertiary General Education, Fine Arts, and Performing Arts Curriculum

LISA LANGLOIS

Introduction

In the fall of 2008, 90 students enrolled in the pilot semester of a new course, Art 110/Wst 110, *Gender and Contemporary Visual Culture*. Over the next 16 weeks students developed visual literacy skills through analysis of print advertisements, children's book illustrations, documentary films from the Media Education Foundation, television shows and commercials, and discussion of artworks by contemporary feminist, activist artists. While they likely enrolled in the new course in order to fulfill two General Education requirements—Tolerance and Intolerance in the U.S.,[1] and Fine and Performing Arts—most of them reported in course evaluations that they had changed their views on social issues, especially gender-based injustice, and that they valued the required activist art projects done for the class.

This chapter discusses the teaching of visual literacy and social justice through contemporary media, examples of contemporary activist artists, and directed assignments that allow students to experience the creative process and activism through making, sharing, and reflecting on their own artworks. I will describe interactions with students in this course both from fall semesters in 2008 and 2009 to address the question of how art aids the transformational process in college students' early adult maturation. In particular, analysis of the content of students' activist art projects and their artists' statements indicates the areas of injustice that they cared about and wanted to change.

I designed the course for first-year students for four reasons. First, new college students are at risk for substance abuse, intimate partner violence, rape, and STDs, and this course provides a safe place to raise awareness. Second, because they are new to college-level learning, they might be more open to artistic experimentation. Third, because they would likely be engaged in psychosocial developmental tasks of developing their identities and autonomy, reflecting on their values and attitudes would seem natural. Fourth, first-year students do not have established circles of friends on campus, and introducing them to activist student organizations right away might encourage them to join and to join with their classmates. Many of these students took their activism outside of the classroom: students of all genders eagerly displayed their activist artwork and artists' statements in a show at the college's scholarly and creative arts conference day, and several declared Women's Studies majors and minors. Some joined the student organization *Two and a Half*, which is dedicated to sexual assault education and prevention.[2] Others took part in the campus Women's Center, "Take Back the Night" marches, performances of *The Vagina Monologues*, and the original, student-written-and-produced "Raise Your Voices" performance, which advocates against sexual assault and relationship violence.

In end-of-term course evaluations, notes to me on exams or assignment sheets, and conversations, many students said that their attitudes had changed significantly. Many reported discussing media with their friends and family and being unable to "just watch" TV or read magazines without critiquing the images. A few said the course was "too feminist," but most students said they liked the course and that they learned a lot. Several students described a transformational moment along the lines of *Until x number of weeks into the semester, I thought you were making a big deal over nothing. Then I realized how sexist and racist the imagery was and I started to see it everywhere.* This essay examines why the constellation of teaching critical thinking, through visual analysis, reading, art making and reflective writing on art, promoted that transformational moment and—more importantly—the enduring activism so many students undertook outside of class. I will suggest that by encouraging students to use multiple intelligences and "studio thinking" (Hetland, Winner, Veenema, & Sheridan, 2007), the course model encouraged multicultural education (Cahan & Kocur, 1996/2004; Ukpokodu, 2010) and facilitated students' feminist activism.

The Students

First-year college students have not completed their transition to full adulthood physically, cognitively, psychologically, or socially (Kuther 2005; Lewis, Mirowsky,

& Ross, 1999). While the State University of New York at Oswego, like other institutions, serves a diverse student body that includes transfer students and nontraditional adult learners, the majority of our first-year students are between the ages of 18 and 21. These students make the transition from adolescence to adulthood at college, which studies show has a positive effect on cognition, identity and self-esteem, and (among other things) openness to new ideas and attitudinal shifts toward "individual freedom: artistic and cultural, intellectual, political, social, racial, educational, occupational, personal and behavioral" (Pascarella and Terenzini, 1991, p. 326;[3] Strange, 2003). Away from home, these students simultaneously learn relativistic thinking, which requires a willingness to recognize the validity of different perspectives, and they individuate from their families, defining their own values as they encounter new people and situations on the college campus.

SUNY Oswego is a residential, comprehensive university located in a rural area on the shores of Lake Ontario. Our students number just under 8,000 undergraduates, nearly all of whom are New York State residents, and 70% of whom are between the ages of 18 and 21 (SUNY Oswego Fact Book, 2009). Thus the first-year students enrolled in Art 110/Wst 110 fit the profile of young adulthood, though their family, geographic, cultural, and educational backgrounds may differ in a number of ways. According to the college's Fact Book (2009), 87.4% of the undergraduates self-identify as white, non-Hispanic; 4.3% identify as black, non-Hispanic; 4.8% identify themselves as Hispanic; and 1.9%, 0.4%, and 1.1% self-identify as Asian/Pacific Islander, Native American, and Non-Resident Alien, respectively. Many of our students are first-generation college attendees. Women students outnumber men at a ratio of 55:45. Of the 208 students enrolled in Art 110/Wst 110 over the two years, 154 (79%) were women, and 54 (21%) were men, although the gender make-up of the class was not determined entirely by student preferences. Incoming college students are placed in three courses before their arrival and only choose two courses with the assistance of an academic advisor. In 2008, the course was brand new, added to the course offerings late in the summer, and many students were pre-enrolled. Others chose it during first-year orientation and advisement in August, due to the scarcity of seats in other classes. First-year program coordinators informed these advisors that it "double-dipped," filling two General Education requirements. That year, of the 93 students enrolled, 66 (71%) were women, and 27 (29%) were men. The following year I saw a larger number of women students who elected the course based on the recommendations of their friends, but also who enrolled despite being Art or Women's Studies majors or minors. This in part explains a shift in gender ratio of 73:27 women to men. More interesting is that in 2008 men were more likely to enroll in 110 with an Art prefix than a Wst prefix, but in 2009 male enrollment was nearly identical regardless of course prefix.

General Education Goals

Targeting two General Education requirements for this course made sense because: (1) due to their content, Women's Studies courses have thus far always met the standards for Tolerance and Intolerance; (2) in my Women's Studies courses students have informally reported that learning media literacy—and visual literacy in particular—leads to an increased awareness of sexism and racism; and (3) as an art historian, I already teach about feminist and activist artists to some degree in all of my upper-division courses. Introducing them earlier made sense because the existing prerequisites for the advanced course inadequately lay the foundations in Women's Studies, the history of women artists, and the basic theoretical frameworks used in Gender Studies.

Art 110/Wst 110 was intended to introduce the material to the young adult population described above, but also to recruit and prepare students for more challenging courses, such as Art 357, *Gender and the Arts*. Offering a course meeting two General Education requirements would guarantee that the course would be filled each term. Prior to the first offering of 110, I shepherded it through governance and then submitted it to the General Education Board for consideration for not only the Tolerance and Intolerance requirement, but also for the Fine and Performing Arts (hereafter FPA) category. The decision to pursue this approval had a twofold purpose: part pragmatic, part pedagogical.

The university needed more seats in FPA courses in order to graduate our students on time. The newly formed School of Communications, Media and the Arts provides nearly all of the seats that meet this New York State-mandated requirement. The Art Department supplies a limited number of seats in non-major targeted studio courses, but can neither accommodate larger numbers of students in the facilities nor afford to dedicate our few professionally equipped, OSHA-approved, and NASAD-accredited studios to classes that do not provide advanced training for our majors, especially the BFA students in studio areas and graphic design. NASAD (the National Association of Studio Art Departments, the organization through which the SUNY Oswego Art Department is accredited) maintains standards of best practices and safety, which require professional facilities with features not found in standard liberal arts classrooms (e.g., cutting-edge computers and software, ventilation systems, hazardous materials storage and disposal, and specific emergency medical equipment such as eye-wash stations). The other avenue for FPA requirement has been a lecture-style art appreciation course, Art 100, that surveys art history and art issues and requires some artistic work such as sketches, journaling, and/or a final collage or drawing. The precedent of a large lecture course that seats 100 students and offers a measurable outcome for "understanding the creative process" facilitated the design and

General Education FPA approval of 110. The new course doubled our capacity for FPA seats for non-majors.

Pedagogically, Art 110/Wst 110, requiring students to make art objects, fulfilled the spirit of New York's FPA requirement, particularly because students submitted an artist statement (based on a series of questions reproduced below) that explained their working processes. Students had to justify their design decisions and demonstrate mastery of the art content by using appropriate terminology. Moreover, students were required to provide a title for each work, a sentence identifying its activist content, a written statement explaining how their design choices support their activist content, and cite at least three feminist readings that informed their decisions. In this way, art majors did not have any advantage over their peers: no matter how skillfully they crafted their projects, their grades depended equally on the demonstration of mastery of the Women's and Gender Studies content.

Despite my advice at the beginning of the semester that art majors should drop the class, each year approximately 10 remained enrolled. They were cautioned that they were limited in the number of credit hours they could take in the Art Department and therefore would do well to save these three credits for an anticipated upper-level course in their areas of concentration. If they chose to remain in the class, they had to commit equally to the feminist component of the course—strong visual work alone would not be rewarded with high marks. In the end, having art majors involved enhanced the general class experience in a way similar to that of the balance of teaching assistants.

In 2008 three students assisted the course: one Women's Studies major, one Childhood Development major with coursework in Women's Studies, and one Art major (studio) who also had taken Women's Studies courses. Since the three T.A.s each presented one time on the material of their choice, and they each met with students in office hours, an atmosphere of collaboration among the four of us seemed apparent. In turn, students collaborated with each other on their art projects: as proofreaders of artists' statements, models for photographs and drawings, actors in videos, and photographers of student performances.[4]

Teaching Methods

Delivered to nearly 100 students in a large hall, 110 would certainly be considered a "lecture course." That said, the material comprised provocative readings and images that could help students practice higher-order thinking and problem solving. In this next section, I will describe some of the activities we tried when working through various kinds of materials. It is striking how a method "works" well with one kind of issue, and yet the same approach and activity might derail discussions

of a different topic. Generally speaking, I strove to incorporate student participation in active learning through a variety of strategies; class time often involved open discussions on images, think-pair-share, and short writing or drawing exercises. For example, before an open discussion of a print ad, students would jot down what they noticed, share with a partner, then participate in the general analysis of the image and its text. At other times I asked them to write a paragraph reflecting on a topic in class, their experiences with an issue (or cultural phenomenon) before college, or in reaction to a film or reading. To the best of my ability I avoided lecturing—except for early presentations that defined terms. Instead I modeled describing and analyzing images (worked examples),[5] or checked comprehension during follow-up to small-group collaborative work.

Passive learning was avoided even when watching videos. Instead, students completed worksheets designed to facilitate note taking on concepts, which were referred to in subsequent classroom discussions, and always turned them in. This use of guided note taking with open-ended questions allowed me to get a feel for the students' comprehension of content and their attitudes toward issues. I had (accurately) anticipated that they would be valuable tools for teaching, correcting misunderstandings, addressing biases, and encouraging students in their pursuit of individual topics for their art projects. What I had *not* anticipated was students' use of these sheets as a way to communicate very personal stories about their own childhoods, upbringings, psychological problems, and personal aspirations. These, coupled with the art projects and artists' statements, so moved me that I decided to publish this chapter. My goal is to share what worked, and what did not work, in the hope that others might find something useful to incorporate in their classrooms. It seems to me that if some of these activities began in the senior year of high school, our students might arrive on college campuses prepared for first encounters with the joys and dangers of their first experience away from their parents.

As described above, students produced artworks and statements that reflected on their intended artistic message and how they communicated their meaning visually. In the fall of 2008, students in 110 completed two activist art assignments. The first called for a two-dimensional artwork relating to the material covered by the midterm, and the second required a three-dimensional artwork concerning the second half of the course. Because I had three teaching assistants, collecting, evaluating by a common rubric, and returning student work was hectic but reasonably well managed. In the fall of 2009, the teaching assistants who had intended to participate had to withdraw—each for a different reason—before the term began. Thus with my enrollment increased from 90 students (2008) to 115 students (2009) and no student assistants, I reduced the art project component from two assignments to one. Astonishingly, an overwhelming number of students' evaluations said they enjoyed doing the artworks and wished there had been a second assignment. This confirmed

my impression that applying their knowledge of both design skills and gender analysis to a problem about which they cared deeply is what made this course effective.

Course Content and Examples of Teaching Strategies

Separation from family during the first semester of one's college years allows the distance necessary for the young adult to reflect on her attitudes. Exposure to new frames both by coursework and peer interaction encourages thinking beyond binaries. Young adults shift from absolute confidence in their worldviews, as learned in childhood, to relativistic thinking in college (Perry, 1981; Perry, 1970; Chickering & Reisser, 1993). The breadth of knowledge encouraged by General Education programs at this level and the multiple perspectives from which students examine problems enables them to see that sometimes the answer "depends" on the situation.

Part of this journey includes reflection on their childhood and their family's values. I observe three types of denial that sexism and racism impose on Americans individually and collectively. First, students believe they are immune to advertisements; they think other people are easily duped, but that they are un-swayed. Second, many students defend sexist and racist advertisements, songs, television shows, movies, and so forth as being intended as jokes, or that critics exaggerate the case. This defense depends on an assumption that those who challenge biased imagery are making a big deal out of nothing or simply "can't get a joke." To defend this position, students find the "exception" where a white or a male is treated similarly. Third, some quietly resent any questioning of media that they have enjoyed as children or young adults.

To address skepticism that advertisements might impact their behavior, I first modeled rejecting a binary, either-or argument. Instead we applied Cortese's (2008) more nuanced theory that advertisements use nostalgia and postmodern self-deprecation to appeal to today's consumers. Practicing visual analysis of advertisements for the widespread "Take Me Fishing" campaign, students clearly identified how nostalgia worked together with gender to create a biased stereotype of girls. This interpretation relies on an acceptance of the notion that advertisers, or indeed "the media," recycle the imagery and attitudes that already exist in American culture. Ads don't *cause* discrimination, they reflect its existence and reify the attitudes that underpin privilege and oppression in our culture. The advertisements that most moved students both years were two print ads by the U.S. Army recruiting parents to support their children's decision to join the army. Comparison of ads targeting white families versus black families in the same publication, *Reader's Digest*, revealed how the stereotype of a homogeneous "white" experience included socially and culturally valued traits (intact marriage, wealth, female retreat from paid work, etc.), while the

stereotype of black families included absent fathers and the resulting necessity for black women to work outside the home. While these might have seemed "natural" to the students at first glance, analysis of the ways that camera angles, lighting, composition of the image, and the texts are used in these ads convinced nearly everyone that they contributed to feelings of white supremacy and reinforced stereotypes that supported discrimination against people of color. Of the many comments on the course students made in their writing or in evaluations, the most commonly cited example of a turning-point in their attitudes was this advertisement. Many students said that they had not believed sexism and racism were still relevant until seeing the "Take Me Fishing" and U.S. Army recruitment advertisements.

Two themes run through the attitude that popular culture is entertainment and thus not to be taken seriously. First, students voiced the theme that feminists overreact to visual culture when the topic of analysis was really "only a joke." I assigned the essay "Heckling Hillary: Jokes, Late Night Television, and Hillary Rodham Clinton," in which Banks Thomas (2007) argues convincingly that the frequency and tenor of "jokes" about political candidates differ along gender lines. After describing how jokes work—the rhetorical devices commonly used—she finds that the discourse regarding Rodham Clinton focused on personal attacks against her character or appearance, while "jokes" about male candidates focused on policies.

Cortese (2008) also addresses the phenomenon of the "joke" in advertisements, but from the perspective of marketing strategies. He argues that modern advertisements comprised a series of images and words intended to genuinely describe the desirable qualities of products and the benefits they would bring to purchasers. Postmodern advertisements, instead, recognize that (depending on the product being marketed) audience members often prefer companies to make self-deprecating ads instead, or to include jokes that mock their corporate identities. So while students are correct in seeing these as intending to be funny, they only understand how the messages contained in the jokes depend on stereotypes that reinforce injustice and cultural misunderstanding.

A pitfall in using popular culture from students' childhood is the resistance to critical analysis of the intersection of gender, race, sexual orientation, physical ability, and social class in objects and images they had enjoyed as kids. In discussions I had facilitated in other courses, some students complained that analyzing Barbie or the movie *Pretty Woman* had "ruined" fond childhood memories.

In anticipation of that reaction for 110, in 2008 and 2009 I tried both to distance the objects of analysis from feelings of nostalgia *and* to validate students' memories of pleasure playing with toys or of enjoying books and television shows. This helped students feel that it was the toy—not the child's enjoyment of playing with it—that needed critical evaluation. On the very first day of the course, and frequently afterward, I told students, "You will see nothing in this section of the course [childhood

socialization] that is not in my house. It isn't the toy that is dangerous, it is the im-
plications of the messages attached to it." Frequently, when I showed a slide of an
image from a children's book or toy advertisement, I disclosed that it belonged to my
daughter, explained why I wanted to discuss it in class, and related how I had inter-
acted with my daughter when playing with the toy or reading the book.

That it is *how* we use children's toys and media, not their existence or children's
enjoyment of them that matters, is exemplified by an in-class exchange with a stu-
dent-parent. My student had returned to school after having a child and was one
of the more mature in the class, though only 23. She said that despite her attempts
to raise her daughter (then 3 years old) as free of harmful gender stereotypes as
possible, her child insisted on pretending she was a princess and begged for
princess dress-up clothes. Assuming that as a Women's Studies professor I wouldn't
approve of princess-play, she wanted to know how I had taught my own daughter
that the princess ideal was "wrong." My student said she never wore dresses and
couldn't understand why her daughter wanted to do so. I complimented her on her
engaged and thoughtful parenting and said as a Women's Studies professor that I,
too, worried about the messages my daughter received from popular culture and
whether or not I should restrict her toys and the content of her books and play.
Then I told her about a conversation I had with my daughter when she was 3 years
old and had received a Cinderella costume from her aunt. My daughter was de-
lighted and wanted to wear it all the time. Thinking that the more forbidden the
fruit, the stronger its appeal, I tried a new strategy: instead of making her feel bad
about her princess-play pleasure, I asked her why she wanted to wear the dress
(which of course came with scepter, shoes, tiara, etc.). "Is it because you want to
look grown up like mommy?" I guessed, and she said, "Yes, you are pretty and I
want to be like you." My reply was, "I want to be like you, too." I was hardly a glam-
orous dresser and I never wore dresses (or tiaras, for that matter), but I suspected
that her mimicking of many other things I did might provide a clue. My daughter
"played" by putting index cards in little boxes between alphabetized dividers and
carried a notebook that she proudly told her pre-school teachers was her "disserta-
tion." At the next class meeting, my student ran up to tell me that she had asked
her daughter the same question and had gotten the same answer. In class she
shared with her 90 peers how valuing her daughter's attempts to mimic her (in the
only way she could) actually led to *less* princess-play and *less* rigid gender-perfor-
mance, not more.[6] As a group we then talked about how mass media and toys were
pivotal yet extremely limiting in the range of ways a child learns to practice that
same-gender emulation, but that as adults we can help children expand that range.

Surely I could then have introduced—however briefly—psychoanalytical theory
or childhood development, and perhaps that would have been better pedagogically;
I also could have talked about long-term implications. However, I did not want to

lose the obvious consensus among the group that toys and movies targeting small children provided a narrow picture of femininity. We re-examined some examples from children's literature briefly and reviewed concepts introduced the previous week: gender identification, prescription, proscription, and difference. Walking through a quick review of an in-class analysis we had done that critiqued Disney's picture book *How to Be a Princess* allowed them an opportunity to use new tools (vocabulary, analysis of the relationship between the pictures and the words, and analogies to anecdotal stories from myself and the student) to objectively critique the material. Acknowledging that children *do* enjoy products targeted for them (and that thousands of talented experts conduct focus groups to figure out *how* to appeal to children and their parents) distanced the students in 110 from culpability for buying these things—and its implication—that being economically dependent on their parents, enjoying their childhood toys, and remembering the experiences fondly was OK. Yet that didn't mean that they should not reflect upon the stereotypes and how they might negatively affect individuals directly or through lack of alternative role models, and so advocate for more alternative images of gender for all of us.

The first time I taught *Introduction to Women's Studies*, I learned from my male students how much they resisted the limiting prescriptive and proscriptive gender schema enforcing a one-size-fits-all [American] masculinity. Students were asked to write a three-page paper about how they were forbidden to/or allowed to play with a toy that was presumably marketed to their "opposite" gender. Predictably, girls were allowed to transgress gender prescriptions more readily, within boundaries, while boys were restricted from doing the same. By prohibition, punishment, and/or mockery, boys are not allowed to play with "girls'" toys. In particular, college-aged men discussed their feelings about the Easy Bake Oven. In large class discussions not only in 110, but in other courses as well, when men describe their frustration over watching their female peers (sisters, cousins, neighbors) using the Easy Bake Oven, most students agree that it is silly for parents to discourage such play. The writing experience and student-led teaching, facilitated by printed, open-ended questions, generally begs the question, "Why are girls allowed to be tomboys when boys are punished as 'sissies' if they transgress childhood gender roles?" To introduce the concepts of "othering," "difference," "hierarchies of difference," and "privilege" is—pardon the pun—child's play

The lessons, which focused on media created for children, emphasized the complexity in the ways individuals experience popular culture and their agency in shaping their own values. I tried to convey this in two ways: first, by having students answer open-ended questions during a viewing of *Barbie Nation* (Stern, NewDay Films, & El Rio Productions, 1998), and second, through the introduction of artists who appropriate Barbie dolls in their activist artworks. Both the film and the selected artists demonstrated strategies for resistance against sexism,

racism, heterosexism, and able-ism in particular, through appropriations of iconic images such as Barbie. Instead of supposedly "ruining" cherished childhood memories and causing college students to either (1) reject the messages of feminism, anti-racism, and multiculturalism, or (2) feel embarrassed about their childhood pleasures, I asked them to consider how the intersection of systems of oppression and unexamined privilege shape our collective attitudes. *Barbie Nation* appealed to students' sense of empowerment in consuming and interpreting mass culture.

Finally, they studied individual artists and their visual strategies to engage viewers and challenge others to question their cultural assumptions. I argued that activist artists such as the Guerrilla Girls and viral activists such as Forkscrew Design participated in consciousness-raising campaigns that spurred further action. Intrigued by the work of Bachman and Attyah (2000), I designed activist art projects through which students could apply what they learned in class and formally share it with their peers.

Student Work

Artists studied that fall were early trailblazers such as Judy Chicago, Lee Krasner, Betye Saar, Faith Ringgold, Adrian Piper, and Ana Medieta, among others. Also examined was contemporary work by established and emerging feminist activist artists such as Rene Cox, Alison Lapper, Barbara Kruger, Jenny Holzer, Cindy Sherman, Jenny Saville, and, of course, the Guerrilla Girls. Yet we couldn't study their work without considering sexism in the art world and the gendered expectation that the creative act is inherently masculine (Jacobs, 1997; Piper, 2010). Most of these artists critique the canon and what Piper has called the "triple negation of colored women artists" (Piper, 2010). The resistance to sexism in art history and the art market is intertwined with the kinds of gender-based oppression they address in their works: violence against women, sexual assault, the body, and the intersection of gender, race, sexual orientation, class, and physical ability.

The activist artwork studied not only served as a model for targeting social injustice, but also as a strategy for a visual critique. The artists whose work was tied most closely to advertisements formed a basis for applying the visual analysis skills the students had developed early in the term. Barbara Kruger had, of course, worked in design, and her ironic appropriation of advertising imagery and slogans from the 1940s and 1950s are easily understood by students because of their extremely gendered and anti-consumerist messages. The Guerrilla Girls' (1998) posters deploy eye-catching design and color to frame their messages and their direct confrontations of museum and gallery curators, critics, and art consumers. Forkscrew Graphic's parodies of iPod advertisements in their iRaq campaign were

easy for students to "read" because of the iconic Apple imagery. Where students needed help, however, was in understanding historically distant allusions and more complicated issues. For example, Rene Cox's "Hottentot Venus 2000" held no associations for them and, like students in the upper-division course Art 357, it had to be contextualized. Students read works by O'Grady (2010) and Gilman (2010), who write about representation of black womanhood and white sexuality in Manet's painting *Olympia* and 19th-century racialized discourses of female sexuality through analysis of *Olympia* and of materials concerning Sarah Bartmann.

Students were required to complete a creative project, thus fulfilling the State of New York's General Education requirements for Fine and Performing Arts, as well as our campus multicultural requirement. The two-dimensional work, in any media or format, had to address an issue covered in the course. Many students made collages, not merely because they believed they would be "easier" but because they were samples from the media they critiqued. In addition, each project had to be accompanied by a form detailing the reasons for each choice the student made both in content and design. Analysis of projects submitted in 2009 suggests that both male and female students who enrolled in 110 that fall, like many students in 2008, were concerned with addressing the media's role in creating distorted perceptions of gender roles and standards of beauty, as well as the implications for self-esteem and discrimination. Out of 90 submissions, 32 in some way addressed unrealistic female body images or standards of beauty in advertisements. Of these students, 26 were women and 6 were men. Only 5 students addressed male body image or standards of beauty, 2 female and 3 male. Related subjects such as eating disorders, cosmetic surgery, male steroid abuse, muscularity as masculinity (Katz, 1999) sometimes overlapped with the dominant themes. Many students either incorporated images of Barbie, cited readings dealing with Barbie, or commented in informal asides handwritten on their statements. It seems that Barbie, as a cultural phenomenon, formed an effective bridge between childhood socialization and young adult anxieties about physical appearances. The second-largest group of projects (9) addressed childhood socialization and female subordination.

Disappointing was the lower-than-expected appearance of themes including gender and anti-violence, anti-war, anti-rape, and anti-racism projects. In 2009, six projects concerned violence and rape; one addressed intimate partner violence wherein men are victimized. Whereas in 2008 at least five projects had an anti-war message coupled with a critique of masculinity, none did in 2009. Only six projects directly took on racism or the intersection of gender and race as their primary topic. Racism and its intersection with sexism appeared more frequently in 2008. While I cannot *know* the reason why, several factors seem likely. In the fall of 2008 George W. Bush was still president, and an end to U.S. involvement in Iraq

seemed unlikely; moreover, in November we had elected our first African American president. The politics of gender and race were constantly discussed, and as a class we watched live when John McCain named Sarah Palin as his vice presidential running mate.

In 2009 Barack Obama was president, and our collective worries focused on the economy and record-high unemployment, which for the first time in decades affected whites in a high enough number to make the news. Our "withdrawal" from Iraq was policy and was barely discussed. Instead of uniting people in pursuit of common goals, media became even more divisive with its coverage of the Tea Party movement. Trivialization of Hillary Clinton, and Nancy Pelosi, the firing of Shirley Sherrod from the Department of Agriculture, and investigation of members of the Congressional Black Caucus: all distracted media consumers from mounting war casualties, increased homelessness, and suicide.

As part of the politics of mass distraction, we have sports to confirm stereotypes and comfort whites generally and white males specifically in hard times: Tiger Woods confirmed fears of the hyper-sexual black male (hooks, 2004), and we had a heated discussion in class over the record fine imposed on Serena Williams for yelling at a line judge during a tennis match. Some students felt—unprompted—that her status as a woman and as an African American threatened officials, so her fine was unprecedented. In effect, they said that her transgression of her dually subservient roles had to be punished. Others claimed tennis was an elite, high-class sport with different rules. Despite the example of John McEnroe, they held that tennis and golf were "different" and that Williams's behavior was much worse than anyone's before her. The "tennis is different" camp seemed more rigid in its defense of the fine than any other of the shifting position/groups all semester. It was the only class where acrimony was palpable, and I believe that the increase in student evaluation comments in 2009 over 2008 that the course was "too feminist" is perhaps attributable to that debate. I can confirm that that unit on gender and sports in the media inspired many projects concerning the sexualized portrayal of female athletes and the lack of coverage of women's sports—topics only two students addressed in 2008.

Strategies for conveying their messages correlated with their subjects. In their written statement, students provided a title for their artwork and described both the subject matter and the content of their piece—it was by identifying the content as their own activist message that many of the projects succeeded. For example, critiques of sexism in childhood socialization frequently took shape as books or flap books; critiques of the role of advertisements or celebrities in fostering unrealistic beauty standards for men and women frequently took advantage of collage; artwork raising awareness about eating disorders often took shape as drawings or paintings, because students often divided the human figure into two halves in order

to graphically contrast the reality of sufferers' bodies with the distorted self-images they often hold. Projects that took on plastic surgery, sexualized violence, or the intersection of gender and race could be collaged or mixed media, allowing students to include handwriting, photographs of themselves or friends, and texts ranging from poetry or rap lyrics to diary entries. Generally, parody played a role if consumer culture was part of the critique.

Example of Student Work

Non-art major Amy Chamberlain's "Monster Beauty" used visual language to critique the narrow range of beauty standards promoted by the industry. This excerpt shows how she described the content of her painted critique:

> Though these standards are unrealizable for most of the female population, constant repetition makes them seem normative.... These industries bank on the common misconception that if a woman doesn't fit the physical convention (or has an "intrinsic defect"), she can be amended; "beauty" is attainable for any woman who purchases and uses certain products. This painting literally illustrates the phenomena above in the only word I see fit: monstrous. I swapped the faceless "industry" with devilish monsters in a diabolical workshop.

Ms. Chamberlain's full artist's statement demonstrated mastery of several concepts introduced in the course, such as market segmentation, how perceptions of an intrinsic defect build anxiety and lead to sales, "the make-over plot" (Ferriss, 2008) and how advertisements rely increasingly on digital technology to create an unattainable ideal. Her goal was to raise awareness of the profit motive that underpins the beauty industry and its de facto exclusion of all real—as opposed to digitally constructed—women.

Chamberlain's written work not only engaged in scholarly readings from the course but also applied vocabulary and concepts related to visual culture to her own evaluation of her painting.

> Starting at the top, three monsters flow across the canvas in a diagonal line meant to guide the viewer along the actions on the conveyor belts. I chose to make the "main monster" tower over the scene to denote his authority over events. I made the medium-sized monster smaller than the first to accentuate the tallness of the woman he is stretching. The tiny size of the third monster was also used to accentuate the tallness of the "finished product" women, as he has to stand on a very tall stool in order to paint their faces.

The student effectively explains the reasoning behind her compositional choice to have all the figures—human and monster—standing on a level ground plain while simultaneously varying in height: following the direction of the conveyor belts, monsters grow smaller while the made-over women grow taller. Thus in the left half of the composition, the figures vary in size, while on the right side, the figures—human and monster—are uniform in scale. Clearly the system results in normative beauty standards and a normalization of the process: the monstrous profiteering of companies that prey on women's insecurities are minimalized, if not trivialized, in our lived experience. Our understandings of our bodies are of course mediated by multiple and intersecting interests.

> The women I represented here are riding along the conveyor belt as if they are products being pieced together on an assembly line. They are interchangeably paper dolls or seemingly made of silly putty; with few defining characteristics of their own, these women are completely adaptable to whatever the beauty convention may be, and therefore more valuable to a society that stresses feminine physical beauty above all.

The political implications of Chamberlain's statements—visual and textual—are clear. Valuing women's ability to conform to the subjective and unstable standard of "beauty" over other achievements undermines the development of women's full capacities and, when achieved, diminishes the accomplishment and, of course, the rewards.

Conclusions

The students in Art 110/Wst 110, *Gender and Contemporary Visual Culture*, applied their study of basic design elements and technique, readings about social injustice and popular culture, and ability to do both visual and content analysis of the images surrounding them. In class they openly discussed issues that otherwise might have been difficult to share, including their personal experience of relationship violence, rape, eating disorders, and the pressure on both women and men to conform to body images and social behavior portrayed in popular culture. The women students were surprised to hear that their male classmates had similar concerns about their own bodies and to hear them describe their anxiety that a younger sister or niece was suffering from an eating disorder, or anger that a female college friend had been raped on campus. The men reported being astonished at the invisibility of male violence (Katz, 1999) and admitted to having been victims of violence and homophobic threats of violence. Student art projects ranged from collage, digital collage with Photoshop, assemblage, photography, video produc-

tion, sculpture, and book making. They participated in lively discussions in class and took their activism with them at the end of the term.

This chapter has used student writing and artworks to argue for the simultaneous teaching of visual, gender, and media literacy, and applied art education as a core for General Education to promote social justice activism.

Notes

1. New York General Education Guidelines include requirements in numerous areas, but "Tolerance and Intolerance in the U.S.A." is an additional general education requirement specific to the SUNY Oswego Campus.

2. *Two and a Half* was formed by a group of first-year students in 2006 in response to sexual violence on campus. The original executive board comprised both men and women and both the e-board and broader membership comprised mostly students of color. They held a tremendous range of events and public programming including presentations at Oswego's annual *ALANA* conference, lunch hour talks, evening discussions, films, workshops, outside speakers, poetry slams, fundraisers, and a culminating event originated by them, a performance called "Raise Your Voices." This original, student-written production changes each year. It also addresses broader implications of intimate partner violence, rape, child abuse, and substance abuse in families, which impact both women and men. The president, Fantashia Hamilton, asked me to be the organization's faculty advisor in August 2007.

3. Cited in Strange, C. "College and Its Effect on Students." *Encyclopedia of Education*, p. 236. GALE|CX3403200123.

4. Majors in Broadcasting, Graphic Design, Psychology, English, and non-declared students worked together.

6. In the following academic year this student became co-president of the Women's Center, co-organized events like "Take Back the Night," and co-directed (and performed in) *The Vagina Monologues*. Her daughter, who attends the SUNY Oswego campus childcare facility, frequently spent time in the Women's Center.

References

Bachman, S.A., with Attyah, D. (2000). Educating the artist: A political statement. In B. Balliet & K. Hefferman (Eds.), *The Practice of change: Concepts and models for service-learning in Women's Studies*. Washington, DC: American Association.

Banks Thomas, J. (2007) Heckling Hillary: Jokes, late-night television, and Hillary Rodham Clinton. In S. Innes (Ed), *Geek chic: Smart women in popular culture*. New York: Palgrave Macmillan.

Cahan, S., & Kokur, Z. (Eds.). (2004). *Contemporary art and multicultural education*. New York and London: Routledge. (Original work published 1996)

Chickering, A.W., & Reisser, L. (1993). *Education and identity.* (2nd ed.). San Francisco, CA: Jossey-Bass.

Cortese, A. (2008). *Provocateur: Images of women and minorities in advertising.* (3rd ed.). Lanham, MD: Rowman and Littlefied.

Ferris, S. (2008). Fashioning femininity in the makeover flick. In S. Ferris & M. Young (Eds.), *Chick flicks: Contemporary women and the movies.* New York: Routledge.

Gilman, S. (2010). Black bodies, white bodies: Toward an iconography of female sexuality in late nineteenth-century art, medicine, and literature. In A. Jones (Ed.), *The feminism and visual culture reader* (2nd ed. pp. 166–180). London: Routledge.

Guerrilla Girls. (1998). *The Guerrilla Girls' bedside companion to the history of Western art.* New York: Penguin Books.

Hetland, L., Winner, E., Veenema, S., & Sheridan, K. (2007). *Studio thinking: The real benefits of visual arts education.* New York: Teachers College Press.

hooks, b. (2004). *We real cool: Black men and masculinity.* London: Routledge.

Jacobs, F.H. (1997). *Defining the Renaissance virtuosa: Women artists and the language of art history and criticism.* Cambridge: Cambridge University Press.

Katz, J. (Writer). (1999). *Tough guise: Violence, media & the crisis in masculinity* [motion picture]. United States: Media Education Foundation.

Kuther, T. (2005) Young adulthood. *Encyclopedia of human development.* Retrieved August 28, 2010 from Gale Virtual Reference Library (Document ID CX3466300658)

Lewis, S., Mirowsky, J., & Ross, C. (1999). Establishing a sense of personal control in the transition to adulthood. *Social Forces, 77*(4), 1573–1599. Retrieved August 28, 2010, from Gale Opposing Viewpoints in Context, http://www.gale.cengage.com/InContext/viewpoints.htm

O'Grady, L. (2010). Olympia's maid: Reclaiming black female subjectivity. In A. Jones (Ed.), *The feminism and visual culture reader* (2nd ed., pp. 208–220.). London: Routledge.

Pascarella, T. and Terenzini, P. (1991) How college affects students. San Francisco: Josey-Bass.

Perry, W.G., Jr. (1970). *Forms of intellectual and ethical development in the college years: A scheme.* New York: Holt, Rinehart and Winston.

Perry, W.G., Jr. (1981). Cognitive and ethical growth. In A. Chickering et al. (Eds.), *The modern American college: Responding to the new realities of diverse students and a changing society.* San Francisco: Jossey-Bass.

Piper, A. (2010) The triple negation of colored women artists. In A. Jones (Ed.). *The feminism and visual culture reader.* (2nd ed. 273–282). London: Routledge.

Stern, S., New Day Films, & El Rio Productions. (1998). *Barbie nation: An unauthorized tour.* New York: New Day Films.

Strange, C. (2003). College and its effect on students. In J. Guthrie (Ed.), *Encyclopedia of education* (2nd ed., Vol. 7, p. 236). New York: Macmillan Reference USA. Retrieved August 28, 2010, from Gale (CX3403200123).

SUNY Fact Book 2008–9. http://www.oswego.edu/Documents/administration/institutional_research/Fact%20Book%202008-09.pdf

Ukpokodu, O. (2010). How a sustainable campus-wide diversity curriculum fosters academic success. *Multicultural Education, 17*(2), 27–37.

Interactive Social Media and the Art of Telling Stories

Strategies for Social Justice Through *Osw3go.net 2010: Racism on Campus*

PATRICIA E. CLARK, ULISES A. MEJIAS, PETER CAVANA, DANIEL HERSON, AND SHARON M. STRONG

Osw3go.net 2010: Racism on Campus, an Alternate Reality Game created by students in Dr. Ulises Mejias's and Dr. Patricia Clark's courses during the fall 2009 and spring 2010 semesters,[1] regarded the very real and material consequences of racism and other types of discrimination through a series of "what if" narrative scenarios. Alternate Reality Games (ARGs) are open-ended interactive narratives that are collectively played by participants in real time using a variety of Interactive Social Media including blogs, wikis, short text messages (SMSs), digital video, podcasts, and so on. Although ARGs are mostly used by advertisers as tools for viral marketing, *serious ARGs* (as they are known) take a real-life situation or social problem and imagine or simulate solutions or approaches to it as in, for example, the ARG *World Without Oil*, whose motto was "Play it before you live it,"[2] a motto adopted by *Osw3go.net 2010*.

However, can a serious ARG such as *Osw3go.net 2010* provide other ways of understanding, and perhaps combating or eradicating racism and other types of discrimination? Does the game really provide the mechanism(s) that allow participants to act otherwise both inside and outside of the social network? The authors of this chapter hypothesize that *Osw3go.net* can be used as a tool to address issues that are difficult for people to talk about face to face. However, this hypothesis is not formulated without considering the very nature of narrative, of storytelling, of language in conveying and contesting versions of the world as we know them. Interestingly, in considering the limits of language, the possibility of social

media as exceeding these limits becomes a matter for interrogation as well. So, what is at stake in considering the material use of Interactive Social Media for enacting social change, as tools for promoting the ideals of social justice, is understanding and unpacking the attendant theoretical implications that play into the construction of narratives or the creation of stories, their interpretations—within virtual contexts—and how these relate to the so-called real world.

This chapter will examine and assess how storytelling and other types of narratives can be used in new media to promote ideals of social justice through the ARG *Osw3go.net 2010: Racism on Campus*. More specifically, the authors will discuss how *Osw3go.net 2010* demonstrates the ways in which the use of new media foregrounds the recursive and collaborative elements of storytelling and writing (and reading) narratives, addressing problems in narratology that scholars such as Gerald Prince have pointed out, especially the fact that "there has been little extensive empirical and experimental (crosscultural) exploration" of "the 'voice' of the reader (or other contextual elements)" of narratives (Prince, 2001).

Ultimately, the goal of *Osw3go.net 2010* was to facilitate a campus-wide conversation focusing primarily on issues of social justice in a local context. However, the authors argue that the *Osw3go.net* experiment evinces the potential for Interactive Social Media to address a range of issues, rendering this new media as a powerful tool for students and teachers to foster an awareness of issues of social justice, both locally and globally. To this end, this essay also will offer strategies for the use of Interactive Social Media in K–16 classrooms.

Background of *Osw3go.net*

The objective in the case of a serious ARG such as *Osw3go.net: Racism on Campus* is not only to raise awareness about a social issue, but to collectively imagine a number of possible responses to it. This kind of scenario analysis can thus be framed as a form of Participatory Action Research (PAR), which is concerned with promoting social justice through research activities that directly involve the members of a community. PAR is a form of collective action through purposeful investigation *by* and *for* the affected community (Cahill, 2007; Fals-Borda & Rahman, 1991; Lewin, 1946; Zuber-Skerritt, 1996).

Serious ARGs seek to involve communities in analyzing a real-life problem, collectively articulating a multitude of realistic and possible responses to it and examining the ethical question of who has the responsibility to act. For instance, in spring semester 2009, before the creation of the *Racism on Campus* ARG, two of Dr. Mejias's classes[3] created an ARG in which they shut down the SUNY Oswego campus to protest budget cuts to the State University of New York system. In spite

of the intense attention the project generated at the beginning, the virtual nature of this simulated protest drove many outside the classes to consider it little more than a prank. But in the absence of any actual organized campus movement to protest the budget cuts, the degree to which the project managed to involve students who had previously little awareness of—or even interest in—New York State budget issues and their impact on public education serves as an indicator of the potential of this kind of endeavor.

Based on this initial experiment, a mission statement was drafted by students and faculty for an annual ARG exercise to be conducted at the college, called *Osw3go.net*.[4] This mission statement reflects the goal of exploring social justice issues through the use of Interactive Social Media as a way to engage the community in participatory action research through the production of narratives:

> Our mission is to conduct an engaging and interactive [Alternate Reality Game] to help our community address present and future challenges. We seek to involve the community in a constructive dialogue about what we can do, individually and collectively, to prepare to meet these challenges. Our focus is on raising awareness, facilitating the generation of solutions, and eliciting action and involvement from members of the community. Additionally, we want to research how new media can be used as a platform for simulation, collective problem solving, and social organizing. (*Osw3go.net 2010: Racism on Campus*, 2010)

As this statement suggests, the goal is to provide a safe space for participants to imagine alternate realities as collective narratives. These narratives enact conflict around social issues, and through them participants experiment with solutions, allowing them to go from imagined solutions to concrete ideas to actual acts—or "from the virtual through the possible to the real," as Hardt and Negri would say (2000, p. 357). In other words, the ARG allows participants to start with the potential or virtual, to give it shape, narrating it with Interactive Social Media, and by using this as a moment of collective self-reflexivity, to make it possible and real. The ARG, therefore, can serve to *intensify* social change. As subjects get involved in the ARG and participate as authors and storytellers, they do in fact narrate the change they want to see and intervene in their own social realities.

On Narratives, Interactive Social Media, and Social Justice

The ways in which ARGs utilize traditional modes of storytelling necessarily interrogate the relationship between the author and the reader, positing narratives as

negotiable sites. Hence, writing and telling stories can be understood as potentially powerful ways of fostering the ideals of social justice. Different types and modes of narration—from the traditional to fan-fiction—evince a dynamism that, at once, challenges the assumed singularity and authority of the author and the putative subordinate position of the reader. The fluctuating roles of author and reader present opportunities for dialogue that, as Gerald Graff puts it, is not merely about building consensus, but also engaging the "conflicts" or differences between all (Graff, 1989). With the very idea of narrative already understood as a site for exchange, the potential for teachers and students to enact, with critical awareness, what they write, tell, hear, or read about themselves and their world is great.

An example of how the creation of narratives and storytelling can be used in promoting ideals of social justice is through what Beverly Daniel Tatum (2007) calls "affirming identity," as one of a set of three strategies she identifies as

> the ABC's [A, *affirming* identity; B, *building* community; C, *cultivating* leadership] of creating inclusive learning environments—environments that acknowledge the continuing significance of race and racial identity in ways that can empower and motivate students to transcend the legacy of racism in our society even when the composition of their classrooms continues to reflect it. (p. 21)

For Tatum, some of the most effective ways of affirming identity for students whose lives are not reflected in the classroom curriculum or misrepresented in mainstream media is creating and telling stories about themselves. The acts of writing and telling "identity stories" are effective in that the stories of non-white and other non-mainstream identities serve to displace the privilege assigned to accounts of accomplishments and achievements by white people that pervade the curriculum and media in the United States (Tatum, 2007, pp. 32–38). This displacement of privilege through the writing and telling of identity stories can provide an opening for critical dialogue on racism and other forms of discrimination.

The potential democratizing effects of narratives are evident in Interactive Social Media, according to Anna Everett (2009), through the ways in which they combine conversation and writing, producing a "technological hybridization of speech and orality (conversation) and literacy (writing) that privileges neither" (p. 13). For Everett, this hybridization brings to the fore the plasticity of the media, making possible the creation and the discovery of social networks that allow "unfettered social and cultural expressions" (p. 14). While there is no guarantee that ideals of social justice—say, for mitigating racism and other forms of discrimination—will prevail in an environment with few or no constraints, the potential for enacting these ideals using a serious ARG bear consideration.

Osw3go.net 2010: Racism on Campus—Scenarios, Play, and Assessment

Osw3go.net 2010: Racism on Campus consisted of five narrative scenarios written by the students in Dr. Clark's seminar. Students were instructed to write the narrative in the style of a "breaking news" story that told players not only of the initial scenario but of possible changing events within the storyline. The purpose of the "breaking news" and update format for the scenarios was to solicit responses from the players and to ensure that the storyline continued. The scenarios were submitted to Dr. Mejias and his students, who edited and fitted the format for the ARG. The five scenarios used were Affirmative Action, Fraternity Prank, Grade Inflation, H1N1, and White Student Union. In addition, other elements in the ARG that players could respond to included a survey and short video clips, all of which ramified from the central focus of discrimination and racism.

Regarding the rules, there were several ways to play. One could choose to play as either himself or herself (as a character that would require creating an onscreen name and a login identity) or as one of the previously constructed characters in each of the scenarios (whose name and password were provided on the website). While participants were encouraged to play themselves, they could do so anonymously. To initiate the game, the participant selects scenarios from the five listed on the website to play. One could participate in just one or all five scenarios.

The Scenarios

The following are the initial "breaking news" stories for each of the five scenarios as they appeared in *Osw3go.net 2010: Racism on Campus* when the game first launched in November 2009:

1. *Affirmative Action*: An email widely circulated on campus claims that a candidate was recently denied a teaching job at Osw3go simply because she is white. A large number of faculty, staff and students in the Osw3go community received an email last week from M3redith Robinson, a recent applicant for a tenure-track position in the Department of English. In the e-mail, Dr. Robinson alleges that she was denied a job simply because of the color of her skin. The Osw3go Observer learned that the Department of English in fact just hired a Native American candidate to teach Medieval Literature. Dr. Robinson claims that she is better qualified than the candidate being hired. In a recent interview she stated: "Frankly, it's no big deal to me. I already got a job offer from an Ivy-League school. I just wanted the Osw3go community, specially the

students, to know that while their school claims to want to hire the best professors, in practice they are willing to let Affirmative Action determine who to hire. I know for a fact that I have more publications than the candidate being hired, and my degree is from a better school. It's a shame to deprive the students in this manner, really." The Osw3go Observer has thus far not been able to reach anyone from Human Resources or the English Department for comment.

2. *Fraternity Prank*: A lecture by a visiting Pakistani professor was disrupted by a student in what some are calling a hate crime and others a simple prank. The lecture, sponsored by the International Student Association and delivered by Dr. R4sa Noor, was interrupted by a male student who jumped on stage wearing a robe, turban, sunglasses and fake beard. Witnesses say he tore open the robe exposing a fake bomb strapped to his stomach, shouting, "It's Jihad time, bitches!" before making whooping cries. Witnesses also report that the t-shirt the student wore beneath the robe had the fraternity letters TK3 written across the chest. Edw4rd Marsha1l, a retired police officer and security guard for the event (not associated with University Police), responded quickly, grabbing the student and escorting him outside. Instead of detaining the student, however, Marsha1l let him go. "It was just a harmless prank," he said afterward. "It was done and over with. I thought the best course of action was to just send him away so the lecture could resume." Dr. Noor is a visiting professor to Stanford University from the National College of Arts at Lahore. She could not be reached for comment. Students attending the lecture said that after the disruption, the lecture concluded quickly and that Dr. Noor was visibly disturbed.

3. *Grade Inflation*: A formal complaint has been filed against Prof. Joan P3ters of the Communications Department for allegedly inflating the grades of students of color. The complaint claims that she has informally admitted on a couple of occasions that she gives students of color higher grades because "they need the extra help." The students who have filed the complaint, all of them white, say this constitutes unfair grading practices. To support their claim, they have collected a number of graded assignments from Prof. P3ters' classes. Papers written by students of color were given the same grade as papers written by white students, even though the quality of the assignment is noticeably lower. Prof. P3ters could not be reached for comment.

4. *H1N1*: A memo discussing plans to compel Latino students and staff to undergo H1N1 screening is raising concerns of ethnic profiling. The memo, leaked to The Osw3go Observer, allegedly comes from someone at the Health Center, although the name of the author has been redacted. In

the wake of an announcement by the Centers for Disease Control (CDC) that a second wave of the H1N1 flu pandemic may hit the US in 2010, the memo states that the Osw3go community "needs to protect the health and safety of its entire community." The memo states that "since H1N1 seems to have originated in Mexico, it makes sense to test students and staff of Hispanic descent to see if they need to be helped first. This can help us prevent the spread of the disease." No one at the Health Center was available for comment.

5. *White Student Union*: In what they say is a response to student clubs that focus on racial minorities, two members of the Osw3go community have decided to form their own organization to celebrate whiteness. B1lly Jones and S4ra Sm1th, campus residents at Osw3go, say they recently attended several events on campus hosted by the Black Student Union, the Asian Student Union and the Latino Student Union. "We tried to engage in the events but felt ostracized, as though we didn't belong," says B1lly. Inspired by these organizations and their own feelings, the two students decided to establish a White Student Union on campus. The two students are in the process of completing all of the necessary paperwork required by the university to start a club. "We are having an information session soon and we invite everyone to come find out what we are about," said S4ra. (*Osw3go.net 2010: Racism on Campus*)

The Game Played

The "play," the chain of posts in each of the scenarios, evidences the hybridization of conversation and writing characteristic of ARGs (Everett, 2009). For example, consider a portion of the responses from the White Student Union scenario:

JOANNE: A white student union will belittle the progress and semantics of our unions, so either learn to feel comfortable in ours, or join a different club, because one could say that any of the clubs besides the Black, Asian, or Latino Organizations are white.

CAIT: I think if anything, students should focus more on creating groups that involve everyone. These clubs themselves split up races and further put the idea in people's heads that we're different.

CHRISTOPHER: We should all be color blind and put behind us the language of racism. Not only should we prevent the formation of this White Student Union, but we should dismantle the Black and Latino Student Unions. These kinds of organizations are just divisive.

JOHN SMITH: Saying "i am a proud black or Asian" is a good thing but saying i am a proud white is almost like saying "good thing i am not a black or Asian"…the white race is often portrayed as a morally wrong race for what it has done in the past toward other races but why should we be punished by what our ancestors have done?

MATTG: Separating yourselves by race only makes things worse and cements the racist ideas into our minds…. Everyone came from somewhere, but the important thing to remember is that we are all here together and nothing will change that.

JOHNNY B: a white student union would be pointless because every thing that is not labeled is white point blank, period.

S4RA: You have your club and we will have ours—what's wrong with that? It's not like we're hating on other minorities, we just want to be white together. You guys get an entire month devoted to you, why can't we have a simple little club devoted to us?

J RABBIT: Why does it only get called racist when it is white people? Reverse racism exists as well, and it is a growing problem.

JOANNE: To put it simply, reverse racism does not exist because minorities do not have the power to institute laws or policies that discriminate against white people.

ALLY913: So apparently you have to be a minority to be allowed to have a group based on your race on our campus?? What is with that? What really kills me is the fact that the two students who made an effort to start this group tried to go to the other student union groups but did not feel welcomed…. How was it not racist for those groups not to have them feel welcomed?

WJONES2: The purpose of the Black Student Union is to foster a sense of community among all students of African diaspora. In actuality I would support a white student union on a campus with a black, asian, etc. majority. Why? Because it would have a real reason to be there.

MS_MESS: I think it's sad that I walk into one of these [group's] meetings and see no white people. That tells us that they don't care to learn about who we are.

PO3TICDR3AM: I do realize that cultural groups can separate or segregate people, but i don't blame that on the club's existence. I blame that on the club members and executive board. If our club leaders had the right mindset and made it a goal to not segregate or separate, beautiful things could happen.

DOODBRO: Who cares if white students want to create their own union? Who are you to tell them they can't? [Are you saying that] If these students want to be in a union they have to join one they don't culturally belong to? (*Osw3go.net 2010: Racism on Campus*)[5]

As this sample exchange from one of the scenarios illustrates, participants' anonymity is safeguarded through screen names they create or through one (or more) of the "identities" and screen names they assume of the cast of characters created in each scenario. Further, that participants can assume other identities encourages dialogue that they might not engage in face to face. In the case of the White Student Union, one of the most frequently visited scenarios, the verisimilitude of such a student organization to actual organizations on campus helped to fuel responses that touch on larger issues regarding race. Hence, the ARG opened the possibility for candid and frank discussions on these issues outside of the network.

While the ARG provides ways to begin and to open dialogue on racism, the authors of this study assert that follow-up strategies need to be employed in order to move participants toward decisions that begin to effectively combat racism and other forms of discrimination in the real world. At the end of the game, participants were invited to attend two "live" discussion forums to talk about some of the larger issues raised in the online posts. During one of the discussion forums, the most-played scenario, the White Student Union, generated one of the most engaging, face-to-face conversations. Not surprisingly, some students' comments demonstrated a sense that issues like race were somewhat sensitive to discuss in person. A few other students—who identified as non-white—were demonstrably outraged at some comments they interpreted as racist and/or as intentionally malicious. The conversation then turned toward the larger issue of white privilege—one that necessarily emanated from the scenario. While the tension in the room was palpable, the exchange forced all to consider their respective positions. The effect of this exchange was the intended purpose of the face-to-face forums, whether or not every person who attended the "live" discussion had actually participated in the ARG. The level of engaged discussion outside of the online social network during these "live" forums further points to the potential of ARG to incite other work in the real world that mitigates racism.

The Game Assessed

While this study is primarily qualitative, important quantitative information was collected. The daily and monthly averages of the number of hits and other data are shown in Table 1. Over the course of the game, there were approximately 6,000 site visits, 200,000 web hits, and 167 story contributions.

Additionally, the data collected on each individual scenario (not highlighted in Table 1) provided information regarding which ones elicited the most participation. Of the five scenarios, the one with the most posts was the White Student Union. There were 53 posts in this section in response to the initial "breaking news" and the subsequent chain of posts that contributed to the entire "story." The second

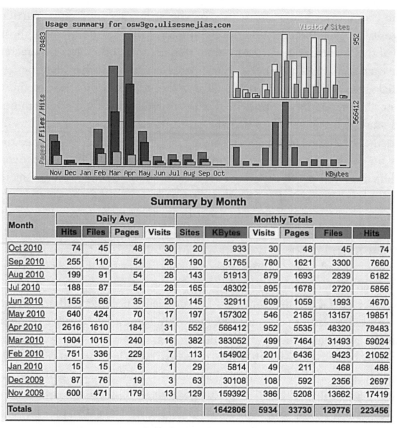

Summary by Month										
Month	Daily Avg				Monthly Totals					
	Hits	Files	Pages	Visits	Sites	KBytes	Visits	Pages	Files	Hits
Oct 2010	74	45	48	30	20	933	30	48	45	74
Sep 2010	255	110	54	26	190	51765	780	1621	3300	7660
Aug 2010	199	91	54	28	143	51913	879	1693	2839	6182
Jul 2010	188	87	54	28	165	48302	895	1678	2720	5856
Jun 2010	155	66	35	20	145	32911	609	1059	1993	4670
May 2010	640	424	70	17	197	157302	546	2185	13157	19851
Apr 2010	2616	1610	184	31	552	566412	952	5535	48320	78483
Mar 2010	1904	1015	240	16	382	383052	499	7464	31493	59024
Feb 2010	751	336	229	7	113	154902	201	6436	9423	21052
Jan 2010	15	15	6	1	29	5814	49	211	468	488
Dec 2009	87	76	19	3	63	30108	108	592	2356	2697
Nov 2009	600	471	179	13	129	159392	386	5208	13662	17419
Totals						1642806	5934	33730	129776	223456

Table 1. Osw3go.net 2010: Racism on Campus Usage Summary.

most played was the Fraternity Prank, which had 39 posts. The remaining two scenarios—H1N1 and Affirmative Action—each had fewer than 20 posts. As mentioned earlier, one possible explanation (among others) for the frequency of play in the top three scenarios might have something to do with their close resemblance to actual events that could take place on a college campus.

A survey and written feedback from the participants and creators of the ARG contributed to the authors' qualitative assessment of the game. Some of the most notable student responses expressed what it meant, personally and academically, to participate in the ARG. For example, when asked about her play of the game, one student stated:

> This ARG was one of the more interesting things about my semester in terms of classes. It was a way to relieve stress from a long day or a long week. My only thing is that I never felt like I could get in to a perfect balance of when I should

play. I tried to participate as much as I could and I did, I appreciated this ex-
perience because it allowed me to participate in a discussion that could easily
be a real life situation. This forced people to respond to the situations at hand
as if they were reality. I think putting people in these situations was a great
idea because you got to see a glimpse of how they might really respond to these
situations. (*Osw3go.net 2010* Survey)

Another student's response to the initial and overall play of the ARG indicates
his/her stake in having the opportunity to candidly discuss and read other posts
dealing with issues regarding race:

> Overall, I played Osw3go several times. The concept was a little intimidating to
> me, so I honestly didn't begin playing until the end of the second week. Once I
> got into it, I felt that it was very rewarding and I played a few more times. It was
> really neat to read other people's comments about certain issues that usually
> would not be brought up. Osw3go gave people a chance to express themselves
> without having to feel guilty about how they feel. (*Osw3go.net 2010* Survey)

The writing process also contributed to the ways in which many of the students
in ENG 537 responded to the ARG in their dual roles of creating and playing the
game. During the writing of the scenarios for the ARG, one student, who created
the initial scenarios, remarked "how [he] wanted to prompt dialogue to ensure that
both included everyone on campus and fostered a place where players could dig
deep, so to speak, and converse about things like prejudice, bias, culture, and soci-
ety that are, for many people, difficult to discuss or acknowledge" (*Osw3go.net 2010*
Feedback). The student further stated:

> When I worked in collaboration to create scenarios like H1N1 and Fraternity
> Prank, I had in mind the potential discussion posts that could further a cam-
> pus-wide conversation about Osw3go as a community, its political stance and
> biases. The game allowed me to do this, and I enjoyed its inherent accessibil-
> ity. (*Osw3go.net 2010* Feedback)

In playing the game after having played central roles in creating the initial sce-
narios, several students remarked on the progress of the narratives and the types of
responses that were part of the unfolding narratives. Another student remarked:

> I looked for its capacity to allow the discussion to progress and produce posts
> and replies that substantiated characters' claims and demands. It also allowed
> all of us [the graduate students] who had worked on [the ARG] to observe

lines of questioning that pushed the scenario.... We were better able to recognize how well questions about topics are posed and answered, which, for me, helped prove [our] hypothesis that the game would bring about a far better understanding of how social media speeds the progress and capacity of a controversial topic (i.e., race, bias-related crime, etc.) and its resulting discourse. (*Osw3go.net 2010* Feedback)

Applications in and across Classrooms

Linda Darling-Hammond (2002) remarks, "With growing immigration, mainstreaming, and awareness of student differences, schools and classrooms represent a greater range of ethnic groups, languages, socioeconomic status, sexual orientations, and abilities than ever before in our history" (Darling-Hammond, French, & Garcia-Lopez, 2002, p. 1). The ever-changing student body demands a classroom that promotes honest dialogue about issues affecting the people in our world. Can a serious ARG such as *Osw3go.net 2010* be utilized in classrooms at all levels to promote such dialogue? The answer is a resounding "yes."

By changing the theme and scenarios of the ARG, a variety of social justice issues can be researched in an interdisciplinary manner by a class, a group of classes, or an entire campus. There are, however, a number of issues that will impact how this experience can scale, and how it can be applied at different levels of schooling. The most obvious one is the hardware and software resources required to run such an experiment. While many "free" applications exist that would allow teachers and students to run an ARG, a certain level of expertise and time commitment is still required. Another issue to consider is the complexity involved in using the technology, in terms of which students and teachers of different abilities might need various levels of support in order to learn to operate successfully. Then there is the issue of assessment methods. The team running the ARG must be clear from the beginning about the learning goals of the experience and how these goals will be evaluated at the individual level. Given that in some cases interaction in the ARG can be anonymous, alternate ways of tracking student participation must be devised. Another important issue that impacts the application of this model is the creation of spaces to discuss the experience, in a face-to-face manner, during and after the game. If the ARG involves a single classroom, this might not be a problem, but for an interdisciplinary ARG that encompasses multiple classes or the whole campus, it can be more of a challenge. Finally, those involved in the design of such an ARG must be mindful of the ethical standards for conducting research with human subjects, and obtain approval from their institution's Human Subjects Board if necessary.

Conclusion

At SUNY Oswego's Quest Day, an annual symposium of student work and research, something happened during this face-to-face discussion of the ARG. This something, most like watching students' minds and worldviews awaken after an indistinguishable time of slumber, was beautiful. As the graduate students, along with Dr. Clark and Dr. Mejias, talked about their work on the scenarios for the ARG as well as the online responses to them, students in the audience grew progressively more interested. Hands were raised to ask questions before any of the panelists had completed commenting on their individual contributions to the ARG; the very sense and feel of the room changed with the dynamic of the conversation, showcasing the curiosity of those who had not previously known the purpose of the ARG project. So, from the preliminary topic of the conversation (to discuss the background and intention of the ARG) ensued a conversation about race, specifically on the SUNY Oswego campus through *Osw3go.net 2010*, and what it meant for students not of color to be writing scenarios involving race, hate, and privilege (of anyone) on campus.

"Most of the early information we receive about 'others'—people racially, religiously, or socioeconomically different from ourselves—does not come as the result of firsthand experience. The secondhand information we do receive has often been distorted, shaped by cultural stereotypes, and left incomplete" (Rothenberg, 2007, p. 123). With such secondhand information, American youth often mature with skewed ideas of others, and not only are the ideas skewed, but there is often little opportunity to dispel any misinformation. The lack of opportunities for open, honest discussion regarding race, religion, and class causes one to ponder whether the possibility exists to initiate constructive dialogue about these topics. Can a virtual conversation take place that educates and informs? Can the educated and informed participants propagate change in the "real world"?

A crucial component of the *Osw3go.net 2010* experience was the inclusion at the end of the simulation of a face-to-face community forum. From the beginning, we decided that this should be part of the experiment. If the goal is not only to involve the community in analyzing a problem and collectively articulating possible solutions to it, but also to examine the ethical question of who has the responsibility to act, we believe the ARG should conclude by obliterating itself as an *alternate reality* and as a *game*, and metamorphose itself into a candid discussion. Participants should put away the masks of anonymity that online interaction affords and come together as a community to assume responsibility for the narratives they collectively generated. The true purpose of the ARG can only be fulfilled by asking at the end: *If this is the alternate reality we imagined, what do we need to do now?*

Notes

1. A total of 60 undergraduate and graduate students helped design and conduct the ARG experience for course credit while enrolled in Dr. Mejias's BRC 420 *Technology and Culture* and BRC 422 *Videogame Theory and Analysis* during fall 2009 and spring 2010. These students were also participants. The 21 graduate students who created most of the scenarios, played the game, and provided feedback—which included a written, narrative assessment, a conversation with Dr. Mejias during his visit to Dr. Clark's class, and a formal presentation at SUNY Oswego's annual campus-wide QUEST conference in April 2010—were enrolled in Dr. Clark's ENG 537 *Ethnicity and Cultural Difference in Literature* and ENG 650 *Special Topics in Fiction* courses during the fall 2009 and spring 2010 semesters respectively. All the students received course credit for their work; three are co-authors of this essay.

2. *World Without Oil* was an online Alternate Reality Game that asked players to use Interactive Social Media to play out the events that could arise from an oil crisis. The game lasted 32 days, and over 1,900 people participated. According to the organizers, "For these people and over 60,000 active observers, the process of collectively imagining and collaboratively chronicling the oil shock brought strong insight about oil dependency and energy policy. More than mere 'raising awareness,' WWO made the issues real, and this in turn led to real engagement and real change in people's lives." Cf. *World Without Oil* (2007). Retrieved August 16, 2010, from http://www.worldwithoutoil.org/.

3. The courses were BRC 450 *Social Networks and the Web*, with 16 students enrolled, and BRC 450 *Videogame Theory and Analysis*, with 20 students enrolled.

4. Spelling "Oswego" as "Osw3go" is a practice known as *leetspeak*, which employs an alternative alphabet where numbers may replace letters. This was used in the title of the ARG and to identify characters in the game (e.g., "M4ry" instead of "Mary") in order to emphasize that the experience referred to an alternate reality and not to any events in real life.

5. Posts to all the scenarios can be accessed and read on the *Osw3go.net 2010* website http://osw3go.ulisesmejias.com/2010/node/25

References

Cahill, C. (2007). Including excluded perspectives in participatory action research. *Design Studies, 28*, 325–340.

Darling-Hammond, L., French, J., & Garcia-Lopez, S. (Eds.). (2002). *Learning to teach for social justice.* New York: Teachers College Press.

Everett, A. (2009). *Digital diaspora: A race for cyberspace.* Albany: State University of New York Press.

Fals-Borda, O., & Rahman, M.A. (Eds.). (1991). *Action and knowledge: Breaking the monopoly with participatory action research.* New York: Apex Press.

Graff, G. (1989). *Professing literature: An institutional history.* Chicago: University of Chicago Press.

Hardt, M., & Negri, A. (2000). *Empire.* Cambridge, MA: Harvard University Press.

Lewin, K. (1946). Action research and minority problems. *Journal of Social Issues, 2*(4), 34–46.

Osw3go.net 2010: Racism on campus. (2010). Retrieved August 16, 2010, from http://osw3go.ulis-esmejias.com/2010/node/25

Osw3go.net 2010: *Racism on campus.* Survey. (April 2010).

Osw3go.net 2010: *Racism on campus.* Feedback of ENG 537 students. (December 2009).

Prince, G. (2001). A commentary: Constants and variables of narratology. *Narrative, 9*(2), 230.

Rothenberg, P.S. (Ed.). (2007). *Race, class, and gender in the United States: An integrated study.* (7th ed.). New York: Worth Publishers.

Tatum, B. (2007). *Can we talk about race?: And other conversations in an era of school resegregation.* Boston, MA: Beacon Press.

Zuber-Skerritt, O. (1996). *New directions in action research.* London: Falmer Press.

In the Grey

Finding Beauty Without Labels

BARBARA STOUT

Figure 1. Barbara Stout with portraits from her In the Grey *series.*

Introduction

My path is to create art, and as an artist my interest is to be responsible to the community and to create work that will be of value as well as bring beauty to the world. To do this, I look to the beauty in each of us, as I think we humans forget how truly exquisite we are. My most recent series of larger-than-life portraits, *In the Grey*, focuses on identity as defined by spirit alone, a multiplicity of expression without confines or constrictions based on our society's prejudices. My intent is not only to allow but to celebrate the human spirit beyond gender roles and to raise questions about societal attitudes toward gender assignment in the process.

About the Series *In the Grey*

In the Grey is made up of larger-than-life ink wash portraits in which I construct ambiguous gender attributes of each face. Although separate portraits, they are designed to be shown as a group, and I think of them as one piece. The monochromatic treatment and the omission of background information in each portrait are designed to highlight both uniqueness and equality. Each one is two-foot square on paper and is created with multiple layers of ink wash.

Realism is particularly important in these paintings, since the clear definition of the features takes the guesswork concerning their sex away from the image and leaves it with the viewer. It opens an arena where it can challenge the visceral and intellectual attempts to codify gender and fosters an opportunity to discuss sexual stereotyping, discrimination, and the role sexual identity plays in culture. What is it that makes one person look male and another female? Why is it so important in many cultures to not make a mistake in identifying gender? And what about those individuals who were born with ambiguous attributes that stay largely hidden from the greater society?

Process

All the faces in my series are constructed from my imagination with supporting source photographs, and all of the photographs were from individuals looking distinctly either male or female. Initially, as I progressed with each portrait, the gender of the subject changed with each added layer of ink wash, shifting a shadow, defining a line, or strengthening a curve. After working with several of these faces,

gender distinction began to disappear, and I was able to see each subject as a unique individual without a gender label. I can't help but wonder what would happen if others could experience this.

The nature of gender assignment is so subjective. I realized articles of clothing were a distraction, so I began leaving out these additional cultural variables. When I'm close to finished, I typically email jpegs to an eclectic mix of friends to get their reaction to the sex. If there is no consensus, this is my cue that I'm in the range of that grey area that I'm seeking.

What Led Me to This Work

I don't think of myself as a political artist, but an artist who is inspired by the world as I experience it. My desire is to share my vision of a more accepting and gentler world. While working with an earlier series of anonymous portraits of a global community, I used realism to portray ethnic and age differences. In working with these subtleties as I built up layers sometimes I would watch as the face would un-intentionally transform gracefully from male to female or vice-versa before the piece was finished.

At the same time I was working on this global community, I began to see doc-umentaries about transgender individuals surface in mainstream media. These were frequently about their transitions from one sex to the other through surgery and other methods. I was mostly queasy after watching these documentaries, never quite sure if they were helpful in unearthing a rarely acknowledged and little-understood group or if the media was exploiting their experiences by, in many cases, turning them into the latest freak show.

I was deeply disturbed to learn about surgeries performed on another group: hermaphrodite and other intersex infants. The details of one intersex person's childhood were depicted in an Austrian documentary directed by Elizabeth Scha-rang, *Tinenfischalarm* (*Octopus Alarm*). The documentary subject, Alex, was listed as male on his birth certificate, but at age 2 doctors performed invasive surgery after which Alex was raised female. In addition to multiple additional surgeries, every night as a small child Alex was required to insert a hard small dowel into his con-structed vagina so that it wouldn't heal shut.

This documentary illustrates how advances in modern medicine now make it possible to perform surgery on babies long before they have any idea who they are and how they might identify, and at the same time hide these people from our consciousness (Dreger, 1998). The reassignment surgeries performed on intersex children have been compared to the practice of female genital cutting (Chase,

2002, p. 126). When I hear stories such as the one from Alex, it seems unquestionably an accurate assessment.

The number of intersex people who are visually atypical enough at birth so that a sex differentiation specialist is consulted is approximately 1 in 2,000. But not all intersex people are visually atypical. The Intersex Society of North America (ISNA) reports that the total number of people whose bodies differ from standard male or female is 1 in 100 births (Dreger, 1998). As educators, we most likely see some of these young people every day. And this number doesn't include those with the body of one sex but who identify with the opposite.

Although sexual reassignment surgery performed on babies was my initial inspiration for this work, I don't equate the visually androgynous with intersex people, as they may or may not appear or identify as such. When their stories come to light I see them as the tip of an iceberg of a society with little tolerance for anyone who deviates from the accepted binary system. I believe gender exists on a continuum in multifaceted incarnations, and this work is my way of valuing those varied grey areas in all of us. Having attended the breakout session on self-identification at the international 2005 Gender Odyssey Conference in Seattle, a colleague described the younger participants who voiced new and creative ways to self-identify. I was delighted to hear about these young people, pioneers in my mind, searching for ways to live without the cumbersome societal norms of gender and gender identification.

Public Reception

I used myself as a model for one of the portraits, and in showing the work there is a vulnerability, wondering what people will think I'm trying to say. When I gave an artist talk recently about *In the Grey*, an acquaintance came up to me and said she started looking at me differently, wondering what was under my clothes. I didn't answer. I could have clarified what was under my clothes, but that's not what this work is about. What motivated my work had exactly to do with her struggle, and so I remained quiet.

Part of the reason I used myself as a model was because I knew I wanted to ask friends to participate. The response was significantly different from my global portrait series. With my earlier series, friends seemed flattered to be part of it. On the other hand, with *In the Grey*, they needed time to consider the request and frequently time to consult with their partners. Some immediately dismissed it, as happened with my male friends, or it was dismissed for them by their partners before I asked the men themselves. I took photos of one male friend of mine, think-

ing I would be using them for the first series. He seemed quite pleased and eager to participate, but when I asked if I could use his photos for *In the Grey*, his reaction was "Of course not." This reaction came from a progressive, highly educated professor, very supportive of the arts in general and a firm supporter of my own work.

Androgyny abounds in popular culture and frequently is entwined with explicit sexuality and, some would say, tied in with a promotion of narcissism (Kaufman, 2009). It is important to me to portray ambiguous gender attributes without sensationalizing the countenance of androgyny.

When I show *In the Grey*, viewers will often automatically assign a gender to the individual portraits, although it can vary which gender is assigned. One time a young man spoke with me about his impressions, and when I began to question his reactions, he answered me back with what I hope the audience will take away from this work: why not let the gender rest in ambiguity? Why not let these faces (and our own) have their own place? And why don't we forge a new place for them to exist?

Suggestions for the Classroom

Self-portraiture can be a powerful tool. Consider a self-portrait by students in which they create an androgynous-looking portrayal of themselves. If drawing skill is a hindrance, it could be done with slices of photos in a collage starting with a photo of the student. Another option would be to use costume or makeup. This one project could lead to a broad range of possible discussion points:

- Sex-role stereotyping
- Gender discrimination
- Social attributes of gender
- The role of clothing and adornment in society
- Biological distinctions of sex
- Sexual orientation
- Gender reassignment surgery
- Medical ethics of gender reassignment surgery to infants. The ISNA believes the current approach is to "cut now, maybe ask about quality of life later," even though doctors are aware of the controversy.
- The varied acceptance of androgyny in different cultures
- Conflicting images of androgyny in religion: Christ, Buddha, angels, the masculinity of God and femininity of Mary (What if someone did a portrait of Mary that looked androgynous?)
- Androgyny in pop culture (Kaufman, 2009)

Another classroom suggestion would be to use writing. Consider having students create a fictional piece with a main character's gender never identified, as in Jeanette Winterson's novel *Written on the Body,* 1992.

Conclusion

In our society, beauty is typically only allowed for two opposing sexes even though we represent a continuum in a multitude of ways. Aside from biology and regardless of sexual orientation, I think many of us feel boxed in by notions of what is acceptable. My intention with this work is to move outside those boxes, and not only appreciate beauty beyond gender distinction, but celebrate it.

> Our deepest fear is not that we are inadequate. Our deepest fear is that we are powerful beyond measure. It is our light, not our darkness that most frightens us. We ask ourselves, Who am I to be brilliant, gorgeous, talented, fabulous? Actually, who are you not to be? You are a child of God. Your playing small does not serve the world. There is nothing enlightened about shrinking so that other people won't feel insecure around you. We are all meant to shine, as children do. We were born to make manifest the glory of God that is within us. It's not just in some of us; it's in everyone. And as we let our own light shine, we unconsciously give other people permission to do the same. As we are liberated from our own fear, our presence automatically liberates others. (Williamson, 1992, p. 190-191)

References

Chase, C. (2002). "Cultural practice" or "reconstructive surgery"? U.S. genital cutting, the intersex movement, and medical double standards. In S.M. James & C. Robertson (Eds.), *Genital cutting and transnational sisterhood: Disputing U.S. polemics* (pp. 126–151). Urbana-Champaign: University of Illinois Press.

Dreger, A.D. (1998). "Ambiguous sex"—or ambivalent medicine? *The Hastings Center Report, 28*(3), 24–35. Retrieved October 28, 2010, from http://www.isna.org/articles/ambivalent_medicine

Kaufman, S.B. (2009, December 2). *From George and Lennox to Gaga and Lambert: Androgyny, creativity, and pop culture* [blog posting]. Retrieved October 28, 2010, from http://www.psychologytoday.com/blog/beautiful-minds/200912/george-and-lennox-gaga-and-lambert-androgyny-creativity-and-pop-culture

Williamson, M. (1992). *A return to love: Reflections on the principles of a course in miracles.* New York: Harper Collins.

Appendix: Intersex Education Resource Websites

Accord Alliance: www.intersexinitiative.org

> Promotes "comprehensive and integrated approaches to care that enhance the health and well-being of people and families affected by disorders of sex development (DSD, which includes some conditions referred to as "intersex")."

Intersex Initiative: www.intersexinitiative.org

> Is a "national activist and advocacy organization for people born with intersex conditions. It was founded by Emi Koyama, a multi-issue social justice activist and former intern at Intersex Society of North America (2001–2002)."

Intersex Society of North America (ISNA): www.isna.org

> The Intersex Society of North America (ISNA) "is devoted to systemic change to end shame, secrecy, and unwanted genital surgeries for people born with an anatomy that someone decided is not standard for male or female."

The Art of Growing Food

SUZANNE BELLAMY

Australian artists and writers have historically juggled a deep sense of identity about place with a need to freely move about the planet as travelers. Living on the oldest continent on earth, far from the intense centers of cultural dynamism in Europe and the United States, it is a twin challenge to open the heart to both home and away, and to find that mix in the work. This has been my own story as artist and writer, activist and internationalist. I have spent most of my creative life engaging with both the land of my birth and the cultures of the planet, constructing a network of friends and art practice in many places. Previous generations of artists have had to make the choice to abandon their home base for London or New York. In the 21st century, it has become possible to live both lives, albeit with a heavy carbon footprint. The cycle of my year as an artist has been one of studio and community work at home, followed by the excitement of encountering ideas and new experiences travelling to the rest of the planet for its summer of festivals, exhibitions, and conferences.

Every year for 16 years now I have held a 3-day Open Studio show on my land at the start of my southern summer. It's the best time of year to show off the garden and the earthworks, to invite friends from near and far, locals and travelers, farmers and artists and family, all kinds of people come to eat, walk about, buy and see the artwork, wander along the creek, check out what has happened in the year passed. Quirky fusions of art and earthworks, garden sculpture, creative garden explorations as well as the artifacts of a studio with kilns and printing press, pots,

prints, and canvases are open for exploration. Over the years I have realized that people like to see where art comes from, the things you see out the window or watch as you focus on the tiny creatures of the earth, the termite mounds and edges of the creek, the forces of the land that help produce the work, colors, and shapes and experiences of place, and the spirit of the land. Somehow going away also intensifies the feeling of being at home, as the ideas gathered from travelling create a new prism to see the shapes of life as it changes. Change held in a balance of integration becomes the challenge. But it is all changing, and that has become central now in my experience. Over recent years I have seen the planet changing on deep levels, learned from scientific, creative, and personal stories about the ideas of a changing time and the issues of transition as communities deal with a new ecosystem. How can I as an artist engage with these changes so that I am learning at deep levels as well as being part of an educational process that explores better outcomes? What do artists do in these times? How can I move from making sculptural earthworks to helping my community and my place survive deep ecological changes? I have tried to tell a story here about how this is slowly happening to me and my community in southern New South Wales, Australia, and how I am shaping my role in this process as an artist. This is about a kind of community art project where the idea of art practice is integral to the defining of the problems, the inventive solutions, and the uncertain outcomes.

The Quinoa Project that I have been engaged in for the last two years was born from engagement with place as a gardener, moved into my art practice, and has now become a creative experiment in community education and change. There are elements of visioning and inventing, fusing old and new processes, making imaginative maps and redefining certainties in the landscape. We are using story, documentation, seed as a creative material, small-scale machines as art tools—mixing up the ways tools and processes have been traditionally seen in culture, farming, and art— and in the process making our brains see and invent a way back to nourishment of the body and the creative spirit. Humans all over the planet are now confronting a level of alienation from core ways of living, as basic food needs at the local, community level are shown to have become precarious. Finding a local way back to having a direct relationship with the simplest tools of living is also the work of artists in this brilliant time of renewal. And so this little story begins.

Early in the year on a hot Australian summer day, I sat in a huge tent with many hundreds of book lovers at Writers' Week, part of the Adelaide Festival of the Arts. The session was overflowing with people listening to two speakers launching new books. One was Adam Nicolson, the grandson of Vita Sackville-West, with his book *Sissinghurst: An Unfinished History* (2008), which describes the struggle to return that amazing iconic English garden to a real working farm producing food rather than keeping it just as a museum-piece of static gardening. The other writer was

Lolo Houbein, a Dutch Australian whose book *One Magic Square* (2008) describes new permaculture-inspired food production ideas in the context of stories of her memories of starving in Europe as a child during World War II, scratching for roots in the snow in Holland. Both speakers were passionate, although in different ways, in their embrace of the creative need to grow real food in real situations, to address changes in climate, alienation from land, and sustainable life processes. Adam Nicolson carried all the celebrity of his famous mother's literary associations with Bloomsbury and Virginia Woolf as well as the aristocratic lineage of the great eccentric English garden. Lolo Houbein, an immigrant with a long memory, embraced the challenging difficulties of the Australian landscape, filled with the urgency of creating ways to sustain ourselves in a world of peak oil and climate change. She belonged to a growing international movement called Transition Towns, a loose affiliation of community projects originating in Totnes in the U.K., and now taking hold in Australia as well as parts of the United States and Europe.

I was excited by the session for many reasons. Here in the center of snobbish mainstream literary culture, the bourgeois heart of colonial Adelaide and its famous literary festival, were masses of people interested in climate change, food security, experiments in creating artwork out of our deepest connections with food, plants, and vegetation, and in creating a literature about that struggle. This is of course an international phenomenon now, as humans grasp our fragility at the most basic level of alienation from daily needs like water and sustenance (Pollan, 2009).

My own small rural community in southern New South Wales had started a Transition Towns group a year ago and I had joined it, hoping to access lots of new ideas and resources for my own gardening as well as my art practice, my writing, and political consciousness. In Mongarlowe, the little village near where I have my own land and studio, we have a lovely festival every 2 years called The Two Fires Festival. Inspired by the great Australian poet Judith Wright (1915–2000), who lived and wrote here in the bush, it is named after a poem of hers describing her two passions, poetry and environmental activism. The festival has been a focus for the interaction of creative ideas and ecology, and here we were introduced to the book and concepts of the Transition Towns movement. Over the last year a group of my friends and neighbors have explored this project with mixed results. A community garden, slow food, food/art experiments, eco-maps of the region, fruit clubs—lots of ideas have changed our lives and sense of the fusion of forces that hold form on the planet. What is new is not the parts, but the way in which these things have become more urgent and central. This is a community in which there are many earth houses, self-sufficiency experiments, and gardeners. My own house/studio is all solar, and I try to live a minimum-impact life here in the forest with native animals and a lovely creek with platypus. But in an ancient, dry continent like Australia, we are beginners, always needing to confront deep alienation

and ignorance from the forces of the land as European colonials and immigrants. Food itself is a complex issue here because of poor soil, lack of water, great distances, and inappropriate animal farming. This is how I came to the idea of growing grains, protein, in the bush—a small idea and a lovely project with lots of interesting dimensions, and gathering in the memory and practices of my own family and childhood.

My parents had been prolific food producers on a small suburban Sydney block, and my childhood memory is filled with chickens and potatoes in rows and pumpkins on the shed roof. They grew endless vegetables and flowers, fruit trees, and eggs. My father's stories were all about how his parents had survived the Great Depression by sharing food with neighbors and relatives, and I grew up on heroic stories of community survival. My sister and I are both committed gardeners—I am on my fifth big garden, having moved several times and lived in the country for over 20 years now. I live at Mongarlowe—a few acres on a good creek with reasonable soil in the old flood areas but mostly native bushland, regrown since the 1840s when this whole area was dug for gold by the Chinese. Through the trees I can see both the Budawang National Park, which is a biodiverse forest system of great integrity, and I can also see a neighbor's cows in paddocks across the road on a large agricultural farm between me and the national park. It is truly a kind of paradise, a great place to live for an artist, in a community where there have always been lots of artists and writers as well as farmers and retired academics from the national capital, Canberra, about an hour away. The local town has good cafes and galleries, and in its way it's a typical rural fusion of cultural and agricultural workers. The Pacific Ocean is down the mountain to the east only 40 minutes away. I came to live here because of this balance of forces, and because ideas matter here and people want to participate in solutions to earth problems and new ways of being community.

The Quinoa Project

I had never grown protein. This really had never occurred to me until I started eating quinoa in the United States a few years ago. Suddenly, as part of the Transition Towns (TT) group, I found myself thinking about food in a new way. With some group enthusiasm and help from a young friend who had a machine called a spader, we ploughed up the field fenced off from the kangaroos and wallabies, and planted an experimental crop of five grains. I found out a lot about quinoa, a native of the Andes, the highest-producing protein grain. For comparison with the other grains as to suitability for this region, we decided to plant amaranth, buckwheat, spelt, and millet. I had no idea how this would all work out, but in the end it was spectacularly

successful. Not only that, it was beautiful to see: the amazing red amaranth, towering millet, subtle versatile quinoa, and the reliable hardy buckwheat. The spelt was a failure, and I think it's really a winter crop anyway. There were a few guidelines, even though we were entering this as true amateurs. If possible we would be low-tech and inventive, so the seed was broadcast by hand, and it also had to be practically sustainable, low watering, low maintenance. Life and art had to go on, and this was planned not as a cash crop but to see how much could be produced for personal needs over a year. The humor really kicked in when it came to harvest. These grains need many kinds of processing, and we didn't have machines for seed stripping and winnowing. Invention became important, and all was documented. This was an experiment, we kept saying to each other, as the grain grew and grew and needed to be stripped and winnowed and seed cleaned, and then what? It was all challenging and great fun. I decided to document all of the steps, to make it part of my artwork life. My favorite scene was of the day we winnowed the seed by setting up a huge fan running off the solar power and threw the seed into the air for the breeze to separate the chaff. Two lovely old dogs sat in the middle of all this, watching human madness and hearing our laughter as this actually worked. Another day I love remembering was when a group of friends came to help strip the quinoa and millet seed, which we really needed to do by hand. There was hot soup and tea, and we stood around a huge table. Everyone seemed to be lulled into a trance of remembering our ancestors doing exactly this, telling stories and knowing something had been lost but was still there in our collective memory. It was all worth it just for that day alone.

We are now into our second year of planting and growing. But how do you go about covering basic protein needs if you are not a big mono-cultural producer with big machines and poisons? If our community has to face the possibility of a sudden change, such as loss of fuel for transport and food delivery, or loss of communications and power, how would it manage? In the TT group we talk a lot about the large global possibilities, of course, but we also think about what makes a community and what its needs are. I find I am starting to sound like my family's stories from the 20th century's tough times. Thinking about food and encountering the needs of the body provoke deep creative urges. I was deeply moved when I heard Lolo Houbein in Adelaide describe being a small child scratching for roots of plants to eat through the snow during the war. She told us that just a few years ago she suddenly thought that it could all happen easily again, that food security is a fool's paradise. What I like about our grain project is that it is done with both the awareness that we have lost core skills and resources but also that maybe we still have time to find our way to these connections without a horrible crisis. Who knows? The key for me has been to combine all the steps into art practice and see it as a kind of community education process. Many people have become interested,

and this year many more are trying themselves to grow grain. Maybe in time we can form a co-op for grinding and storage and try ever-more-interesting things. Friends in the group are starting to invent low-tech machines for seed cleaning and winnowing, new ideas and old problems meeting in the backyard welding rooms and forges of a little country community.

My tentative conclusions so far are that the quinoa is worth growing and has a high yield; it needs a long time drying, so there has to be space to hang it and store it. We will come up with better and faster ways of stripping and cleaning but keep to the simplest methods. The surprise element was the beauty of it all, much like growing vegetables but with some added challenge and focus. In many ways it reminded me of the old arts and crafts movement beliefs—integrating beauty and function in personal ways, living sustainably in creative ways. At other levels, the practice held some power to restore memory of ancestral lines of working together, of seeing food production as central to well-being. I have no illusions about this year of quinoa; it has been carried out with enthusiasm and been quite restorative with no frills and no pretensions. But I do find myself refreshed intellectually in ways that surprised me.

Just a week ago I travelled to Sydney to hear the great Indian ecology and seed campaigner, Dr. Vandana Shiva, receive the prestigious Sydney Peace Prize for her work as an earth warrior. Two thousand people at the Sydney Opera House listened to her speak after receiving her prize. It was inspiring as well as intellectually challenging to hear her address what she sees as the war against nature being waged by big companies like Monsanto, who are destroying food and core nutritional needs for us humans. I was able to meet Vandana Shiva later and ask her about her involvement with Transition Towns. She has been involved with the Totnes TT movement in the U.K. from the start and sees it as a very crucial model for community response to climate change, as well as the destruction of seed and earth by the food multinationals. Again, here was an example of mainstream culture beginning to grasp the issues of food and its centrality to our crisis. Vandana Shiva stood in an iconic temple of Australian culture to be honored and heard for her pioneering work among women in villages in India trying to save their seed and their land and water. Here in Australia these issues are also beginning to break through our collective consciousness. How long will it be before this is a real emergency? Are we there yet?

Urbanization, globalization, lack of space and water have all made it seem like we are no longer called upon as humans to produce our own food. Fewer and fewer humans are involved in the process. Food is clinically produced on a mass scale with less nutrition and more poisons and toxicity, travelling vast distances to markets depressed by trade wars and restrictions, as more and more productive land is alienated from high-end usage. Meanwhile, famine and disease abound. At the

global level this feels overwhelming. Small community experiments, when compared with this level of crisis, seem trivial. But ideas are like seeds, and they revive us; they bring back old forms of practice and thinking in order to combine in new ways and make new pathways. In the process of growing our grain, we talked to the farmers of our community. One of the best ideas in the TT movement is that you need to be able to work with people you don't agree with. What a concept, coming out of a political culture that thrives on combat. I had to really think about that one. It occurred to me that farmers and artists in these times have a great deal in common. We live in a culture where the artifact has lost a lot of its core value, where actually being a producer of objects—food, seed, pots, sculpture, original human products of the imagination—is not greatly valued. I have always made art, always written, and also grown food. Somehow now I see these as all interconnected in a new way.

Growing protein as an art practice has become a memory track, not one where I am engaging in a dystopic future landscape of earth crisis but as a comic memory of social community dreaming. My studio is like a garden, and now my materials are seeds and earth, created artifacts capable of sustaining the spirit and the body. I am making an eco-map of the village and town, photographing and documenting all the processes from plowing to harvest and storage, and keeping a record of the stories surfacing from the experiment as it unfolds. I will be able to exhibit and talk about these ideas at the next Two Fires Festival early next year, as the cycle continues.

On the day we gathered to strip the quinoa seed from its stalks, we talked about our ancestors, about the old goddesses of the grain, as though they could be seen through the seed itself. The seed carried the stories, and we responded to that. The memory is in the seed. This is like the memory being in my cells. Once we have lost the wild seed and its story, we have lost the way to look after ourselves. I am sure this is also the message of activists like Vandana Shiva and her Indian rural women's movement. A country like Australia can have the illusion of wealth and plenty, but this is floating on a fragile soil, cyclic droughts, alienated farmlands, huge transport dilemmas, the loss of the urban market garden culture, and the loss and poisoning of vegetal biodiversity. It is claimed now that the only remaining real biodiversity in this country is in the suburban backyards of the cities, the verges along rural roads, the small acreages like mine nestled in the forest systems so harmonious with the ideas of permaculture. So many of the great food-producing zones are overwhelmed with poison and low productivity, it is said. This may be all too alarmist (though I doubt it), but it makes sense to work with the miniature solutions as well as think of the large, overwhelming ones.

It is clear that in a country like Australia a new agricultural revolution is needed. Reliance on food imported from China makes no sense if peak oil hits us and

transport costs escalate, not to mention questions of toxicity. The big cities no longer have their encircling market gardens, and farmers are being forced off productive lands by trade barriers and farm policies inimical to good food. Of course there are rebellions against this drift, but small communities like ours have a role to play in changing consciousness as we learn of the errors of judgment of the past. My experience this past year with growing protein has been that there is a lot of curiosity and good humor out there for hearing about the project if it is presented with strong creative art practice ideas. It seemed to help that I was prepared to seek lots of advice from more traditional farmers who actually also have the deep memories of the older practices that predate the pressure to artificially augment yields and be overwhelmed by giant companies. We all share at heart a strong peasant consciousness, and we know that this is a force that can make revolutions, as the 20th century shows us. Once the imagination is stirred and the feeling of trying something on a small scale is embarked upon, there are no limits to ideas taking off. This region has strong LandCare groups, all kinds of experiments with new plowing, permaculture and changes in animal farming practices, new breeds, and better soil conservation. It is a battle on all levels as the possibility of climate change crisis is considered in personal and global dimensions. Small experiments abound in such times.

Since protein is so important, and large-scale wheat production has become problematic, finding small-scale ways in which to provide an alternative makes sense. Our themes have become clearer now that this is an ongoing project. At no time have I imagined the quinoa project as commercially viable, although there is no reason why it could not be. It is, after all, a very expensive grain to buy organically in the health food stores, so even growing a small percentage of our home needs makes sense. I see it more as an educational journey through questions about an integrated life, a community thinking about its own best interests, sharing ideas and stories, experimenting and encouraging small-scale inventing of low-tech machines, and working with people whose ideas are sourced from very different perspectives. It appeals to me to be preparing for major earth changes in a positive and humble way, experimenting, daring to remember old practices as much as embracing the new times with openness. I have been reading about the amazing boiler technology now being developed for sustainable winter heating in countries like Scotland, where old methods and new efficient machines are dealing with the possibility of freezing in a new ice age. For many years I have followed the brilliant ideas of Scott Nearing, whose passive solar greenhouses in Maine in the United States were so inspiring. There are people picking up small-scale, efficient experiments all over the planet, and there are artists and writers along the way taking inspiration from this ferment and change, using the tools of the imagination to bring these ideas into accessible places as we all move into the new times. Art practice

that is earth based, educational, and community driven has a role in the biodiversity of the planet.

References

Houbein, L. (2008). *One magic square*. Adelaide, Australia: Wakefield Press.
Nicolson, A. (2008). *Sissinghurst: An unfinished history*. London: HarperPress.
Pollan, M. (2009). *In defense of food*. NY: Penguin Books.

Activist Art in Social Justice Pedagogy

BARBARA BEYERBACH AND TANIA RAMALHO

This book resulted from our passions for *social justice, art, and education.* As the contributions came in, we could identify common threads and distinctive ideas—gems—that did not surprise us as much as they enchanted us, handlers of a newly found treasure.

Our concerns for social justice mobilize us to challenge conditions that menace human survival. Many of us are conscious of injustices and want to do something about them. Each contributor to this book engages with social justice questions, targeting some of the most pressing:

- poverty, hunger and food security, environmental degradation;
- displacement, landlessness, and precarious working conditions of rural workers;
- the history of genocide, survival, and self-determination of Native Americans;
- resistance and organizing in poor urban communities;
- racism;
- the invisibility of women's contributions to society, and the troubling of gender and sexual orientation.

All of the issues are local but interconnected globally; their relationships simply cannot be disentangled.

Art, in turn, is a practice with two interrelated values, aesthetic and pedagogical. Our primary interests in the book are the pedagogical, the ability of art to educate, to foster learning about self and society, and about one's place in a world that calls for change in the face of complex problems. Contributors, again, have practiced or witnessed work in the arts or education through the arts, addressing social justice through various media—visual, musical, performance, and gardening. Also, these contributors have shed light on aspects of art that are important for a clearer understanding of its power in many guises.

As we read the works of the authors in this volume, we sought common themes that could inform our teaching and become steady guideposts to the future. We identified six such themes: art as discipline, art as process for developing voice and identity, art as engaged citizenship, art and the curriculum, art's impact on students, and art and the future. We subsume these under an evocative title: the transformative power of art. We issue a call for all educators to commit to incorporating activist artwork in their own spheres of influence and thus use the transformative power of art to charge personal and social change and to foster beauty in the world. We also offer additional resources to support approaches to studying artists' work, lives, and activism; engaging students in activist arts; and developing critical thinking and critical literacy through engagement with the arts. The annotated bibliography that appears later in this chapter describes the resources and indicates for whom the work might be useful, the multicultural topics addressed, and curricular connections.

The Transformative Power of Art

Art as Discipline

Art is a discipline, and like all disciplines it has distinctive ways of thinking, understanding, and representing the world. Art is also a contested space where views—theoretical and political—about the discipline and its history are sometimes in conflict with one another. Nonetheless, there is a range of acceptable beliefs about art and its practices that makes up a body of disciplinary rules.

Artists operate in the psychological realm of the *imaginal*, a place connected to the unconscious that lies between the mind and the material world of matter. Harrell, a Jungian clinical psychologist, reminds us in Chapter 5 of this volume that the *mundus imaginalis* is "a *real* place of undeniable and razor-sharp truth that can be entered through image. All artists have known this since the beginning of time" (Harrell, p. 62). In their work, artists engage imaginal figures (dream images, feelings, perceptions) and archetypes, "defined as infinite patterns of human experience like: mother, father, life, death, teacher, engulfment, and erotic love" (Harrell, pp. 64–65). They draw from the imaginal to make the invisible visible through artistic production, and this

can be revolutionary. Images generated can be powerful, but while images do not make objects *literally* present, they stand "more alive than the mental construct that might define [them]…present and absent…because imagination renders [them] ensouled.… The act of focusing on its imaginal figures in art is the transcendent function that Jung talks about, the act of living consciously in the tension between what is and what is not" (pp. 66; 68). Russell, in her article herein on AfroReggae, also claims that *art speaks to the soul*, and therefore it has the potential to reach people. It stands in contrast to the soul-less, fast-paced and disenchanted modern life.

Chris Capella, Native American art teacher whom Jennifer Kagan observes at Onondaga Nation School (Chapter 8), considers the *investigative nature of art projects*. Art comes about through active engagement with an object. Every human being has inborn talent for art, can learn *technique* to practice it, and thus can become an artist. *Critique*, the practice of assessing an artist's works, contributes to an artist's maturation. In the process of becoming, artists learn humility, and they mature. As educators we can engage learners in meaningful art processes as well as teach explicit strategies such as borrowing, juxtaposition, recontextualization, and layering (Desai et al., 2010) that students can learn to employ in their own production of art and the interpretation of art by others.

Artist activists Bellamy, Stout, and Chicago reflect on the thought processes taking place in their art practices and productions dedicated to making social impact. At full maturity as an artist, Australian Suzanne Bellamy (Chapter 14) entertains the relationship between art and the present ecological and social crises, and change. For her, the work of artists is to find "a local way back to having a direct relationship with the simplest tools of living" (p. 194) with "art practice [being] integral to the defining of the problems, the inventive solutions, and the uncertain outcomes" (p. 194). Bellamy calls for action.

Stout consciously looks at beauty in each of her subjects to produce portraits that trouble binary notions of gender. Her goals are to serve the community, spread beauty, and celebrate the human spirit. Speaking on behalf of women, Chicago realizes her feminist vision through individual and collective artistic labor. Working collectively has afforded her the creation of monumental works of art, such as *The Dinner Party*— about the historical erasure of women's achievements through the age. Despite the enormous controversy that it generated, the work achieved global outreach and impacted individuals and movements for social change. The desire to have *The Dinner Party* become an everlasting tribute to our cultural heritage fueled Chicago's and others' efforts to secure for it a permanent home. She writes that "this would never have happened had my art not acted as a vehicle for social change and an instrument of realizing at least a modicum of social justice" (ch. 10, p. 140 in this volume).

The ways in which these contributors describe their experiences with art is very much in agreement with John Dewey's (1934) notion of art as experience. Art

involves psychological processes of inquiry, meaning making, and ethical choices that foster action. These engender art as an integral part of the construction of democratic life (Goldblatt, 2006).

Art as a Process for Developing Voice and Identity

Several authors illustrate the power of art to engage people in developing voice, individually and collectively, and in interrogating their own and other's identities. Schools' over-reliance on the printed word as the path to learning and expression has marginalized those who might more easily express themselves through other media. Art has been seen as a way to engage learners who are resistant to the mainstream schooling curriculum, but beyond that as developing critical and imaginative skills in all students. In this spirit, Winslow demonstrates (Chapter 7) how her community college students use documentary film to voice a stand on a social issue. Kagan describes how Capella expects her elementary and middle school students to become artists, express themselves, and connect with their heritage and community. In this process they internalize the identity and come to see themselves as artists.

Parsons (Chapter 6) discusses the power of photography to interrogate tensions and conflicts that arise when constructing Self in relation to Other. In schooling, students are exposed to the world outside family in a manner that can stress the self when exposed to contradictory messages about racism, poverty, gender, and sexual orientation expectations, and the like. Art processes help learners explore these tensions. Parsons calls for a critical practice of photography, focusing attention on the "colonizing gaze" inherent in the history of photography, and develops in his students an awareness, the impact of this gaze on Self and Other. He writes: "Photographic and multitextual images can be used mono- or dialogically. The difference involves making objects out of subjects" (p. 82).

Seppi (Chapter 9) also troubles the notions of identity and culture, specifically the question of what constitutes Native American and American Art as she explores the life and work of Kay WalkingStick. Seppi illuminates the shifting terrain of identity in WalkingStick: of mixed race, raised by her white mother in a white community, at the same time that her Cherokee ancestry is revered in the home. Such anxieties are communicated through WalkingStick's art, as Seppi illustrates. She shows us how Native American art history comes out of a social political situation constituted by a devastating history and, within that history, how Kay WalkingStick's art making embodies personal acts of self-discovery, or performative acts of self-identification. As educators, we try to cultivate a more critical gaze toward self and society, and examining activist art is a powerful vehicle for developing this critical perspective.

Art as Engaged Citizenship

Engaged citizens are both informed and active participants in community affairs within defined spheres of action, including art. Activist art can raise questions, inform, and mobilize action on social justice issues. Examples from our authors are extensive. In Chapter 2, Russell discusses the power of stencil art in the migrant farmworker movement to illustrate their presence and plight, and the indispensability of their labor in food production. In a subsequent contribution, Russell (Chapter 3) also shows the influence of AfroReggae musical performances that convey the independence and self-determination of shantytown dwellers in Rio de Janeiro in their fight against poverty and violence. Ramalho (Chapter 2) does the same for the visual and poetic imagery and songs of the Landless Rural Workers' movement, also in Brazil. Stout's representations of gender-ambiguous individuals challenge us to examine our expectations and to consider moving beyond restrictive gender binaries. Bellamy's art of growing food, as she participates in the Transition Towns sustainability movement, connects local to global concerning food security, and demonstrates the humanizing power of art in the processes of creative problem solving for sustainable communities (Chapter 14).

Art has the power to bring together diverse peoples around a common vision for humanity. Locally, AfroReggae brings the poor people from Rio's *favelas* and its privileged residents of the *asfalto* together for musical performances while drawing inspiration glocally from hip-hop movements around the globe. Baca's mural projects in Los Angeles are occasions for rival high school gang members to meet, reconstruct and represent their heritages as part of the multicultural history of California. Parsons takes his student teachers from upstate New York to work with inner-city students in New York City, using photography to mediate their encounter. Through discussions and reflections on their photographic "give back" project, they create and trouble the knowledges necessary for their development as teachers and learners and, ultimately, as citizens and human beings.

Clark and her colleagues (Chapter 12) show how the creation of narratives and storytelling through the use of social media promotes social justice by affirming, challenging, and disrupting identity politics. Their project combined conversation and writing—a hybrid speech with orality plus literacy—simulating face-to-face dialogue in a community forum. The online simulations, based on writing and telling identity stories, had learners interrogate notions of privilege and justice through a dialogue on race, trying on various identities, and bringing this learning from cyberspace back to engagement in face-to-face conversation about specific race issues on campus. Transversing real and imaginal spaces fostered dialogue among learners about their perspectives; then they shift, consider new perspectives, and move toward action. These examples showcase the power of art to mold citizens who be-

come informed, have the opportunity to shape and experiment with new identities, develop skills, and act in ways that bring about change to their communities. In each of the themes in this concluding chapter we articulate relationships among art, power, and social justice education. These themes are significant on their own but also overlap with and reinforce each other, offering different lenses or vantage points for viewing art, power, and social justice pedagogy. Curriculum brings together ideas expressed in other themes.

Art and the Curriculum

A number of the essays collected here illustrate how art can support learning objectives across the curriculum. In Chapter 8, Kagan describes how elementary and middle school teacher Capella teaches critical literacy and social studies as well as technology integration in her art classes. Kibbey, in Chapter 4, makes an impassioned plea for *visual literacy* and reminds us of the connection between visual media and technological literacy through which students must interpret, negotiate, and make meaning from images they are fed. She writes that

> visual literacy is applicable to all subject areas just as it is broadly utilized in the
> real world—not just compartmentalized in subject-specific courses and text-
> books. In order to prepare literate consumers, visual literacy must be addressed
> in the formal education process. It should begin early in elementary school and
> continue through high school. It should be embedded within the visual art cur-
> riculum, but also with interdisciplinary links and applications to be reinforced
> in all content areas.... (Kibbey, p. 53)

Visual literacy, as a key critical thinking skill, is engaged in all discipline areas. In like manner, new social media technologies, as Clark and colleagues demonstrate in their anti-racist work, have much potential for use throughout the curriculum. Nordlund, Speirs, and Stewart, in Chapter 10, which discusses K–12 teaching of Chicago's *The Dinner Party*, describe curriculum as fluid and changing, with content evolving as new communities of teachers and students add layers of meaning to our understanding of women in relationship to culture, history, and society. They have learned that the best curriculum is flexible and adaptable to different students, teachers, and settings. While the art of *The Dinner Party* is central to this curriculum project, it extends to all curricular areas. For example, the concepts of collaboration and relationships are topics of history and language arts lessons, as prompted by these very important aspects of Chicago's art, as well as by the historical connection between first-wave Women's Movement activists Elizabeth Cady Stanton and Susan B. Anthony, featured figures in *The Dinner*

Party. Art has the power to make the curriculum more integrated, coherent, and above all meaningful to the lives of students.

Impact on Students

Art impacts students in many ways, starting with the development of identity and voice described above. Kagan emphasizes that if the teacher treats the students as artists from a young age as teacher Capella does, the identity sticks, and students *learn techniques, become investigators, step out of their boxes* to understand their own history, and create works of art. She bridges learning in art to learning in life, particularly the ability to navigate through the dominant culture. Students in Capella's class observe the development of multiple projects at multiple stages, they learn the importance of critique and feedback, and they are provided with authentic viewers for their works. In this process, Capella encourages students to *develop the habit of Good Mind* and to *become positive role models* while they live and breathe community.

Beyerbach, in Chapter 1, shares her practice of having student teachers investigate the experiences of ethnic groups in the United States. She employs an arts-based strategy that results in *decreased resistance* of preservice teachers to confronting the historical oppression of Americans from African, Asian, Latino, Middle-Eastern, and Native descent, and to recognizing and challenging prevailing institutional and personal forms of racism and white supremacy.

At the same time that the arts support *raising consciousness* about social injustice, they entice action. Nordlund and colleagues describe teacher Hannah Koch's lessons from *The Dinner Party* Curriculum Project. In one of the activities, students critically *examine the humor, satire, and irony* in political cartoons of suffragist Nina Allender. Students then produce their own cartoons *to provoke and/or persuade an audience*, and submit them to critique. The best cartoons are published in the school newspaper. Students learn that "art…can be a powerful form of activism" (p. 149).

Harrell's imaginal realm, between the mind and the material, is the world of images that ideologies try to colonize and dominate. Paying attention to the imaginal world of students is what education through the arts does best. Expression through art can bring the unconscious to consciousness.

Kibbey describes examples of decolonization and actualization in the student outcomes of visual and media literacy education such as *understanding biases and manipulative marketing and advertising techniques*. Discussing the recognized media literacy program at South Jefferson High School, where students created and exhibited their own media projects to the community, Kibbey writes:

> [Students] learned to be critical viewers, and it opened up new worlds for them. No wonder it was their favorite class, the one they came to school for.

And no wonder they wanted to repeat it. It was an amazing example of a relevant and challenging curriculum where applied learning as well as activism took place. (ch. 4, p. 59).

Likewise, Langlois describes her preservice "gender and visual arts" students' activist projects on topics such as beauty, body image, sexism in advertising, sexual violence, warm masculinity, and racism. They become aware of biases, share personal stories related to oppressions, and take action against these through their projects. She argues for the simultaneous teaching of visual, gender, and media literacy, as well as for art education as a core for General Education to promote social justice activism.

These works indicate that the impact of activist art teaching strategies is cognitive and socio-emotional in nature. Beyond the individual, it can also lead to increased student attendance, retention, and achievement; in other words, the arts can be a central component of successful education and schooling.

Art and the Future

Authors in this volume unite in their vision of art as shining hope for the future: "When educators choose to initiate activist pedagogy, there is accountability to our future" (ch. 10, p. 151). Describing art as an inventive, imaginative, soulful, and humanizing process that raises consciousness and connects us across differences, they voice an urgent need to engage learners in art processes and activist art projects. In activist pedagogy, students critically examine questions as artists and can recognize the power and contributions of visual voice, say Nordlund and associates:

> Teaching directed at social justice, as modeled in *The Dinner Party* Curriculum Project, consists of humanizing a community of learners to become agents of change. Change then emerges from building social capital with those who will act in ways that make social justice in the future. By investing curriculum inclusive of activist art and activist pedagogy aimed at developing students' dispositions of critical thinking, reflection, and social responsibility, educators invest in a changing consciousness." (ch. 10, p. 152)

As Harrell's work with teachers in her *Imagination Through the Curriculum* course shows, images from the collective unconscious, reflecting a culture's myths, fairy tales, and dreams, are embedded in all kinds of art. By becoming aware of these images, we can learn to empathize with the dreams about a more socially just world. Quoting Zabriskie, Harrell writes that imagination is "a laboratory, not a fantasy, a flight, avoidance, or defense, but a vector toward actualization, a way

station between what is and could be" (ch. 5, p. 69). Bellamy likewise reminds us that "We all share at heart a strong peasant consciousness and we know that this is a force that can make revolutions" (ch. 14, p. 200). She argues that an earth-based, community-driven art practice offers hope for our future.

Bellamy's longing for communities to employ artists and art when addressing pressing problems recalls the image we saw of a group of young children on the rooftop of a *favela* in Rio de Janeiro playing violins to the AfroReggae beat of John Lennon's "Imagine," and singing "Imagine all the people, living life in peace...." As this image resurfaces, our souls compel us to action, to continue the struggle in the construction of a more socially just and humane world.

References

Desai, D., Hamlin, J., & Mattson, R. (Eds.). (2010). *History as art, art as history.* New York: Routledge.

Goldblatt, P. (2006). How John Dewey's theories underpin art and art education. *Education and Culture*, 22(1), article 4. http://docs.lib.purdue.edu/eandc/vol22/iss1/art4

Selected Published Resources for Social Justice Through the Arts

For the past several years, in anticipation of writing this chapter, we have been going to conferences with an eye toward finding social justice artist activists and learning more about their work. In addition to attending our regular conferences—the National Association of Multicultural Education, the National Women's Studies Association, and the American Educational Research Association, we also attended art-focused conferences such as those of the College Art Association, the Folk Art Society of America, and the New York State Art Association. We have sought out local exhibitions and performances focused on social justice issues in every town we visited; we have gone to sessions by artists, art educators, activists, and theorists; and we have taken public art tours with the Feminist Art Project in Los Angeles and New York City, and the Folk Art Society in Santa Fe. We are overwhelmed by the number of artist activists we find in each community once we start looking, and by the rich potential for integrating their work into K–16 curriculum. In our own community, we have attended exhibits at the Art Rage gallery (http://artragegallery.org/); explored the poster art of Amy Bartell and Michelle Brisson (http://www.aeoriginals.com/pages/posters.html) distributed by the Syracuse Cultural Workers (http://syracuseculturalworkers.com/); seen activist exhibits at the Syracuse Community Art Center; and attended guest lectures and/or exhibits on our own campus by Sama Alshaibi, Kara Walker, and Sister Corita, to

name but a few. We traveled to Brooklyn to explore *The Dinner Party* exhibit at the Brooklyn Museum. At the National Association of Multicultural Education we attended Gary Howard's session on the Wilderness Project (http://www.nwproject.com/)—an inclusion-oriented multimedia performance aimed at equity, sustainability, and social justice. We spent additional hours investigating curriculum resources on activist art and artists, and we engaged in many conversations with the authors of the essays collected in this volume. As we prepared this manuscript, we encountered others working on volumes on the same topic (e.g., George Noblit and colleagues put out a call for chapters for a book called "A Way Out of No Way, The Arts as Social Justice Through Education" and received 226 chapter proposals [Noblit, personal communication], and Lee Anne Bell and Dipti Desai put out a call for chapters for a special issue of *Equity and Excellence* on Social Justice and the Arts, due out in August 2011) and were encouraged by the proliferation of recent scholarship in this area. The resources shared in this chapter are largely gleaned from these pursuits—glocal in the sense that they grew from a local connection or interaction and often led to global connections, themes, and issues. In no sense, then, can they be said to be exhaustive; rather, they are illustrative of the many resources available to the educator who is looking and listening for activist art.

Selected Resources

Cahan, S., & Kocur, Z. (Eds.). (1996). *Contemporary art and multicultural education.* New York: New Museum of Contemporary Art and Routledge.

This book examines art as a means of social change, including a range of visual images by activist artists, autobiographical information about the artists that sets the work in a larger historical context, and themed lesson plans for using the images with middle and high school students as well as college-level learners.

Coutts, G., & Jokela, T. (Eds.) (2008). *Art, community and environment: Educational perspectives.* Bristol: Intellect.

This resource book for teachers and teacher educators examines the relationships among art, community involvement, and environment in urban and natural contexts around the world. Connections are made between art and issues in environmental biology and social studies courses.

Cowhey, M. (2006). *Black ants and Buddhists: Thinking critically and teaching differently in the primary grades.* Portland, ME: Stenhouse Publishers.

Focused on early childhood, this narrative about Cowhey's interactions with her preschool students incorporates many examples of how arts are integrated to help children think about social justice issues.

Davis, H. (Ed.). (2009). Exhibitions. *The Artists, 26*(5), 16–19.

This article on imagining peace illustrates an example of artist activism for social justice and is appropriate for high school and college-level learners.

Davis, J. (2008). *Why our schools need the arts.* New York: Teachers College Press.

Intended for educators, this book provides a rationale for including arts in the schools as well as multiple examples of how the arts promote critical thinking and action for social change.

de Lange, N., Mitchell, C., & Stuart, J. (Eds.). (2007). *Putting people in the picture: Visual methodologies for social change.* Rotterdam, The Netherlands: Sense Publishers.

The authors illustrate how photo-documentary, drawing, video, and other visual and arts-based tools can be used by educators and activists to engage communities to study and bring about social change.

Desai, D., Hamlin, J., & Mattson, R. (Eds.). (2010). *History as art, art as history.* New York: Routledge.

This is a source of information on the thinking strategies embedded in the disciplines of art and history, with examples of curriculum units focused on social justice topics designed to develop these thinking strategies.

Frascina, F. (2009). *Modern art culture.* New York: Routledge.

Diverse authors explore theoretical issues around themes relating to modern art culture, such as histories and representations, inclusions/exclusions, and bodies and identities.

Gandini, L., Hill, L., Cadwell, L., & Schwall, C. (2005). *In the spirit of the studio: Learning from the atelier of Reggio Emilia.* New York: Teachers College Press.

Written for early childhood educators, this work includes lots of visuals in a descriptive exploration of art contexts in North America, inspired by the creative and well-known early childhood centers in Reggio Emilia, noted for its rich visual and imaginative learning environments and engagement of young children in deep aesthetic experiences.

Goldberg, M. (2006). *Integrating the arts: An approach to teaching and learning in multicultural and multilingual settings.* New York: Pearson Education, Inc.

This book is a practical resource with K–8 lesson plans and descriptions of how to integrate the arts throughout the curriculum in multicultural/multilingual settings.

Goldblatt, P. (2006). How John Dewey's theories underpin art and art education. *Education and Culture, 22*(1), article 4. http://docs.lib.purdue.edu/eandc/vol22/iss1/art4

In this article, Goldblatt synthesizes Dewey's ideas about art as experience, a democratizing force toward humanization.

Greenberg, J. (2008). *Side by side.* New York: Harry N. Abrams.

Appropriate for elementary through high school, this book compiles artwork from around the world, matched with poetry that was inspired by the work, shared in both English and the author's native language.

Hetland, L., Winner, E., Veenema, S., & Sheridan, K. (2007). *Studio thinking: The benefits of visual arts education.* New York: Teachers College Press.

For teachers and teacher educators, the authors argue for the benefits of visual arts education as well as illustrating how to practically create spaces for different types of studio thinking, including lesson plans to promote different types of thinking through a range of media.

Holzer, M., & Noppe-Brandon, S. (Eds). (2005). *Community in the making: Lincoln Center Institute, the arts, and teacher education.* New York: Teachers College Press.

Twenty authors, educators, and teaching artists from K–12 and higher education discuss the rich collaboration between the Lincoln Center Institute and the aesthetic teacher education curriculum based on the work of Maxine Greene.

Houseworth, L.E. (2009, July/August). Kerry Washington: Proof that beauty isn't just skin deep. *Urban Influence,* 57–60.

Kerry Washington's story illustrates how this young actor works for social justice, including women's rights and peace activism.

Johnson, B., & Blanchard, S.C. (2008). *Reel diversity: A teacher's sourcebook.* New York: Peter Lang.

This is a teacher resource for infusing diversity and social justice issues into secondary and higher-education classrooms using pop culture film clips and incorporating lesson plans to promote cross-cultural dialogue.

Krensky, B., & Steffen, S. (2009). *Engaging classrooms and communities through art: A guide to designing and implementing community-based art education.* Lanham, MD: Altamira Press.

For educators and activists alike, authors provide strategies for engaging learners in community-based activist art.

Leavy, P. (2009). *Method meets art: Arts-based research practice.* New York: The Guilford Press.

This book provides an overview and examples of arts-based qualitative research approaches from a variety of disciplines.

Macedo, D., & Steinberg, S.R. (2007). *Media literacy.* New York: Peter Lang.

Articles examine a broad range of issues about critical literacy, how media culture influences decision making and understanding, and how to critically examine media and messages.

Martinez, E. (2008). *500 years of Chicana women's history*. New Brunswick, NJ: Rutgers University Press.

This book is a source of information, images, and history of Chicana women for use in the K–12 curriculum.

Menkart, D., Murray, A.D., & View, J. (2004). *Putting the movement back into civil rights teaching: A resource guide for K–12 classrooms*. Washington, DC: Teaching for Change and PRRAC.

This book is an information-packed resource with many teaching ideas and images to use to help K–12 students understand the civil rights movement and the process of social change.

Meyer, R.K. (2009). The amazed world of Ik-Joong Kang. *The Artists*, *26*(5), 32–37.

The artist's work featured in this article illustrates how to engage young (and all) children in a large-scale social justice visual arts project.

Naidus, B. (2009). *Arts for change: Teaching outside the frame*. Oakland, CA: New Village Press.

This book offers inspiring examples of how the author and others engage community in arts-based activism in many contexts.

Nieto, S. (2008). *Dear Paulo: Letters from those who dare teach*. Boulder, CO: Paradigm Publishers.

This book is based on letters illustrating how Freire has impacted the practice of educators for social change, including examples of arts as contributing to social change.

Olshansky, B. (2008). *The power of pictures: Creating pathways to literacy through art, Grades K–6*. San Francisco, CA: Jossey-Bass.

This book includes many images and ideas for how to use art to promote literacy and engagement of young learners.

Perez, L.E. (2007). *Chicana art: The politics of spiritual and aesthetic alterities*. Durham, NC: Duke University Press.

This book is a resource for teachers, with many images and analysis of the role of artist activists in reclaiming voice and representation of Chicana history.

Powell, M., & Speiser, V. (2005). *The arts, education, and social change*. New York: Peter Lang.

Authors in this book look at how the arts can transform education and society, both in the United States and beyond, across a variety of arts and contexts.

Runnell Hall, M. (Ed.). (2008). *Conscious women rock the page: Using hip-hop fiction to incite social change*. New York: Sister Outsider Entertainment, LLC.

The author offers lesson plans and background information about activist hip-hop, women artists that are sure to engage today's students.

Satrapi, M. (2007). *The complete Persepolis.* New York: Pantheon.

This graphic novel is sure to engage young adult readers and help them understand issues in Iranian culture from the perspective of a young, middle-class woman.

Springgay, S., Irwin, R., Leggo, C., & Gouzouasis, P. (Eds.). (2008). *Being with A/r/tography.* Rotterdam, The Netherlands: Sense Publishers.

Authors examine the role of arts-based research in promoting social change.

Sullivan, G. (2005). *Art practice as research.* Thousand Oaks, CA: Sage Publications.

The author examines multiple examples of arts-based research.

Tafolla, C., & Teneyuca, S. (2008). *That's not fair! Emma Tenayuca's struggle for justice.* San Antonio, TX: Wings Press.

This is a beautifully illustrated children's book in English and Spanish focused on farmworker issues of social justice.

Zinn, H., Konopacki, M., & Buhle, P. (2008). *A people's history of American Empire.* New York: Metropolitan Books.

This is a graphic novel of Zinn's engaging people's history, focused on the struggle for justice.

Selected Websites with Images and Information

Chicana and Chicano Space: http://mati.eas.asu.edu:8421/ChicanArte/index.html

This website is posted by the Hispanic Research Center at Arizona State University. The project directors are Dr. Gary Keller Cárdenas, Regents Professor and Director of the Hispanic Research Center, and Dr. Mary Erickson, Professor of Art in the School of Art. It features art images, analysis, and biographical information, as well as lesson plans of artists such as Yolanda Lopez, Judith Baca, and Frida Kahlo.

Dream Yard Project: http://www.dreamyard.com

The largest arts education program in the Bronx, Dream Yard provides in- and out-of-school art education, with a commitment to social justice. In their work, participants collaborate in art projects that are community based and aimed at building social consciousness and imagination. Art is viewed as a humanizing act.

The Feminist Art Project, Rutgers University: http://feministartproject.rutgers.edu/

This site is a constantly updated resource of history and images of feminist art.

The Fundred Dollar Bill Project: http://fundred.org

> This project engages U.S. students from around the country in creating "fundred" dollars to exchange for real dollars in Washington, D.C., to detoxify soil in New Orleans neighborhoods.

Facing History and Ourselves: http://www.facinghistory.org

> This project uses new media to engage youth from middle school through college in studying history connected to issues in our world today. Operating in eight countries, this professional development resource features current websites, articles, films, study guides, lesson plans, and blogs that reflect themes such as identity, membership, civic participation, stereotyping, and rights. The Arts and Literature theme, for example, includes films such as *Amanda* that focus on the Black South African freedom music and the role it played against apartheid, and an article on how an Indonesian artist used painting to unite a nation.

Independent Television Services: http://www.ITVS.org

> ITVS provides many programs for all ages on topical social justice issues from diverse perspectives. The community classrooms component creates short film modules and curricula for use in the classroom. Some series, such as the Future States Project, use viral media (YouTube) to reach a broader audience. ITVS launches community viewings of films such as *Me Facing Life,* which explores the life of a young woman in prison for life, or *Pushing the Elephant*, about rape as a weapon of war, as well as about peace and reconciliation. The Women's Empowerment Initiative explores global women's issues with lesson plans and activities. *Hip Hop: Beyond Beats and Rhymes* explores gender-based violence.

Kara Walker: http://learn.walkerart.org/karawalker

> Walker is an African American artist best known for room-size tableaux of black cut-paper silhouettes that examine the underbelly of America's racial and gender tensions. Walker's images raise issues relating to themes of race, representation, desire, shame, and the collusion of fact and fiction in history. Her work generates both controversy and discussion of social justice issues.

Landless Voices: The Sights and Sounds of Dispossession: http://www.landless-voices.org/

> This site is a rich archive of art/media-related materials (posters, photos, music, and films) on the Landless Movement in Brazil, based at the School of Modern Languages of the University of Nottingham, U.K.

The National Chavez Center website: http://chavezfoundation.org

> This is a historic resource on Chavez's activism with rich photographic images of historic moments and movements.

The Quilt Index: Documenting and Accessing an American Art: http://quiltindex.org

> This site focuses on quilting arts, historically art of underrepresented groups that can be woven into history lessons K–16.

Sama Alshaibi, artist: http://www.samaalshaibi.com/

Sama Alshaibi is an auto-ethnographic photographer and filmmaker, born in Basra, Iraq, to an Iraqi father and a Palestinian mother. She is now a U.S. citizen. Her provocative work, featured on this site along with biographical information, explores displacement, loss, living in war, and identity. The site features individual and collaborative work drawing from border experiences, and binaries.

Social and Public Art Resource Center (SPARC): http://www.sparcmurals.org

This site is a great resource on Judith Baca's work with high school students in mural construction in Los Angeles, as well as many other real and virtual mural projects for social change.

Tina Takemoto, visual and performance artist and theorist: http://www.ttakemoto.com/

Takemoto is a queer artist/activist/scholar whose work challenges stereotypes and engages critical responses. Takemoto is an associate professor of visual studies at the California College of the Arts, San Francisco, and writes and performs on issues relating to illness, grief, gender, race, and sexuality.

WAAND: Women Artists Archives National Directory [brochure; retrieved from Mabel Smith Douglass Library, Rutgers University]: http://waand.rutgers.edu/

This site features images by women artists.

Yarn Bombing http://yarnbombing.com/

This site features the work of knitters, predominantly women, who install knit graffiti in public spaces with the intention of "improving the urban landscape one stitch at a time." Yarn Bombing installations around the world are featured, as well as discussion forums and community-based activist projects.

About the Authors

Suzanne Bellamy is an Australian artist and writer exhibiting internationally. Her work in art/text fusions explores visual arts and performance processes, the work of Virginia Woolf, Gertrude Stein and lesbian modernism, musical abstraction, ecology, and the history of ideas. Her most recent painting exhibition, "Moving Heaven and Earth," was at the Metro Center, Syracuse, New York, in June 2010. She is completing a Ph.D. in Australian Studies at the University of Sydney. Website: suzannebellamy.com

Barbara Beyerbach is a professor at the State University of New York at Oswego in the Curriculum and Instruction Department. She serves as a co-director of Project SMART (Student-Centered, Multicultural, Active, Real-World Teaching), a teacher professional development program aimed at creating urban/rural partnerships to improve education K–16. She is the author of numerous articles in the areas of teacher professional development, culturally relevant teaching, and professional development schools, and is co-editor (with R. Deborah Davis) of *"How Do We Know They Know?" A Conversation About Pre-Service Teachers Learning About Culture & Social Justice* (2009).

Chris Capella is from the Onondaga eel clan and has been working as an art teacher at the Onondaga Nation School for the past 10 years. She has attended

many state and national conferences on art. Her goal is for her students to see that art is everywhere and that they continue their artwork in high school and beyond. Chris's students continue winning many awards at the annual New York State Fair's Indian Village.

Peter Cavana is an English M.A. student at the State University of New York at Oswego (class of 2011). His background is in adolescent education, English, and French. Presently he is a university Residence Hall Director, Master Writing Tutor for the Writing Center at Oswego, and an adviser in the Student Association.

Judy Chicago is an artist, author, feminist, educator, and intellectual whose career now spans over 4 decades. Chicago pioneered feminist art and art education in the early 1970s, after which she embarked upon her signature work, *The Dinner Party*, executed between 1974 and 1979. Her prodigious career of art making has included individual studio work in an extensive range of media, most recently in glass, and such collaborative series as the *Birth Project*, the *Holocaust Project*, and *Resolutions: A Stitch in Time*. She is also the author of 12 books based on her own artistic production and pedagogical approach, as well as texts that examine the careers of other artists, including her most recent publication *Frida Kahlo: Face to Face*. Chicago has remained steadfast in her commitment to the power of art as a vehicle for intellectual transformation and social change and to women's right to engage in the highest level of art production.

Patricia E. Clark is Director of African and African American Studies and is an associate professor who teaches African American, 20th-century, and contemporary American literature, and black women writers in the Department of English and Creative Writing at the State University of New York at Oswego. Some of Clark's recent presentations and work examine recastings of race and gender identities presented within "classic" literary motifs, narrative structures, and genres in contemporary black American literature. Her published and forthcoming work focuses on comparative foodways in Africa and the Americas, specifically how gender, ethnicity, and national identities are understood and negotiated through narratives about food practices. Clark is currently working on a book manuscript that examines black female subjectivity and identity formation through representations of food practices and rituals in cookbook writing by black women in the United States, the Caribbean, and West Africa.

R. Deborah Davis is currently a tenured associate professor at the State University of New York at Oswego in the Curriculum and Instruction Department, where she teaches *Culturally Relevant Teaching* and *Foundations of Education* and is also the Diversity Coordinator for recruitment in the School of Education, Director of Teacher Opportunity Grant. Davis is also education subdivision editor of the Black Studies and Critical Thinking (BSCT) series at Peter Lang Publishing. Dr. Davis is the author of *Black Students' Perceptions: The Complexity of Persistence to Graduation at an American University* (2004); co-editor with Barbara Beyerbach and Arcenia London of an anthology, *"How Do We Know They Know?" A Conversation About Pre-Service Teachers Learning About Culture and Social Justice* (2009); a book chapter (2009); a book review (2008); a monograph (2004); and various articles and presentations on topics of diversity and socialization in education contexts. Dr. Davis earned her MPA at Maxwell School of Citizenship and Public Affairs, and her Ph.D. in Higher Education Administration, School of Education, Syracuse University.

Mary Harrell is an associate professor for the Curriculum and Instruction Department, School of Education at the State University of New York at Oswego. Mary holds a Ph.D. in psychology with a specialization in depth psychology. As a Jungian-oriented therapist she is in private practice in Oswego. Her research agenda involves educational reform as well as social activism through archetypal psychology. Mary's invited chapter entitled "Social Justice Teaching: Being Fully Present in Relationship," in R.D. Davis, B. Beyerbach, and A. London (Eds.), *"How Do We Know They Know?" A Conversation About Pre-Service Teachers Learning About Culture and Social Justice* (2009), explores the way in which aspects of archetypal psychology enrich teacher-student relationships.

Daniel Herson is currently finishing his master's degree in English literature at the State University of New York at Oswego, focusing on 19th-century literature from a disabilities context. His thesis looks at Poe's Dupin from the context of disabilities studies. Mr. Herson's two undergraduate degrees are in Theatre and Creative Writing, and in 2006 he was awarded the Pillar Prize for children's writing for *Dragon's Breath*, a one-act children's play. Mr. Herson has also published a story, "Castling," in the *Great Lakes Review*.

Jennifer Kagan is an assistant professor at the State University of New York at Oswego in the Curriculum and Instruction Department, where she specializes in literacy issues. She has worked for 9 years in various capacities at the Onondaga Nation

School, as professional development coordinator, literacy coach, inquiry group facilitator, college professor running a clinical literacy course, and tennis coach.

Jacquelyn S. Kibbey is an associate professor and the M.A.T. Art Education Coordinator at the State University of New York at Oswego in the Curriculum and Instruction Department. Previously she was the Art Coordinator for the Fairbanks North Star Borough School District in Alaska for 10 years.

Lisa K. Langlois is an assistant professor of art history at the State University of New York at Oswego. Her research focuses on Japan and gender and national identity formation at international expositions. Her book chapter, "Japan—Modern, Ancient, and Gendered at the 1893 Chicago World's Fair," appears in *Gendering the fair: Histories of women and gender at world's fairs*. Boisseau, TJ and Markwyn, A. eds., (2010), Urbana, Chicago, and Springfield: University of Illinois Press.

Ulises A. Mejias is an assistant professor in the Communication Studies Department at the State University of New York at Oswego. His research interests include network studies, critical theory, philosophy of technology, and political economy of new media. Recent publications include "The Limits of Networks as Models for Organizing the Social" in the journal *New Media & Society*, and "Peerless: The Ethics of P2P Network Disassembly" as part of the 4th Inclusiva-net Meeting organized by Medialab-Prado in Madrid (both in 2010). He has also presented his work in various national and international venues, including the National Communication Association, the Society for Social Studies of Science, the Institute of Network Cultures, and the International Association for Computing and Philosophy.

Carrie Nordlund is an assistant professor of art education at Kutztown University of Pennsylvania. She is the author of articles on reflective practice and feminist pedagogy. Her current research interests also include dialogic classrooms and Waldorf schools. She maintains an art exhibition record promoting an ethic of artist, researcher, and teacher.

Dennis Parsons currently teaches in the Curriculum and Instruction Department at the State University of New York at Oswego, and is committed to sustaining

partnerships with rural and urban public schools. His publications lean toward the examination of literacy, media and the arts, and popular culture.

Tania Ramalho, a Brazilian American, is an associate professor at the State University of New York at Oswego. She teaches critical literacy and pedagogy in the School of Education's Curriculum and Instruction Department. She serves as a board member of the *International Journal of Development Education and Global Learning*, associated with the University of London's Institute of Education and the London Development Center.

Leah Russell is a recent graduate of the master's program in Latin American and Iberian studies at the University of California at Santa Barbara. As an undergraduate she studied several languages, including Spanish, Brazilian Portuguese, and Italian. Her academic work includes conducting research on cultural movements both within the United States and across Latin America, while her activist work focuses on advocating for youth and promoting workers' rights to collective bargaining. She is employed as an English as a Second Language Educator by the Center for Court Innovations, and as an adjunct Women Studies Professor at SUNY Oswego.

Lisa Roberts Seppi earned her Ph.D. in Art History at the University of Illinois, Urbana-Champaign, and teaches modern art, contemporary art and critical theory, and Native American art history at the State University of New York at Oswego. Her dissertation, "Metaphysics and Materiality: Landscape Painting and the Art of Kay WalkingStick," recontextualizes WalkingStick's work in relation to the larger discourse of American art history, including feminist art history and representations of the female nude, the metaphysics of modernism and abstract art, and 20th-century practices of landscape painting. Her essays on Native American art have appeared in *Native American Art in the Twentieth Century: Makers, Meanings, Histories* (1999) and *Native North American Artists* (1997).

Peg Speirs is Interim Associate Dean, College of Visual & Performing Arts, and Professor of Art Education, Department of Art Education & Crafts, Kutztown University. Dr. Speirs has authored and co-authored articles for publication and co-edited the text *Contemporary Issues in Art Education* (2002), published by Prentice Hall. Dr. Speirs is an artist, curator, and co-owner of Gallery 908 in Reading,

Pennsylvania, and Morgan's Retreat, a creative research community under development in Kensington, Ohio.

Marilyn Stewart is Professor of Art Education, Kutztown University. She is the author of *Thinking Through Aesthetics,* co-author of *Rethinking Curriculum in Art,* series editor of the Art Education in Practice series by Davis Publications, co-author of Davis Publications' middle-school art textbook program, and senior author of its elementary textbook series, Explorations in Art. The National Art Education Association named her a Distinguished Fellow in 2010 and National Art Educator of the Year in 2011. A frequent speaker and consultant to numerous national projects, Dr. Stewart has conducted over 160 extended staff-development institutes, seminars, and workshops in over 25 states.

Barbara Stout, in addition to teaching in the Art Department at the State University of New York at Oswego, is currently working on her second public art commission for SUNY Upstate Medical University in Syracuse, New York. Her work has been shown nationally and internationally, including at the China National Academy of Fine Arts, Hangzhou, and Yangzhou Art Gallery in China. Stout has received a New York Foundation for the Arts Mark10 Fellowship and a Washington Island Arts Council Working Artist Grant. Website: www.barbarastout.com

Sharon M. Strong is an English language arts Teacher in upstate New York. She teaches grades 10, 11, and 12. She has a B.A. in English and a B.S. in adolescent education. She is currently pursuing her M.A. in English at the State University of New York at Oswego. She lives with her husband, three children, two dogs, and two cats.

Jane Winslow is a video producer/director of documentary and educational programs revolving around topics in the arts, spirituality, gender, and social issues. At the State University of New York at Oswego, she is an assistant professor in the Communication Studies Department teaching classes in production and post-production, TV screenwriting, and the documentary. Jane has presented at conferences and media festivals nationally and internationally; done gallery shows and published her documentary still photography; and won numerous awards for her video programs, including *Awareness, Option, Control: Take Control,* an all-student-crewed project for the King County Prosecutor's Office, which has won several awards in the professional education program division.

Studies in the Postmodern Theory of Education

General Editor
Shirley R. Steinberg

Counterpoints publishes the most compelling and imaginative books being written in education today. Grounded on the theoretical advances in criticalism, feminism, and postmodernism in the last two decades of the twentieth century, Counterpoints engages the meaning of these innovations in various forms of educational expression. Committed to the proposition that theoretical literature should be accessible to a variety of audiences, the series insists that its authors avoid esoteric and jargonistic languages that transform educational scholarship into an elite discourse for the initiated. Scholarly work matters only to the degree it affects consciousness and practice at multiple sites. Counterpoints' editorial policy is based on these principles and the ability of scholars to break new ground, to open new conversations, to go where educators have never gone before.

For additional information about this series or for the submission of manuscripts, please contact:

Shirley R. Steinberg
c/o Peter Lang Publishing, Inc.
29 Broadway, 18th floor
New York, New York 10006

To order other books in this series, please contact our Customer Service Department:

(800) 770-LANG (within the U.S.)
(212) 647-7706 (outside the U.S.)
(212) 647-7707 FAX

Or browse online by series:
www.peterlang.com